Forms and Functions of Narrative Digital Games

This book looks closely at the endings of narrative digital games, examining their ways of concluding the processes of both storytelling and play in order to gain insight into what endings are and how we identify them in different media.

While narrative digital games share many representational strategies for signalling their upcoming end with more traditional narrative media – such as novels or movies – they also show many forms of endings that often radically differ from our conventional understanding of conclusion and closure. From vast game worlds that remain open for play after a story's finale, to multiple endings that are often hailed as a means for players to create their own stories, to the potentially tragic endings of failure and "game over", digital games question the traditional singularity and finality of endings. Using a broad range of examples, this book delves deeply into these and other forms and their functions, to reveal the closural specificities of the ludonarrative hybrid that digital games are, and to find the core elements that characterise endings in any medium. It examines how endings make themselves known to players and raises the question of how well-established closural conventions blend with play and a player's effort to achieve a goal.

As an interdisciplinary study that draws on game studies as much as on transmedial narratology, *Forms and Functions of Endings in Narrative Digital Games* is suited for scholars and students of digital games as well as for narratologists yet to become familiar with this medium.

Coming from a mixed background in software engineering and comparative literature studies, Michelle Herte graduated at the Institute of Media Culture and Theatre, University of Cologne, where she was a Research Associate. She is currently working in employee training with a focus on digital skills.

Routledge Advances in Game Studies

For more information about this series, please visit: https://www.routledge.com

Forms and Functions of Endings in Narrative Digital Games

Michelle Herte

Routledge
Taylor & Francis Group

LONDON AND NEW YORK

First published 2021
by Routledge
2 Park Square, Milton Park, Abingdon, Oxon OX14 4RN

and by Routledge
52 Vanderbilt Avenue, New York, NY 10017

Routledge is an imprint of the Taylor & Francis Group, an informa business

© 2021 Michelle Herte

British Library Cataloguing-in-Publication Data
A catalogue record for this book is available from the British Library

Library of Congress Cataloging-in-Publication Data
A catalog record has been requested for this book

ISBN: 978-0-367-47991-6 (hbk)
ISBN: 978-0-367-54253-5 (pbk)
ISBN: 978-1-003-03753-8 (ebk)

Typeset in Sabon
by codeMantra

Contents

Figures

Acknowledgements

No researcher is ever alone on the path to a project's completion, and so this book owes much to the constant support of the many people around me. While I am grateful to everyone who guided, advised, motivated, or otherwise helped me along the way, naming them all would seem to be an impossible task, so that the following list is bound to remain incomplete.

First, I would like to express my deepest gratitude to my advisor Benjamin Beil for his unwavering support, helpful advice, and profound belief in my work from its earliest stages onwards. My project benefited no less of the guidance of my advisors Werner Wolf and Jan-Noël Thon, whom I thank for their constructive criticism and insightful suggestions. I also wish to thank Stephan Köhn for lending me his assistance during the study's earlier stages.

I am indebted to the a.r.t.e.s. Graduate School for the Humanities Cologne for accepting me into its integrated track and, thus, providing both financial and ideological support that was instrumental to my project's success. I wish to extend my profound gratitude to the Graduate School's associated professors Hanjo Berressem and Frank Hentschel, as well as the other fellows and associates whose feedback and valuable ideas helped refine my own.

I would like to express my sincere appreciation to my fellow PhD students at the Graduate School and at the Department of Media Culture and Theatre of the University of Cologne for countless stimulating conversations as well as for their invaluable companionship. In particular, I would like to thank Hanns Christian Schmidt, Phillip Bojahr, Léa Perraudin, Federico Alvarez Igarzábal, Mirjam Kappes, and Sung Un Gang.

I am grateful to my publishers at Routledge, specifically to editor Suzanne Richardson for believing in my work and patiently answering all my questions. Only minor changes have been made after this book was accepted as PhD dissertation at the University of Cologne and granted the best possible result of *summa cum laude*.

Special thanks go to my family, my parents, Irene and Jean-Claude, and my sister Nadine for always believing in me and keeping me down to earth.

I am equally grateful to my close friends – near or far – for giving me emotional support and the occasionally much-needed distraction from academia.

Finally, my most heartfelt gratitude goes to my husband Marco for his relentless support and unparalleled patience – and not least for his personal gaming contributions that greatly benefitted my research.

Introduction

"And who cares about endings."[1] – On this study's aim and motivation

Playing a digital game is a process that requires effort – effort that is rewarded by various means. Beyond the scope of demonstrating personal skill by overcoming difficult challenges and "beating" the game, rewards in contemporary digital games are often narratively motivated. On the one hand, uncovering the story's outcome becomes one of the main goals of narrative digital games as it answers "the primordial narrative desire" "to know how it ends" (Ryan 2001b, 257). On the other hand, games promise enhanced emotionality and moral significance by "adapt[ing] to the choices you make", resulting in a "story [...] tailored by how you play"[2] that ideally concludes in the most satisfying way for each player. To be sure, not nearly all narrative digital games participate in the trend of narrative individualisation and multiple endings. Yet, not even those that do are likely to fulfil all the promises made in marketing.

In his review of FABLE III (Lionhead Studios 2010), which compares the morally good and bad paths of the game, journalist Matt Peckham paints a rather gloomy picture of player choice and game endings:

> The game ends the same, whatever you do. [...] Was I expecting more? No, but yes. No, because that's how it's always been in roleplaying games. For the good action, turn to this page. For the bad action, turn to the other. Sometimes the game world shifts slightly, but mostly you're given one of two tacked on endings. And who cares about endings. They're not rewards. How the game plays is. Endings usually disappoint.
>
> (Peckham 2010)

Notwithstanding that Peckham's statement is highly subjective, it appears curious for disagreeing with what is, perhaps, the most widely accepted quality of endings in general, namely their outstanding significance for meaning-making in any narrative media artefact and for the acceptability

of the story's eventual discontinuation (see e.g. Korte 1985, 17; Christen 2002, 10; Hickethier 2007, 117; Wolf 2013, 257f.). Is Peckham's statement, thus, just a spiteful reaction against the ending's conventional status, born from his disappointment with the available outcomes of FABLE III? Or does it point to a medium-specific quality of digital games? Are the endings of the ludonarrative hybrids that narrative singleplayer games are less crucial than those in other narrative media? Yet, if they were, why would multiple endings even be considered a desirable feature, one that is frequently used in advertising? Moreover, is a game's outcome not traditionally vital for players of any game, by its power to mark success or defeat? Can endings, both in digital games and other media, even be as easily separated from the other parts of a reception (or playing) process as Peckham's emphasis on "how the game plays" over how it ends suggests?

These and other questions will be addressed in this study and it will come as no surprise that Peckham's harsh judgement of digital game endings will not be confirmed. While the journalist's low expectations might point to a prevalent flaw in narrative digital games – one that would require an empirical study to be assessed – intersubjective aspects prove that endings are not at all insignificant in the medium. On the contrary, there is much to say about them, both regarding how they are represented and how they function within narrative media artefacts in general as well as with reference to the specific modal and medial qualities of digital games.

While some dedicated contributions to literary and film studies seem to have settled central issues surrounding the subject, there is an awareness "that the notion of ending in narrative is difficult to pin down" (Miller 1978, 3). The multimodal constitution of digital games poses the problem of aligning the "visibly-appointed stopping place" (James [1875] 1986, 37) of their stories with the termination of play, effectuating structures that challenge traditional narratological ideas about the ending – regarding, for example, its position and its finality. Thus, narrative digital games more than ever press the question of what an ending effectively is. It is the purpose of this study to answer this question by identifying a "transmedial core" of the ending that allows to grasp its fundamental qualities beyond the boundaries of single media. Simultaneously, it aims at providing insight into the medial configuration of digital games by analysing the modal interrelations of both their ways of concluding and refusing to conclude on a narrative as well as a ludic level.

Spoiler alert! – What to expect from this book

The research aim of this study is twofold, following both the fundamentally narratological question about the nature of endings – a prototypical element of narrative structures – and the question of how narrative and ludic phenomena interact, clash, or converge in digital games. At first glance, both questions might seem incidental to this study's main research objective: the

forms and functions of digital game endings. Yet, they invariably arise in an analysis that intends to contextualise and explain ending phenomena in digital games beyond their superficial enumeration and classification. Reciprocally, refocusing these questions in the close context of digital game endings adds a fresh perspective to existing research. For the purpose of finding the ending's transmedial core, this study provides a due extension to narratological research on endings, which has not yet considered ergodic[3] and procedural media. For game studies, the focused analysis allows drawing conclusions about the multimodality and the narrative affordances of digital games while avoiding any claim to cover these complex media artefacts in their entirety. As my project is, thus, inherently interdisciplinary, crossing both modal and media boundaries, clear definitions of the terms and concepts used are essential to avoid misinterpretation, both within and of this study – which is, of course, highly indebted to the research it is trying to amend, and that provides its theoretical and methodical foundation.

The first part of this study begins by defining the most abstract principles to establish a secure framework for the analysis. These include narrative and narrativity, which are most appropriately specified in the field of transmedial narratology. At the heart of transmedial narratology lies an abstract, media-independent understanding of narrative that rejects a purely language-centred approach without getting trapped in media-relativistic universalisations, instead accounting for varying affordances in a way that can be called "media-conscious" (Ryan and Thon 2014). To avoid vagueness in abstraction, this study follows Werner Wolf's cognitivist conceptualisation of narrative as a cognitive frame, that is evoked in the recipient's mind by certain signals present within a media artefact, which pertain to an established, intersubjective prototype (see e.g. Wolf 2004). This cognitive definition helps understanding narrativity as a gradable concept, with some media artefacts being more narrative than others, although different media seem more or less prone to narrativity in general. For a better understanding of the affordances that benefit narrativity, which is necessary to understand the narrative potential of digital games, I consult Lars Ellestöm's concept of media modalities that breaks media down into their material, sensory, spatiotemporal, and semiotic qualities, further accounting for their defining qualifying aspects such as conventional practices connected to them (see Ellestöm 2010). Beyond these modalities, ergodicity and procedurality are discussed as defining features of the digital game in addition to its ludic qualities. Regarding the medium's modal hybridity, the concept of cognitive frames is helpful again, since the narrative frame is only one of a range of discursive macro-modes that a media artefact can pertain to such as the argumentative or the descriptive mode (see Wolf 2007). In addition, I propose the ludic as another discursive macro-mode that predominates in (digital) games.

Building on these definitions, the second part of this study's theoretical discussion broaches the issue of ending. Drawing mostly on research

from literary and film studies, the corresponding section elaborates on the ending's role as a prototypical feature in narrative structures and how it relates to the principle of closure. It continues the cognitivist angle of the preceding chapter by following Barbara Herrnstein Smith's definition of closure as the recipient's "expectation of nothing" (Herrnstein Smith 1968, 34) and relating it to a "sense of an ending" (Kermode [1967] 2000) that is evoked by the media artefact. A summary of closural signals, i.e. representational strategies used to evoke this sense of an ending, in literature and film will form a basis for identifying both medium-specific and transmedially relevant means of effectuating closure. Besides affordances resulting from media modalities, conventions – both within and beyond media boundaries – will feature as an important factor for closural expectations. Refusing to take any convention for granted, the chapter subsequently questions the seemingly indisputable role of the ending's position in a media artefact. Although position is of utmost importance, unilinear media artefacts with multiple endings, such as John Fowles' novel *The French Lieutenant's Woman* (1969), prove that it cannot suffice for a thorough definition of what an ending is. To further investigate the essence of endings, they are, finally, assessed against their opposite, i.e. potentially endless continuation in, for example, hyperfiction.

After this primarily narratological introduction of the ending, the second half of Chapter 2 puts it in context of the ludic mode, following the question if and how games prototypically end. Indeed, teleology is highly relevant for games, which prototypically include goal rules that define their endpoint and valorise their outcomes. The discussion of various types of goals and styles of play occasionally leaves the realm of narrative digital singleplayer games, which is otherwise the declared focus of this study. The distinct affordances and conventions of non-narrative and multiplayer games affect the potential end of play to a considerable degree that goes beyond the scope of my project, for example, because a social dimension affects prevalent goals and incentives for play. In contrast, some types and goals of play closely resemble prototypical characteristics of narrative endings, hence suggesting the potential of ludonarrative synergies in narrative digital games.

This potential is further assessed in the subsequent close analysis of digital game endings, which begins with the examination of their inner workings in Chapter 3. In order to identify the conventional representational strategies that are used to evoke closure in the medium, the chapter examines endings in isolation from the remaining parts of a game. A typical digital game ending can be divided into four main phases: (1) the beginning of the end, (2) the ludic finale, (3) the narrative finale, and (4) the paratextual ending phase. All phases are characterised by a variety of conventional closural signals, which will be identified qualitatively from a broad corpus of narrative digital singleplayer games, historically ranging from the 1980s to today, with a focus on contemporary examples. Despite

my attempt to cover a wide range of games and genres, there is no need to deny that, just as in any other game-related research that requires a broad overview over the medium, "the game researcher enters the field with preferences for specific types of games, and the selection of games influences the researcher's arguments" (Juul 2005, 17). Nevertheless, this influence is, arguably, negligible at least for some aspects of this study, given that it focuses on identifying ending conventions, disclosing their representational variety without claiming to be comprehensive. Apart from their closural effect, the representational strategies discernible from the corpus will be checked for their modal pertinence, i.e. if they predominantly trigger the ludic or the narrative frame, potentially exhibiting multimodal functionality if they address both. Furthermore, representational strategies found in digital game endings might fulfil other functions than that of evoking a sense of an ending, for example, inducing the wish to prolong instead of terminating the playing process. In this context, the chapter also discusses how closural conventions can be undermined and to what effect. These questions are the focus of the chapter's concluding analysis of THE STANLEY PARABLE (Galactic Café 2013), which combines a dense metareferentiality that exposes various digital game tropes with a variety of endings that thoroughly undermine conventional expectations of closure.

Finally, the micro forms identified in Chapter 3 will be used in a broader perspective that relates endings to the overall structure of digital games in Chapter 4. Seen in context, digital game endings reveal structural forms that appear specific to the medium, from circular structures that are generally known from other media but enhanced by the digital game's procedurality (e.g. in JOURNEY [thatgamecompany 2012]) to the inherently ludic feature of failure and its potentially game-terminating effect – "game over" – that remains in an ambivalent relation to closure. Most of these forms entail a pluralisation of the ending that seems to contradict its defining finality and meaning-making power in the narrative prototype. While fake endings, which first evoke and then revoke closure, appear as a metareferential and still unconventional deviation from the prototypical "Aristotelian unity" (Wolf 2004, 90) of beginning, middle, and end (see Aristotle 2008, 14), the "post-ending phases" of open world games and various forms of multiple endings are as conventional in the medium as the "premature" endings effectuated by failure. For the purpose of determining the representational and functional variety of these macro forms, the chapter relies on the same, broad corpus of narrative digital games as Chapter 3, occasionally providing case studies of peculiar examples. For instance, FALLOUT 3 (Bethesda Game Studios 2008) serves to highlight the ambiguous closural effect of endings in open world games by opening its game world for post-ending play only with the release of downloadable content (DLC), and the 32 outcomes of ZERO TIME DILEMMA (Spike Chunsoft 2016) vividly exemplify crucial functionalities of multiple endings in digital games. In general, the chapter will show that the ludic and

narrative functions of all discussed structural variations can range from diverging (e.g. in open world games that ludically open a game after its narrative completion) to converging (e.g. in games with multiple endings that use the defining ludic variability of outcome for narrative individualisation). Transmedial considerations will feature throughout this study, especially where a comparison of media qualities directly contributes to the analysis of ending forms and functions.

In light of the ever-increasing prevalence of digital technologies, media boundaries keep blurring. The (at the time of this study's finalisation) recent interactive film BANDERSNATCH (David Slade 2018) – a stand-alone film that is closely tied to the anthology TV series BLACK MIRROR (Charlie Brooker and Annabel Jones 2011–2018), blurring media boundaries in this aspect as well – is only one example among many, but one that shows the relevance of discussing endings in a transmedial context. Being distributed via the streaming service Netflix, BANDERSNATCH relies on the service's digital disposition to incorporate interactive, or ergodic, features, demanding viewers (or players?) to make decisions in predetermined situations. As a film, BANDERSNATCH seems outstanding, or at least unusual for the multiplicity of endings that results from these user choices and that is highly unconventional for the medium. Yet, if it were to be seen as a digital game – "interactive film" as a genre label is often applied to narrative digital games with comparatively low ergodicity, ranging from DRAGON'S LAIR (Rick Dyer / Don Bluth 1983) to LIFE IS STRANGE (Dontnod Entertainment 2015) – the multiple endings of BANDERSNATCH merely conform to a highly conventionalised way of "ludifying" stories that even traces back to non-digital ludic artefacts, such as the "Choose Your Own Adventure" books, which figure prominently in the film. While this study does not purport to redefine media – or even just endings – in order to explain such borderline phenomena, it seems clear that understanding the forms and functions of endings and how these are affected and re-formed by media-specific affordances and in multimodal contexts can help understand the often highly specific constitutions of contemporary narrative media artefacts.

Notes

1 Quoted from Peckham (2010).
2 Both quotes are taken from the paratextual message "This game series adapts to the choices you make. The story is tailored by how you play", which famously appears in most adventure games by Telltale Games, first occurring in THE WALKING DEAD (Telltale Games 2012).
3 Espen Aarseth introduces the term *ergodic*, which "derives from the Greek words *ergon* and *hodos*, meaning 'work' and 'path'" as a specific quality of media artefacts that require "nontrivial effort" to be traversed by the user (Aarseth 1997, 1). The term and its possible advantage over the related and more commonly used *interactive* are further explained in Chapter 1.2.

1 Transmedial narratology and the multimodality of narrative digital games

1.1 Transmedial narratology – A media-conscious approach to the study of narrative

Framing the project of transmedial narratology

Narrative has always been a phenomenon spread across different media, a fact that has increasingly gained relevance as well as recognition with the significant growth of media diversity during the 20th century.[1] As it is now "well-known that we humans are story-telling animals and that our stories can be transmitted by more media than verbal texts [...], further belabouring these and similar facts is no longer necessary in narratology" (Wolf 2014a, 126). Wolf's remark implies that such "belabouring" is not only abundant in narratological studies that address (either exclusively or additionally) any other than the verbal medium but also that it indeed seemed necessary in the light of verbally biased classical narratology that initiated and, thus, formed and dominated narratology as a discipline (see Meister 2014, 623; Ryan 2014a, 471). Even the general acceptance of the media diversity of narrative barely affected the prevalence of verbally biased concepts in narratology (see Kuhn 2011, 25), which can largely be attributed to the vast influence of Gérard Genette. Following his work, "narratology developed as a project almost exclusively devoted to literary fiction" (Ryan 2014a, 471). Transmedial narratology is an attempt to fill this gap between the long-acknowledged diversity of narratology's research objects and its well-established, but monomedially restricted theories and methods. While there is no strictly unified research project, it may safely be assumed that each attempt to conceptualise narrative in a transmedial, intermedial, or cross-medial way pursues the goal of what Marie-Laure Ryan and Jan-Noël Thon call a "media-conscious narratology" (Ryan and Thon 2014).

First of all, some terminological clarification seems due, since so much as naming the project seems to be fuel for discussion. Indeed, all three terms – transmedial, intermedial, and cross-medial – have been used to describe the occurrence of narrative across various media. But even though each approach pursues its own specific research question guided by a more or less explicit

explanation of the chosen terminology, there is no consensus about their exact meaning. While "cross-medial" is less used in narratology (a rare example being Meister et al. 2005) than "in the context of journalism or advertisement campaigns" (Thon 2016, 28), the varying uses and presumed relations of transmediality and intermediality are quite complex. As arguably the most widespread term, intermediality has a particularly rich research history in its originating realm of German-language academia (see Wolf 2002a, 18). Wolf even defines transmediality as a subset of intermediality (see Wolf 2002a, 28). Yet, despite his strikingly different typology, Wolf's understanding of transmediality is congruent with that of Rajewsky who distinguishes the three basic categories of intramedial (involving only one medium), intermedial (involving at least two distinct media), and transmedial (media unspecific) phenomena (see Rajewsky 2002, 13). Although Rajewsky's definition of transmediality "remains relatively vague" (Thon 2016, 29) due to her study's focus on intermediality, it is clear and convincing enough to support the choice of calling the project in question *transmedial* rather than *intermedial* narratology, because narrative fits the definition of phenomena that are delivered through a wide variety of media, without necessarily tracing back to a particular "source medium" while their realisations are still shaped by each medium's specific means (see Rajewsky 2002, 13). Since Wolf's and Rajewsky's conceptualisation "tends to privilege representational strategies rather than what these strategies represent" (Thon 2016, 30), it is also distinguished from transmediality as it appears as a trending buzzword even beyond academia in the context of transmedia storytelling (see Jenkins 2006), which foregrounds narrative content (see Thon 2016, 27).

Rather than as yet another terminological alternative, Thon and Ryan introduce the aforementioned "media-conscious narratology" as a methodological statement on how transmedial narratology should operate in response to existing criticism of the project. Accordingly, the idea of "media-consciousness" aims "at the middle ground between 'media blindness' and 'media relativism,' acknowledging both similarities and differences in how conventionally distinct narrative media narrate" (Thon 2016, 21).[2] A brief discussion of some arguments opposing transmedial narratology will explain why this seemingly trivial demand of a middle ground is a necessary precondition for any narratological study concerned with multiple media, or at least striving to be transmedially expandable.

First, there is the issue of media blindness, which is less an argument against transmedial narratology than a methodological problem. Defined as "the indiscriminating transfer of concepts designed for the study of the narratives of a particular medium (usually those of literary fiction) to another medium" (Ryan 2004, 34), media blindness seems to bear more relevance to narrative studies of single media than to transmedial narratology in particular. Early narratological studies of digital games, for example, have often been accused of this practice, and the expansion of the narrator concept beyond the realm of the verbal stems from the same ignorance of

media specificities (see below). Although the actual effect of media blind-
ness on narratology in general might remain "questionable", as "what at
first glance may appear to be a severe case of 'media blindness' will, on
closer examination, often turn out to be a matter of emphasis rather than
principle" (Thon 2016, 21), the idea still serves as a useful reminder for
transmedial narratology to constantly question the applicability of its own
concepts rather than unjustifiably universalising every aspect of narrative
found in established monomedial narratological studies. The importance of
this reminder cannot be overstated, as transmedial narratology necessarily
builds upon established theories which are either biased towards a single
medium or, even worse, only "seemingly independent of [... but] implicitly
tied to a particular medium" (Hausken 2004, 392).

Yet, there are many reasons for expanding existing narratological con-
cepts beyond their original monomedial use. Wolf proposes four criteria to
determine if such a transfer can be meaningful: (1) "[t]he export-facilitating
potential of the phenomena under consideration" (i.e. a preferably low
degree of medium specificity of the concept), (2) "a clear narratological
conceptualization" (i.e. a precise definition that is flexible enough for the
concept to be exported), (3) "formal appropriateness" (i.e. a similarity of
the phenomena under consideration that can be observed in a broader con-
text than that of single media artefacts), and (4) "the heuristic value of
the exported notion for the use in the import field" (i.e. to fill in a termi-
nological or conceptual gap in the target domain) (Wolf 2005, 86–8). Al-
though these criteria appear somewhat fuzzy themselves and are ultimately
dependent on the scope and aim of each study that exercises such an export
of concepts, referring to and reflecting them as a guideline at least ensure a
media-conscious treatment of narratology to a certain degree.

Second, on the far end of the extreme of media blindness, there is media
relativism, which forms an actual opposition against the idea of transme-
dial narratology itself:

> Radical relativism regards media as self-contained systems of signs, and
> their resources as incommensurable with the resources of other media.
> [...] This view comes in a strong and a weak form. In the strong form,
> the signified cannot be separated from the signifier. [...] [T]he strong
> interpretation kills in the egg the project of transmedial narratology. In
> its weaker form, media relativism accepts common meanings but insists
> on the uniqueness of the expressive resources of each medium, thereby
> forcing the theorist to rebuild the analytical toolbox of narratology
> from scratch for every new medium.
>
> (Ryan 2005, 3)

Therefore, radical relativism would dismiss even a well-considered transfer
of concepts that follows Wolf's criteria, as it does not acknowledge simi-
larities between phenomena in different media, so that there can never be

"formal appropriateness". The attempt given by Ryan herself to invalidate the relativist position by enumerating some terms and concepts that have already been successfully applied across media (see Ryan 2005, 3) might appear understandably sketchy and unconvincing to non-narratologists in particular (see Eskelinen 2012, 201). However, a more clear-cut refutation seems superfluous in the light of transmedial narratology's prevalent definition of narrative as a cognitive schema (see Wolf 2004) that, first of all, entails a level of theoretical abstraction from "the unique expressive resources of each medium" (Eskelinen 2012, 200) that are overemphasised by media relativism. Hence, the explanation of this cognitive approach in the following shall suffice to demonstrate the inadequacy of media relativism in this context. For those who may still not be convinced, I will combine this approach with Lars Elleström's concept of media modalities to substantiate "the fact that different media often incorporate common tracks or semiotic systems" (Ryan 2004, 34).

The media relativist position is supported by a third opposition that lies within the verbally biased roots of classical narratology and that, according to Ryan, forms "the main obstacle to the transmedial study of narrative [...], namely [...] the language-based, or rather, speech-act approach to narrative" (Ryan 2005, 2). In such an approach, "the condition for being a narrative is the occurrence of the speech act of telling a story by an agent called a narrator" (Ryan 2005, 2), which obviously denies narrative potential to all media that lack a verbal dimension. Although occasional cases of extreme expansions of the concept of narrative indeed advise caution in broadening the definition (see Ryan 2005, 3), it is questionable how and why one would still prefer this restrictive approach in the light of an abundance of studies of narrative in non-verbal or at least not verbally dominated media that exist today. According to Monika Fludernik, the reluctance to let go of the narrator concept can be attributed to the roots of narrative in oral storytelling (see also Ryan 2014a, 475):

> [O]ne can trace the recurrent personalizations of the narrative function which regularly results in the ontology of a 'narrator' to the influence of the very same schema, namely that of the typical storytelling situation: if there is a story, somebody needs must tell it. [...] The persistence of this preconceived notion that *somebody* (hence a human agent) must be telling the story seems to derive directly from the frame conception of storytelling rather than from any necessary textual evidence.
>
> (Fludernik 1996, 47)

Even if a narrator were considered an essential part of the narrative prototype – which it is not in the definition used in this study – a single deviation from this prototype does not result in a media artefact being non-narrative or lacking in narrativity (see below). It seems there is merely a historical, or rather etymological, reason for insisting on the presence of

a verbal narrator. Yet, in the same way language is known to constantly change, it is only appropriate to reconceptualise terms and definitions to fit the contemporary reality of their related research objects, i.e. in this case, narrative artefacts spread across an itself constantly changing media landscape. The project of transmedial narratology is ultimately devoted to this cause, and accordingly dismisses the narrator as a prerequisite for narrativity (see Wolf 2004, 91).[3]

In his criticism of the project, Markku Eskelinen describes this dismissal as a feeble attempt of finding something transmedial in narrative other than the story (see Eskelinen 2012, 201). At the same time, he accuses transmedial definitions of narrative of "destroy[ing] the distinction between story and narrative, by reducing the latter to the former" (Eskelinen 2012, 201). Indeed, phenomena on the level of story – which, "[a]s a mental representation, [...] is not tied to any particular medium" (Ryan 2007a, 26) – can easily be recognised as transmedial and, thus, constitute a good portion of narrative's prototypical features (see below). Ryan even concludes that

> if narrative is a discourse that conveys a story, this is to say, a specific type of content, and if this discourse can be put to a variety of different uses, none of them constitutive of narrativity, then its definition should focus on story.
>
> (Ryan 2007, 26)

A focus on story, however, need not be equivalent to a limitation to story, and despite Ryan's admittedly dubious conclusion, she rightly notes that "narrative is a *discourse*" (Ryan 2007, 26, my emphasis), just as Chatman, in a passage also quoted in Eskelinen's criticism (see Eskelinen 2012, 201), defines "any text that *presents* a story" (Chatman 1990, 117, my emphasis) as narrative. Since even in classical narratology, there is far more to narrative discourse than the presence of a narrator, dismissing it as a narrative prerequisite does not result in story being the only viable transmedial aspect of narrative.[4] Although most elements of discourse are indeed highly dependent on the individual resources of each medium, there are still some major characteristics of narrative which cannot be attributed to story alone. One of these characteristics is the ending, as I will argue in this book. In order to provide a solid theoretical foundation for this argument, it is first necessary to discuss the definition of narrative and narrativity that transmedial narratology offers.

Narrative, narrativity, and narremes

In contrast to classical approaches that focus on what narratives are and which elements constitute their structures, transmedial narratology – in accordance with other narratological strands such as cognitive narratology – shifts the emphasis to the question of how and why certain media artefacts

are perceived as narratives, or which features contribute to their overall narrativity. While the use of narrative as a noun entails a binary classification of media artefacts, narrativity refers to narrative as an adjective, implying a qualitative difference between more and less narrative artefacts:

> The term's advantage [...] is built into its grammatical status as a reference to a property or properties rather than to a thing or class. As what one might call an 'adjectival' noun, narrativity suggests connotatively a felt quality, something that may not be entirely definable or may be subject to gradations.
>
> (Abbott 2014, 588)

Such a gradable concept is a fundamental prerequisite for a functioning transmedial narratology, as it allows a comparison of artefacts across various media under the same label (narrativity) without claiming a false uniformity that would undermine media specificities. Furthermore, it enables narratological analysis of media artefacts that may not be predominantly narrative, but that bear some interesting narrative qualities, as is often the case with digital games.

In what is probably the first thorough attempt at defining the term, Gerald Prince emphasises that, in addition to textual criteria, any artefact's degree of narrativity is highly dependent on the subjective interests of the recipient and the general reception context (see Prince 1982, 147). This significance of subjectivity for determining narrativity, as dissatisfying as it might seem to someone looking for a clear-cut definition, must not be mistaken for the pan-narrativism that occasionally sprouted during the so-called "narrative turn" (see Prince 1996, 97f.), in which anything is subsumed under the category of narrative as long as someone can somehow tell a story about it.[5] Rather, it is an effect best explained by a cognitive approach, such as that of Werner Wolf, who adapts cognitive frame theory and earlier cognitive narratology (see e.g. Fludernik 1996) for an explicitly transmedial narratology (see Wolf 2002b, 2004, 2006, 2014a). Here, narrative is defined as "a cognitive frame or schema" (Wolf 2004, 84), i.e. a phenomenon inherently "located in the minds of people" (Wolf 2004, 84). Similarly, Ryan mentions the "narrative script" as a "mental image" (Ryan 2005, 6), tying her concept to the aforementioned difference between narrative as binary and narrativity as a gradual category by distinguishing

> between 'being a narrative', and 'possessing narrativity'. The property of 'being a narrative' can be predicated of any semiotic object produced with the intent to evoke a narrative script in the mind of the audience. [...] 'Having narrativity', on the other hand, means being able to evoke such a script.
>
> (Ryan 2005, 6f.)

The vague factor of subjectivity that is found in Prince is formalised by the cognitive approach as individual variations of such scripts, schemata, or frames that, by definition, possess a certain intersubjective stability:

> [O]n the one hand frames are cognitive guides of interpretation that are cultural constructs and hence have a certain historical and cultural flexibility according to different cultures and periods. [...] This 'dynamic' plasticity also applies to the modification of frames through personal experiences or cultural artefacts that open up new perspectives and contribute to the emergence of new frames. On the other hand, as acquired notions, frames have at least a relative stability and tend, in particular in everyday situations, towards stereotyping (otherwise they could not function as interpretive guides nor could they raise expectations).
>
> (Wolf 2006, 4)

This tendency towards stereotyping enables narratologists to find the features that are most likely to trigger the narrative frame in the mind of a recipient and hence to make them perceive an artefact as narrative. Here, the artefact itself finally comes into play as the material interface where those features manifest in the form of "framings", i.e.

> codings of abstract cognitive frames that exist or are formed within, or on the margins and in the immediate context of, the framed situation or phenomenon and – like the corresponding frames – have an interpretive, guiding and controlling function with reference to it.
>
> (Wolf 2006, 6)

Note that by this definition, framings can pertain to paratextual as much as to intratextual phenomena (see also Wolf 2014a, 128) – this will become particularly relevant in the analysis of endings.

Given the cultural, historical, and individual flexibility of cognitive frames, it is impossible to define a comprehensive list of framings that are mandatory for the activation of the narrative schema. Instead, the cognitive approach and the assumption of narrativity's gradability call for "a relatively flexible conceptualisation in which a maximum number of traits constitute the ideal prototype as an abstract notion or schema, while concrete phenomena are assessed according to their greater or lesser resemblance with the prototype" (Wolf 2004, 85). Consequently, in such a prototypical or, in Ryan's terminology, "fuzzy-set definition" (Ryan 2007, 28) of narrative, narrativity increases with the number of framings, or, in this case, "narremes" (Wolf 2017, 260),[6] present in the media artefact. There is not yet a final consensus about which traits exactly should be considered essential parts of the narrative prototype – a deficiency that may be attributed as much to the flexibility of cognitive frames as to the general problem of any

academic discipline to unanimously define its main research object. I will limit my discussion of definitions to those most relevant in the immediate context of transmedial narratology, namely that of Marie-Laure Ryan and that of Werner Wolf.

Ryan, who early on provided one of "the most systematic and promising work[s] on narrativity" (Prince 1996, 99), describes her own definition of narrative as "an open series of concentric circles which spell increasingly narrow conditions and which presuppose previously stated items, as we move from the outer to the inner circles, and from the marginal cases [of narrativity, MH] to the prototype" (Ryan 2007, 28). Being slightly rephrased and regrouped each time Ryan addresses the issue, these concentric circles start with the "spatial dimension" of "a world populated by individuated existents" that is, second, "situated in time and undergo[es] significant transformations" which are "caused by non-habitual physical events" ("temporal dimension") (Ryan 2007, 29). The third, "mental dimension" of Ryan's model specifies that these events be related to the "goals, plans, [and] emotions" (Ryan 2005, 4) of "intelligent agents" (Ryan 2007, 29). Finally, there is the "formal and pragmatic dimension" which attributes causality, coherence, closure, factuality of the events within the storyworld, and meaningfulness to the narrative (see Ryan 2007, 2). Although some of the formal and pragmatic criteria could as well be defined as pertaining to discourse,[7] this set of conditions clearly fulfils Ryan's demand to focus a transmedial definition of narrative on elements of story. At least, the story-related view is the way Ryan herself intends the conditions to be understood, as she emphasises when conceding another, discourse-related understanding of narrative degrees that she, however, explicitly refrains from (see Ryan 2007, 34).

While Ryan's fuzzy set of conditions certainly contains the main contributors to narrativity, Wolf points out that discourse is also "pertinent to narratemes" (Wolf 2004, 91). Building upon a list of narrative features by Prince that closely resembles Ryan's conditions (see Prince 1996, 98), Wolf argues that a solely story-centred approach turns out to be too narrow:

> A narrative as the concretisation of the corresponding cognitive frame is the representation of (elements of) a possible world that is 'dynamic' owing to a temporal dimension and can be (re)experienced in the reception process; it comprises different states or events that are centred on the same anthropomorphic being(s) and are related to each other in a potentially meaningful way which includes more than mere chronological sequence.
>
> This formula only enumerates core narratemes whose absence renders the narrativity of a given text or artefact questionable, but does not yet describe the prototype in full. For this, additional narratemes are required [...]

(Wolf 2004, 89–91)

Accompanying this quote is a figure that gives a decent overview of nar-remes (see Wolf 2004, 90) which is, however, not meant to be carved in stone, as Wolf showed in a recently revised version of it (see Wolf 2017, 261). A comparison of the two versions reveals that, unsurprisingly, the "core narratemes" mentioned earlier are the most stable features of the model, while "additional narratemes" have both been dropped (e.g. "fictionality", "Aristotelian unity" or "'strategic' repetition") and added ("(seeming) past-ness of the story") (compare Wolf 2004, 90, 2017, 261).

Since a thorough discussion of all possibly narrativity-inducing framings goes beyond the scope of this study, more intriguing than the changes of single features in Wolf's model is his classification of narremes into differ-ent types and degrees of importance. First, the distinction between "core-narremes (indispensable for all narratives)" and "additional narremes (present or implied in typical narratives; may be missing in less typical narratives)" (Wolf 2017, 261) adjusts the simplified formula of "the more narremes present, the higher the degree of narrativity" by ascribing nar-remes at least the basic "comparative weight and [...] relative importance" (Prince 1996, 103) that Prince called for. Second, Wolf finds narremes to operate on different levels of narrative and hence divides them "into three groups: a) general, qualitative narratemes (or 'basic narremes' in the revised version [see Wolf 2017, 261]), b) content narratemes, and c) syntactic nar-ratemes" (Wolf 2004, 88). The first group contains the most abstract qual-ities of narrative: representationality, experientiality, and meaningfulness, the latter being its only plain overlap with Ryan's conditions of narrativity. Most of Ryan's conditions, i.e. her first three dimensions of narrative, cor-relate with Wolf's second group of "content narratemes" that holds the "'building blocks' of narrative possible worlds and mainly concern[s] the level of *histoire*" (Wolf 2004, 88), providing spatial and temporal setting, events, and intelligent agents. In charge of the "narrative 'mortar'" (Wolf 2017, 261) are the "syntactic narratemes, which predominantly involve the level of *discours,* [and which] result from a specific selection [...], combi-nation and presentation of the aforementioned building blocks. Together with these they contribute to realising the general narratemes" (Wolf 2004, 88). While all of Ryan's conditions can be found neither in the original nor in the revised version of Wolf's list of narremes, clearly most of what she identifies as the "formal and pragmatic dimension" of narrative belong to this third group, even though this gives them the discourse-related meaning that Ryan tried to avoid.

Bringing the "medial" into transmedial narratology – Narrative potential and media modalities

As Ryan's dismissal of discourse criteria resulted primarily from her de-mand of a medium free definition of narrative, instead of arguing about the pertinence of single criteria to the level of story or discourse, it should

be verified if the given definitions satisfy this demand. As a matter of fact, the medium free basis for the definition of narrative provided by cognitive frame theory – which defines framings (including narremes) as equally abstract, and thus transmedial, as their corresponding frames (see Wolf 2006, 10) – does not ensure a thoroughly "media neutral" (Wolf 2017, 260) selection of narremes. An early version of Wolf's transmedial approach has accordingly been criticised for its literary bias in reference to the narrative prototype (see Wolf 2002b; Kuhn 2011, 54; Thon 2016, 28) which he disposed of in his refined definition, quoted earlier. Both Wolf's and Ryan's conditions are indeed phrased and defined in a sufficiently abstract way to fulfil the demands of media neutral narremes. Yet, both agree "that media are not neutral conduits without any impact on what is transmitted by them" (Wolf 2014a, 126), "[b]ut the shape of the pipe affects the kind of information that can be transmitted, alters the conditions of reception, and often leads to the creation of works tailor-made for the medium" (Ryan 2014a, 468). Hence, although "thinking narrativity and its possibilities in general requires these factors' bracketing" (Prince 1996, 101),[8]

> every transmedial approach to narratological analysis that is not able to in some way specify its concepts with regard to the question of how these phenomena are realized in different narrative media runs the risk of losing a significant amount of its analytical power.
>
> (Thon 2016, 25)

I emphasise this because of impending confusions between discussing narratology as a theory, which necessitates abstraction to highlight the universal features of narrative, and using narratology as a method, or toolkit, that requires a consideration of the media in which the frame narrative is realised within actual media artefacts (see Thon 2016, 5).

Besides the fact that the medium shapes the realisation of narremes, it is also important to note that different media are not equally suited for evoking the narrative frame (see Ryan 2004, 12; Herman 2009, xiif.; Wolf 2014a, 126). This difference in narrative potential results directly from the media's specific affordances that entail a varying aptitude to implement certain narremes. For example, many of the core narremes – actions/events, causality, teleology, and chronology (see Wolf 2014a, 90) – rely on a form of temporality that allows the representation of change, which single pictures, for example, can at best suggest (see Wolf 2004, 94). In the context of "defining media from the perspective of transmedial narratology" (Ryan 2005, 18), Ryan provides a list of features that influence a medium's narrative potential: (1) The "spatio-temporal extension" divides media into "purely temporal", "purely spatial", and "spatio-temporal" ones (Ryan 2005, 19). Closely tied to this are the (2) "kinetic properties" which define a medium as either "static" (necessarily all purely spatial media) or "dynamic" (necessarily all purely temporal media) (Ryan 2005, 19). Furthermore, media

differ according to (3) the "number of [sensory] channels" they employ and (4) the "priority" these sensory channels are given (Ryan 2005, 19). These features "affect the narrative experience" (Ryan 2005, 19) by providing the necessary affordances to realise certain narremes. Hence, the feature of "temporal extension" enables a medium to easily realise the core narremes mentioned earlier. A model that is more elaborated than Ryan's brief list is that of media modalities by Lars Elleström (2010).

Elleström developed the concept of media modalities as a basis for comparative media studies (or intermedial studies, in his terminology) that identifies media bottom-up by their inherent as well as culturally and conventionally ascribed qualities, as opposed to other definitions that are tailored to "a small selection of established media and their interrelations" (Elleström 2010, 35).[9] His idea of "seeing a medium as a complex of interrelated facets" (Elleström 2010, 37) resonates with what Thon perceives as the "consensus both within media studies and beyond [...] that the term is best understood as referring to a multidimensional concept" (Thon 2016, 17), while his integration of the concept of multimodality results in a more detailed and systematic model than the examples of the multidimensional approaches by Schmidt and Ryan that Thon discusses (see Thon 2016, 17f.; see also Schmidt 2000; Ryan 2005, 2014a). Roughly corresponding to what are the institutional (Schmidt) and the cultural (Ryan) dimensions in those approaches, Elleström complements his modal definition with "two qualifying aspects" (Elleström 2010, 24) that address the "origin, delimitation and use of media in specific historical, cultural and social circumstances" ("contextual qualifying aspect"), and "the aesthetic and communicative characteristics of media" as they are formed by convention ("operational qualifying aspect") (Elleström 2010, 35). Since "none of these qualifying aspects are truly stable" (Elleström 2010, 26), they encourage a media definition that is conceptually close to my adopted definition of narrative, namely "a prototypical understanding of mediality and of what constitutes a conventionally distinct medium" (Thon 2016, 19).

Although a reflection of the qualifying aspects is thus crucial to any meaningful comparison of media, the narrative potential of a medium is primarily determined by the core of Elleström's model, the four modalities: "I call them the *material modality*, the *sensorial modality*, the *spatiotemporal modality* and the *semiotic modality*" (Elleström 2010, 15, original emphases). Before further defining these modalities, Elleström emphasises that they form a holistic concept,

> [A]ll media [...] are necessarily realized in the form of all four modalities; hence, it is not enough to consider only one or a few of them if one wants to grasp the character of a particular medium.
>
> [...] The modalities are obviously interrelated and dependent on each other in many ways, but nevertheless they can be rather clearly separated theoretically.
>
> (Elleström 2010, 16)

Despite their intrinsic interdependencies, the order of the four modalities in Elleström's list is meaningful, as they range "from the tangible to the perceptual and the conceptual" (Elleström 2010, 15): While the material modality concerns "the latent corporeal interface of the medium", the sensorial modality defines "the physical and mental acts of perceiving the interface of the medium through sense faculties" (Elleström 2010, 36). The spatiotemporal and the semiotic modality both address conceptual factors, with the former referring to "the structuring of the sensorial perception of the material interface into experiences and conceptions of space and time" and the latter to "the creation of meaning in the spatiotemporally conceived medium by way of different sorts of thinking and sign interpretation" (Elleström 2010, 36).

All four modalities are realised in many "variants" which Elleström calls "modes" (Elleström 2010, 16). These range from human bodies, light or sound waves for the material modality, to seeing, hearing, feeling, tasting, and smelling for the sensorial modality (see Elleström 2010, 36). For the spatiotemporal modality, Elleström distinguishes three levels of modes for each time and space, namely the media's material manifestation, the cognitive space and perceptual time present during the reception process, and, finally, the cognitive evocation of a virtual space and/or time (see Elleström 2010, 36). The semiotic modality refers to the well-known distinction between symbolic, iconic, and indexical signs.

Despite their undeniably substantial effect on the actual shape of narrative media artefacts, the material and the sensorial modality are both not directly linked to a medium's narrative potential in general. Yet, certain material and sensorial prerequisites seem necessary for the two conceptual modalities to afford narrative potential. For instance, it seems unlikely that a hypothetical medium which provides neither the seeing nor the hearing mode would be able to produce a noteworthy degree of narrativity, since it can safely be said that these two senses dominate human perception and enable most of what belongs to the semiotic modality, i.e. any type of signs.

The spatiotemporal modality is the first to be directly related to narrative potential, as can easily be concluded from my earlier examples of change-requiring narremes (i.e. actions, causality, etc.), as well as from the core narremes spatial and temporal setting. While the levels of spatiality are of marginal interest to this book, the ending's intrinsic tie to temporality warrants a closer look at these levels. First, there is "time as a trait of the interface of the medium" (Elleström 2010, 21), as, for example, in the duration of a movie or a piece of music. This is not to be confused with the inevitable fact "that all media are obviously *realized* in time" (Elleström 2010, 20, original emphasis) and that the act of perceiving a media artefact always involves a temporal dimension. Elleström gives a vivid example of how time as a trait of the interface differs from perceptual time:

> If one closes one's eyes in the middle of a dance performance, something is missed and the spatiotemporal form cannot be grasped in its

entirety. If one closes one's eyes while watching a photograph, nothing is missed and the spatial form remains intact.

(Elleström 2010, 19)

Hence Elleström remarks that "perceptual time" is "always present" (Elleström 2010, 36). Third, there is "time as an interpretive aspect of what the medium represents (virtual time)" (Elleström 2010, 21), i.e. an illusion of time similar to how media with a two-dimensional spatial mode (such as paintings, photographs, or film) can create the illusion of depth (see Elleström 2010, 20). For instance, the representation of an animal mid-leap can evoke virtual time in a single picture. According to Elleström, "all sorts of time represented by verbal narration" (Elleström 2010, 21) are also cases of virtual time, although he points out a difference between media that create virtual time, as in the example of the single picture, and those that produce sequentiality despite lacking a temporal quality in the interface by presenting a series of static elements such as comics do (see Elleström 2010, 20f.).

The conceptualisation of virtual time (and space) already requires an act of interpretation or meaning-making that is closely tied to the types of signs used by the medium, i.e. to the semiotic modality. Medial differences in the use of symbolic versus iconic signs are one of the main causes for discussion about "the primacy of language as a narrative medium" (Ryan 2014a, 475). While the literary bias of classical narratology has been shed by the transmedial approach adopted in this study, it is still true that language as a variant of the semiotic modality highly increases a medium's narrative potential, since it "is able to make relations of causality explicit" and to "express emotions and intents unambiguously" (Ryan 2014a, 476; see also Wolf 2004, 94).[10] Some typically less narrative media, such as instrumental music, that feature a reduced set of semiotic modes while at the same time being strongly temporally organised – with a dominating sequentiality on the level of the interface – indicate a higher significance of the semiotic modality for narrative potential than that of the spatiotemporal one. This falls into place with the fact that the semiotic modality is the one most closely related to meaning-making, and hence meaningfulness, which is one of the three core narremes in Wolf's prototype.

It was briefly mentioned that narrative framings can occur on both a media artefact's intratextual and paratextual level. In general, paratextual framings can be grouped into intracompositional phenomena, i.e. those that are part of the media artefact proper, and extracompositional, or contextual, factors.[11] Paratextual factors that affect the evocation of the frame narrative involve characteristics that are ascribed to a medium by its contextual qualifying aspects (i.e. the "practices, discourses and conventions" (Elleström 2010, 25) that influence, for instance, the predominating expectation of narrativity in today's literature and film) as well as individual contextual framings of particular media artefacts (such as labelling a book "novel", or advertising a movie with a phrase like "based on a true story").

Prince emphasises that the contextual relativity of narrative degree is also highly dependent on the "situation and interests" of the receiver (see Prince 1982, 147), which of course pertains to individual differences of cognitive frames and how easily and by what means they are actually triggered. While factors like these are largely inaccessible to narratologists, there are plenty of framings that belong to the media artefact's close paratext and are thus stable beyond individual interpretations of narrativity (see Wolf 2006, 19f.). It is vital to consider such intracompositional paratextual framings in studies – like this one – that focus on the artefact's "framing borders, be it in a spatial or a temporal sense [...], as the 'edge' in both respects is indeed a privileged place for signalling relevant frames" (Wolf 2006, 22), including that of narrative. A book carrying the label "novel" on its cover will thus be more readily processed as narrative than one without it, regardless of its contents (at least during the first moments of the ensuing reception process).

To summarise, the narratological basis for this study is mainly provided by Wolf's media neutral definition of

> 'narrative' as an abstract, cognitive frame that depends on extracompositional factors and consists of a plurality of 'narratemes', i.e., intracompositional factors that are maximally present in prototypes and whose relative occurrence in concrete artefacts or texts (that need not be 'narrations': transmitted through narrators) renders them 'stronger' or 'weaker' 'narratives' [...], and determines their degree of 'narrativity'.
> (Wolf 2004, 89, original emphasis)

In order to make this transmedial approach applicable for a comparative analysis of endings in different media, I have combined it with Elleström's multimodal conception of mediality. As the central focus of this study is the endings of digital games, I will now move on to discuss this medium's specific narrative potential, and how its particular multimodal constitution can not only be acknowledged but also beneficially integrated into a narratologically oriented approach.

1.2 Digital games and narrativity or the delicate question of modal dominance

The medial qualities of digital games

As a comparatively young field of research, digital game studies might struggle even more with the challenge of finding a generally accepted definition of the discipline's central research object than narratology. The task is not exactly alleviated by the subject's apparent complexity, which is reflected in descriptions of digital games being "multilayered" (Jannidis 2007, 293), "hybrid" (Beil 2012, 14), "strongly multimodal" (Elleström 2010, 38), and "perhaps the richest cultural genre we have yet seen" (Aarseth 2001b) that

necessitates interdisciplinary thinking to fathom it in its entirety (see Backe 2008, 95). Even the conception of the digital game as a medium has been contested (see Aarseth 2001b; Eskelinen 2012, 344), and neither is there a consensus on its denomination that varies from *digital* to *computer* to *video game*.[12] Labelling the digital game a medium rather than a cultural genre does not only reflect its most common use but is legitimised by Elleström's media definition (see Chapter 1.1). According to him, the digital game is a "qualified medium" (Elleström 2010, 38), i.e. a medium not sufficiently defined by the four media modalities alone (which would be the case for a "basic medium"), but in need of further specification via the two qualifying aspects (see Elleström 2010, 27), which encompass essentially those "more or less freely adopted conventions" (Ryan 2004, 19) that separate genre from medium.[13]

Although multimodality per se is nothing special in Elleström's terminology, as "all media are multimodal as far as the spatiotemporal and the semiotic modalities are concerned" (Elleström 2010, 24), digital games are one of the few media that stand out as they "are multimodal on the level of all four modalities" (Elleström 2010, 24). While the semiotic modality of the digital game is variable due to its underlying technical medium (see Elleström 2010, 30), the computer, which translates the abstract signs of program code into any desired output signal (within the limits of the interface such as the screen), the spatiotemporal modality of the medium is of such a complex nature that both space and time of the digital game keep attracting academic interest.[14] A particularity of digital games' temporal structure consists in their "partially fixed sequentiality" (Elleström 2010, 19) which results from the computer's procedurality, i.e. the dynamic execution of predetermined rules (see Bogost 2007, 4f.), and which contrasts with the unchanging progression of media artefacts with "fixed sequentiality" such as film (see Elleström 2010, 19).

Procedurality itself is a feature of the computer as a technical medium that does not specify whether the rule-based, dynamic changes of corresponding media artefacts are induced by external influence such as a user's interaction with the system.[15] However, such a "participatory" quality of procedural environments does not only make them more "appealing to us" (Murray 1997, 74); it is also a defining qualifying aspect of the digital game as a medium, since all games – digital or not – require active engagement by at least one player. In Juul's "classic game model" (Juul 2005, 23) this aspect is subsumed under the term *"[p]layer effort*: The player exerts effort in order to influence the outcome" (Juul 2005, 36). This also ties in with Espen Aarseth's definition of the participatory quality of "ergodic literature" that requires "nontrivial effort […] to allow the reader to traverse the text" (Aarseth 1997, 1), which refers to concrete actions that exceed both trivial activities like turning the pages of a book and the cognitive activities of understanding and interpretation (see Aarseth 1997, 1–5).[16] Eskelinen refers to the ergodic as "the only necessary one" in a "dynamic

configurative system[] of feedback loops" that constitutes a game, as it operates "between players and manipulatable game elements" (Eskelinen 2012, 309f.).[17] A more common, but also somewhat problematic, term used to describe such feedback loops is *interactivity*. Sprouting from very distinct theoretical approaches, interactivity and ergodicity accentuate different aspects of the participatory quality of digital games. While the concept of interactivity highlights the user's potential of manipulating and individualising the media artefact, and renders the "reception"[18] as a communicative process, ergodicity emphasises the additional effort demanded from users of corresponding media artefacts. The positive connotation of interactivity might have caused its problematic standing as an overused and notoriously underdefined term that often entailed an overemphasis of the user's power, especially during the rise of computer-based media artefacts in the 1990s (see Aarseth 1997, 48–51, 88f.; Murray 1997, 128 for early criticism of the term's vagueness). Adding to the confusion of the proper definition of interactivity are its different uses in a variety of disciplines such as sociology, communication sciences, and computer sciences (see Neitzel 2012, 81; Matuszkiewicz 2014). In contrast, ergodicity is more uniformly defined and academically closer to digital game studies, even though Aarseth's distinction of "nontrivial", ergodic effort from trivial, non-ergodic actions remains admittedly vague (see Bryan 2013, 7).

Whichever terminology one might prefer, there are several types of participation in a digital game that "can [...] be distinguished on the basis of the freedom granted to the user and the degree of intentionality of his interventions" (Ryan 2001b, 205). Moreover, "the sense of agency" (Murray 1997, 126) differs for different types of interaction, or ergodic effort. Defined by Murray as "the satisfying power to take meaningful action and see the results of our decisions" (Murray 1997, 126), agency seems crucial for games which by definition allow players to influence the game's outcome. Yet, not only do games of chance exist, in which player actions do influence the outcome but are arguably neither meaningful nor decisions; but as procedural artefacts, digital games can, on the one hand, evoke a false sense of agency and interactivity based on the player's misinterpretation that can either be coincidental or deliberately induced by the game's design (see Bryan 2013, 14). On the other hand, they can suppress a sense of agency by obscuring and delaying effects of player actions (see Chapter 4.3).

The digital game's narrative potential

The participatory and procedural nature of digital games, which can theoretically lead to dramatic changes in the presentation of the media artefact from one playing process to the next, has been one of the main reasons for calling the medium's narrative potential into question. Since players have the ability to act in, and thus affect, the game world, unfolding events are at least partially self-attributed and experienced in the present tense, in contrast

to non-participatory, traditionally narrative media where events are usually attributed to other sources and witnessed as concluded, past events (see Neitzel 2000, 250f.). Hence, one of the medium's most characteristic qualities seems to strikingly contradict "the sense of the precedence of the event" that is argued to be "a defining condition of narrative" (Abbott 2008, 535). Rather than denoting a formal necessity of recounting events in the past tense – which would reinforce the verbal bias of narratology – this condition of precedence refers to "the idea that the story is already there to be rendered" (Abbott 2008, 536) because "a 'script,' a material configuration of the narrative in whatever medium, palpably precedes reception" (Wolf 2013, 249). Thus, theatre and film, for example, can elicit narrativity despite their "simultaneous narration", since they "are nonetheless fabricated objects that convey a story and that can convey it again and again" (Abbott 2008, 536). In contrast, game events are not simply presented in a simultaneous manner, but are actually produced, or fabricated, only during play time, determined by player input or other factors influencing the procedural execution of the rules. Can it be concluded, then, that the lack of a sense of precedence in digital games prevents them from successfully activating the frame narrative? Or is it necessary to shed the condition of precedence in order to adequately describe the "radically different" form of "future narratives" that narrative digital games are supposedly part of (see Bode and Dietrich 2013, 1–4)?[19]

Two adjustments to the former statements should suffice to explain why this is both not the case: First, in order to fit the definition of narrative as a cognitive frame that is evoked by a combination of narremes, the sense of precedence of events or the "(seeming) pastness of the story" (Wolf 2017, 261) needs to be understood as *just one* prototypical narreme rather than a necessary narrative feature (see Wolf 2013, 256). As with all narremes, "its absence reduces narrativity" (Wolf 2013, 256) but does not cancel it. Furthermore, even a sense of "presentness" is not contradictory to, but typical of narrative in the sense of aesthetic illusion:

> [A]esthetic illusion is [...] a composite effect consisting of a predominant, largely emotional immersion and a residual (latent) distance [...] [This is] the very ambivalence of aesthetic illusion itself: its main part, the immersion of the recipient in a represented world, equals a sense of being recentred in an ongoing, lifelike present, which consequently seems to have an open horizon and triggers the impression that this world is autonomous, independent of its mediality. [...]
>
> The second constituent of aesthetic illusion, the residual distance, correlates with the (often suppressed) awareness of the mediality of the narrative representation and hence, in most cases [...] with the awareness of the precedence/pre-existence and closure of the representational script [...].
>
> Both the sense of pastness/precedence and the sense of experiential presentness can simultaneously exist. [...] [T]hey have become part of

our cultural expertise in dealing with (illusionist) narratives and ad-
dress different mental layers in the reception process. [...]

(Wolf 2013, 252–4)

Player agency in digital games is, thus, another means to evoke this sense
of experiential presentness – a function, or effect, that has been extensively
studied within the context of the digital game's immersive capacity (see
Thon 2008; Neitzel 2012).

Furthermore, to proceed to the second adjustment, a player's freedom to
act and determine the course of the story is, in most cases, not nearly as
far-reaching as the digital game's medial features of procedurality and er-
godicity suggest. This particularly applies to highly narrative digital games
(i.e. games that realise a large number of narremes) in which ergodicity is
often restricted to overcoming challenges in a strictly predetermined man-
ner, while both the sequence and content of the unfolding events stay the
same with each successful playthrough. Jesper Juul defines this specific
structure of digital games as one of "progression" that contrasts with the
"primordial game structure" of "emergence" (Juul 2005, 5). While pure
games of emergence provide "a small number of rules that combine and
yield large numbers of game variations for which the players must design
strategies to handle" (Juul 2005, 5), progression games require "the player
[...] to perform a predefined set of actions in order to complete the game"
(Juul 2005, 5). Juul attributes the origin of this structure to the highly nar-
rative adventure genre (see Juul 2005, 5), but there are also less narrative
games of progression such as platformers like SUPER MARIO BROS. (Nin-
tendo 1985) or SUPER MEAT BOY (Team Meat 2010) – the latter fulfilling
the definition particularly well due to its exceptionally high demand of pre-
cisely timed player actions. Regardless of their overall degree of narrativity,
progression games elicit a clear sense of precedence since they openly com-
municate their predetermination of event sequences by marking player ac-
tions as right or wrong, as they either result in further progress or failure.[20]

However, pure progression games are only the tip of the iceberg of the
current variety of narrative digital games. As Juul notes, "[p]rogression
and emergence are the two extreme ways of creating games. In practice,
most games fall somewhere between these poles" (Juul 2005, 82). Hence,
a methodically sound analysis of digital games has to acknowledge the full
potential of this spectrum and, thus, the ergodicity and sense of present-
ness that dominates the majority of games. Even pure progression games
rely on the player's ergodic effort to realise the potentialities offered by the
program:

It is only in the course of play that possible plots are realized, individual
objects combined, and actions produced and arranged in a chronologi-
cal order. The program itself does not contain a chronological sequence
of events; rather, it specifies possible sequential and causal relations by

means of algorithms, object definitions, and databases. Any potential narrative only comes into being during the game and not before, for only then are chains of actions formed. A game can only be considered a narrative when it is actually played.

(Neitzel 2005, 60)

Then again, even though the ergodicity of digital games is one of the medium's most decisive features, it is marginal to a game's degree of narrativity since "the basic configurations [...] remain parts of a fixed, scripted programme" (Wolf 2013, 253) in which all potential narremes are already implemented to be realised at the appropriate time (e.g. in reaction to a certain player action). "In this regard", concludes Britta Neitzel, "[...] computer games are conceptually related to possible worlds theory and practice [...]. Like possible worlds, computer games work in the subjunctive mode: they pre-form possibilities of what can actually happen in a digital environment" (Neitzel 2014, 617). While this "subjunctive mode" is theoretically interesting regarding narrative structure and the possible realisations of narremes – such as meaningfulness or teleology – it barely affects the medium's narrative potential per se. Unless either a human gamemaster or a hypothetical artificial intelligence controls and adapts narreme realisations during the playing process "the whole of the game system is a created and finished object" (Domsch 2013, 11), albeit one that might cause more or less diverging manifestations in a player's perception. Yet, as the narratological approach adopted in this study locates narrative on a cognitive level anyway, those differences just add an extra, so to speak "intratextual" layer to the contextual features affecting narrative interpretation.

Judging from their modal and qualifying media features then, nothing militates against granting digital games full narrative potential, and yet narrativity was one of the most widely and passionately discussed issues in the beginnings of digital game studies. Above actual disagreement on the subject matter, the infamous narratology versus ludology debate was fuelled by misunderstandings caused by strikingly different conceptions of narrativity that – making matters worse – often remained vague and undefined (as noted by Eskelinen 2012, 215), as well as "by the fear that established disciplines such as literary or film studies would incorporate computer games into their own territories, treating them as derivatives of literature or film" (Neitzel 2014, 611) and in the process marginalising, or even completely ignoring their "gameness". Such marginalisation was often accompanied by undue narrativisation of digital games on the part of narratologists – or better: "narrativists" (Backe 2008, 103)[21] – against which the extreme end of ludology claimed the inexistence or, at least, insignificance of narrative elements in digital games (see Neitzel and Nohr 2010, 417–20).

In retrospect, the debate predominantly stands as a memorial against simplified transfers of theories and methods from other disciplines, such

as (classical) narratology, to new research objects, such as digital games. In order to redeem (media-conscious) narratological research on digital games against ludologist criticism, a number of studies have provided conciliatory approaches to game narrativity that "explicitly include[] the basic elements of games [...]: the rules, variable outcomes and player activity" (Eskelinen 2012, 212), and in the process reflect the difference between stating that a game *is* a narrative versus that it possesses narrativity (see e.g. Kocher 2007; Backe 2008; Kücklich 2008; Calleja 2011; Engelns 2014).[22] Apart from academia, the increasing prevalence of narrativity in digital games themselves further corroborated the value of narratologically invested game studies. Although there are still innumerable digital games that completely lack any, or realise only a negligible amount of narremes, the medium in total shows a change in qualifying aspects, inasmuch as narrativity has become one of its conventional features.[23] More precisely, narrativity is an important operational qualifying aspect of the genre, or "sub-medium" (Elleström 2010, 29), "narrative digital game" (in want of a more succinct term) which, in turn, can be taken as a dominating form of contemporary digital games. Hence, narrative digital games need to be analysed as the hybrid structures they are, within which both the narrative and the ludic – and arguably any other discursive macro-mode (see below) – can dominate (see Beil 2009, 75).

The ludic as a discursive macro-mode

A promising point of departure for conceptualising this hybridity of digital games is once more found in cognitive frame theory which offers a distinction of "basic semiotic macro-modes or [...] 'macro-frames'" (Wolf 2007, 18). Aside from the previously discussed narrative frame, Wolf names the descriptive, the argumentative, and definition as examples for such macro-modes that each are "a mental construct [...] that is aimed at regulating specific forms of organizing signs in various genres and media for specific purposes" (Wolf 2007, 8). While as cognitive frames they are "highly abstract" and, accordingly, "to a large extent media-independent" (Wolf 2007, 18), their material realisations are influenced by the modalities and qualifying aspects of the medium. The idea behind semiotic macro-modes is not to unambiguously classify a media artefact as a whole, but to acknowledge its potential modal diversity on a micro-level even though one single mode usually dominates on a macro-level, informing the artefact's genre (see Wolf 2007, 19). For instance, a novel might contain both passages dominated by either descriptive or narrative (or other) framings, while the narrative mode dominates the overall text. In order to conceptualise the multimodality[24] of digital games, I propose to understand the ludic as another of those semiotic, or "discursive macro-mode[s]" (Wolf 2007, 6).

In a similar fashion, Klevjer refers to the suggestion of "simulation" as "a new discursive mode" put forth in a conference paper by Espen Aarseth

(see Klevjer 2001). Yet, as Klevjer himself notes, "games are more than simulations" (Klevjer 2001), comprising features such as goals and player agency. Another similar suggestion – which matches my proposal to focus on the ludic as a mode of discourse organisation on the same level as, for example, narrative – appears in Eskelinen's ludological perspective on transmediality:

> It is only in the functional framework of several well-defined modalities that the question of transmediality can be fruitfully raised. In addition to the (until now) hegemonic modes of story and narrative, which provide only a partial perspective, we also have the modes of game, performance and presentation [...] to consider if we are interested in constructing a fuller and more balanced view of transmediality.
>
> (Eskelinen 2012, 346f.)[25]

The transmediality of games is obvious enough, considering that there are both digital and non-digital games, the latter showing a striking diversity in their material modality (see Juul 2005, 48–52). In contrast to narratives, games have always been defined with that transmediality in mind, and nobody would have questioned the ludic qualities of the first digital games, although the technical medium of the computer, with its ability to procedurally execute actions on its own, offered arguably as many innovations to games as to narrative. Yet, precisely because of this procedurality, games and computers seem to be inherently related, as they are both characterised by the performance of actions within the bounds of predefined rules. Accordingly, Eskelinen attributes the transmedial core of the game mode to "a common *immaterial support*: the upholding of rules that can be performed by humans or computers" (Eskelinen 2012, 253). Of course, since not just any computer program is also a game, there have to be more features that distinguish the ludic from other discursive macro-modes and might thus be called prototypical ludic framings.[26]

Existing definitions of games provide abundant material to identify these ludic framings. As with narrative, there is a wide range of definitions and almost as many attempts to combine these into a comprehensive list. Juul, for example, derives the six features of his "classic game model" (Juul 2005, 6) from a selection of seven relevant studies of play and games,[27] eliciting the following formula:

> A game is [1] a rule-based system with [2] a variable and quantifiable outcome, where [3] different outcomes are assigned different values, [4] the player exerts effort in order to influence the outcome, [5] the player feels emotionally attached to the outcome, and [6] the consequences of the activity are negotiable.
>
> (Juul 2005, 36)

Parts of these features have already been described in the context of the qualifying aspects of the digital game. While the ludic mode and the medium digital game naturally share many characteristics, I would like to point out – for accuracy's sake – the clear conceptual difference between the abstract, cognitive frame that is the former and the communicative and aesthetic device that is the latter. Moreover, as a culturally distinct type of games, digital games not only show material and technological differences, but "also modify the conventions of the classic model. Games *have* changed" (Juul 2005, 7). Besides the changes that Juul further specifies in his study,[28] parting from the classic game model can also refer to the digital game's parting from the clear predominance of the ludic mode that, in its transmedial abstract form, is unaffected by the medium's historical changes.

So, to finally return to what Juul's classic game model can tell about ludic framings: Since "[f]eatures 1, 2, and 4 describe the properties of the game as a formal system" (Juul 2005, 37) and are thus closest to the constitution of the media artefact itself, they might be identified as the "core" ludic framings, without which the artefact in question would most likely not be perceived as a game at all. Similarly, Eskelinen finds a "consensus or majority agreement among game scholars and designers on rules, goals (or variable outcomes), and player effort as the main definitional features of games" (Eskelinen 2012, 236). Eskelinen later modifies this list to explicitly include the game system itself – that is also part of Juul's definition, but bound together with rules as one feature – matching the following definition by Aarseth: "Any game consists of three aspects: (1) rules, (2) a material/semiotic system (a gameworld), and (3) gameplay (the events resulting from application of the rules to the gameworld)" (Aarseth 2004a, 47f.; see also Eskelinen 2012, 329).[29] "Gameplay" in this sense roughly corresponds to the feature of player effort, but foregrounds the game system's dynamics, both evading the question of which actions should actually be considered an "effort" on part of the player (compare the above-mentioned question of where ergodicity begins) and – at least terminologically – undermining the participatory aspect of games by eliminating the player from the definition.

Despite the variety of terms and specifications in use that each highlight different aspects of digital games according to their originating research perspective, they share enough common ground to provide a reasonable basis for distinguishing predominantly ludic from predominantly narrative sequences in digital games. A majority of studies on narrative digital games indeed suggest that this modal identification is unproblematic in the first place, since narrative and ludic sequences are usually clearly separated from each other (see Backe 2008, 109; Engelns 2014, 280f.). In a typical game that upholds this modal segregation, narrative "cutscenes" "which are fully pre-produced and in which players cannot intervene" alternate with ludic "playscenes" "in which the players can intervene (and must intervene to get the game going)" (Neitzel 2014, 615). Thus, ergodicity appears as the main

trait of the ludic mode, while the lack thereof is equally taken to charac-
terise narrative sequences.[30] A popular question for game scholars, design-
ers, journalists, and players alike is how well those modally distinct scenes
complement each other in a game to either create a coherent world and the
impression of a consistent whole, or result in the infamous mismatch of
"ludonarrative dissonance" (Hocking 2007; see Juul 2005, 163; Engelns
2014, 127). Despite recognising the narrative and the ludic, or the ergodic,
as being "dialectic, not dichotomic" (Aarseth 1999, 34), early game studies
claimed that a true, simultaneous integration of both was unlikely, if not
impossible (see Aarseth 1999, 35; Ryan 2001a; Neitzel 2014, 608f.). How-
ever, "the narrativity of computer games is not restricted to [cutscenes]"
and even in the case of clear-cut alternations "the playscenes are meaning-
ful for the cutscenes and the story of the game" (Neitzel 2014, 616), and
often vice versa. Hence, playscenes can contain important narrative events,
such as the final fight against the villain (see Backe 2008, 174), as well as
pertain to another range of narremes – like setting (see "environmental sto-
rytelling", Jenkins 2004, 118–29) or characters – that might be superfluous
from the perspective of ludic efficiency, but serve to enhance the storyworld
in general (see Thon 2016, 107). Likewise, those narremes, and even pre-
dominantly narrative sequences in total, can enhance the understanding of
the rules and goals of the game (see Juul 2005, 163), and the purposeful
narrativisation of rules – "especially those that are 'unrealistic', such as the
rebirth of a character, or its special abilities" (Domsch 2013, 23) – serves to
further a coherent ludonarrative experience. In Juul's words:

> Rules and fiction interact, compete, and complement each other. [...]
> The player [...] experiences the game as a two-way process where the
> fiction of the game cues him or her into understanding the rules of the
> game, and, again, the rules can cue the player to imagine the fictional
> world of the game.
>
> (Juul 2005, 163)

Yet, despite the variety of links between the ludic and the narrative that can
turn a game into "a synergetic system in which the whole is more than the
sum of its parts" (Sallge 2010, 93, my translation from the German), the
quest for ludonarrative synergy does not lead to a wondrous amalgamation
of what are still two distinct discursive modes. Rather, the elements of dig-
ital games are ambiguous, not ambivalent (see Beil 2009, 74) in that they
can pertain to both narrative and ludic framings, while typically one of
them will clearly dominate at a given time. In less typical situations, modal
dominance may be highly dependent on the individual playing process and
the player's cognitive response. For example, a game sequence might con-
vey narrative information (e.g. via dialogue or audio-log) while at the same
time challenging the player to fulfil a certain task (e.g. defeating enemies) –
depending on the challenge's difficulty and urgency as well as the player's

concern for the story, either the ludic or the narrative mode can be seen to dominate the sequence. On a global scale, this ambiguity of modal dominance is even characteristic of the hybridity of narrative digital games that are neither simply narratives with ludic elements nor games disguised as narratives (see Backe 2008, 327).[31]

On a side note, the modal hybridity, or multimodality, of digital games is not even that astonishing, considering that all media artefacts typically employ more than one discursive mode. Digital games can also activate any other discursive frame besides the narrative and the ludic. For example, Ian Bogost emphasises the argumentative power of digital games, particularly so-called "serious games", in his study on procedural rhetoric (see Bogost 2007). What does seem rather exceptional, however, is the overall balance of the narrative and the ludic in many contemporary digital games that results in the aforementioned modal hybridity or ambiguity. While, at this point in my study, this claim might be a mere derivative from previous research on narrative digital games, my upcoming analysis of their endings will further examine its validity in the close context of a key part of any narrative media artefact. Prior to that, however, further remarks are due on what, exactly, constitutes this key part, the ending, itself.

Notes

1 Marie-Laure Ryan traces the awareness of this medial diversity of narrative back to "Plato's distinction between a diegetic and a mimetic mode of narration" (Ryan 2014a, 469).

2 Thon here refers to Ryan, who was the first to explicitly address the conflicts of both media blindness and media relativism with transmedial narratology (see Ryan 2004, 34f.).

3 A detailed discussion of the narrator problem in the context of transmedial narratology can be found in Thon's *Transmedial Narratology and Contemporary Media Culture* (see Thon 2016, 138–66).

4 To be sure, transmedial narratology still acknowledges the narrator, yet not as a general narrative principle, but in the sense of "narrating characters" (Thon 2016, 165), which are "an *optional* strategy of narrative [...] representation" (Thon 2016, 151, original emphasis). Prior to distinct transmedial approaches, a similarly restricted concept of the narrator has been, for example, proposed by Bordwell (see Bordwell 1985, 61f.) and Walsh (see Walsh 1997). The *Handbook of Narratology* also defines the prototypical narrator as a "single, unified, stable, distinct human-like voice" that can mostly be attributed to "a fictional agent who is part of the story world" (Margolin 2014, 649).

5 The problem of pan-narrativism or undue narrativisation is further discussed in the context of the narratology-ludology-debate in game studies (see Chapter 1.2).

6 Wolf adopts the term *narreme* – but not its definition or meaning – from the narrative theory of Didier Coste, where it denotes the minimal unit of narrative discourse (see Coste 1989, 36). In this sense it has also been used by Prince (1999). Note that there are two slightly different versions of the term: "narreme", which Wolf introduced in his first, German language, paper on the issue (see Wolf 2002b), and "narrateme", which dominated Wolf's English

language publications (see e.g. Wolf 2004) until recently. Apart from direct quotations, this study follows the recent preference of the shorter version, as both are interchangeable.

7 Coherence, for example, can, of course, be attributed to the storyworld in total, but discourse, in its sense of organising and shaping the story, also clearly contributes to the coherence of the mental construct of this storyworld in a recipient's mind. Similarly, closure is too easily subsumed under the story paradigm here, as further discussion of the ending in this study will show.

8 To be precise, with "these factors", Prince is referring not only to the qualities of the medium but also to "circumstances, the talent of the sender, [and] the concerns of the receiver" (Prince 1996, 101).

9 An example of how Elleström honours this bottom-up approach is his refusal to grant literature the status of a medium, "since there is a distinct and extensive modal difference between the material, sensorial and spatiotemporal modalities of visual text and auditory text" (Elleström 2010, 27). Consequently, and more precisely, he defines the medium that is commonly referred to with "literature" as "visual literature" (Elleström 2010, 27).

10 Note that the difference between media using symbolic signs and those that resort to iconic and indexical signs does not equal the distinction between a diegetic and a mimetic mode of narration. While Ryan defines diegetic narration as "the verbal storytelling act of a narrator" and mimetic narration as "an act of showing, a 'spectacle'" (Ryan 2005, 11), they are not strictly bound to the semiotic modality. For instance, mimetic narration, too, can be transmitted by symbolic signs, as "the dialogues of a novel are islands of mimetic narration" (Ryan 2005, 11). For a thorough review of the duality of *diegesis* and *mimesis*, as well as the related conflict "telling v. showing", I recommend the respective entries in the *Handbook of Narratology* that both focus on verbal examples for both terms in question (see Halliwell 2014; Klauk and Köppe 2014).

11 In Gérard Genette's influential conceptualisation of paratext, this corresponds to the distinction of peritext (intracompositional framings) and epitext (extracompositional framings) (see Genette [1987] 1997, 5).

12 One of the three terms that I deliberately avoid is the admittedly well-established *video game* due to its slight bias towards visual aspects in comparison to the other two. Although both *digital* and *computer* refer to technical aspects of the medium, they remain rather unspecific about the actual technologies being involved, at least if a computer is understood as any type of technical device endowed with the ability to execute algorithms and some sort of input and output interface, be it the components of a PC, a home console, a handheld, a tablet, a smartphone, or any similar device. However, as *computer* is more commonly used in the narrow sense of a desktop computer or notebook, *digital game* is the preferred terminology of this book.

13 This is obviously based on a very specific conception of both *medium* and *genre*, which is, however, the most relevant one in this context (see Backe 2008, 37 for a discussion of the digital game as a cultural genre in reference to the quoted article by Ryan), and therefore shall suffice here, in order not to overstrain the reader's patience with yet another terminological discussion that would not further aid this study's purpose.

14 For example, Mark J. P. Wolf dedicated a chapter to each space and time in his book *The Medium of the Video Game* (2002). Other studies preoccupied with digital game space include Aarseth (2001a), Taylor (2003), Bartels and Thon (2007), while time has been further discussed by Juul (2004), Hitchens (2006), and Zagal and Mateas (2007), among others.

15 The distinction between procedurality and interactivity is important, as there clearly are procedural artefacts that run without any external influence

(e.g. self-sufficient simulations), or at least without any form of human user input (e.g. if they are automatically fed environmental data such as temperature) (see Bogost 2007, 40–3).

16 Although Aarseth's terminology shows a clear literary bias, the value of his concept of ergodicity is not restricted to the primarily verbal examples he uses, but can be (and has been) fruitfully applied to media artefacts beyond the verbal to use Wolf's terminology introduced in the beginning of this chapter. Despite a low "export-facilitating potential" due to Aarseth's medium specific phrasing, the concept's "clear [...] conceptualization", "formal appropriateness", and "heuristic value" still warrant its meaningful transmedial transfer (see Wolf 2005, 86–8).

17 The other feedback loops involved in the system are the "transactional" ("between players") and the "simulative" ("between game elements") (see Eskelinen 2012, 309f.).

18 Admittedly, the term *reception* is rather inappropriate in the light of the concrete actions users of interactive, or ergodic, media artefacts have to execute during this process. However, I will occasionally resort to use it for the sake of linguistic simplicity and brevity in want of a better alternative.

19 Bode's concept of future narratives is neither specifically tailored to nor limited to digital games, but aimed at all forms of participatory narrative that include at least one nodal situation, i.e. a point in the narrative that requires user choice (see Bode and Dietrich 2013, 1–4). A more detailed look at digital games through the lens of future narratives is provided by Domsch (2013). Yet, even aside from any supposed sense of past-, present-, or futureness of narrative media artefacts, Bode's theory is largely inappropriate for a media-conscious narratology, since it is based on an extremely broad, borderline pan-narrativist definition of narrative: Taking pride in "not subscrib[ing] to any essentialist view of what narrative is [...] [so] that I can locate and identify it everywhere I see it happening" (Bode and Dietrich 2013, 74), Bode not only discards the idea of gradable narrativity as meaningless (confounding it with "narratability" along the way) (see Bode and Dietrich 2013, 72) but also circularly defines "the form of narration" as the only way of meaningful communication:

> Because it is only then that whatever is communicated is communicated as a meaningful sequence. That is so by definition. (You might say we loaded the dice by defining narrative in such a way. Yes. In that case we'd stand guilty as charged.)
>
> (Bode and Dietrich 2013, 75, original emphasis)

20 This presupposes that failed attempts are not counted as events, an assumption that can and will be contested in Chapter 4.4.

21 The most famous example for such undue narrativisation is Janet Murray's description of the game TETRIS as "a perfect enactment of the overtasked lives of Americans in the 1990s" (Murray 1997, 144). While this passage in her book is still clearly intended to show and discuss the digital game's narrative potential, it is worth mentioning that her definition of "a game [as] a kind of *abstract storytelling*" (Murray 1997, 142, my emphasis) that can be understood as a "symbolic drama" (Murray 1997) explicitly refers to a (from a media-conscious perspective unacceptably) broad understanding of narrative that does not justify to equal her interpretation with an attempt "to find or forge a story" (Eskelinen 2001).

22 Although it follows a similar agenda, I have not included Britta Neitzel's *Gespielte Geschichten* (2000) in this list since it predates most of the debate.

23 The increasing significance of narrativity in digital games has been noticed even while the ludology versus narratology debate was still ongoing, e.g. by Britta

Neitzel (2000), Mark J. P. Wolf (2002), or Jesper Juul (2005). This development has been attributed to an increasing complexity of "the video game's use of space and time" (Wolf 2002, 93), better graphics (see Wolf 2002, 93; Juul 2005, 162), a change in perspective together with the use of anthropomorphic avatars (see Neitzel 2000, 180), and the endowment of meaning to goals as narrative quests (see Neitzel 2000, 181–87; Wolf 2002, 101). While many instances of digital game narrativity are indeed merely "instrumental" (Ryan 2001a), and narrative understanding optional for a successful playing process (see Juul 2005, 202), the claim that "digital games don't even try to be serious" (Klevjer 2001, 9) with respect to their narrative content cannot be upheld anymore in the light of the "more complex stories with contents clearly addressed at an adult audience" (Domsch 2013, 177) that can be seen in many contemporary digital games.

24 Multimodality, in this sense, refers to the multiplicity of such semiotic, or discursive, modes and differs strikingly from multimodality in the sense of Elleström's media modalities. As unfortunate and even inaccurate as this ambiguous use of the term may be, I am confident that context will provide enough clarification to avoid any misunderstandings in the course of this book. In general, Elleström's modalities feature when regarding the characteristics of media and their affordances, while discursive modes are relevant in the context of a media artefact's meaning and related cognitive processes.

25 The peculiar distinction between narrative and story in this passage results from Eskelinen's very narrow, narrator-based understanding of narrative (see Eskelinen 2012, 102–22).

26 In analogy to *narreme*, those framings could as well be called *ludemes*. However, this is a term already in use in a different context, as defined by David Parlett: "[A] ludeme or 'ludic meme' is a fundamental unit of play, often equivalent to a 'rule' of play; the conceptual equivalent of a material component of a game" (Parlett 2007). The term has been adopted and thus further spread within digital game studies by Espen Aarseth (2014). While Parlett's definition does not necessarily contradict a redefinition of *ludeme* analogous to that of *narreme*, the dubious benefit of such a redefinition to this study would probably be outweighed by the terminological confusion that would arise not despite, but precisely because of the seeming similarities between both concepts.

27 The referenced studies are Huizinga [1949] (2003), Caillois [1958] (2001), Avedon and Sutton-Smith (1971), Suits (1978), Kelley (1988), Crawford (1997), and Salen and Zimmerman (2003) (see Juul 2005, 23). It is worth noting that Juul tailored his definition to games alone, ignoring other forms of play – a distinction that is less remarkable from an English speaker's perspective than from the point of view of German or Scandinavian languages that provide only a single word for play and game (see Juul 2005, 28f.). In his seminal study *Les Jeux et Les Hommes*, Caillois overcame the same linguistic problem in French by introducing the terms *paidia* and *ludus* to distinguish between free forms of play and rule-governed, goal-oriented games (see Caillois [1958] 2001, 13). Accordingly, the discursive mode discussed here is called the *ludic*, and not the *paidic* mode.

28 For example, since a computer administers the upholding of rules and what they entail, digital games can be more complex than what the average human player can or would be willing to handle (see Juul 2005, 53). The medium also brought forth endless games without any outcome, but even with a clear ending, the player's emotional attachment to that outcome is often less clear than the typical win-or-lose situation in classic games (see Juul 2005, 53f., see also Chapter 4.3 on the hierarchisation of multiple endings).

29 Another noteworthy difference to Eskelinen's former definition is that this list does not include the feature of goals or variable outcome, since it "logically result[s] from rules and player effort" (Eskelinen 2012, 329). This logical dependency does obviously not undermine the importance of this feature that is even more crucial in the context of this study on endings, as is shown in the following chapter.

30 The plain oversimplification of equating non-ergodic with narrative sequences is apparent in non-ergodic cutscenes that rather pertain to the descriptive macro-mode, such as tracking shots that give a first impression and overview of a new area once the player enters a location for the first time, a convention employed in many games with segmented game worlds that add a puzzle aspect to spatial exploration.

31 In fact, Backe refers to this as modal amalgamation ("Verschmelzung beider Komponenten"), a form of fusion that I just denied. This is nothing more than a minor terminological mishap at worst, since Backe otherwise claims an all too clear distinctiveness of ludic and narrative sequences. The "amalgamation" he proclaims here, then, denotes nothing more than an overall balance between ludic and narrative passages on a macro-level of the given examples (see Backe 2008, 327).

2 What makes an ending an ending?
Point of departure

2.1 Ending and closure as part of the narrative frame

Approaching the ending – "The expectation of nothing"[1]

To claim that the ending[2] is a key part of narrative media artefacts certainly raises the expectation of it being a prototypical narreme. This issue will be assessed in this chapter. Indeed, the prototypical status of endings has been acknowledged ever since Aristotle's insistence on the wholeness of dramatic action which is one of the fundamentals of narratology – a whole being "that which has a beginning, a middle, and an end" (Aristotle 2008, 14). Hence, both Ryan and Wolf affirm the prototypicality in their transmedial definitions of narrative, either with explicit reference to "Aristotelian unity (beginning, middle, end)" (Wolf 2004, 90) as a syntactic narreme or rephrased in the demand for "[t]he sequence of events [to] form a unified causal chain and lead to closure" (Ryan 2007a, 29). Although Aristotelian unity no longer figures in Wolf's remodelled version of the prototype, the narremes "teleology" and "(seeming) pastness of the story" (Wolf 2017, 261) are still closely related to the ending.

The significance of endings is perceivable on a structural level – described by Jurij Lotman as "the curious fact that the most significant elements of a poetic structure come at the end of the segments (lines, strophes, chapters, works)" (Lotman 1977, 92) – as well as on a cognitive level, as "the desire to know how it ends" can be identified as "the primordial narrative desire" (Ryan 2001b, 257). This desire in particular can be explained by the ending's meaning-making potential, which bears similarity to meaning-making processes in everyday life:

> In part, we value endings because the retrospective patterning used to make sense of texts corresponds to one process used to make sense of life: the process of looking back over events and interpreting them in light of 'how things turned out.'
>
> (Torgovnick 1981, 5)

Frank Kermode's *The Sense of an Ending* (1967), the seminal study on literary endings, was largely motivated by this tight relation of endings and meaning-making. Yet, Kermode's study is of questionable value to research interested in endings as an integral part of narrative structure, because it focuses on the end – and the apocalypse in particular – as a literary motif, is highly interspersed with theological terminology, and its explicit intention to contribute to the human quest of "mak[ing] sense of our lives" (Kermode [1967] 2000, 3) entails a problematic tendency towards universalisation (see also Torgovnick 1981, 7f.). Nevertheless, "the sensory, psychological, even epistemological satisfaction that accompanies closure" (Kelleter 2012, 12, my translation from the German) and, accordingly, endings seems indisputable. The ending is crucial in the process of sense-making in the reception of a (prototypical) narrative media artefact because it

> gives relevance and coherence to ideally all its preceding elements; it is the end which traditionally contains poetic justice in fictional stories; it is the end which helps the reader decide whether a biography, for instance, is classifiable as a tragedy or a comedy; in short, it is above all the end which gives meaning to the story as a whole and justifies the selection of story elements according to relevance, atmosphere, causality, and teleology.
>
> (Wolf 2013, 257f.)

This meaning-making function of endings is facilitated by the so-called "recency effect", a counterpart of the "primacy effect", which are both psychological terms for the heightened significance of first impressions and most recent experiences, respectively, which Meir Sternberg has applied to literary beginnings and endings (see Sternberg [1978] 1993, 93–8). The recency effect thus helps to explain why "the end is privileged both during and after the viewing [or reception in general, MH] as a source of validation of the reading process" (Neupert 1995, 32).

Besides "complet[ing] the meaning of what has gone before" (Miller 1981, xi), the main function of endings is "to justify the cessation of narrative" (Miller 1981, xi). Such justification is not necessarily a matter of content, since successful closure, or the "sense that nothing necessary has been omitted from a work" (Torgovnick 1981, 5), largely depends on "the honesty and the appropriateness of the ending's relationship to beginning and middle, not the degree of finality or resolution achieved by the ending" (Torgovnick 1981, 6). Notwithstanding the questionable use of the terms "honesty" and "appropriateness", Torgovnick's statement not only implies rightful criticism of overly content-focused research on endings. It also points at the essential prerequisite for aesthetic experience according to philosopher John Dewey, i.e., the close interrelation of all parts of an artwork, which "are linked to one another, and do not merely succeed one

another. And the parts through their experienced linkage move toward a consummation and close, not merely to cessation in time" (Dewey [1934] 2005, 57). According to Dewey, the ending in its relation to the whole therefore plays an integral part in demarcating the aesthetic from other types of experience:

> In an intellectual experience, the conclusion has value on its own account. It can be extracted as a formula or as a 'truth,' and can be used in its independent entirety as factor and guide in other inquiries. In a work of art there is no such single self-sufficient deposit. The end, the terminus, is significant not by itself but as the integration of the parts. It has no other existence. A drama or novel is not the final sentence, even if the characters are disposed of as living happily ever after.
>
> (Dewey [1934] 2005, 57)[3]

While Dewey abstractly presupposes the structural integrity of an artwork, which entails the consummating function of the ending, literary scholar Barbara Herrnstein Smith provides some examples to better grasp the crucial difference between ending and mere cessation:

> There is a distinction [...] between concluding and merely stopping or ceasing. The ringing of a telephone, the blowing of the wind, the babbling of an infant in its crib: these stop. A poem or a piece of music concludes. We tend to speak of conclusions when a sequence of events has a relatively high degree of structure, when, in other words, we can perceive these events as related to one another by some principle of organization or design that implies the existence of a definite termination point. Under these circumstances, the occurrence of the terminal event is a confirmation of expectations that have been established by the structure of the sequence, and is usually distinctly gratifying.
>
> (Herrnstein Smith 1968, 1f.)

Accordingly, expectation is the key element in Herrnstein Smith's definition of closure itself, which

> may be regarded as a modification of structure that makes stasis, or the absence of further continuation, the most probable succeeding event. Closure allows the reader to be satisfied by the failure of continuation or, put another way, it creates in the reader the expectation of nothing.
>
> (Herrnstein Smith 1968, 34)[4]

Although Herrnstein Smith's concept of closure arguably loses some of its value when adapted to media artefacts that are less densely structured than her research object poetry, it offers a valuable cognitive specification of Aristotle's logically accurate, but vague definition of the ending as "that which

itself naturally (either of necessity or most commonly) follows something else, but nothing else comes after it" (Aristotle 2008, 14).

Aristotle's vagueness resonates with the fact that, at least in terms of narrative content, all endings are inherently arbitrary. The structures described by Aristotle are supposed to be "the *mimesis* of an action" (Aristotle 2008, 14), an action that is placed within a temporal and spatial setting which provides the basis of the storyworld. Yet, such a world "does not have any limitation, as the expression 'world' emphasizes" (Bunia 2006, 368f.), and

> something may always happen, up to (if not beyond) the last word, because while life goes on, in fact or fiction, there is always room for changes, flukes, hitches, sequels, contingencies of every kind. Owing to the pressure of these, narrative becomes doubly end-oriented, always reaching for a chronological, along with a textual, future and driven by a mimetic, as well as an artistic, teleology. (And against their pressure, indeed, not even the strongest assurance or firmest sense of an ending will really bring to an end our tendency to wonder about what comes next, as writers of series have always known and as Conan Doyle found out when his public refused to accept the extinction of Sherlock Holmes.)
>
> (Sternberg 1992, 527)

Despite this damage to its finality, the ending's inherent arbitrariness further increases its significance, because as they are chosen from "an indefinitely large set of possibilities, [...] the actual cut-off points gain salience from all the might-have-beens" (Sternberg 1990, 931). Since "the less predictable the cutting, the more perceptible" (Sternberg 1990, 931) it becomes, endings often mark a deliberately metareferential accentuation of the narrative's upcoming termination (see Christen 2002, 94–9; Grampp and Ruchatz 2013). Yet, "the eye-catching and memorable quality of endings [that] is typically constituted by some strikingly foregrounded formal or structural traits" (Hopps et al. 2015, 10) also functions as an attempt to disguise their arbitrariness. "Endings [...] thus tend to be 'artful' in the double sense of this word – not only cleverly thought out, but also artificial or potentially deceptive" (Hopps et al. 2015, 11). While the meaning-making function of endings naturally aids this deception – as satisfied recipients are less likely to question a cut-off point – their foregrounded traits not only "enhance their particular aesthetic appeal" (Hopps et al. 2015, 10) but also first and foremost contribute to evoking the ultimately desired expectation of nothing.

Evoking the sense of an ending – Closural signals

Just as in the case of narrative in general, there is a certain intersubjective stability in the cognitive recognition of endings, or "the reader's sensing that the ending is near", that can be explained by "various cognitive

principles and mechanisms" (Wenzel 2015, 25). Yet, as is the case for any cognitive frame, these principles and mechanisms are not simply universal, but are learned and constantly reshaped by experience (see Christen 2002, 58). This entails a cultural (and historical) relativity of endings that Frank Kermode illustrates with the example of a story known as "The 'wife' who 'goes out' like a man" from the Native American Clackamas tribe, which attracted discussion as it refuses closure by Western standards, but is deemed to possess "a structurally sound closure" (Kermode 1978, 153) within its original cultural context (see Kermode 1978, 152f.).[5]

Even though the sense of closure still depends on individual reader expectations (see Herrnstein Smith 1968, 212f.), which, in turn, are shaped by individual experience, a common cultural and historical repertoire of media artefacts guarantees the intersubjective stability of some aspects of ending. In the following, those aspects, which are to closure what narremes are to narrative, will be called closural signals. Adapting Tobias Hock's film-related definition

> I understand the term 'closural signal' in a cognitive-probabilistic manner, i.e., any feature of a [media artefact] (whether it belongs to the level of content or form) that increases the [recipient]'s expectation that the [media artefact] is about to end (not immediately, but at least soon) is called 'closural signal.'
>
> (Hock 2015, 66)

As Hock indicates, closural signals are scattered across various dimensions of a media artefact. Different approaches offer different terminologies to address these dimensions; yet the most common distinction certainly is that between content and form, or story (*histoire*) and discourse (*discours*) (see Korte 1985, 15; Neupert 1995, 15; Christen 2002, 27; Bunia 2006, 360; Grampp and Ruchatz 2013, 14; Wolf 2014a, 128; Wenzel 2015, 25), which can be further specified into various sub-categories (see, for example, the detailed, but heterogeneous, typology of Korte 1985, 57–176). Usually, the story–discourse distinction refers to the "(intra)textual" level of the media artefact alone, although the paratextual level can also "include formal and content aspects" (Wolf 2014a, 128).[6] Admittedly, though, the latter seem to be infrequent and less important in the specific case of paratextual closural framings.

Furthermore, endings can be segmented into more or less distinct different phases, from beginning closural signals – the classical "resolution" or "untying" of the narrative conflict (see Bordwell 1982, 4) – to the evocation of a final stability in an epilogue (see Bordwell 1982, 4; Korte 1985, 100), to the paratextual delimiters on the ending's material borderline (see Bunia 2006, 361–3). The ending can also be analysed either in isolation or in relation to the whole, as some closural signals are meaningful on their own, while others gain significance only in contrast to, or in continuation of, the residual text (see Krings 2003, 24).

Regardless of terminology and conceptual granularity, a clear distinction of closural dimensions is essential for a thorough analysis of endings in any medium, but even more so with regard to non-linear and multilinear narrative structures, which are abundant not only in hyperfiction but also in digital games (see Douglas 1994, 162). So far, there is no transmedial study of endings that meets this basic requirement, nor a transmedial study of endings to begin with. Existing research either opts for universalisation while remaining theoretically vague (e.g. Kermode [1967] 2000; see more examples in Douglas 1994, 162), or is exclusively concerned with a single medium or genre.[7] Yet, monomedial studies are still valuable within a transmedial approach, not only because they occasionally explicitly state the medium-independency of numerous closural framings (see Korte 1985, 191f.) but also because the recurrence of features in different studies indicates their transmedial relevance. The variability of ending signals seems to be restricted, probably because the number of underlying cognitive principles that are fundamentally able to evoke closure is equally limited (see Korte 1985, 192; Wenzel 2015, 25). Accordingly, the abstract cognitive patterns listed by Wenzel (see Wenzel 2015, 25–8) relate to the concrete closural signals repeatedly identified in research. In the following, the ending's various dimensions will be illustrated by a digest of prominent closural strategies as a foundation for the analysis of closural signals in narrative digital games, which further extend this diversity by the ludic dimension. The transmedial closural principles will be re-evaluated on the basis of this study's findings on digital game endings in the conclusion.

The most apparent closural signals are those on the intratextual level of content, which were, unsurprisingly, the first to attract academic attention with the ostensible shift from "closed" to "open" endings in modern literature (see Friedman 1966).[8] Content closural framings can be subsumed under the function of completing the action (in the Aristotelian sense) and providing a solution to the narrative conflict(s). Obviously, the concrete manifestations of this principle vary strikingly, depending on the individual story. Their basic outline is often determined by genre such as the dénouement in the detective story (see Korte 1985, 67). The most common concrete content signals are marriage and death of the protagonist, which can be roughly equated with the happy ending and the sad, or tragic, ending, respectively (see e.g. Korte 1985, 85–94, and Grampp and Ruchatz 2013, 17 on both; Bordwell 1982 and Christen 2002, 37–42 on happy endings; and Strank and Wulff 2014, 20f. on sad endings). However, neither are all endings that close with marriage happy nor are those in which the protagonist dies necessarily tragic (see Korte 1985, 68). As Bordwell notes, (happy) endings need to be motivated to unfold their conventional closural effect (see Bordwell 1982, 6). To say it with Sternberg's "Proteus Principle": "in different contexts [...] the same form may fulfil different functions *and* different forms the same function" (Sternberg 1982, 148). Although Sternberg uses the concept for formal linguistic purposes, it can be fruitfully applied

to almost all kinds of closural signals, since context often determines their range of effect on evoking a sense of an ending. Wenzel's cognitive patterns can be understood as an attempt to eradicate this context-sensitivity from theory by increasing the level of abstraction. In his approach, intratextual closural signals on the level of content are explained with the two following cognitive principles:

> I) the mental disposition of structuring time in terms of goals, breaks and periods (a principle which accounts for the frequency of such closural motifs as death and marriage)
>
> II) the final confirmation or sudden, surprising change of a certain frame of expectations, a perceptive mechanism that [...] covers those endings that have traditionally been described in literary studies with more specific concepts such as 'denouement,' 'catharsis,' 'surprise ending' or 'epiphany.'
>
> (Wenzel 2015, 25)

The closural effect of surprise, which is identified as one of the three narrative universals in Sternberg's narratological work, is dependent on "whether [it] only unsettle[s] or also resettle[s] the earlier course of events" (Sternberg 1992, 521). Such is the nature of the dénouement, while an unsettling surprise is the basis of the cliffhanger, a form of ending that uses the potential closural effect of sudden change, combined with the narrative desire for a conflict's solution for maintaining the recipient's constant interest in a serial narrative (see Fröhlich 2015, 66–92).

Surprise is a suitable example for demonstrating that closural dimensions are often closely interrelated, since a "sudden, surprising change of a certain frame of expectations" (Wenzel 2015, 25) is just as fundamental to the closural principles on the level of form, where it features as "the pattern of contrast" (Wenzel 2015, 25). This pattern manifests itself in a wide variety of "terminal modifications of form" (Wenzel 2015, 25) that either break the previously established narrative conventions – e.g. by changing genre (see Grampp and Ruchatz 2013, 16), language register (see Korte 1985, 155–8), or colour scheme (see Christen 2002, 85) – or increase the distance between the recipient and the media artefact (see Korte 1985, 191). The latter can be done either in a literal sense – for example, by zooming out, or moving the camera away from the protagonists in a film (see Christen 2002, 66f.) – or by highlighting the media artefact's artificiality by the use of peculiar, or just peculiarly numerous rhetorical devices (see Korte 1985, 153; Krings 2003, 136) or iconographic techniques (see Christen 2002, 66–79). Other ways of creating distance by highlighting artificiality are "retrospective patterning" (Herrnstein Smith 1968, 119; Korte 1985, 72–80) – a way of looking back upon the narrative by, for example, providing a summary, or a moral of the story[9] – as well as various metareferential techniques (see Christen 2002, 94–9; Grampp and Ruchatz 2013, 16).

The second "gestalt pattern" governing intratextual closural signals on the level of form is that of "repetition and symmetry" (Wenzel 2015, 25). While repetition often occurs within the ending itself – e.g. the repetition of certain words and phrases, or sentence structures to create a rhythmic effect in literature (see Korte 1985, 163–7; Krings 2003, 42–5) – this principle particularly concerns the overall structure of a narrative arte-fact. Closure is here evoked by tying the ending to the beginning, either in the form of (purely stylistic, or content-related) framing, circularity, or by repeating single terms, phrases, or images that can also stem from the artefact's paratext such as "a surprising allusion to the work's title" (Hopps et al. 2015, 10; see Korte 1985, 134f.; Neupert 1995, 21; Chris-ten 2002, 72; Krings 2003, 43; Grampp and Ruchatz 2013, 21–3; Hock 2015, 73–5).

Another significant closural principle that is not quite covered by Wen-zel's typology is that of "diegetic reduction" (Hock 2015, 76; see also Christen 2002, 80), or stopping time (see Korte 1985, 191; Christen 2002, 71). While media artefacts with a temporality "manifested in their material interface" (Elleström 2014, 15), such as film, can use this mode to effec-tively stop time (see Christen 2002, 71), those with a virtual temporality, such as written literature, can at least simulate this effect, and occasionally mimic audiovisual closural signals such as a fade-out or a freeze-frame (see Korte 1985, 140–7).

Finally, there are "closural allusions" (Herrnstein Smith 1968, 61), which evoke the sense of an ending via (iconographic or verbal) vocabulary from a closure-related semantic field, "the imitation of something being closed up/leave-taking", or "actions and motifs that are directly concerned with the process of ending or closing something" (Hock 2015, 72; see Herrnstein Smith 1968, 172–82; Korte 1985, 80f.).[10] Closural allusions can also take over the role of otherwise typically paratextual signals. For example, the "Explicit" (see Korte 1985, 43–6), or end title, – most commonly: "The End" – might be integrated into the last sentence. In general, "The End" takes a paradoxical standing, since it is on the threshold of the media arte-fact's final boundary, being placed within the media artefact, but referring to its outside (see Böhnke 2004, 193).

Many paratextual signals – like most closural markers on the intratex-tual level of discourse – vary strikingly in different media according to their respective affordances. Yet, those differences should not be taken as an occasion for media relativism. Rather, tracing back individual affordances to media modalities and individual closural signals to closural principles can help to accurately define their transmedial range. For example, Bunia refers to the necessity of a material delimiter, or "the support provided by the medium" (Bunia 2006, 360), for an ending "to be recognised as such" (Bunia 2006, 368). While for literary texts, the material boundary of the book or a significant change in print layout serve as such delimiter (see Herrnstein Smith 1968, 211; Korte 1985, 147), films, TV series, and even

digital games – as I will later illustrate – mostly rely on a form of credit roll to indicate the "difference between text and non-text" (Bunia 2006, 362; see Christen 2002, 62). Occasionally, such delimiters can inform the recipient's expectations of the upcoming ending before being encountered: The pages of the book are tangibly and visibly running out during the reading process, or the time passed while watching a movie nears its maximum length, which might be known beforehand from contextual information. Well aware of this effect, the narrator of Jane Austen's *Northanger Abbey* channels it into a metareferential closural signal by remarking near the novel's end that the characters' anxiety at this point "can hardly extend, I fear, to the bosom of my readers, who will see in the tell-tale compression of the pages before them, that we are all hastening together to perfect felicity" (Austen [1817] 2006, 259).[11]

While literature and film even in their digitised forms (such as e-books) often deliberately provide information about remaining page numbers or minutes of film (e.g. pressing the pause button while watching a DVD or streaming a movie online will conventionally produce a visual indication of the viewing progress), a digital game's length and duration usually remain obscure, even if the game offers some indication of progress (e.g. by showing a percentage of completed levels). This difference not only stems from the fact that the duration of a digital game is often not determined before the actual individual playing process but also from the medium's restricted accessibility, which it shares with most digital literature. To formalise this quality, Aarseth includes the category of "access" (Aarseth 1997, 63) in his "typology of textual communication" (Aarseth 1997, 58), distinguishing between "random" and "controlled" access (Aarseth 1997, 63). While random access, i.e. the accessibility of any part of the media artefact at any given time during reception, is materially built-in in books, it is usually deliberately granted in software for reading e-books, for example. Technologies used for filmic reception basically grant random access as well, although it might be controlled by convention in certain situational contexts such as in the cinema. With their ergodicity, digital games – as well as hypertext literature, to a certain degree – employ a distinct form of controlled access that requires particular user actions in order to proceed. This restricted accessibility entails a form of control over the reception process and, consequently, recipients' expectations of endings that accounts for some of the most conspicuous closural forms in digital games, such as the abundance of multiple endings, as I will argue in my upcoming analysis.

Identifying endings – Conventionality and position

In the previous section, the closural effect of various intra- and paratextual signals was traced back to cognitive principles. Yet, the ending's arbitrariness and artificiality indicate that evocation of a sense of an ending is not

inherent to each closural signal but can be enforced by conventionalisation. Conventionality and closural effect are in a reciprocal relationship. On the one hand, "closural markers become conventions because they can effectively evoke a *sense of an ending*" (Korte 1985, 194, my translation from the German), but on the other hand, it is exactly their conventionality that thenceforth further strengthens their closural effect (see Korte 1985, 194). While conventionality influences each part of a narrative media artefact in one way or another, endings (as well as beginnings) are affected by it to an exceptional degree due to their exposed position (see Korte 1985, 21f. and 195), up to the point that

> [i]t may be argued that all endings are garbled quotations of other already existing endings [...]. What this means is that new patterns of expectation [...] are formulated on the basis of existing patterns, and on our ability to understand the new pattern depends the whole conception of the 'stability of the crafted text.'
>
> (Kermode 1978, 151)

In other words, "conventions are a vocabulary of forms, with authors and readers of a given period agreeing upon their meaning and function" (Goetsch 1978, 237, my translation from the German), which makes them openly acknowledged framings. As such, they are subject to historical and cultural variation (see Wolf 2006, 33), which also affects how binding they appear to producers (see Korte 1985, 22f.).[12] In their research on endings of 19th- and 20th-century novels, both Korte and Goetsch note changes in closural conventions that can have alienating effects on non-contemporary readers (see Goetsch 1978, 236f.; Korte 1985, 179f.). However, such changes are slow processes, and conventions – just as cognitive prototypes – are stable to a certain degree (see Goetsch 1978, 237). As they become increasingly expectable, conventions can ultimately diminish the ending's significance (see Christen 2002, 42). For example, "[b]y the nineteen-sixties and nineteen-seventies, the 'open' ending had become too trite and expected to have great imaginative force" (Torgovnick 1981, 206). Then again, overused closural signals that have come out of fashion might gain renewed significance as their effect is de-automatised with their loss of conventionality (see Korte 1985, 198). Apart from simple overuse that leads to trivialisation, a plausible reason for an ending convention to wear off would be cultural changes associated with it. For example, the gradually fading acceptance of the standard model of married family life in Western cultures during the 20th century might have lowered the power of marriage as an effective closural signal on the level of story.[13]

Apart from historical and cultural context, the conventionality of narrative media artefacts is also a question of genre (see Korte 1985, 198). In some cases, there are very specific ending conventions such as the protagonist's lonely ride into the sunset in movies of the Western genre (see Strank

and Wulff 2014, 23). Further within the realm of film studies, David Bordwell points out that

> because the film is of a certain type, we expect it to conclude a certain way. In the classical American cinema, the comedy, the detective film, the musical comedy, the romance film, and other genres typically carry the happy ending as a convention, while the gangster film and the film of social comment usually carry some expectation of an 'unhappy' ending.
>
> (Bordwell 1982, 4)

Paradoxically, it is precisely because of the ending's exceptional significance in a narrative media artefact that the recipient's high expectations of those generic conventions can also undermine this significance, since predictability diminishes the ending's decisive meaning-making effect (see Christen 2002, 42). Yet, highly predictable closural signals fulfil the increased necessity of framing that can be attributed to overall unconventional media artefacts. I extrapolate this from the fact that "literary texts and other medial products usually require *more* framings than stereotyped everyday activities or communicational situations" combined with the "tendency of aesthetic works [esp. unconventional ones, MH] [...] not only to *refer* to existing frames but to *create* new, or at least more or less modified ones. Obviously, framing is then all the more necessary" (Wolf 2006, 14, original emphasis). Indeed, ending conventions often feature just as much in media artefacts with unconventional narrative structures, such as backward narration (see Brütsch 2013, 302), as in conventional ones. Even notoriously "open" narrative artefacts, such as a great deal of postmodern fiction, often simply relocate the main evocation of closure from the level of content to less obvious stylistics, i.e. the level of discourse (see Krings 2003, 147; Wenzel 2015, 31f.).

Undoubtedly, the most important and least frequently undermined ending convention is that of its position, which is determined by the media artefact's paratextual delimiters. Yet, as the sense of an ending results from the combined effect of a range of different, both intratextual and paratextual, closural signals, even the position at the artefact's final borderline is not strictly necessary for this effect to arise. To better explain the potentially flexible location of the ending, I will approach it from its other, usually inner, boundary: the beginning of the ending.

As Sternberg puts it, "the quest for closure does not get under way unless (and, literally, until) a breach in order makes itself felt" (Sternberg 1992, 525). However, this quest is only one of several "gap-dependent interests" (Sternberg 1992, 524) during a narrative reception process and breaches in order are, accordingly, abundant in narrative media artefacts. Even if the ending's position is taken for granted, presuming that its beginning is the final breach in order before this position, it is still uncertain what, exactly,

constitutes this breach. Structurally, possible breaches in literary texts include chapters, paragraphs, sentences, and even single words (see Korte 1985, 14), while film endings might be considered as the final shot, scene, or sequence (see Christen 2002, 17), to give only a few examples. Strank and Wulff propose to understand the ending as the final coherent narrative sequence of a media artefact (see Strank and Wulff 2014, 17), a definition that at least rules out extremely short dimensions, such as a single word or shot, but the actual extent of the ending (either absolute or relative to the text's length) still remains unclear. Rather than being a flaw of Strank and Wulff's approach, this vagueness results from the immense variability of both media forms and closural signals.

Hence, both literary and film scholars concede that "the beginning of the ending eludes definite determination" (Korte 1985, 14, my translation from the German) and needs to be assessed individually for each narrative media artefact (see Torgovnick 1981, 6; Krings 2003, 11; Strank and Wulff 2013, 38). As Wenzel concludes

> the vexed question of where exactly an ending starts [allows] [n]one but pragmatic, arbitrary solutions [...], not only because the length of endings tends to grow disproportionally to the overall text length [...], but also because, as every writer knows, the choice of the starting-point of an ending is very much an individual and to some extent a random affair.
>
> (Wenzel 2015, 29)

Authors, or producers, "choose" this starting-point of the ending simply by applying conventional closural markers – either on purpose or not. Once again contingent on cognitive resources, the beginning of the ending can be identified individually with the start of the sense of an ending that is triggered by certain prototypical framings. In principle, this can happen at any point in the narrative, especially since most intratextual closural markers are not restricted to endings, but are universal representational strategies that evoke closure in combination with a cluster of other closural signals. Conventionally, such a closure-inducing accumulation would "clearly [...] be desirable only at the end [i.e., the final position, MH] of a poem or piece of music" (Herrnstein Smith 1968, 35), or any other highly structured media artefact. Yet, the quote indirectly confirms the possibility of undermining, or simply ignoring this desirability, which affects both the ending's significance in general and the hegemonic status of its position in particular. Phenomena drawing this hegemony into question – if ever so slightly – both include media artefacts that prematurely create a sense of an ending and those that deny it altogether.

Although all dimensions of a narrative media artefact can contribute to the evocation of closure, narratologists commonly agree upon defining the ending as that of the discourse (see Christen 2002, 17; Prince [1987] 2003, 26).

However, this definition actually refers almost exclusively to the aspect of the ending's position, favouring discourse not for its own sake, but as a dismissal of the level of story due to the possibility of achronologically sequenced plots. Yet, as has been shown, there are other discursive closural signals apart from plot structure, as well as signals on the level of content, that can add to a sense of an ending in the middle of a narrative as well. Such premature closural effects characterise media artefacts with multiple endings. For the time being, the discussion will be limited to unilinear, non-ergodic narrative media artefacts, i.e. media artefacts that do not allow any form of actual narrative branching.[14] While being indeed unconventional in such media, multiple endings are extraordinarily significant in ergodic media, digital games in particular, where they exist as parallel potentialities of which only one is actualised during the final part of each playing process. In contrast, unilinear media artefacts, such as a typical film or novel, are forced to arrange multiple endings in a predetermined sequence if they wish to include them, inevitably creating a form of hierarchy, since the recency effect makes the last ending to be encountered appear as the most important, or even the only actual ending (see Krings 2003, 133).[15]

Two famous examples of unilinear narratives with multiple endings among researchers are Tom Tykwer's movie RUN LOLA RUN (1998), which presents three alternative versions of the unfolding story with three different outcomes, and John Fowles' novel *The French Lieutenant's Woman* (1969), which includes three endings with a varying degree of closure and seriousness (on part of the narrator). In one metaleptic passage of the novel, in which the narrator himself meets his protagonist Charles on a train, he broods over how best to end the narrative, considering "the conventions of Victorian fiction [which] allow, allowed no place for the open, the inconclusive ending" (Fowles [1969] 1996, 408), "the freedom characters must be given" (Fowles [1969] 1996, 409), and the skill of a writer in persuading readers that the outcome of their novels "conform[s] to reality" rather than to what "he himself favours" (Fowles [1969] 1996, 409) – in other words, the ability to disguise the ending's contingency. As the authorial privilege "to show one's readers what one thinks of the world around one", i.e. to promote a specific mindset, seems "futile" (Fowles [1969] 1996, 409) to the narrator in this case, he ponders how to avoid deciding between the two essential possible outcomes to his story – will Charles and Sarah (the eponymous "woman") finally get together, or not? He concludes that "[t]he only way I can take no part in the fight is to show two versions of it" (Fowles [1969] 1996, 409). Yet, the medium of the book and the genre of the novel interfere with his conclusion[16]: "That leaves me with only one problem: I cannot give both versions at once, yet whichever is the second will seem, so strong is the tyranny of the last chapter, the final, the 'real' version" (Fowles [1969] 1996, 409). Arguably, Fowles could have avoided this problem altogether by further breaking the formal norms of the novel and putting both versions in two parallel columns (see Korte 1985, 204), or with a (quasi)

ergodic approach, just as some of his contemporaries did. For instance, B. S. Johnson's short story "Broad Thoughts from a Home" (1964) ends with the narrator's "magnanimous gesture" to offer the reader "a choice of endings to the piece" that culminates in the invitation "to write his own ending in the space provided below. If this space is insufficient, the fly-leaf may be found a suitable place for any continuation. Thank you" (Johnson 1964, 75).[17]

However, at this point of my study the poetological contemplations of the narrator of *The French Lieutenant's Woman* are more insightful than Johnson's humorous delegation of the author's responsibility to find a proper ending to his readers, since they confirm the aforementioned points about the ending's qualities – from the recency effect, to its meaning-making potential, to its arbitrariness and conventionality, up to multiple endings' unavoidable hierarchy in unilinear narratives. While the novel's narrator pretends to solve the problem by tossing a coin to determine which ending to place last, the fact that he is indeed able to include both versions despite the "tyranny" of narrative conventions accounts for the significance of closural signals besides position. In fact, in Chapter 4.4, long preceding the narrator's reflections, he already "brought this fiction to a thoroughly traditional ending" (Fowles [1969] 1996, 342), which even included an epilogue describing the fates of the story's minor characters, introduced by the maximally conventional phrase "And so ends the story" (Fowles [1969] 1996, 340), among other closural signals. Although this ending is revealed to be nothing more than the protagonist's imagination, and readers could easily guess that it was fake from about 130 pages of the book still waiting to be read, it nevertheless *is* an ending, as the narrator kindly emphasises for those not convinced by the sense of an ending evoked by the passage itself. While the narrator's metareferential commentary here aims at the meaning-making potential of endings that resonates with the protagonist's life situation, the curious effect of this fake ending as well as the two later, supposedly equal, alternative endings is a loss of finality that is characteristic of multiple endings (see Korte 1985, 215). Despite "the tyranny of the last chapter" (Fowles [1969] 1996, 409), the mere presentation of alternative versions diminishes the totalising meaning-making effect of the ending and undermines narrative's prototypical teleology, in contrast highlighting the arbitrariness of the final event. This applies not only to narrative artefacts with multiple endings that explicitly try to opt out of giving one definite ending, such as *The French Lieutenant's Woman*, but also to those that do not revolt similarly against their unilinearity, but deliberately declare one of the presented versions of their story as the final one.

The movie RUN LOLA RUN belongs to this latter category, as it presents three versions of protagonist Lola trying to deliver money to her boyfriend Manni as fast as possible, two of which end in the death of one of them. In the movie's final "run", both Lola and Manni are successful in their own quests, meeting each other unharmed. The metaleptic sequences between

the runs, Lola's (logically inexplicable[18]) increased knowledge about obstacles and difficulties she has to overcome, as well as the story's increasing turn for the better, culminating in a happy ending, clearly indicate an increasing acceptability and, therefore, relevance of the presented outcome that is finally affirmed by the movie's credit roll (see Kuhn 2011, 325). The teleology here seems quite clear; yet the presence of the other, worse versions of the story still is reminiscent of the ending's arbitrariness, which protagonist Lola keeps stubbornly – and, ultimately, successfully – fighting back, and destabilises its finality compared to conventionally structured narratives.[19] Multiple endings in unilinear narrative artefacts, thus, demonstrate both that the final position in the reception process still holds defining power as a prototypical closural signal – since the last ending encountered inevitably gains more weight – and that it is nonetheless possible to evoke a sense of an ending at any other point. In conclusion, although they openly remind of the arbitrariness of narrative content and reduce the ending's sense of finality, I agree with Krings that multiple endings are no means of refusing closure, or even a form of "non-ending", as postmodernist literary theory suggests (see McHale 1987, 110; Krings 2003, 133–5), but rather encourage reflection about ending conventions and closural expectations.

In contrast, fragments completely deny the sense of an ending, either deliberately (the fragment as a genre, or narrative form) or involuntarily (the fragment as a historically incomplete media artefact never finished by the producer), adding another question mark to the supposedly fixed connection of ending and position. Fragments are fragments precisely because they stop, and do not conclude.[20] Hektor Haarkötter uses the fragment's refusal to end for questioning the conventional expectation of being able to understand a narrative artefact and the ending's vital role in this hermeneutic process (see Haarkötter 2007, 190–203). As a way to find meaning in exactly this refusal of closure, Romanticism elevated the fragment, with its close ties to the infinite and the universal, to one of its essential philosophical concepts (see Endres 2017, 306f.). The, often inconsistent, writings of Friedrich Schlegel, who influentially defined the fragment as a poetic and philosophical term, show that the concept is inherently contradictory on many levels (see Endres 2017, 306f.). This resonates with a paradoxical quality of narrative reception processes, which fill recipients with both the narrative desire to know the ending and the desire to perpetuate the pleasure of the aesthetic experience. The following section will trace how a tendency against closure and towards endless continuation can further affect narrative forms. In doing so, it will also bridge the gap of the previous remarks on the qualities of narrative endings to those of the ludic.

Denying closure – Narrative endlessness

One aspect defying narrative's prototypical teleology has already been mentioned in the previous discussion of the ending's contingency. In order

to argue against early narratological studies that exaggerate closure's "totalizing power of organization" (Miller 1981, xiiif.), D. A. Miller emphasises the fact that "the narratable inherently lacks finality. [...] It can never be properly brought to term. The tendency of a narrative would therefore be to *keep going*, and a narrative closure would be, in Mallarmé's phrase a 'faire semblant'" (Miller 1981, xi, original emphasis). The latter correlates with the ending's aforementioned necessity to disguise its arbitrariness in order to not forfeit part of its significance. From this, Miller develops his argument that "[o]nce the ending is enshrined as an all-embracing cause in which the elements of a narrative find their ultimate justification, it is difficult for analysis to assert anything short of total coherence" (Miller 1981, xiii). Debatable as this statement might be in general, it certainly loses ground in the light of narrative as a cognitive frame defined by prototypicality, as even the theoretical assumption of all-embracing teleology does not forbid – but rather enables – analysis to identify and examine deviations from this prototype. Yet, Miller's remarks are valuable as a reminder that closure is no prerequisite for narrativity, especially in contrast to other studies at the time such as Frank Kermode's essay "Sensing Endings" (1978). Here, the "enshrinement" of closure culminates in Kermode's postulation of "dispersed" endings that would pervade those texts that deny closure at their "terminal ending" (i.e. at the last position), instead "supplementing" it in small portions throughout the text (see Kermode 1978, 155). By calling any meaningful parts in a narrative media artefact "little ends in themselves" (Kermode 1978, 155), Kermode seems to avoid admitting the fact that the cognitive process of meaning-making accompanies the whole reception process and is not necessarily reliant on closure – although *if* provided, closure significantly affects narrative meaning, potentially even completely overturning a previously assumed interpretation. Again, Kermode's universalist and religious rhetoric complicates the transfer of his ideas to transmedial narratology. On the contrary, Miller's alternative approach is valuable for its interest in narrative strategies and "principles of production" themselves, rather than "the frequently evoked conflict between the closed form of art [...] and the openness of life" (Miller 1981, xi), as much as for its moderation, since his "real argument [...] is not that novels do not 'build' toward closure, but that they are never fully or finally governed by it" (Miller 1981, xiii–xiv) – although I suggest exchanging the word "never" in this sentence with "rarely".

Narrative endlessness or a drive towards infinity – like in the Romantic idea of the fragment – is a rare phenomenon compared to the prototypicality of endings and closure, not only because bringing a narrative media artefact to an end is, pragmatically speaking, easier than upholding its endless continuation but also because the denial of a sense of an ending is, fundamentally, not defined positively on its own, but merely as a negation of the default case: "The non-ending gains its effect only from its contrast to the defined ending" (Korte 1985, 218, my translation from the German).

The expectably low interest of narratological research in such a niche phenomenon increases with the postmodern wave of "open-ended" narrative artefacts. However, those are, again, mostly concerned with the ending's contingency on the level of story.

A phenomenon that is intrinsically tied to a wider range of dimensions of endlessness, including – maybe most importantly – reception and production processes, is seriality. While seriality and narrativity are not contingent on each other (i.e. there are both abundant non-serial narrative media artefacts and serial forms that do not at all trigger the frame narrative) narrative serial forms make perfect use of the potentially endless continuation of that which is narrated. They thus abandon the task of satisfying the narrative desire for closure, at least to a certain degree (see Fahle 2012, 177), in favour of meeting "a basic human desire for entertainment" (Hickethier 1991, 17f., my translation from the German). Since there is no final fulfilment of this constantly renewed desire, serial narrative forms are exceptionally well-suited for economic purposes, which accordingly make up a significant incentive for their production in various media from the 19th century onwards (see Hickethier 1991, 17f.; Grampp and Ruchatz 2013, 8f.; Allen and van den Berg 2014, 3). In contemporary media culture, seriality is abundant, or even dominant, in most narrative (or potentially narrative) media such as the TV series (as per definition), comics, films (especially in high-budget productions), and digital games. This broad cultural relevance of seriality might entail an influence on the contemporarily prevalent narrative prototype in the form of generally lowering recipients' expectations of absolute, final closure, thus arguably increasing importance of endlessness in narrative forms relative to the "cross-historical" prototype or narrative archetype.

However, serial narrative artefacts are not simply endless. On the one hand, the often-proclaimed inherent endlessness of the (TV) series is rarely more than an "operative fiction" (Grampp and Ruchatz 2013, 3) and its narratives are not endless, although they are often staged as if they were (see Grampp and Ruchatz 2013, 3). On the other hand, even supposedly endless series – since they might still await either their cancellation or completion – constantly present endings (with a varying degree of closure), namely at the interim boundaries of their single instalments or episodes. Hence, serial narrative forms do not actually subvert narrative's prototypical teleology, but cultivate it to uphold the recipient's interest with "the deferral of a final ending, [and] the promise of continuous renewal" (Kelleter 2012, 12, my translation from the German). By providing a constant cycle of building up and releasing suspense, of perpetually beginning and ending, serial forms oscillate between feeding the desire to know how it ends and that to sustain the pleasurable immersive experience. The interim endings of serial narrative forms can thus console the "equivocalness" that Rowe generally ascribes to endings, which, as much as they are desired for giving a sense of completion, "also entail[] a sense of loss, of emptiness" (Rowe 1988, 1).

Seriality is, however, not necessarily pre-planned, and narrative media artefacts can be, and frequently are, serialised in retrospect by sequels added at any later point in time. While such sequelisation is often motivated by the producer's wish to repeat the first instalment's economic success, the process narratively degrades the formerly "final" ending to an interim one.[21] Conversely, some single media artefacts exploit the series' seeming promise of endlessness by feigning seriality, in order to create a feeling of openness without actually rejecting the sense of an ending (see Korte 1985, 208). They achieve this by announcing a continuation of the narrative – with a simple "To be continued", for example – that turns the recipient's expectation of nothing into the expectation of a sequel, thus marking their ending as temporary and reducing its closural effect.

While seriality is mostly relevant in popular culture, and highly motivated by economic interests, another structural variation adds an aspect of narrative endlessness within the genre of hyperfiction, which, even during its heydays in the 1990s, remained a niche phenomenon that was given more academic than public attention. Although hyperfiction, or hypertext in general,[22] is not bound to electronic media by definition (see Aarseth 1997, 79),[23] the affordances of the technical medium computer enable the implementation of endless continuation in one narrative media artefact. After warning about hasty generalisations of hypertext regarding its immense variability, Aarseth further points out that "hypertext is as much an ideological category as a technological one" (Aarseth 1997, 79). Thus, although hyperfiction's technologically afforded endlessness is as optional per its media modalities as its technological realisation per se, the ideal of hyperfiction theory virtually dictates it. The most commonly envisioned form of endlessness in hypertext is that of a net-like structure which links narrative fragments without any clear beginning and ending (see Porombka 2001, 18).[24] The revolt against classical narratological principles, such as "(1) fixed sequence, (2) definite beginning and ending, (3) a story's 'certain definite magnitude,' and (4) the conception of unity and wholeness associated with all these other concepts" (Landow 2006, 218f.), is thus an essential feature of hypertext poetics. With these principles, however, "the very concept of hypertext prevents the powerful narrative effects of suspense, surprise and sudden turn, because these effects rely on a careful management of the disclosure of information over time" (Ryan 2007b, 263). As such, hyperfiction rejects a range of narremes, which results in an overall reduction of narrativity and, hence, acceptability of the text, since it counteracts reading habits and reader expectations (see Ryan 2001b, 257; Ryan 2007b, 263).[25]

Hyperfiction's prescribed revolt against closure obviously clashes with recipient expectations based on the narrative prototype, which is one reason why the acceptability and readability of hyperfiction are frequently debated among critics and scholars. J. Yellowlees Douglas acknowledges the strong

impact of the conventional expectation of an ending in her essay about the possibility of finding closure in hyperfiction:

> Even though in interactive narratives, we as readers never encounter anything quite so definitive as the words 'The End', or the last page of a story or novel, our experience of the text is not only guided but enabled by our sense of the 'ending' awaiting us. [...] The anticipation of endings is, in this sense, integral to the act of reading, even when there is no such thing as a physical 'ending' [...].
>
> (Douglas 1994, 184)

She concludes that

> when we navigate through interactive narratives, we are pursuing the same sorts of goals we do as readers of print narratives – even when we know that the text will not bestow upon us the final sanction of a singular ending that either authorizes or invalidates our interpretations of the text.
>
> (Douglas 1994, 185)

Confronted with an infinite or at least vast amount of narrative content, finding closure does not only grant prototypical narrative satisfaction but also is the only way out of a hypothetically endless reception process that is otherwise inevitably disrupted by exhaustion. Douglas highlights the ergodic aspect of the fact that, in contrast to "print readers [who] encounter texts already supplied with closure and endings, readers of interactive fiction generally must supply their own sense of an ending" (Douglas 1994, 164). With four of her own different readings of Michael Joyce's *afternoon: a story* (1987), Douglas tries to demonstrate that a satisfying degree of closure is individually achievable even without exhausting every bit of narrative content. Against the rules of reception that are learned with the cognitive frame narrative, "interactive narratives invite us to return to them again and again, their openness and indeterminacy making our sense of closure inevitably simply one 'ending' among many" (Douglas 1994, 185).

This supposed plurality of endings is, however, quite different from the multiple endings discussed earlier. While hypertext theory pioneer George Landow sees no fundamental difference between the final moments of hyperfictions' and other narrative media artefacts' reception processes, "because readings always end, but they can end in fatigue or in a sense of satisfying closure" (Landow 2006, 229), this holds true only from a strictly reception-centred point of view. The fact that the recipient's individual sense of an ending will always differ from the one laid out by the media artefact due to subjective factors (see Korte 1985, 225) does not at all relativise the

latter, but rather proves that it is all the more necessary to distinguish the two as clearly as possible. This applies specifically to studies, such as the present one, which focus on the representational strategies used to evoke a closural effect. Correspondingly, Riccardo Fassone notes that

> [c]losure is [...] both a designed feature of an object, meant to evoke a sense of completeness, and an inescapably phenomenological occurrence. While rhetorical, textual, and structural strategies used by designers and authors to provide closure may be described, the very phenomenology of closure is obfuscated to the scholar by its experiential nature.
>
> (Fassone 2017, 47f.)

To undermine this difference is to neglect the endlessness of the hypertext net itself, which is a defining quality of the genre, as noted earlier.

The lack of closural signals in hyperfictions is the main reason for probably the majority of their readings ending in fatigue, rather than in satisfying closure – to reuse Landow's words.[26] In addition, readers of vast ergodic media artefacts are at risk of "identify[ing] the task of interpretation as a task of territorial exploration and technological mastery" (Aarseth 1997, 87), shifting their attention away from understanding the content to completely exhausting the material. While he does not dispute the dominant role of the quest for closure in any narrative reception process, Porombka disagrees with Douglas on the possible outcome of this quest in the readings of hyperfiction, because *there is nothing to find. In hypertext, there is only infinite reading-on or sudden break-off*" (Porombka 2001, 339, my translation from the German, original emphasis). The suddenness of such a break-off – which, in contrast to the reception of fragments, is necessarily initiated by users themselves – implies that they are not accompanied by any sense of an ending, but are a surrender to one's own exhaustion, or lack of interest (see Porombka 2001, 330–2).

The preceding discussion of not only hyperfiction but also multiple endings, fragments, and serial narrative forms has shown that endings and closure cannot simply be taken for granted, despite their prototypical nature. Yet, it has also become clear that any revolt against the prototype entails difficulties, reducing narrativity and certainly impeding, or at least complicating, the reception process. Serial narrative forms compromise between the prototype and – in this case largely economically induced – a tendency for endlessness by providing a constant cycle of ending and continuation. Hyperfiction, on the other hand, embraces its denial of closure, condoning the negative effects on its acceptability.

Ultimately, the degree of satisfaction or frustration with any media artefact's ending or non-ending is up to the individual user to decide. Yet, beyond personal preferences, Douglas' and Porombka's diverging understandings of satisfactory closure in hyperfiction can be explained in

ludological terms – an interdisciplinary step justified by both scholar's use of game terminology (e.g. "quest", "goal") and interactive fiction's own ergodicity and further "flirt[ation] with game conventions" (Eskelinen 2012, 81). In short, Douglas and Porombka can be said to assume different types of goals or different modes of play for readers of hyperfiction. Since those are crucial to the understanding of the ending in the ludic mode, they will now be discussed in detail within this context.

2.2 Endless play and ludic closure

Playing to an end – Teleology in digital games

In Chapter 1.2, goals have been mentioned as a defining feature of games, either explicitly stated as such or implied as a logical consequence of the combined features of rules and player effort. Sometimes, goals are even defined as a subset of rules, since they take part in defining the game as a system. In contrast to "world rules" that establish the set-up of and the possible actions within a game world (or game system), "goal rules" designate which of the possible actions are desirable (see Backe 2008, 286).[27] Hence, as it "provide[s] a sense of direction and a challenge" (Juul 2007, 191), a goal's main function is to give meaning to player effort:

> Without a clear goal, meaningful game play is not possible; if players cannot judge how their actions are bringing them closer to or farther away from winning the game, they cannot properly understand the significance of their actions, and the game collapses into a jumbled heap of ambiguity.
>
> (Salen and Zimmerman 2003, 258)

This meaning-making function of goals is evocative of that of the ending in narrative, and, fittingly, reaching the goal typically (but not necessarily) marks the end of the playing process. Foreboding a game's endpoint long in advance, a goal might thus be understood as a core ludic closural signal. Its motivational function, however, is more than a convenience for the player's sense of purpose. Due to the intricate relation of player and game system, it functions as a driving force for the game itself, because a game's implemented potential events cannot be actualised without player effort.

> In short, it is up to the player to produce (cause) the sequences of game events (effects) to close the causal gap between these two positions (initial and final). The relation between player actions and game events is by necessity conditional (otherwise there would be no challenges): the purpose success and sometimes also the intention success of the player's actions are not guaranteed.
>
> (Eskelinen 2012, 311f.)

Thus, even considering highly narrative digital games, there is an ontological difference between the game's ending and the ending of a non-ergodic narrative media artefact, since the latter exists independently of its reception, while the former only fully comes into being with the player's progress (see Eskelinen 2012, 311f.; Neitzel 2014, 617).[28]

Bearing in mind this ontological difference, ludic goals and narrative endings still share another quality: Both involve a form of constraint that can have powerful, even dominating, influence on the process of interpretation and play, respectively. The extent of this power is, however, conventional rather than compulsory. In the case of games

> [g]oal-dependent constraints are less absolute than rule-dependent ones because (depending on the game structure and type of goals) the players can also play to a varying degree against goals, pursue objectives other than the implied or explicitly prescribed goals, not orient their actions towards the goal(s) at all, or remain largely passive and inactive in the game without major or immediate consequences or punishments. So although rules and goals belong to the same game structure and work together in constraining, directing and enabling the player's actions, their influence on player effort differs in both range and emphasis.
>
> (Eskelinen 2012, 275)

It should be noted that the influence of rules that are not goal-related (i.e. world rules in Backe's terminology) is also dependent on a game's mediality. Although all games are per definition "governed by rules" (Caillois [1958] 2001, 10), digital – or better: dynamic (see Aarseth 1997, 62f.) – media can "[e]nforce the rules by which they are to be engaged" (Domsch 2013, 9). Other than non-digital games, which require players to actively accept their rules as "imperative and absolute, beyond discussion" (Caillois [1958] 2001, 7), digital games preclude cheating or negotiating the rules since these are implemented in the code and inflexibly upheld by the software (see Fassone 2017, 14f.).[29]

Apart from mediality issues, the range and emphasis of constraint also vary with respect to goals alone, since "games differ in the extent to which they force the player into pursuing the goal" (Juul 2007, 194). The possibility of counteracting or simply ignoring the given goals of a game hints at the fundamental difference between *paidia* and *ludus* as defined by Roger Caillois: In his terms, *paidia* – the "primary power of improvisation and joy", "the spontaneous manifestations of the play instinct", "whose impromptu and unruly character remains its essential reason for being" (Caillois [1958] 2001, 27f.) – is turned into *ludus* by the addition of "conventions, techniques, and utensils" (Caillois [1958] 2001, 29), which, most importantly, include rules and goals. *Ludus*, therefore, is constrained and directed, or "discipline[d] and enriche[d]" (Caillois [1958] 2001, 29) *paidia*. Yet, even though the existence of rules and goals sets games apart from other types

of play, the two concepts "are not categories of play but ways of playing" (Caillois [1958] 2001, 53). While "goals are not the only reason people play games" (Salen and Zimmerman 2003, 258), they are the defining incentive of *ludus*, which Caillois also terms "the taste for gratuituous[!] difficulty" (Caillois [1958] 2001, 27) that is motivated by "the pleasure experienced in solving a problem arbitrarily designed for this purpose" (Caillois [1958] 2001, 29). Hence, teleology is the decisive element that sets *ludus* and *paidia* apart. But does teleology necessarily involve reaching the end of the playing process? A differentiation of various types of goals will shed light on this question.

Goals and completability

Within the diverse field of game studies, several aspects come up in search for a classification of goals. Apart from the aforementioned degree of bindingness for players, these include the goal's origin, valorisation, stability, orientation, and range. In the following, rather than to propose a coherent typology, and without making any claim for comprehensiveness, these terms will be used to address the various interrelated dimensions of goals and their role in effectuating what might be called "ludic closure".

The aspect of origin refers to the difference between "given (or player-independent) and chosen (player-dependent) goals that can be either personal or social" (Eskelinen 2012, 243). This leads back to my previous discussion of closure in hyperfiction, insofar as given goals can be compared to a sense of an ending implemented in the media artefact itself by the use of closural signals, while chosen goals resemble the individual pursuits of closure which, for example, Douglas describes in her readings of *afternoon: a story* (see Douglas 1994). Accordingly, only the former qualifies as an aspect of ludic endings within this study's focus on intracompositional framings, even though in reality, the achievement of a chosen goal might as often terminate the playing process as that of a given goal. In the same way as it is impossible without empirical data to judge whether a narrative reception process is interrupted with or without an individual sense of closure – and whether the recipient intends to continue the process at another time or not – the interruption of the activity of playing can neither be generalised as the achievement of a chosen goal, since it is essential that playing is "a free and voluntary activity" during which players are "free to leave whenever they please" (Caillois [1958] 2001, 6).

Games with given goals try to minimise the risk of the player prematurely abandoning the game by increasing the goal's value. In the sense of *ludus* proper, "reaching a solution has no other goal than personal satisfaction for its own sake" (Caillois [1958] 2001, 29), so that the mere existence of a goal, with its sense of direction and meaning-making function, is already a form of valorisation. Yet, this valorisation can be taken to various degrees. For example, goals can be defined as winning conditions that explicitly set

apart successful from unsuccessful playing processes, and winners from losers. Traditionally, this is the most common form of goals, but narrative digital games in particular have frequently shown "the willingness to let go of the concept of the game deciding on a winning or losing state, and especially of an absolute valorisation of the winning state" (Domsch 2013, 179). However, it has become common practice even for those games to reward the player outside the game proper with so-called achievements, or trophies, for reaching given (though not always openly stated) goals that are collected as part of a metagame on gaming platforms such as Steam, Xbox Live, or PlayStation Network. Although the scope of this study leaves no room to discuss this metagame aspect, the implementation of such external rewards testifies to the motivational value of goals.[30]

Since the achievement of a goal can fulfil its rewarding function only if failure is also possible, the aspect of valorisation is deeply connected to the ludic's defining quality of variable outcome. This quality goes back to play being an "uncertain activity" (Caillois [1958] 2001, 7):

> An outcome known in advance, with no possibility of error or no surprise, clearly leading to an inescapable result, is incompatible with the nature of play. [...] The game consists of the need to find or continue at once a response *which is free within the limits set by the rules*. This latitude of the player [...] is essential to the game and partly explains the pleasure which it excites.
>
> (Caillois [1958] 2001, 7f., original emphasis)

Without this uncertainty, goals could merely inform player expectations but not grant a sense of direction and meaning to their actions, since only one direction would be possible in the first place. Hence Juul's plain conclusion that "if the outcome is the same every time, it does not qualify as a game" (Juul 2005, 31). There are, however, various ways of integrating variable outcome into a game beyond the binary distinction of failure and victory. Their relation to goals does not only affect the aspect of valorisation but also that of stability.

In their game classification typology, Elverdam and Aarseth address the stability of goals in the category "struggle": "Goals describe if the game has an exact and unchanging victory conditions[!] (absolute) or if the goals are subjective to the unique occurrences in a specific game or the players' interpretations (relative)" (Elverdam and Aarseth 2007, 14).[31] A prominent and historically important type of relative goals is the "improvement goal" (Juul 2013, 85). This type is best illustrated by games, such as TETRIS (Alexey Pajitnov 1984), that urge players into reaching a highscore – the most common type in the age of arcade gaming. Apart from technological reasons (see Fassone 2017, 68), the popularity of highscore-based games in the arcade era is related to the benefits of numerical rating systems that provide both an unambiguous form of evaluating outcome and a continuous

incentive for playing, guaranteed by its relativisation of success and failure. In games like TETRIS, there is no victory in the sense of the player winning against the "opponent" computer – a general goal that is at least implicit in most singleplayer games (see Neitzel 2000, 32f.) – as the player eventually succumbs to the constantly increasing difficulty (e.g. higher speed, more enemies) of a hypothetically indefinite playing session. Hence, although it might be valued as success in relation to the previous record, any outcome of such a game still equals failure, and reaching the goal simultaneously sets up another, higher goal. Improvement goals are conflicted in themselves, as they actually comprise "dual goals between progressing in the game and getting a high score" (Juul 2007, 195). Unless there is a limit provided by the game system itself,[32] they "concern our ongoing personal struggles for improvement, and can by definition never be reached" (Juul 2013, 85f.). Due to their loss of value right at the moment of their achievement, improvement goals are closely related to what Juul calls "transient goals" (Juul 2013, 85).

Transient goals are those that are "tied to [a] specific game session" (Juul 2013, 85), and are thus typical for games that are played in matches such as almost all card and board games or Juul's example of the digital fighting game SUPER STREET FIGHTER IV (Capcom 2010). They usually show a high degree of valorisation as they clearly separate success from failure, but the value of achieving them decreases rapidly after the match – at least if no contextual values are assigned (such as matches in a championship). Hence, transient goals are stable, or absolute, as the goal stays the same in each playing process, but relative since there is no way to "beat" the game itself. Pointing this out only makes sense in contrast to Juul's third category of goals, which ties in with both aspects of a goal's range and orientation: the "completable goal" (Juul 2013, 85).

Completable goals are typical of games of progression, which pose the same sequence of challenges with each playing process, culminating in a predetermined endpoint. Games like these can be "beaten", "can be completed once and for all" (Juul 2013, 85). The value of this achievement will always stay the same as the player who does reach the end "will always be someone who has completed [the game]" (Juul 2013, 85). This contrasts with most traditional or non-digital types of games, which show a cyclical structure (see Neitzel 2005, 46; Backe 2008, 320) that entails the goal's transiency. In those, the player's situation is always the same at the beginning of each playing process (apart from potential improvements of skills exercised during play), while in completable games, a second playthrough is profoundly affected by the player's knowledge of all imminent challenges. The decreased replay value that accompanies the exhaustive accumulation of information in one playing process (see Juul 2005, 67–71) and the general teleological structure of such games are reminiscent of narrative reception processes and narrative structures in general. According to Backe, the similarities are "so obvious that a

combination of both seems practically unavoidable" (Backe 2008, 322, my translation from the German). Indeed, a smooth combination of narrative and ludic features would seem to require a selection of features that are as close to the prototype as possible for both discursive modes. Although completable goals fulfil this requirement, their striking similarity to prototypical narrative structures as well as their relative historical recency (which coincides with the rise of narrative elements in games in general)[33] raises the question if they are an effect of imposing prototypically narrative concepts – like that of closure – on games in the first place (see Neitzel 2005, 45f.; Backe 2008, 165f.).

However, I advise caution for assuming a narrative origin in structures like completable goals, since different types of goals and winning conditions – i.e. conditions that define the endpoint of a game, even if that does not equal closure or completion – have always been a part of the ludic prototype, which, moreover, has since been affected considerably by digital technologies. Instead, it seems more appropriate to ascribe certain structural traits to "transmodal principle[s]" (Dena 2010, 196), which "can be realized in different modes. This means that similarities between narrative and game modes are not necessarily an indication of co-presence or the need for a demarcation shift. Instead, similarities indicate elements which are non-mode-specific" (Dena 2010, 196). Just as Dena's example of causality, which is also customarily ascribed to narrative, teleology is best understood as a transmodal principle.

In general, teleology in games simply designates the existence – and the player's pursuit – of a goal. It is, thus, as prototypical to the ludic mode as it is to narrative, and not at all an exclusive trait of games of progression. Hence, Fassone's distinction between "teleological play" and "completist play" in analogy to Juul's categories of progression and emergence seems misguided, or at least mistermed, since both clearly involve pursuing a goal, either "to *finish* the game" or "to *complete* it" (Fassone 2017, 51, original emphasis).[34] Regardless of the terminology, Fassone's categories are a valuable recognition of the two differing directions towards which goals can be oriented. Furthermore, even though in practice there is no one-to-one relation between the pairs teleological–completist and progression–emergence, Fassone reasonably reconfigures Juul's categories from a point of view that focuses on the mode of playing rather than on game structure. In doing so, Fassone also refers to Ceccherelli's (2007) distinction of vertical and horizontal gameplay (see Fassone 2017, 77f.). While the former implies successive advancement through hierarchically organised game events, the latter denotes both taking on parallel organised challenges that are commonly accessible in a random order and the spatial exploration of the game world. Fassone adds to Ceccherelli's concept of gameplay orientation by highlighting the ends that motivate the two directions of play. In his terms, bringing a game to an end either means "to reach the end screen" (teleological) or "to explore fully, both spatially and procedurally, the game's affordances"

(completist) (Fassone 2017, 51).[35] Not all digital games afford both horizontal and vertical gameplay, though, and even if they do, they do not necessarily offer a definite endpoint in both directions. For example, games with improvement goals typically enable vertical gameplay only, without leading to an "end screen" other than the inevitable "game over". A genre which is well-known for encouraging both directions of gameplay is that of open world games, which is later discussed with respect to the compatibility of two given goals with different orientations in a single game, and how this affects the potential sense of an ending of the game in question (see Chapter 4.2).

Finally, open world games, like all games that encourage horizontal gameplay, also serve as good examples for the variability of goal range. Until now, all types of goals have been addressed based on the assumption that "[a] game's goal defines its endpoint; once it is reached, the game is over" (Salen and Zimmerman 2003, 258). Global goals like this, which are typically known from the start and terminate the game on their achievement, are indeed the most common type of goals in both digital and non-digital games. However, the technological disposition of digital games facilitates a degree of complexity that makes them prone to include a variety of goals of varying range within one game.

In vertical direction, temporary or sub-goals are mere stages on a path towards a global goal that can be arranged in a fixed or variable sequence, with either all sub-goals being mandatory or not (players might be given a choice to fulfil either sub-goal A or sub-goal B to proceed). This type of goal is also found in many non-digital games that need not be very complex, since most tasks can be broken down into a sequence of sub-tasks that can consequently be formulated as sub-goals. Such sub-goals are, however, rarely explicitly stated and need to be inferred from the given global goal and the game rules. In digital games, an open display of sub-goals is much more common than in non-digital games, motivated by a high degree of complexity, the technologically facilitated obscurity of game rules (which can prevent players from inferring sub-goals without further information), or simply the increased length of a single playthrough, which is usually separated into several sessions.

In horizontal direction, games can include local or side-goals that need not at all be related to a global goal. According to Mark J. P. Wolf, an increased number and complexity of goals reflect the heightened importance of digital games' diegetic worlds (see Wolf 2002, 100f.). Accordingly, an abundance of local goals is characteristic of open world games and digital roleplaying games (two genres that considerably overlap), where they are commonly referred to as "side quests" that are clearly set apart from the "main quest". Both local and temporary goals might yet again be divided into smaller sub-goals. They do not, however, need to be accompanied by one global goal that forebodes the game's endpoint, since not every digital game even has an endpoint.

While goals are commonly – and mostly rightly so – associated with a game's endpoint, their various dimensions show that they are far from being a ludic equivalent of narrative endings. Still, both share some characteristic qualities beyond their prototypical location at the end of the playing or reception process such as arbitrariness and a both constraining and meaning-making function. In narrative digital games, goals and endings coexist within the same media artefact. Reflecting the possible interrelations of the narrative and the ludic mode in general, they do not stand as separate entities, but connect in a variety of ways, the basic conditions and consequences of which will now be reviewed.

Tying loose ends – The (narrative?) sense of an ending in digital games

Despite the growing significance and modal dominance of narrative in a wide range of contemporary digital games, there is still some truth to the claim that "the narrativity of games is not an end in itself but a means towards a goal" (Ryan 2004, 349). With respect to game endings, the narrative serves the ludic mode by "cue[ing] the player into making assumptions about the game rules" (Juul 2005, 177), including goal rules. Moreover, a narrative context semanticises otherwise abstract goals, possibly disguising their arbitrariness and increasing the player's interest and motivation for pursuing them. Due to the player's active role, this function of the narrative works best when it represents a relatable and positive value system, because, "[u]nlike a reader, the player enters a game with an unspoken agreement to accept the rules of the game, including the valorisation rule" (Domsch 2013, 152). As the level of narrative representation might tie this valorisation rule to ethical and moral issues, this unspoken agreement can have precarious consequences:

> The problem with valorisation in video games is that, through semanticization, the two systems of valorisation are short-fused. Games provide players with value systems that are indisputable and absolutely justified, but present them in such a way that they are understood as elements of a fictional world that is modelled on the *a priori* world of the player's experience.
>
> (Domsch 2013, 152)

In other words, "[t]he very 'rules' and cause-and-effect logic that dictate the events of the video game's diegetic world contain an implied worldview which matches actions with consequences and determines outcomes" (Wolf 2002, 109). This effect is unique to procedural media and can be used intentionally in the sense of the "persuasive and expressive practice" of "making arguments with computational systems" that Bogost calls

"procedural rhetoric" (Bogost 2007, 2f.). Yet, if the argument being made or just the worldview implied in the combination of rules and storyworld deviates too far from the player's range of acceptability, the game is at risk of not being played at all.

> Superficially, it would seem that the player is only attached to the outcome on the level of the rules, and as such, it would be irrelevant whether the goal of the game is to commit suicide or to save the universe. Yet, players undoubtedly also want to be able to identify with the fictional protagonist and the goal of the game in the fictional world, and hence the fictional world is very important to the player's motivation.
>
> (Juul 2005, 161)

Hence, although avatar goals and player goals need not be congruent (see Neitzel 2000, 99), aligning them increases the chances of the narrative's positive influence on player motivation. This explains why

> [i]t is hard to create a tragic video game – tragedies are about events beyond our control that are then transformed into something more meaningful through the tragedy, but games are mostly about having power and overcoming challenges. A bad game is one in which the player [or rather: the player-character, or avatar, MH] dies without being able to prevent it. This is not to say that it cannot be done, but just that there are some inherent problems in the game format that makes creating tragic games difficult.
>
> (Juul 2005, 161)

Although I would not go as far as to label games with unavoidable avatar death as "bad", the rising number of games with a rather tragic story – e.g. RED DEAD REDEMPTION (Rockstar Games 2010), THE WALKING DEAD (Telltale Games 2012), or the MASS EFFECT trilogy (BioWare 2007–2013) – does not refute Juul's claim: It is difficult for designers to create a tragic game that still induces sufficient motivation for playing and does not result in a feeling of anger or frustration after reaching the game's end. However, these effects are, on the one hand, highly subjective and, on the other hand, have most likely become more acceptable alongside the overall growth of the medium's narrative variety. In fact, a notion of tragedy is not as alien to games as Juul suggests, in the sense that reaching the final goal of a game is as "equivocal" in nature as finishing a narrative reception process (see Rowe 1988, 1):

> [A] game's goal is the death of play, the mark of the end, foretelling the moment the magic circle will disappear. There is a curious poetic quality to the struggle of game players as they make their way through the

system of a game, playing to no end but the one provided by the game itself, even as their joyful pursuit of that end means the death of their pleasure. Until, of course, the next game begins.

(Salen and Zimmerman 2003, 258)

That last statement is likely to be undermined in narrative digital games with completable goals that void the pleasure of a game's prototypical repeatability (see Juul 2005, 97). The more dominant the narrative mode, the stronger this effect, since the goal of finding out how the story ends is meaningless after being achieved once – at least in the case of unilinear narrative structures.[36]

As has been mentioned earlier, reaching the ending is the prototypical goal of narrative reception, and thus always implicit in a narrative digital game, irrespective of the imbedded worldview and its motivational potential. The expectation of an ending can be problematic for games that are not completable, such as most games from the arcade era, with their focus on constant improvement. While arcade games rarely showed more than a rudimentary degree of narrativity, there is at least one case of uncalled-for expectation of an ending in the player community of the game BATTLEZONE (Atari 1980) that Fassone recalls in detail (see Fassone 2017, 71–3). Long before a definite endpoint became conventional in digital games, players of BATTLEZONE – a game that became famous for being the first action game to use a first-person perspective – created myths of an alleged finale taking place inside the volcano visible, but never accessible, in the game's background, although the game actually "relied on the convention of increasingly hard, unwinnable gameplay" (Fassone 2017, 73). Rather than being the effect of a putative increase in narrativity, however, Fassone is certainly right to assume that this, in this era atypical, expectation of an ending results from the game's increased realism – or better: decreased level of abstraction – which "compelled players into imagining the world of BATTLEZONE as logically consistent" (Fassone 2017, 73). Yet, although BATTLEZONE's degree of narrativity is extremely low, technological advances like this belong to the impulses that aided the proliferation of narrative digital games (see Neitzel 2000, 169–78), which, in turn, led to an evolution of the medium's conventions from teleologically infinite and endlessly repeatable games to those that are completable and provide narrative closure (see Kücklich 2008, 30; Fassone 2017, 66).

Note that *evolution* does not equal *replacement*, as endlessness still prevails in the medium, for example in simulation games (see Neitzel 2000, 242) – such as the ongoing game series SIMCITY (first game by Maxis in 1989) or THE SIMS (first game by Maxis in 2000) – in competitive Massively Multiplayer Online Games (MMOGs) – such as WORLD OF TANKS (Wargaming 2010) – and in casual mobile and online games – such as TEMPLE RUN (Imangi Studios 2011) or FARMVILLE (Zynga 2009) (see Fassone 2017, 69). While such games are indeed typically low in narrativity, does

this justify the conclusion that endings are an inherently or even exclusively narrative trait? Backe comes to exactly this conclusion in claiming that games only end "when the player loses interest" (Backe 2008, 166, my translation from the German). He arrives at this point after criticising Ryan for referencing only one specific kind of digital games when assuming that a game ends with the achievement of a certain goal (see Ryan 2001b, 182; Backe 2008, 165). As has just been established, it is true that different types of games employ different types of goals, which do not at all necessarily entail completability. Yet, Backe's conclusion at this point seems just as restricted and awry in its comparison of the narrative and the ludic.

Backe tries to argue for closure being a narrative concept with the example of chess, which has no ending other than that of each single match – representing the type of transient goals. Hence, in contrast to reaching the end of a story, the endpoint of a game is an individual matter, dependent on player concern alone, and not even on factors like the player's mastery of the game (see Backe 2008, 166). While elsewhere, Backe rightly notes that "without any rudimentary narrative elements, finite progression games cannot be more complex than their endless counterparts" (Backe 2008, 322), this type of games still exists, presenting endings without narrativity. Puzzle games like SOKOBAN (Thinking Rabbit 1982) come to mind, which, hypothetically, could be played endlessly, given an infinite supply of new levels. Yet, there is no such supply, but the game ends after a fixed number of increasingly difficult challenges. Since repeatedly engaging in a once successfully overcome puzzle is at most – probably not – as interesting as reading a detective story twice (see Backe 2008, 320f.), the game's endpoint can be assumed to be quite stable. SOKOBAN's extremely low degree of narrativity proves that attributing the completability of games to an exclusively narrative feature is an overgeneralisation. Moreover, the rudimentary sense of ending evoked by "beating" SOKOBAN can be attributed to a rudimentary form of non-narrative causality that is not based on the content of the levels, but on their increasing degree of difficulty.[37]

That closure is not at all exclusive to the narrative mode, but characterises a broad range of cultural phenomena, including games, is already mentioned in Herrnstein Smith's *Poetic Closure* – which, incidentally, focuses a type of closure that is also not particularly narrative in nature:

> It would seem that in the common land of ordinary events [...] we create or seek out 'enclosures': structures that are highly organized, separated as if by an implicit frame from a background of relative disorder or randomness, and integral or complete. Not only works of art are thus distinguished, of course; other events and activities, such as games, may exhibit the qualities just described. A game of chess or football has integrity and a relatively high degree of structure; it also concludes and not merely stops.
>
> (Herrnstein Smith 1968, 2)[38]

The quote highlights a twofold kind of closure: First, closure in the sense of an ending as it has been discussed in this study, and, second, (en-)closure in the sense of a distinct separation from "real life". As one of the fundamental characteristics of games, this separation is commonly described as a "magic circle", a term coined by Johan Huizinga for the "secludedness" of play in general (see Huizinga [1949] 2003, 9f.), which makes "the game's domain [...] a restricted, closed, protected universe" (Caillois [1958] 2001, 7). Herrnstein Smith's twofold meaning of closure, which is either "spatially or temporally perceived" (Herrnstein Smith 1968, 2), resonates with both Huizinga's and Caillois' definition, who likewise distinguish between temporal and spatial limitations of games (see Caillois [1958] 2001, 6f.; Huizinga [1949] 2003, 8–10). These limitations are a necessary prerequisite for playing games, as they set the scope of their rules: "The confused and intricate laws of ordinary life are replaced, in this fixed space and for this given time, by precise, arbitrary, unexceptionable rules that must be accepted as such and that govern the correct playing of the game" (Caillois [1958] 2001, 7). Similarly, the reception of narrative media artefacts is distinct from "ordinary life" and follows certain rules, which are, however, rarely as explicitly stated as in games.[39] One rule of narrative reception that demonstrates its separateness is "the willing suspension of disbelief" (Coleridge 1817, 2), which is the backbone of the "reception contract" that enables aesthetic illusion (see Wolf 2014b, 271). Just as following the rules of a game, suspending disbelief only makes sense within the set boundaries of the narrative artefact.[40]

This other aspect of closure, or rather closedness, covers an extremely broad range of phenomena, as it encompasses all the framings and delimitations of media artefacts in general, irrespective of their effect or function beyond merely separating the artefact from essentially everything that it is not. For example, endings belong to this category as much as the material picture frame, page margins, size, duration, or beginnings. Thus, this study uses closure exclusively in its first sense in order to focus on framings that signal termination and conclusion.

After agreeing with Herrnstein Smith's conceptualisation of closure, which extracts it "from its narratological habitat and adapts it to the wider [...] arena of human experience" (Fassone 2017, 47), Fassone concludes that digital games clearly belong to the category of "objects that have a high degree of integrity and structure" and, thus, "seem to be able to prompt the experience of closure more reliably than other, less organized experiences of human life" (Fassone 2017, 48). He then poses the "problem [...] to identify the constitutive parts of a video game that elicit closure. Is it in the story? Or in the gameplay?" (Fassone 2017, 48) While Fassone's own analysis quickly moves from this question (see Fassone 2017, 51–3), this study will focus on it in detail, showing that closure is relevant for both the narrative and the ludic mode. Although narrative and ludic closure are fundamentally different – most generally because they operate in two distinct

discursive modes – the phenomena serving as closural signals for each mode are likely to overlap to some degree, since they are both closely tied to the same transmodal principles such as teleology.

While Backe's previously discussed hesitation to acknowledge a prototypical teleology of games clearly results from his narrow and narratologist concept of closure, there are two issues contributing to it that are worth noting. On the one hand, the prototypical ludic quality of repeatability seems to fundamentally contradict conclusion and finality. Yet, this repeatability is but "a loose idea" (Juul 2005, 45) that bears no immediate consequences for endings, because: first, within the confined space of a single match, the outcome of a game is just as final as the ending of a prototypical narrative, and, second, reading, watching – or playing – any narrative artefact can generally be repeated, regardless of its mediality. Arguably, the repeatability of a non-ergodic narrative is even higher than that of a prototypical game, since its events will unfold and be told in exactly the same way in each reception process. Thus, the significant quality of games is not that they are repeatable, but that they stimulate and reward repetition, which they do so by definition – at least to a basic degree – by providing variable outcome (see Wolf 2002, 107). In digital game parlance, this is called "replay value", a term that indicates that this quality is not at all consistent over the medium as a whole.[41]

Closure is so easily attributed to the narrative mode alone, on the other hand, due to its significance within the narrative prototype, which seems considerably higher than that of goals and outcome in the ludic prototype, at least when zooming in on digital singleplayer games. This claim might be confusing in the light of my previous remarks on goals' defining quality for the ludic mode. However, it has also been shown that not all goals define a game's endpoint, and digital games even historically emerged as prototypically infinite as a result of the digital medium's innovation of types of endless games (see Juul 2005, 53f.). Furthermore, within the definition of the digital game as a distinct medium per media modalities and qualifying aspects, the distinction between *paidia* and *ludus* plays a minor part at best. Hence, even digital media artefacts that are essentially paidic are commonly labelled "games", ignoring the ludic implications of the term, such as in the case of the SIMS series, which would be more accurately described by a term like "software toy" (Eskelinen 2012, 291f.).[42] The paidic nature of such games accounts for their inherent endlessness, but also sets them apart from "mere" simulation – in the sense of non-playable procedural artefacts. Like simulations, endless "simulation games", such as THE SIMS, SIMCITY, PRISON ARCHITECT (Introversion Software 2015), the GOAT SIMULATOR (Coffee Stain Studios 2014), and many more, "offer[] no challenge, no goals to achieve" (Klevjer 2001), but differ from simulations in enabling and encouraging playful agency by design.

From open-ended, emergent software toys to unilinear, completable progression games there is a huge variety of both endlessness and endings in

digital games. Endless games range from the almost purely paidic type to open world games with temporal and local goals to "those Sisyphean games that set an objective which has no possible win state" (Domsch 2013, 72), i.e. infinite games with improvement goals. The most constitutive parameters for the finiteness of a game are genre (see Backe 2008, 166), a progression structure, completable goals, and narrativity. In conclusion, the ludic mode – in its very own sense and dimensions – appears torn between closure and endless continuation. The combination of this quality with the prototypical teleology of the frame narrative adds another layer to this tension, which is further complicated if the previously discussed forms of narrative endlessness, such as narrative seriality, also come into play. While this chapter has focused on the basic parameters involved in this tension, other factors shape and characterise game endings, which – like narrative endings – can span multiple phases and may be analysed both in isolation and in the context of the game as a whole. The aim of the following analysis is to show the ways in which games combine various forms and degrees of ludic and narrative closure and how these combinations re-inform their respective monomodal meaning and constitution.

Notes

1 Quote taken from Herrnstein Smith (1968, 34).
2 At this point, some words on my terminological preference of *ending* over the plausible alternative *end* seem due. Although *end* and *ending* are nearly synonymous in everyday language, the former not only carries the additional meaning of an aim or purpose, but also denotes a single point in time rather than an extended period. While I do not intend to overstate this difference, I prefer *ending* as much for its unambiguous indication of temporal extension as for its clear prevalence in the existing discourse on narrative media artefacts.
3 Incidentally, the quote hints at a presumably fundamental difference between narrative and ludic endings, since the outcome of a game typically does have "value on its own account" (Dewey [1934] 2005, 57), proclaiming victory or defeat that carries a meaning independent of the playing process. As will be shown later, digital games not necessarily apply this traditional, binary distinction between winning (good outcome) and losing (bad outcome).
4 While Herrnstein Smith's definition is quite useful, she uses it on the basis of a normative understanding of closure as the appropriate and most valued form of an artwork (see Herrnstein Smith 1968, 36). I emphatically distance myself from this simplified equation of "closed" art as "good" art, which is not only found in Herrnstein Smith. Many 20th-century studies on endings explicitly or implicitly value either the closed, or, on the contrary, the "open" form (see Friedman 1966). However, any study's normative assessment of closure does not automatically invalidate its findings on endings.
5 Another venture into a cross-cultural comparison of closure is found in Krings' study on short story endings (see Krings 2003, 137–46). While she constitutes no fundamental differences between the endings of British and American short stories compared to those of Maori literature, she still finds some peculiar closural signals in the latter that resemble the Maori's oral literature, as well as a decrease in finality expressed by Maori authors (see Krings 2003, 145f.).

6 One of the earliest studies to systematically consider paratextual closural signals is that of Barbara Korte, who speaks of "emic" (i.e. intratextual) and "etic" (i.e. paratextual) closural markers (see Korte 1985, 36). The somewhat peculiar terminological pair was introduced into a narratological context by Franz Stanzel within the more specific context of narrator figures and personal pronouns, which is closer to its origin in text linguistics (see Stanzel [1979] 2008, 217–23).

Also note that this study predominantly considers those paratextual phenomena that still belong to the family of intracompositional or "message-based framings" (Wolf 2014a, 127), i.e. framings that are still immediate part of the media artefact, in contrast to extracompositional or contextual framings, such as author interviews or movie trailers.

7 Dedicated contributions include Herrnstein Smith (1968) on poetry, Torgovnick (1981) and Korte (1985) on the novel, Gerlach (1985) and Krings (2003) on short stories, Neupert (1995) and Christen (2002) on film, Grampp and Ruchatz (2013) on TV series, and Fassone (2017) on digital games. Other relevant studies are even more restricted to certain forms of ending such as the "open" ending (see Friedman 1966), the happy ending (see Bordwell 1982), the twist ending (see Strank and Wulff 2014), or the cliffhanger (see Fröhlich 2015). Some anthologies suggest a transmedial approach, but – as is common for anthologies (see Thon 2016, 15) – end up being collections of papers that are, again, dedicated to single media, genres, or media artefacts (see Hopps et al. 2015; Wagner 2016).

8 Not only was the "open" ending not as revolutionary as Friedman suggested (see Richter 1974, 2–9), but the open-closed dichotomy itself has repeatedly been deemed deficient, even with regard to content alone (see Torgovnick 1981, 207f.; Korte 1985, 184f.; Christen 2002, 33; Krings 2003, 27f.; Wenzel 2015, 30).

9 Wenzel subsumes such ways of directly addressing the recipient under the neither particularly form- nor content-related "[r]eader-activating types of closure" (Wenzel 2015, 17f.). Although he does not explicitly mention it, metareference would probably belong to the same category. However, this category is inconsistent with the established typology of closural dimensions, and its defining attribute of "requir[ing] some increased processing effort from the reader" (Wenzel 2015, 17f.) is unfortunately vague. Moreover, since said phenomena primarily concern the level of discourse, they are located within this dimension here.

10 Wenzel attributes closural allusions to the pattern of repetition; yet this presupposes a form of meta-repetition that is unsuitable for an analysis of strictly message-based framings. Moreover, such meta-repetition beyond the single media artefact is, obviously, a feature of all common closural signals, and thus not distinctive.

11 This upcoming felicity must have felt so certain to the narrator and contemporary readers due to the 19th century's prevalent literary conventions, which required a happy ending (see below).

12 In Victorian times, for example, novelists were pretty much forced to apply established conventions if they wanted their novels to be well received, or even published in the first place (see Goetsch 1978, 247–52).

13 On the decline of marriage as a closural signal in the 20th-century novel, see Korte 1985, 90f.

14 Instead of "linear", I use the term "unilinear" in order to clearly distinguish truly non-linear media artefacts from those that are multilinear, or "multicursal". While multilinear artefacts are structured in branches that each proceed in a linear fashion, unilinear or "unicursal" artefacts offer no such branching, and non-linear artefacts can typically be navigated in random order (see Aarseth 1997, 5–8).

15 For Krings, literary texts with multiple endings strictly speaking only provide one ending, since there can be just one ending on the level of discourse, even though the story level might provide different outcomes (see Krings 2003, 133). While this does not dissuade her from using the term "multiple endings", it shows a slight overemphasis on position that seems peculiar, since a large part of Krings' study is dedicated to diverse discursive closural signals.

16 I would like to emphasise that this interference does not unavoidably result from the medium's modalities, but from its conventional qualifying aspects, as the following quote accurately explains:

> [I]n a bound book of fiction [...] the default position is that you [...] accept the sequence in which the parts of the novel have been arranged by its author. You can do anything with a book – but what the book as a material structure 'asks' you to do in this culture, in which the proper processing of such sign complexes is strongly conventionalized, is to read the bound book from the beginning to its end, left to right, top to bottom, page after page, line after line – unless it signals otherwise.
>
> (Bode and Dietrich 2013, 26)

17 Further examples of literary pieces that similarly oppose the conventional necessity to provide a singular, arbitrary ending to their stories are given by Korte (1985, 215–17) and Krings (2003, 132–35).

18 Thon notes that the representation of the movie's storyworld and the ontological status of the metaleptic sequences are ambiguous, so that it is not too far-fetched to interpret Lola's increased knowledge, for example, as the logical consequence of her actually turning back time in order to save Manni (see Thon 2016, 82–4). This ambiguity certainly further diminishes the sense of an ending potentially evoked by the unacceptable outcomes of the first two runs. Both the unacceptability of the bad outcomes and Lola's improving performance are the main reason why the film is often said to follow a digital game logic, since failure and repetition are a strong convention of the medium. How this affects the potential closural effect of failed attempts in a digital game will be addressed in detail in Chapter 4.4.

19 The most prominent representative of movies that depict several versions of the same story, or parts of the story, is probably still GROUNDHOG DAY (Harold Ramis 1993), although this movie is less interested in the different outcomes of protagonist Phil's countlessly relived February 2nd – "Groundhog Day" – than in working towards the clear goal of his happy ending with his love interest Rita. The same structure can be found in the science fiction blockbuster EDGE OF TOMORROW (Doug Liman 2014) and the slasher film HAPPY DEATH DAY (Christopher Landon 2017), while movies that present only two or three different versions of their story show an increased focus on their outcomes such as SLIDING DOORS (Peter Howitt 1998) or PRZYPADEK (Krzysztof Kieślowski 1987).

20 Note that conclusion, or ending, and cessation are not simply a binary pair, but the extreme ends of a continuum. Since the sense of an ending heavily relies on cognitive processes, and even the theoretical abstractions of cognitive frames lack final definability, the degree of closure – its appropriateness, persuasiveness, impact, and significance – is always subject to individual interpretation. As different recipients might put more or less weight to different ending dimensions, or different closural signals, this individually assessed degree might vary considerably.

21 Note that, vice versa, it frequently happens due to commercial failure that the first instalment of a series remains its last, and its interim ending the final one. In such cases, the intended serial quality should be reflected in analysis, and the artefact is a fragment in the context-related sense of the term.

22 I use both the terms *hypertext* and *hyperfiction* to refer to what is also called "net literature", with the sole difference that *hyperfiction*, in my terms, refers explicitly to narrative hypertexts.

23 Despite Schäfer's fascinating paper on "net literature" before the digital revolution, in which he points out that "hyperfictions [...] are not necessarily dependent on computers" but on the implementation of the idea of "letting the reader determine how he traverses the text by choosing from different story threads" (Schäfer 2007, 122), I assume the term's more common conception that confines it to the digital realm. This seems to be even more reasonable in the context of closure and endlessness, not least since the same author in an earlier paper clearly links the possibility for endless reading to electronic media (see Gendolla and Schäfer 2001, 78).

24 In contrast, Eskelinen assumes that in "hypertext reading [...] reading it all is usually possible" (Eskelinen 2012, 80). While the reality of hypertext artefacts might be closer to Eskelinen's diagnosis, the following discussion deliberately presupposes the realisation of hyperfiction theory's ideals as the best-suited example of actual endlessness in narrative media artefacts.

25 Let me emphasise that a reduction in narrativity does entail neither a decrease nor an increase in the media artefact's (aesthetic) quality.

26 Anne Mangen and Adriaan van der Weel address hyperfiction's low acceptance in mainstream literature within a distinctly reception-centred perspective in their essay "Why Don't We Read Hypertext Novels?" (2017) (see also Ryan 2001b, 257). They attribute the problem partly to the genre's fundamental inability to "provide closure, even of the most elementary nature" (Mangen and van der Weel 2017, 173).

27 Although Backe makes this distinction with narrative digital games in mind – as those are the focus of his study – it is applicable to all types of games. The basic set-up of the pieces at the start of a game of chess, for example, also belongs to the game's world rules. The term "world", which indicates a basic degree of narrativity, might hence better be replaced by "system" in this general sense.

28 Nevertheless, players usually do not *create*, but merely *trigger* game events. While games vary in the degree of influence their players have on the choice and shape of events, they are always pre-shaped by design. The potential state of being of game events is located somewhere between the actual state of being of, for example, a printed text, and the hypothetical state of being of just any imaginable thing.

29 To be sure, cheating in digital games is very well possible, but to counteract their world rules requires intervening in the code itself, which, in turn, presupposes certain technical skill and game-external effort on the part of the player. There are also several other ways of cheating, which do not necessarily require to go against the rules of the game system such as looking up the solution to a puzzle online or in a guide book. Mia Consalvo discusses the various forms of cheating and their level of acceptance by both the industry and players in her dedicated monograph *Cheating – Gaining Advantage in Videogames* (2007).

30 Achievement systems open up yet another category of goals, since they are given goals that are, however, given outside the game itself. As a metagame, achievement systems furthermore create their own goals and incentives that go beyond single games. For a deeper discussion of the functions of achievement systems with a particular focus on them as metagames, see Jakobsson (2011) and Gläser and Schemer-Reinhard (2015), respectively.

31 The category of struggle is further defined by the dimension of challenge that can be completely "predefined" ("identical"), "come from a predefined framework that is varied by mathematical randomness (instance)", or "from game agents whose actions are autonomous (agent)" (Elverdam and Aarseth 2007, 13).

32 For example, some variants of TETRIS include a "victory" condition that terminates gameplay. In Nintendo's 1989 GameBoy version, the game ends with the launch of a space shuttle once players reach a certain score.

33 The rise of both completable goals and narrativity in digital games – which are not dependent on, but facilitated by each other – must at least partly be attributed to economic factors, as home consoles entered the market and the game industry's main source of profit shifted from continuous payments at arcade machines to singular purchases of games played at home. Lowering a game's appeal to be played again by making it completable increased the incentive for players to buy another game (see Kücklich 2008, 30).

34 Fassone also uses the pair "narrative and [...] completist focus" (Fassone 2017, 53) as equivalent terms. While it is probably safe to assume that teleological play in most contemporary digital games is indeed motivated by an integrated narrative level, the alternative term not only ignores all possible forms of non-narrative teleological – or vertical (see below) – play; it also implicates a vagueness of the term "narrative" that, in the context of this study, is even more unwelcome than the awkward, pleonastic conception of a "teleological goal" that is suggested by Fassone's initial definition.

35 The phrasing of Fassone's definition of completist play is reminiscent of common definitions of the paidic mode. Yet, the two concepts should not be confused, since Fassone's labelling clearly denotes a striving for completion which, with its stipulation of a goal, is fundamentally contradictory to *paidia*.

36 Note that other incentives can very well motivate and cause pleasure during a repeated playing or reception process of both ergodic and non-ergodic narrative media artefacts. The knowledge of a story's unravelling can cause a different kind of pleasure as the recipient's attention is not bound by their curiosity, making cognitive room for the perception of details or hints at the upcoming ending. Narrative digital games can additionally motivate repetition by offering higher difficulty settings, which further challenge the player's acquired skills, or other gameplay variations – for example, taking on a stealth, rather than a violent approach in a game like DEUS EX: HUMAN REVOLUTION (Eidos Montreal 2011), or playing with a different character with individual skill-sets such as in BORDERLANDS 2 (2K Games 2012).

37 Although causality features as a prototypical narreme, according to its aforementioned transmodality (see Dena 2010, 196), the existence of causal links does not necessarily trigger the frame narrative. Nevertheless, it remains a prerequisite for a discernible degree of narrativity in digital games (see Backe 2008, 85).

38 While Herrnstein Smith's quote is particularly suited to make a case here, distinct forms of ending also surface in highly structured activities that predominantly operate in yet another discursive macro-mode than both the narrative and the ludic such as the argumentative mode.

39 In contrast to narrative artefacts, which usually strive to disguise the arbitrariness of their boundaries, games are well-nigh forced to handle this straightforwardly, since they rely on the player to know and actively execute their arbitrary rules. To circumvent this, digital games can utilise the technological medium's rule-enforcing power, which can be helpful for seamlessly integrating narrative elements.

40 The seclusion of both narrative and games might be subverted to some degree, for example by professional play, or non-fictional narratives that can be used for argumentative purposes with real-life consequences. To keep the strict rule of separateness, Caillois, for example, has dismissed professional play from counting as play altogether, precisely because of its "contagion of reality" (Caillois [1958] 2001, 45). Matching his overall aim of highlighting "the

ambiguity of play", Brian Sutton-Smith criticises this fundamental exclusion of play's productivity (see Sutton-Smith 1997, 203; also Eskelinen 2012, 314).

41 Besides repeatability, repetition is generally of utmost importance for the structure of games, as they are played by repeating the same action, or set of actions, over and over again. Moreover, digital games are famous for the conventional possibility of retrying after failure. Repetition is, however, also a transmodal principle that can be just as important for the narrative mode, as witnessed by Wolf's early inclusion of it in the list of syntactical narremes (see Wolf 2002b, 47f.).

42 Similarly, though on the other end of the spectrum, there are so-called "walking simulators", such as DEAR ESTHER (The Chinese Room 2012), that have caused a debate about the label "game", since they often not only lack challenge but also arguably any dimension of play with their reduced possibility of player action that is restricted to movement in the virtual world, occasionally even enforcing a unilinear path.

3 Ludic and narrative micro forms

The ending in isolation

3.1 Isolating and dissecting digital game endings

In the preceding chapter, I argued with reference to John Dewey's aesthetic philosophy that endings gain significance not on their own, but only in relation to the media artefact's whole. For the sake of identifying closural signals, however, it is not only tolerable but also essential to analyse endings in isolation of the residual artefact, as I will do in this chapter. Before turning to the larger structures that the various forms of digital game endings create on a global level, their inner workings and conventions need to be understood on a local level. It is crucial to identify common representational strategies and their functions for a game's ending to identify the medium's closural conventions, which might exude their closural effect even in isolation, i.e. for recipients ignorant of the residual artefact (imagine, for example, an onlooker watching someone play only the final part of a game). However, this chapter's isolation of endings is rather a guideline than a strict rule, since closural signals occasionally lose their effect in relation to the whole, and ignoring contextual information might lead to severe misconceptions, as Sternberg's Proteus Principle implies.[1] For example, the difficulty of a final challenge can only be measured in relation to previous challenges, the resolve of the narrative conflict cannot be assessed without prior knowledge of said conflict, and a seemingly spectacular (or unspectacular) setting, staging, or challenge might turn out to be quite ordinary (or surprisingly extraordinary) in context of the whole.[2]

In order to reveal the inner workings of digital game endings, they need to be formally dissected on both axes of (macro-modal) ending dimensions and (chronological) ending phases. First, as the previous chapter has shown, closural signals operate on different levels of a narrative media artefact. To the previously discussed intra- and paratextual signals on either the level of story or discourse the digital game adds aspects of ergodicity and options for player agency which pertain to a ludic dimension. Together, those aspects define the modal layering of a game's ending that can vary not only for different phases but also within a single ending phase. The idea of modal layering follows the concepts of modal dominance and

multimodality, which imply that several discursive modes can be active simultaneously. Although other discursive macro-modes, such as the descriptive mode (see Wolf 2007), also partake in this layering, they will be largely neglected in discussions of modal dominance in favour of this study's focus on the interrelations between narrative and ludic functions.

It is important to note that multimodality can affect even single closural signals, so that these cannot simply be compiled to a list of means with either narrative or ludic functions. While some representational strategies might lend themselves easily to a singular classification, others are particularly interesting for their multimodal functionality. The benefits of a multimodal approach become clear in reviewing previously used criteria for strictly distinguishing ludic and narrative elements of digital games. For example, Backe referred to differences in visual representation as proof of "a certain aesthetic independence of purely narrative passages" (Backe 2008, 76, my translation from the German) in contrast to ludic sequences. Yet, not only does he himself mention existing exceptions (see Backe 2008, 76), but the (increasing) range of examples that withstand the rule seems enough to question it altogether, as there are both games without any variety in visualisation, as well as games with a wider range of visual variation that cannot be attributed to different modal functions.[3]

The problem of digital game elements refusing to be classified according to established criteria has also been addressed with reference to game audio. Since sound in digital games often does not conform to the distinction between extradiegetic and diegetic space established in film studies, Kristine Jørgensen introduces the concept of *transdiegetic space* to describe those elements that affect both levels (see Jørgensen 2009, 97–9). Transdiegetic sound is a prime example of digital game elements that operate in both the narrative and the ludic mode, although they are typically stronger rooted in one of them, "either by being extradiegetic sounds that communicate to entities within the diegesis [...], or by being diegetic sounds that directly address external entities" (Jørgensen 2009, 99). Jørgensen herself notes that "the transdiegetic function is an overarching property of different elements in computer games" (Jørgensen 2009, 114) and not just sound. Yet, she concludes that

> [a]lthough it is possible to argue that all games by definition are transdiegetic systems since they are user systems that exists[!] solely on the basis of allowing the player to execute agency in a virtual environment through an interface, it should be kept in mind that computer games also utilize a range of features that support the classical division between the diegetic and the extradiegetic.
>
> (Jørgensen 2009, 114)

While the triad of extradiegetic, diegetic, and transdiegetic is not the focus of this chapter, it is conceptually helpful for the classification of the modal functions of representational strategies, which also partly support and

partly refuse the classical distinction between the narrative and the ludic, as they can pertain to either, both, or neither of these discursive macro-modes.

On the second axis – since the ending of any media artefact is not a single point in time, but an extended sequence of varying length – digital game endings can be segmented into a set of prototypical phases of closure. First, there is the initial phase of the ending's beginning. As has been discussed before, the ending's beginning is not always easy to identify, as the "breach in order" (Sternberg 1992, 525) that demarcates it might be debatable. Although this is also the case for many digital games, the chapter on this particular phase will show that the medium conventionally employs some strategies that mark a specific breach in order to initiate the final phase of the game.

The second and third phases of a conventional digital game ending are the ludic and the narrative finale, typically in this order. Although the labels for the two phases might suggest otherwise, they do not reaffirm the rather dated concept of strictly alternating, modally distinct ludic and narrative sequences that fall short of the reality of most contemporary digital games (see Chapter 1.2). As multimodality, or varying modal layering, also affects ending phases as a whole, the labels merely acknowledge the overall predominance of the respective macro-mode, while both phases are not reduced to either ludic or narrative elements.

Finally, games usually finish with a paratextual phase, conforming to the ending conventions of nearly all media, which are often bound to it by material limitations (e.g. the back cover of a book). Ending paratext is located on the threshold dividing the domain of the media artefact from the outside world, and thus often fulfils functions that are neither narrative nor ludic such as giving information about the production team. While there are also forms of paratext in digital game endings that show narrative or ludic characteristics, neither of the two modes show a conventional predominance during the paratextual phase. However, the paratextual phase is occasionally overpowered by ludic or narrative elements, going as far as to merge functionally different ending phases. Such forms demonstrate best why the phasic model of digital game endings suggested here should be understood as an idealised approximation that – as any attempt for theoretical abstraction – cannot adequately describe all instances of its object of reference.

This chapter follows the conventional sequential structure of digital game endings from their beginning to their final paratextual delimiters. The conventionality of this structure already implies that it can be altered at will, from omitting to repeating one or several phases. A familiar example of alternative ending organisation is that of the narrative post-credits scene in film, which is also common in digital games. Occasionally, post-credits scenes in games have an ergodic dimension such as in BIOSHOCK INFINITE (Irrational Games 2013). Here, ergodicity is reduced to basic avatar movements, so that the sequence as a whole still serves a predominantly narrative function. More elaborate ludic post-credits sequences are either part of open world games (as "post-ending phases", see Chapter 4.2) or games that

evoke a false sense of an ending, i.e. that feign closure, including paratextual signals, mid-game (although usually close to the ending, see Chapter 4.1). As such structures operate on a larger scale of the artefact, they will be discussed in Chapter 4.

While the preceding theoretical discussion occasionally used non-narrative digital games as examples, the initially announced restriction to digital games with a considerable degree of narrativity, which entails a modal dominance of narrative at least during some segments of the media artefact, takes full effect from here on. As the following analysis is concerned with specific representational strategies that can be identified as the medium's repertoire of closural signals, games without endings are naturally left out as well. This includes, on the one hand, games that do not supply a sense of an ending other than one that is highly contingent on player interpretation – comparable to the quest for closure in hyperfiction readings (see Chapter 2.1) – or one that solely relies on the achievement of chosen, i.e. player-motivated goals. On the other hand, "unintentional" game terminations, such as the "kill screens" of early arcade and home console games, do not qualify as endings according to this book's definition, since they are but mere cessations.[4]

3.2 "Once you enter this area, there is no turning back."[5] – The beginning of the end

Initiating the sense of an ending

The sense of an ending is a cognitive sensation that starts slowly and grows stronger the more closural signals accumulate. Often, it is hard to determine the starting point of this sensation, even when assuming complete intersubjective stability. While some narrative media artefacts highly obscure the breach in order that initiates closure, others highlight it. Digital games are no different. The following section examines breaches that can clearly be identified as initiating a game's ending phase, how they are highlighted by several representational strategies, and which further functions these strategies fulfil. Note, however, that as in any other medium, not all digital games provide a clear breach, and that breaches also occur in other segments of a game without any relation to its ending. Besides, game endings differ in length as much as those of any other potentially narrative media, largely depending on the game's overall length, just as a novel typically shows a more prolonged ending than a short story. However, the exact duration of a game ending is even more difficult to determine, since individual playing processes take a varying amount of time. Yet, this temporal variability can be assumed to be lower compared to the rest of the game, since ending sequences are usually tightly structured and rarely give room for exploration. On the other hand, the typically high difficulty of the final challenge can result in a striking difference in duration for skilled and less skilled players. Even more so than for the endings of other media,

any durational aspects of digital game endings are, hence, best discussed in relation to the whole artefact or average playing process.

A term that inevitably comes to mind in the discussion of game endings and how to identify them is *endgame*. It designates the final stage of a playing process – or any process in general, as a figure of speech – and is most commonly used in the context of chess and Massively Multiplayer Online games (MMOs). While the exact start of the endgame phase is often unclear in chess, MMO endgames usually begin when players have levelled their avatar to the maximum, which is necessary to unlock certain quests that are commonly known as endgame content.[6] Reaching the maximum level designates a clear breach in order. However, the endgame of an MMO does not designate an ending as per this study's definition, and since the social (including competitive) aspects of MMOs further complicate the matter of their (potential) endings and teleology, they – like any other type of multiplayer games – cannot adequately be discussed here.

Recently, players have been using the MMO-based term also for specific features of singleplayer games. This seems reasonable within the limits of certain genres, such as singleplayer roleplaying games (RPGs), which share many characteristics with conventional MMOs, since these are often RPGs as well (MMORPGs). In FINAL FANTASY XV (Square Enix 2016), for example, the endgame can be said to begin in chapter 15 of the game, which is only accessible after the completion of the game's main questline and storyline. Just as achieving the maximum avatar level in an MMO, reaching chapter 15 in FINAL FANTASY XV unlocks new quests to discover and challenge in the freely explorable game world. This form of "post-ending" openness – which mainly refers to ludic, but potentially also to narrative continuation – will be further discussed in Chapter 4.2.

Overall, the term *endgame* in its most general sense is certainly suited to describe the final phase(s) of digital games, since these are, by definition, (complex) processes. However, considering its specific use in – either digital or non-digital – ludic contexts, the term bears no significant relevance to the beginning of the ending as it is understood here. What, then, are suitable measures for identifying the starting point of a digital game's ending? Among the numerous representational strategies used to create a final breach in order, which will be discussed subsequently, some are familiar from other media such as a sudden change in setting or protagonist, or paratextual labelling (e.g. a chapter title with closural allusions). The strategy that will open this chapter, however, is closely tied to the medium's ergodic dimension.

Point of no return

In the game BASTION, players navigate between a hub-world (the "Bastion") and different areas, or levels, via a map-like interface called the "Skyway". Upon trying to enter the final area, "The Tazal Terminals", by selecting the corresponding icon on the map and confirming the choice with another button, the level is not immediately loaded as in all prior cases. Instead,

the screen changes to the message: "Once you enter this area, there is no turning back. Are you ready?" Players are offered the choice to proceed or to cancel the action (see Figure 3.1). Why does the game pose this question, demanding an additional action of players who already made (selecting the area) and confirmed (clicking the button) their choice? The reason is given in this sub-chapter's title: Unlike flying to any other area in the game, entering the Tazal Terminals marks a point of no return, triggering events that will render any later exploration of the game world impossible. There will be no further opportunity to level up, find equipment improvements, or tackle certain challenges (e.g. to get an achievement in the metagame), because after completing the Tazal Terminals, the Skyway is no longer available and only a final choice inside the Bastion remains to finish the game. The game's narrative development already hints at the looming ending at this point, but the additional question dispels any doubt about it.

Reducing the freedom of play by eliminating gameplay features, such as the navigational interface of the Skyway, is a common closural strategy of digital games, of which the point of no return is only one form. BAS-TION explicitly announces this reduction with the quoted warning, which functions both as a closural signal that marks the beginning of the ending, and as a courtesy towards players for offering them an opportunity to reconsider and complete any secondary goal before finishing the game and its story. The closural function of the point of no return is analytically invaluable for its distinct and undisputable final breach in order. Yet, as it is typically accompanied by a range of other closural signals to trigger the beginning sense of an ending, the warning function of the point of no return is arguably more important. As ergodic media artefacts, digital games rely on the active, non-trivial effort of players in order to proceed. The point of no return uses this quality of the medium for a distinct break that halts the game until the player decides for an action. Hence, apart from offering

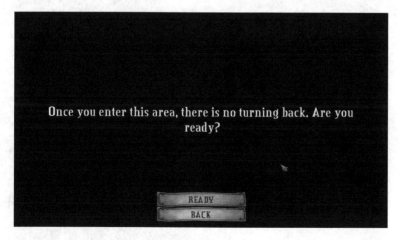

Figure 3.1 BASTION, point of no return.

players the opportunity to postpone the action and go back, the point of no return furthermore grants them a pause to prepare themselves for the imminent challenge of the game's finale.

In general, points of no return are abundant in most digital games, especially in those with a progression structure. Pure games of progression can even be described as a continuous series of points of no return, since progress is only possible in one direction. As most digital games couple both ludic and narrative progression with spatial advancement, a point of no return usually corresponds to a spatial threshold in the game world as well. To announce points of no return in tightly structured games that do not provide opportunities for exploration, such as the first-person shooter (FPS) HALF-LIFE (Valve 1998), would be superfluous. If there is only one line of quests or challenges to follow, and if there is nothing else to do other than fulfilling the prerequisites for progression, then there is no threat in not being able to return, and a warning, like the one in BASTION, would be meaningless. Vice versa, the more opportunities for free exploration, and the more optional challenges, the more likely it is that a game communicates any impending cut that will erase these opportunities, in order to avoid building up player frustration, and to invite players to fully explore the game.

Marked or unmarked, points of no return do not necessarily initiate the ending, since they can be scattered throughout the game. For example, there are four points of no return in DEUS EX: HUMAN REVOLUTION (Eidos Montréal 2011)[7] that warn players about the cancellation of remaining side quests when they are about to leave an area (see Figure 3.2). None of these designate the beginning of the game's ending, as the last marked point of no return occurs still too early in the playing process. In the further context of

Figure 3.2 DEUS EX: HR, point of no return at end of chapter.

this study, the term *point of no return* will be used exclusively to designate those points that are related to a final breach in order, as only these can fulfil a closural function.[8]

The point of no return that *does* initiate the ending of DEUS EX: HR – the beginning of "Chapter 15 – Tipping Point", which displays some other closural signals that will be discussed shortly – remains largely unmarked: There is an intradiegetic question that needs to be answered positively to proceed, but it is not accompanied by any warning about the impossibility to turn back as in the points of no return before, since the area being left behind offers no side quests. The example shows that points of no return are signalled with a varying degree of explicitness. A minimum of explicit marking is necessary for a point of no return to function as a closural signal, since an unmarked point – i.e. one that is recognisable only in hindsight or may be inferred from other closural signals – lacks any representational quality.

The representations of points of no return differ not only in degree but also in modal dominance and narrative level. While narrative relevance is basically optional, an elementary ludic relevance is guaranteed, since the point of no return is not only announced but also the player has to react to it. The point of no return in BASTION is purely extradiegetic, as the warning message directly addresses the player, and is devoid of cues to the storyworld. Its minimalistic design resonates with the message's predominant ludic function, accepting a possible breach of immersion. The (non-closural) points of no return in DEUS EX: HR, in contrast, are at least partly located on an intradiegetic level, as the question to proceed or not is uttered by another character and directed at avatar Adam Jensen in the player's stead. The warning that accompanies the dialogue options, however, fulfils the same ludic function as that in BASTION, is directed at the player, and unambiguously identifiable as extradiegetic from its mention of "side quests". Such narrativisation of the point of no return by relocating it to the intradiegetic level is a common representational strategy. It transfers the decision to proceed or not to the fictional realm, making it is as much the protagonist's as the player's action, while the protagonist of BASTION is not part of the final confirmation process.

MASS EFFECT 2 (BioWare 2010) opts for a fully intradiegetic representation of its point of no return that matches the game's overall high degree of narrativity and its encouragement of player identification with the customisable avatar. Here, the fictional A.I. EDI demands confirmation of the chosen destination from protagonist Shepard, explaining the impending inability to go back by summarising the danger of the upcoming journey that the characters have discussed in detail before. The ludic consequences of this point of no return are not clearly stated at this point, but have been made clear during prior conversations, in which the term "suicide mission" has been established for this final quest – again, all intradiegetically. The possible answers to EDI's question simulate the protagonist's point of view and speech (e.g. they speak of Shepard in the first person). Moreover, there

are three instead of the conventional two possible answers, although these ludically still amount to a binary decision: In addition to the option to cancel the action ("Wait. I need everything ready."), players are given the opportunity to adjust their confirmative answer to their own idea of the protagonist's personality by giving either a positively connoted, virtuous answer ("We have to rescue our crew.") or a more self-centred, impatient one ("I'm done waiting around."). Although the difference between the two confirmative answers operates purely on the narrative level, they reflect the game's moral system that locates the protagonist's personality on a scale between "Paragon" and "Renegade", depending on player choices. While this moral system indeed has ludic consequences during the playing process, the game also frequently alludes to it to let players determine narrative nuances without any ludic consequence, just like at this point of no return. Remarkably, MASS EFFECT 2 later offers players the opportunity to return after its ending, i.e. to take on side quests that were left open at the beginning of the suicide mission. Thus, the game retroactively invalidates the ludic meaning of its point of no return, instead emphasising it as a means for creating a dramatic effect. In fact, the point's ergodic relevance is somewhat dependent on players' skills and their rating of the final challenge's difficulty, as the game upholds narrative coherence, so that side missions are only available if avatar Shepard and, in some cases, the characters involved in the corresponding quests have survived the suicide mission.[9]

Often, the diegetic state of the message marking a point of no return is ambiguous or, to use Jørgensen's terminology: the message is transdiegetic. Conforming to the standards of strategy games, XCOM: ENEMY UNKNOWN (Firaxis Games 2012)[10] lacks an avatar who functions as the protagonist, focusing the story more on plot than on characters. Yet, players of XCOM: EU are still assigned the role of a (never shown) character in the story, namely that of the "Commander" of the "Extraterrestrial Combat Unit" ("XCOM") that defends Earth against alien invaders. Non-player characters (NPCs) address players in the name of their assigned role; yet the game mechanics exceed narrative plausibility, since, for example, the player controls every move and action of each soldier during a combat situation.[11] The message designating the game's point of no return stays within this narrative ambiguity, as it addresses the player as "Commander" within the fictional realm but seems to have no intradiegetic source. While the message still uses intradiegetic terms, its function seems to be predominantly ludic, as it warns about "all forward progress [being] stopped". In contrast, the message in MASS EFFECT 2 highlighted the narrative consequences of the dangerous journey, increasing suspense rather than reminding of potentially unsettled quests.

To be precise, the representational strategy called "point of no return" in this study rarely occurs at the technical point of no return in the program, but shortly before it, in the last moment that still allows turning back. The game PSYCHONAUTS (Double Fine Productions 2005) undermines this convention by marking its point of no return in the exact moment of its occurrence, denying players any option to reconsider their action of progressing.

The signal announcing the point of no return is the extradiegetic message "Saving AUTOSAVE: POINT OF NO RETURN". While autosaves at important moments are common throughout the game, this one is marked as exceptional by its telling name as much as by the message itself, since prior checkpoints are saved without any notice. Moreover, whereas previous autosaves subsequently replace each other, the point of no return appears in an additional save slot. Yet, as the message disappears once the saving process is complete without demanding any player action, this point of no return attracts less player attention than the conventional strategy. However, the game still caters for players' potential wish to undo this choice, as loading the save file puts them back to the moment *before* the decisive action, i.e. the moment that conventionally would prompt a warning about the point of no return, which is also the last moment to allow players to go back and fulfil any of the game's optional challenges.

To summarise, the closural signal of the point of no return most conventionally serves a predominantly ludic function. While narrative framings can be used to represent it, and can even be highlighted as the predominant mode, such as in MASS EFFECT 2, it is more common that the narrative remains subdominant, as the point essentially signals a ludic breach. It is first and foremost the player who is unable to return, and who is thus warned about this severe cut in the playing process. The following closural signals, on the other hand, mostly pertain to the narrative mode, although they can also entail ludic consequences.

Changes related to content narremes

The two abstract principles that can effectuate a clear breach in order are pauses, or interruptions – exemplified by the point of no return – and substantial changes in any significant element of a media artefact. In digital games, this can affect both ludic and narrative elements. The previous section has shown that ludic changes often accompany a point of no return, such as when the world map and related travel mechanics are no longer available after beginning the final section of BASTION or MASS EFFECT 2. However, ludic changes are often implicit – the idea to use the world map after the point of no return might not even occur to players – and accordingly bear no significant closural effect. In contrast, substantial changes within established narrative elements that are concretisations of content narremes, such as the spatial and temporal setting, or the protagonist, are common signals to indicate the beginning of a digital game's ending. It should be noted that the narreme-related elements in a digital game are not completely detached from its ludic mode, as both settings and characters can affect gameplay: For example, movement under water usually works differently from movement on land, just as different avatars often react differently to player input (e.g. they are slower or faster) or offer an altogether different set of skills. Yet, the narreme-related changes that initiate a game's ending typically entail no, or just minor ludic consequences, so that their predominant operational mode appears to be the narrative.

The most conventional form of narreme-related change at the beginning of digital game endings is that of the spatial setting. In the previous section, I mentioned that most points of no return are accompanied by such a change in place. Yet, the bond is not reciprocal, since a change in setting does not entail a (marked) point of no return. As advancing in a digital game is often coupled to spatial progression, players usually visit a variety of different locations during a single playthrough, so that changes in place occur frequently. This is most apparent in platformers, such as the SUPER MARIO series (Nintendo 1985–2017), and other types of games in which moving from point A to point B while overcoming various obstacles is the main goal. However, even in games that do not directly link spatial and ludic progression, a change in place is usually highlighted by the fact that it is bound to a ludic achievement, i.e. completing a quest or mission inside one area before proceeding to another. Among the potentially frequent setting changes, the last one conventionally stands out, as it leads either to a (audiovisually) spectacular location or to one that gains special meaning from the game's narrative context. This extraordinary quality of the last change of place makes it recognisable as a closural signal (see also Chapter 3.4). Most commonly, audiovisual and narrative exceptionality coincide.

Among the spatial tropes that signal an upcoming finale are places that are, in a way, located outside, or at the boundaries of the known game world, difficult to reach for protagonists, and usually inaccessible or even unknown before the change takes place. This is particularly common in RPGs, such as XENOBLADE CHRONICLES, which locates the game's finale in outer space, or NI NO KUNI: WRATH OF THE WHITE WITCH (Level-5 2013), which reveals a floating castle in the sky as its final setting (see Figure 3.3). As has been hinted at, the change of place that occurs after the point of no return in MASS EFFECT 2 also leads to a formerly inaccessible

Figure 3.3 NI NO KUNI, the outside of the game's final setting, the "Ivory Tower".

location, namely the core of the galaxy, which harbours both the enemy base that is the mission's destination and a dangerous black hole.

The galactic core's hazardousness in MASS EFFECT 2 shows another common way of indicating a setting's exceptionality, i.e. to represent it as particularly dangerous. While BioWare's RPG mostly establishes this danger in prior dialogue sequences and cinematic cutscenes following the point of no return, this strategy is most readily apparent in the typical final lava worlds of the SUPER MARIO series. As one of the most well-known digital game series of all time, SUPER MARIO undoubtedly influenced the conventional status of places filled with fires and lava as final settings.

The final change in place of HALF-LIFE fulfils both the criteria of exceeding the game world's formerly known borders and being exceptionally dangerous, as it takes the avatar to the alien dimension Xen, the first and only extra-terrestrial location of the game (in fact, the only location outside the complex of the Black Mesa company). HALF-LIFE is also one of the rare examples in which the spatial change *does* entail at least minor ludic consequences, as Xen's lower gravity alters the game's jump mechanic by enabling longer and wider jumps than before.

In all the above-mentioned games (save the SUPER MARIO series, due to its lower narrativity), the final setting's apparent extraordinariness is also narratively framed, as has been mentioned for MASS EFFECT 2. Many digital games prioritise such narrative exceptionality over ostentatious audiovisual spectacle. For example, the Lake View Hotel, the final location of the survival horror game SILENT HILL 2 (Konami 2001), does not appear extraordinary, neither in context of the game world nor in real-life standards. Yet, it has been loaded with meaning from the game's very beginning, in which a letter of his deceased wife tells protagonist James Sunderland that she is waiting for him in their "special place", said Lake View Hotel. SILENT HILL 2, thus, communicates the hotel as the game's final destination, so that reaching it initiates a sense of closure.

A third strategy of marking a change in place as extraordinary is to let the game's ending take place in the location of its beginning. As has been noted earlier (see Chapter 2.1), tying the ending to the beginning is a common closural signal in narrative media artefacts, so that digital games can draw on this established convention.[12] Among games that do so is the adventure game THE SECRET OF MONKEY ISLAND (Lucasfilm Games 1990), which, in its final chapter, leads avatar Guybrush Threepwood back to Mêlée Island™, where he became a pirate in the game's first chapter. While players of MONKEY ISLAND have spent a considerable amount of time – nearly half of a typical playthrough – on Mêlée Island™, FINAL FANTASY XV lets players return to a setting which they know from the beginning of the game, but had no access to: The metropolis Insomnia is only shown in the game's opening cutscene before the player takes control, but its meaning as avatar Noctis' hometown, which is taken over by enemy forces shortly after the introduction, resonates throughout the game.

Connections between beginning and ending that exceed single game boundaries within a series can be found in HALO: REACH (Bungie 2010) and SYSTEM SHOCK 2 (Irrational Games / Looking Glass Studios 1999). In both games, the ending takes place within the setting of the series' first instalment. In fact, the decisive change in place in SYSTEM SHOCK 2 puts players into the exact same room of its predecessor's first ludic sequence – although within the game's diegesis, it is only a virtual recreation of the place that had been destroyed in the finale of SYSTEM SHOCK (Looking Glass Technologies 1994).

As a reminder that representational strategies with a closural effect often gain this effect only in combination with a range of other closural signals, another example shall briefly be presented. Just as HALO: REACH and SYSTEM SHOCK 2, METAL GEAR SOLID 4: GUNS OF THE PATRIOTS (Kojima Productions 2008) recreates a space known from the series' first instalment, when the fourth act of the game transfers players back to Shadow Moses Island, the setting of the entire game of METAL GEAR SOLID (Konami Computer Entertainment Japan 1998). Although the game makes use of an exceptionally powerful representational strategy to mark this significant change in place, it is not accompanied by any other closural signals and occurs too early to likely initiate a sense of an ending.[13] Note, however, that a premature closural effect unrelated to a game's actual ending is generally possible given the presence of other closural signals. While this applies to all media, the digital game's medial qualities stimulate the deliberate implementation of such false closure, as its ergodicity and controlled access enable games to conceal information about upcoming sequences, or to hide entire segments, lest players make specific choices, show an exceptionally good performance, discover a secret path, and so on (see Chapter 4.1).

Until now, only one type of change in narrative content that contributes to initiating a sense of an ending has been discussed. Although there are indeed others, it should be emphasised that a change in place is, in fact, by far the most conventional narreme-related change for marking a final breach in order in digital games. Other variations confront players with a different avatar or temporal setting at the beginning of the ending; yet those are rare and, arguably, less impactful than the change of spatial setting, as the following examples will show.

Among the few games that present a significant avatar change near their end are BAYONETTA (Platinum Games 2009), DEADLY PREMONITION (Access Games 2010), RED DEAD REDEMPTION, L.A. NOIRE (Team Bondi / Rockstar Games 2011), and HOTLINE MIAMI (Dennaton Games 2012). In all cases, the change has substantial impact as players were in control of one and the same avatar up to this point. Although the avatar has a distinct ludic function, the change has only minor ludic consequences, if any.[14] In three out of five examples, the change is only temporary: While the familiar protagonists return into the player's hands after a relatively short playing sequence in BAYONETTA and DEADLY PREMONITION, L.A.

NOIRE only briefly switches back to original avatar Cole Phelps during the final three (out of 21) cases of the criminal investigation game. The avatar change in RED DEAD REDEMPTION is final; yet it would be wrong to claim it as a breach in order at the ending's beginning, since most of the ending sequence has already taken place when players find themselves in control of Jack, the son of previous avatar John Marston.

While RED DEAD REDEMPTION accompanies its change of avatar with fast-forwarding in time, so that Jack is now old enough to plausibly be a gunslinger, HOTLINE MIAMI and DEADLY PREMONITION couple their protagonist swap with a leap backwards in time. In both games, the flashbacks serve the purpose of closing gaps in the story and are given a particularly powerful impact with the change of avatar: In HOTLINE MIAMI, the new avatar is a biker whom the player had killed a few intradiegetic days ago in the role of the prior protagonist[15]; and DEADLY PREMONITION suddenly puts players in the shoes of the game's villain, the "Raincoat Killer", years before the game's diegetic present. Both cases use the combined change of diegetic time and avatar to convey a narrative twist, another conventional closural signal, as Strank and Wulff (2014) have thoroughly analysed in their study of twist endings in movies.[16] Another flashback, with neither an avatar change nor story twist, occurs at the beginning of the ending to ALAN WAKE (Remedy Entertainment 2012), where it is used to supply some of the protagonist's backstory.

Apparently, in the rare cases of avatar and time changes at the beginnings of game endings, they primarily serve another purpose than that of initiating a sense of an ending. Either, the change introduces a new narrative perspective and fills narrative gaps (as in DEADLY PREMONITION, HOTLINE MIAMI, and ALAN WAKE) or it increases suspense in a situation in which the game's main avatar is in danger (as in BAYONETTA, where the avatar change occurs after the titular heroine has been knocked unconscious and kidnapped). While the former potentially resonates with a closural function – since filling narrative gaps is a typical content closural signal in the resolution phase of endings – the latter is equally addressed when such changes occur in no particular relation to a game's ending such as in THE LAST OF US (Naughty Dog 2013), which switches to protagonist Joel's companion Ellie in a sequence in which Joel is suffering from an infection. Thus, it is debatable if such narreme-related changes have a distinct closural effect at all. I would argue that they belong to a set of representational strategies that are not conventional closural signals on their own, but that can add to the corresponding effect if employed during endings. For example, after players have been accustomed to one avatar, a sudden change can be alienating, corresponding to the fundamental closural principle of increased distance between recipient and media artefact. Thus, although the second change of avatar back to Ellie in the epilogue of THE LAST OF US brings players closer to this also familiar character, it estranges them fundamentally from Joel, the character with whom they spent most of their playing

time in close connection. The estrangement is narratively supported by the lie that the protagonist tells his trusting young companion, covering up his (prescribed) betrayal of their previously shared goal – shared also by the player – during the game's finale. Hence, the final change of perspective gains additional closural effect in the sense of players being "done" with Joel that exceeds the termination of his function as an ergodic tool.

Paratextual and extradiegetic labelling

A third set of signals that mark a closure-initiating breach in order is neither particularly narrative nor ludic. It concerns paratextual markers that occur whenever the beginning of the ending is captioned, a convention that is well-known from other narrative media artefacts such as novels and films that are segmented into parts or chapters. Just as in those media, similar breaches in order in digital games initiate a sense of an ending if they include closural allusions of a more or less direct variety, the most obvious one being the use of the word "final". Besides the narrative convention of such captions, direct announcement of the impending finale is also common in some non-narrative ludic contexts, for example the "match ball" in tennis. The paratextual and extradiegetic labelling of digital game endings can foreground either the narrative or the ludic mode, or highlight both of them equally. Despite this modal variability, I included the term extradiegetic next to paratextual to describe these closural signals, since their paratextuality is sometimes questionable – a problem that arises not least due to the debatable transferability of Genette's paratext concept to digital games in general, as well as to the varying degree of closeness of paratextual intertitles to the text itself (see Genette [1987] 1997, 297f.).

Apart from the modal variability of closure-initiating captions, they also differ in their degree of ergodicity and emphasis: Some forms of paratextual labelling pass by the players' eyes automatically, while others demand active player input; some captions are presented emphatically, in full screen as a clear interruption, while others are displayed in passing in a corner of the screen, or are even only visible outside the game proper such as in the names of save states. The non-ergodic caption with high emphasis, such as it appears in MONKEY ISLAND, ALAN WAKE, and HOTLINE MIAMI, is most closely related to the convention familiar from other narrative media. In the given examples, the chapter captions are presented as separate intertitles that appear only long enough for players to read the text. Their verbalisations – "Last Part – Guybrush kicks butt" (MONKEY ISLAND), "Episode Six: Departure" (ALAN WAKE), "Nineteenth Chapter: Resolution" (HOTLINE MIAMI) – all include common closural signals. This conventional way of presenting intertitles can, however, also be used to highlight the ludic mode, such as in TEKKEN 5 (Namco 2005), which announces the last part of its "story mode" as the "final stage", together with the series'

conventional, both written and spoken call to players to "get ready for the next battle". The ludic focus of the intertitle answers a generic convention of fighting game loading screens.

The emphasis of such conventional intertitles can be strengthened by a demand for player input such as in BAYONETTA, CATHERINE (Atlus 2011), or THE WALKING DEAD. In both BAYONETTA and CATHERINE, the intertitles operate in both the narrative and the ludic mode: While the caption "Epilogue: Requiem" in BAYONETTA foregrounds the narrative, the display of the game's difficulty setting below the caption and the additional option to save the game highlight the ludic mode. Vice versa, CATHERINE labels its ending sequence as the "Final Stage", in accordance with the game's arcade-like structure, but draws attention to the narrative mode with an intradiegetic announcement. In THE WALKING DEAD, the ergodic break of the intertitle reflects the serial release of the game's episodes: The fifth and final episode of the game series' first season alludes to the upcoming ending with the pressing title "No Time Left", and the fact that, in a manner of vague foreshadowing, the teaser picture is the only episode title screen not showing protagonist Lee, who dies in the season finale. Strictly speaking, however, the labelling here occurs outside the game proper, visible only in the game's menu, so that it is rather comparable to a table of contents than to a chapter title in a book.[17] Similarly, the closure-evoking titles of the final chapter and mission in UNCHARTED 4: A THIEF'S END (Naughty Dog 2016, the final chapter being titled "A Thief's End" as well) and HITMAN: BLOOD MONEY (IO Interactive 2006)[18] (the final mission being labelled "Requiem") are only encountered in the game's menu – or in contextual paratext such as walkthroughs.

In general, the differences in ergodicity and emphasis of paratextual labels are not directly related to their closural effect, since games establish them long before the beginning of their endings, so that players are used to their specific forms and occurrences – other than the marked autosave "point of no return" in PSYCHONAUTS, for example. The sense of ending is, hence, mainly initiated by verbal cues given in those captions, as the given examples illustrate. However, ergodicity naturally supports the potential closural effect of extradiegetic labelling, since it requires active acknowledgement by the player. Therefore, the lowest closural effect – apart from chapter titles hidden in game menus – arises from closural allusions that are found in quest names or goal announcements that are displayed during a playing sequence. For example, upon entering the Ivory Tower in NI NO KUNI, as soon as players take control of avatar Oliver after a short cutscene, the game displays the message "It's the final battle! Defeat the White Witch and save the world!" at the top of the screen, which disappears automatically after just a few seconds. Regardless of their actual closural effect on players, all forms of paratextual and extradiegetic labelling are relevant as an objective demarcation of a breach in order via their use of verbal closural signals.

3.3 "Here it is, the big boss!"[19] – The ludic finale

The final challenge

After a breach in order has signalled the beginning of a digital game's ending, players will typically expect a "grand finale", a climactic ludic sequence that is staged in a spectacular way and that challenges the player's skill to a maximum. Although not all digital game genres – especially those with only minor ludic features such as the so-called walking simulators – feed this expectation, it certainly is one of the medium's most common, widely known, and impactful conventions. The form of the final challenge usually complies with the game's previously established mechanics, so that the game's focus on platforming, combat action, tactical combat, puzzles stays mostly intact. The common types of challenges in ludic finales can roughly be combined into three groups:

1 Final encounters within a confined space against either one strong opponent (a "boss"), a large number of enemies, or both. The "confrontation of the player with a 'boss', an opponent at the end of a level, or a group of levels, that is significantly stronger and tougher than most opponents" is, according to Backe, "a convention almost as old as the digital game itself" (Backe 2008, 437f., my translation from the German). The final boss during the last playing sequence is the ultimate form of this convention, which is found in a variety of genres, from first-person shooters (e.g. Nihilanth in HALF-LIFE) to even classic adventures (e.g. LeChuck in THE SECRET OF MONKEY ISLAND). The convention is so strong that it has long since become a trope in popular culture, sprouting even dedicated parodies such as the flash game YOU HAVE TO BURN THE ROPE (Kian Bashiri 2008), which consists of nothing more than a final boss encounter (followed by a disproportionately long credit roll). Although certainly most conventional, the final boss encounter is not the only feasible form of a final challenge, even in games with a focus on combat. METRO LAST LIGHT (4A Games 2013) and BIOSHOCK INFINITE, for example, confront the player with waves of multiple standard opponents in their finale, rather than with one particularly strong foe. Both forms can be combined, so that a powerful final boss and multiple standard opponents have to be fought either at once or subsequently during the ludic climax.

2 A final level or puzzle. In contrast to the extermination of one or more enemies in final encounters, the main goal of a final level is to safely move the avatar from one point in the game world to another while facing various obstacles. A final level is generally included in most games that are divided into distinct ludic sequences – be they called levels, or cases, stages, races, dungeons, missions, and so on. I would like to extend the term to refer to final ludic sequences with a focus on spatial progression even in games that lack such distinct structures, mainly to include escape sequences, which appear in level-structured games like

New Super Mario Bros. Wii (Nintendo 2009) as well as in games with a focus on spatial exploration and a generally openly accessible world such as Super Metroid (Nintendo 1994). Both examples place a final escape sequence after a final boss encounter,[20] demonstrating that different forms of ludic finales can be combined in one game ending. Vice versa, many final encounters are preceded by a final level, which is also the case for New Super Mario Bros. Wii as well as for most RPGs or action adventures that are divided into distinct dungeons such as Ni No Kuni's Ivory Tower or Hyrule Castle in The Legend of Zelda: Twilight Princess (Nintendo EAD 2006).

The final puzzle – which is found in its purest form in dedicated puzzle games like the Professor Layton series (Level-5 2007–2017) – is grouped together with the final level due to the frequent combination of puzzle and platforming mechanics that makes solving puzzles the prerequisite for spatial progression such as in Braid (Number None 2009) or Catherine.

3 A final choice. This form of final challenge takes the ludic finale closest to the narrative mode. Ergodic narrative decision-making is probably the closest possible form of intertwining the two discursive macro-modes that has even been called a "method to avoid ludonarrative dissonance" (Unterhuber and Schellong 2016, 21, my translation from the German). While the ludic difficulty of a challenge is generally debatable (see below), it is simply irrelevant for the final choice, as the ergodic action required to make a final decision does not require any skill. The felt difficulty of a final choice resides solely in its narrative context that might confront the player with a moral or ethical dilemma. A final choice — usually – but not necessarily – entails the existence of multiple endings (see Chapter 4.3). It is both found in combination with other forms of ludic finale – such as the final choice in Deus Ex: HR, which follows a final boss encounter – and on its own in games that generally focus their mechanics on narrative decision-making such as The Walking Dead.

The list should be taken as a general overview rather than a strict classification, since some final ludic sequences show characteristics of more than one group. For example, the last mission of the combat-focused strategy game XCOM: EU demands spatial progression through the alien mothership while fighting enemies, including a powerful boss, and the escape sequence of Metal Gear Solid is staged as to focus on spatial progression, suggesting a final level type of finale that, however, happens automatically while the player rather needs to fight waves of enemies.

What is common to all these forms is that they are conventionally designed to appear extraordinary in comparison to previous ludic sequences in the game. As the mechanics of the ludic finale usually comply with what has been established throughout the game, the general ludic set-up of the final situation is familiar to the player but taken to an extreme – an extreme that is responsible for the challenge's closural effect. Strategies used to evoke a feeling of

extraordinariness and spectacle include (a) gameplay variations, (b) audiovisual representational cues, and (c) story elements. The three dimensions will be discussed separately in the following, although occasional cross-references cannot be avoided, primarily because they are all communicated by – sometimes the same – audiovisual means. Hence, the audiovisual dimension often serves as a bridge between the other two, since – to generalise Tim Summers' statement about game music – audiovisual cues "contribute[] to, and connect[], both narrative and ludic components of the game" (Summers 2016, 155). All strategies discussed in this section predominantly serve the ludic mode on a macro-level; yet the basis of their distinction is their differing modal predominance on a micro-level, with group (a) pertaining to the ludic mode, group (b) to the descriptive mode, and group (c) to the narrative mode.

Ludic design and gameplay variations

While audiovisual and narrative cues are typically easy to identify, ludic factors can be hard to assess in an intersubjectively plausible way. Both the exact duration and the difficulty of a challenge depend on player skills, and potentially even on time and effort invested into easing the challenge in advance, for example by maximising the avatar's level or obtaining better equipment.[21] Although some design strategies clearly reveal the intention to increase the duration or challenge of the ludic climax, the issue of difficulty remains subjective to a considerable extent. As this study has no access to empirical data that would permit profound evaluation, it can only be assumed that the majority of digital games is designed to comply with the convention of maximum difficulty during the final ludic sequence. The convention itself stems from the traditional imperative of a concurrent increase in progress and difficulty that guarantees the prolonged appeal of (non-narrative) singleplayer games (see Backe 2008, 321). Its prevalence is indirectly confirmed by those few examples that observably undermine it by modifying game mechanics and other ludic characteristics in such a way that they ipso facto diminish the ludic finale's difficulty, such as THE DARKNESS (Starbreeze Studios 2007), which sacrifices the conventional intensification of the challenge to ergodically confirm the narrative development of a powerful demon taking control of the protagonist's body (see Beil 2009, 86).

The ludic design strategies discussed in the following pertain mostly to the first two forms of ludic finales, i.e. final encounters and final levels and puzzles, since final choices are innately characterised by minimum ergodicity that offers little room for modification. The first group of strategies refers to those that clearly aim at increasing a challenge's length or difficulty. As the ludic finale conventionally complies with the game's established mechanics, this often entails a simple increase in characteristic ludic features of the game such as an excessive amount of a final boss's life energy, extraordinarily strong attacks of the opponent, an unusual (spatial) length of a level, or the increased complexity of a puzzle. A more distinct closural

function is served by design strategies that are frequently used as exclusive features of the game's ludic finale, such as time limits, the separation of the ludic sequence into several phases, and unique weapons or skills, that are only available during the game's ending.

Time limits are often found in final levels, which are then most conventionally staged as escape sequences, as well as in final encounters. Since the purpose of a time limit is to increase a challenge's difficulty as much as to evoke a general feeling of pressure and urgency, communication of the time limit to players is essential. Usually, this is done by explicitly stating it in form of an on-screen countdown such as during the finales of SUPER METROID and RESIDENT EVIL (Capcom 1996). Alternatively, the countdown display might be integrated into the diegetic space without forcing it into the player's field of vision, such as in PORTAL (Valve Corporation 2007), which shows it on several screens on the walls of the final encounter's arena (see Figure 3.4). Occasionally, subtler means are employed, as shown by METAL GEAR SOLID 3: SNAKE EATER (Konami 2004), which communicates the time limit of its final encounter only by verbal announcements: In set intervals, protagonist Snake's former mentor and final opponent "The Boss" reminds Snake (and the player) of the time left until a bomb strike that will kill both characters and, hence, lead to failure. This representational strategy both increases pressure on the player, who cannot continuously access crucial ludic information, and highlights narrative immersion, as no countdown display distracts players from the narratively loaded and beautifully staged encounter that takes place in a flower field.

A seeming opposite to time limits is the separation of the ludic finale into multiple phases that essentially aims at increasing the final challenge's impact via extended duration. However, the combination of a sense of

Figure 3.4 Intradiegetic time limit during final boss encounter of PORTAL.

urgency with the (sometimes painful) necessity to endure it throughout several stages can even heighten the effect of both strategies. Alternatively, time limits can be given separately for different phases of the finale, as is the case in METAL GEAR SOLID, which sets a three-minute time limit during the final part of the boss encounter, followed by another ten-minute countdown for the final escape sequence (regardless of the amount of time the player took to complete the previous segment).

I distinguish between two types of multiphase ludic climaxes: First, the ludic finale can be separated into different types of final phases such as an escape sequence that follows a boss encounter – as in METAL GEAR SOLID or SUPER METROID – or, vice versa, a final boss encounter that follows a final level – as in NI NO KUNI or RESIDENT EVIL. Generally, the longer a game and the more diverse its mechanics, the more likely it is that the ludic finale encompasses multiple stages. Although such ludic diversification of the finale is extremely common, it can only be ascribed a closural function if it is exclusive to the final part of the game, as it otherwise merely conforms to an established alternation of different types of challenges. For example, the ludic finale of NI NO KUNI does not gain its closural effect from the combination of a boss encounter following the exploration of a dungeon, since this is the usual procedure of ludic progress during most of the game, but rather from these sequences' specific design (in all three aspects of gameplay, audiovisuality, and story).

In contrast, multiphase final encounters, the second type of multiphase finales, have a particularly strong closural effect, since they often exclusively occur during the game's last playing sequence. Although it affects all kinds of final encounters, the separation into multiple (most commonly three) phases is the most conventional for confrontations with a final boss. The convention – just as the final boss encounter itself – is particularly strong in RPGs, as is again perfectly illustrated by the three-stage encounter at the end of NI NO KUNI. Yet, it is not at all limited to the genre, as the predominance of multiphase encounters at the endings of nearly all games in both the SUPER MARIO and THE LEGEND OF ZELDA series proves. The transition from one phase to the next is usually triggered when the opponent's life energy drops to a certain amount (often represented as the depletion of a health bar, which is then refilled at the start of the next phase). As phases are typically separated by non-ergodic sequences, such as a brief dialogue or cutscene, they increase the finale's duration and, hence, the sequence's impact even for highly skilled players, and might offer a welcome break for those that struggle. Although transitions may be accompanied by checkpoints that allow players to begin at the stage during which they failed rather than replaying all phases of the fight – which, however, is also common – saving the game is conventionally not possible in between phases, so that players are forced to overcome the challenge in a single playing session.

Apart from clearly non-ergodic breaks, phases are distinguished by at least one of several potential changes that render final encounters more interesting or challenging: The first group of changes concerns the boss itself, that is

either replaced by another boss – such as the magical being Zodiarchy that threatens the protagonists of NI NO KUNI after they defeated the White Witch, Cassiopeia – or the same boss transforms into a stronger state of being – as it happens between the first two phases of battling Cassiopeia (see Figure 3.5). The second group of changes alters the boss's attacks, attack pattern, gear, or location in a way that affects the game mechanics – such as when METAL GEAR

Figure 3.5 NI NO KUNI, boss transformation and change during three-phase final encounter.

SOLID switches to a fistfight between avatar Snake and his nemesis Liquid on top of the destroyed war machine Metal Gear Rex, after the same machine had to be destroyed by the use of a missile launcher in the encounter's first phase.

A remarkably unconventional variation of a multiphase boss encounter is found in METAL GEAR SOLID 4, as the phases here show none of the afore-mentioned opponent changes or transformations. Instead, the transitions from one phase to another affect background music, HUD[22], and visual per-spective. Moreover, the game mechanics are considerably reduced through-out the whole encounter: No items can be used, no weapons equipped, not even the menu screen can be accessed, and the only possible actions besides moving the character are an evasive dash, a hit, and a grab. These distinc-tive features serve a metareferential closural function, as the encounter sym-bolises the progression from the first to the (then) latest instalment of the METAL GEAR SOLID series: Music and HUD in the phases match the re-spectively numbered games, and the slight change in perspective as the cam-era moves in closer to the avatar also reflects the slight perspective changes throughout the series (see Figure 3.6). Even the scene of the fight itself is

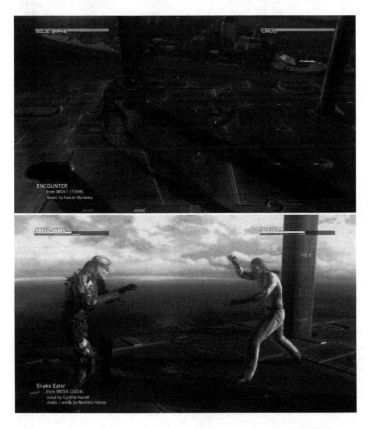

Figure 3.6 METAL GEAR SOLID 4, first and third phase of final encounter.

reminiscent of that of the fistfight in the final encounter of METAL GEAR SOLID, and the reduced mechanics echo the comparatively limited player actions available in the first game, estranging players from the mechanics they have been familiarised with while playing METAL GEAR SOLID 4. Yet, the quick time events (QTEs) during the showdown, which occur when players use the grab move, ludically tie the encounter to more recent trends at the time of the game's release. The sequence evokes a sense of an ending by using the conventional closural signal of referring to the game's beginning in a series-encompassing, metareferential way, and further strengthens it by metareferentially repeating the full journey through the series as the fight progresses. In the final phase of the encounter, movement is significantly slowed down until it becomes completely impossible and players are left only with the option to deliver an attack. The visuality of this final phase matches that of the cutscene right before the ludic climax, in which protagonist Snake and antagonist Liquid Ocelot start their fight without the player's involvement. Now, however, both fighters are visibly exhausted, the blows are slowed down, and the necessity of the player triggering an attack further decelerates the process – matching the closural signal of slowed down or frozen time.

Both the deceleration of movement speed and the alteration of the game's formerly complex mechanics to few simple actions during the final encounter of METAL GEAR SOLID 4 belong to another strategy of giving the finale a sense of extraordinariness via ludic characteristics that can be summarised as a reduction of resources or game mechanics. Such reductions can be used to varying effects: In METAL GEAR SOLID 4, the focus is on the finale's spectacular staging and dramatic effect, while arguably easing the challenge of the fight. In contrast, the reduction of resources during the final boss encounter in SYSTEM SHOCK most likely increases the challenge: Here, the player's field of vision is subsequently reduced as an image of antagonist A.I. SHODAN's face gradually, pixel by pixel, superimposes the screen (see Figure 3.7). This reduction both serves a narrative purpose, as it represents

Figure 3.7 SYSTEM SHOCK, SHODAN's face filling the screen in the final encounter.

SHODAN seizing control of the avatar, who is combatting her mainframe in her native domain, the cyberspace, and intensifies the challenge's urgency via the visually implied time limit.

THE EVIL WITHIN (Tango Gameworks 2014) achieves a similar effect of urgency with another method of reduction in the final phase of its last boss encounter: Here, the avatar is immobile, pierced to a pole, and players cannot even move the camera away from the inevitable approach of the enemy creature, which they can, however, stop with a conveniently appearing rocket launcher. By predetermining the choice of weapon, in contrast to previous boss encounters, and furthermore removing most of the HUD, the gameplay reduction of the sequence simultaneously draws attention to the action's dramatic effect and visual spectacle, consistent with the overall focus of the final encounter, during which both the short ergodic sequences and the alternating cutscenes are crammed with gory action.[23]

The rocket launcher sequence in THE EVIL WITHIN is as much an example for a reduction of gameplay as for its seeming opposite, the addition of an extraordinary attack, skill, or weapon that comes into existence only during the finale. The rocket launcher even has a particularly strong closural effect for being the icon of *the* final, decisive weapon ever since its appearance in RESIDENT EVIL, which shares its director, Shinji Mikami, with THE EVIL WITHIN. As RESIDENT EVIL shows, final weapons are not always mandatory to use, i.e. they do not necessarily entail a reduction of gameplay, but may simply add to the avatar's inventory or range of skills. The trope of the special weapon is also found during the final boss encounter of SUPER METROID (the "hyper beam") and, in a particularly impressive way, during the final mass encounter of BIOSHOCK: INFINITE, where players can command the giant, formerly hostile, mechanical creature Songbird.

Like THE EVIL WITHIN, BASTION forces players to use its special weapon, the Battering Ram, found in the final level, but to an even stronger dramatic effect that extends to the narrative layer. The weapon is extremely powerful, effective even against large groups of enemies, and additionally serves as a shield, so that it significantly eases the challenge of the ludic finale. Yet, carrying the large ram also considerably slows down the avatar's movements. Compelling the player to proceed as a slow, but ultimate force of destruction, the weapon symbolises the weight of the game's narrative conflict, as the nameless protagonist (representing the tyrannising supremacy of his people) pursuits his friend, but also traitor Zulf (representative of the oppressed people) with both characters aiming for what they believe is best for the world that was nearly destroyed by the recent "Calamity". The symbolic conflict culminates in the following player choice to either leave Zulf to die or carry him to safety, which means abandoning the ram and with it any chance of defending the avatar against enemy attacks.[24]

Usually, sequences that force players to use a special weapon or skill obtained during the finale are much shorter, limited to a single action. Such

ludic climax points are characterised by a maximum reduction of mechanics and usually require no skill on part of the player. The final attack is released at the simple press of a button, gaining significance via audiovisual spectacle, narrative meaning, or both. Following an ending convention of the whole series, PERSONA 5 (P-Studio 2017) presents an impressive example of such a decisive final blow that is accompanied by a maximum degree of spectacle. Although players just successfully passed the bulk of the final boss encounter against the skyscraper-sized "Yaldabaoth, God of Destruction", the non-ergodic sequence before the final phase presents the party as nearly defeated. Yet, out of the friends' team spirit and the general public's faith in them arises a new power within the protagonist in form of the Persona Satanael, which even surpasses Yaldabaoth in size. In the following brief battle sequence, the only action available to the player is Satanael's skill "Sinful Shell", which the combat menu describes as "a bullet made from the Seven Deadly Sins that can pierce even a god". The spectacular effect of the attack is even more emphasised when, following the player's action, it is shown not in the game's combat graphics, but in a fully animated, cinematic cutscene in which Satanael delivers a devastating headshot to the incredulous adversary. Although the ergodic effort is immensely low in this form of final blow, the demand for action marks a distinct inclusion of players, bestowing them with a sense of responsibility for this crucial act of the protagonist.

METAL GEAR SOLID 3 emphasises this responsibility in a less audiovisually spectacular but equally narratively loaded manner. After successfully defeating "The Boss" in the encounter's main phase, players need to press the attack button once more to conclude the ludic finale, so that avatar Snake takes a final shot, fulfilling the last wish of his former mentor by putting an end to her life. By insisting on player action while denying the ludic element of choice (apart from the choice of not performing the action and, hence, not advancing the game), a final reduction of gameplay features like in PERSONA 5 and METAL GEAR SOLID 3 has a powerful closural effect, as it puts narrative emphasis on the action and gradually leads players out of the ergodic experience. While the brief sequences of final blows perform this transition in a rather rough, staccato manner, "ergodic epilogues" that allow players to interact during predominantly narrative ending sequences fulfil the same functions in a smoother way (see Chapter 3.4).

Audiovisual staging of the ludic climax

The previous description of the final encounter in PERSONA 5 already hinted at the possible scale of audiovisual spectacle in ludic finales, the means of which are further assessed in this section. Audiovisual factors are mainly responsible for setting the mood of the ludic finale. While maximum difficulty and maximum impact on the story are the standard for the ludic and narrative dimension of the climax, the audiovisual design determines its

character, emphasising the excitement of the challenge, the life-threatening urgency of the situation, the heart-breaking dilemma of the avatar, and so on.

Just as in other audiovisual media, a major part of mood-setting is played by the musical score. Tim Summers identifies one of the core functions of music in digital games as "texturing" (Summers 2016, 59) which he defines as follows:

> Musical signifiers 'fill out' or 'apply a texture' to the visual and other textual aspects of the game. Games use music to elaborate beyond the aspects of the text. Music may introduce entirely new associations to the game, or accentuate less prominent features of the text to a position of significance and distinction. The game is enriched and allows greater engagement on the part of the player.
>
> (Summers 2016, 83)

This texturing effect is responsible for the traditionally important part that game music plays in "cultivating immersion" (Summers 2016, 59). While music in digital games generally fulfils a range of other functions, including the communication of gameplay-relevant information (see Summers 2016, 117–42), that of texturing dominates during ludic finales and partakes in evoking a sense of closure. The filling purpose of musical texturing should not be mistaken for music being "a passive or submissive accompaniment to a visual track, [as it] is instead a constitutive part of the game experience" (Summers 2016, 80) that "acts as another sense, providing access to that which is not otherwise available for detection, or accentuating, enhancing and making salient ideas, information and concepts unmarked and only at the fringes of awareness" (Summers 2016, 72). While the former (i.e. the communication of the otherwise undetectable) is less important during ludic finales, because these sequences conventionally aim at extraordinariness and spectacle on all levels, the significance of the latter cannot be overestimated within this conventional conglomerate of climax markers.

Music is relevant for all kinds of ludic finales, with game mechanics – during endings as well as throughout the whole game – usually determining the basic style of the score, so that time-critical and combat sequences are typically accompanied by propulsive tracks, while more restrained and solemn music dominates final decisions or puzzles. In DEUS EX: HR, for example, the repeated deep, dramatic brass sounds within an otherwise minimal score that plays during the final decision contrast with the energetic and feverish score of the previous boss encounter. The latter is a typical example for one of the most significant among the digital game's "own musical traditions" (Summers 2016, 149), as music during final boss encounters seems to be a convention just as powerful as this type of final challenge itself. Summers discusses this convention in the broader context of the score of FINAL FANTASY VII (Square 1997) (see Summers 2016, 157–76). Using

the example of the game's different combat themes, he points out how the music reflects and supports its overall structure as "a hierarchy of cues is used whereby more challenging and more significant enemies use increasingly rarely heard pieces of music" (Summers 2016, 167). On top of this hierarchy is the theme of the game's final boss encounter, entitled "One-Winged Angel", which Summers describes as "a moment of great musical spectacle, monumentalizing the challenge facing the player and the ludic and narrative zenith that this battle represents" (Summers 2016, 167). A prominent element of "One-Winged Angel" is the choir parts that include the frequent repetition of antagonist Sephiroth's name, provoking a sense of awe for the powerful enemy. In addition to its pure sonic impact, choir parts often stand out for being used only during finales. This appears to be a conventional strategy for musically rendering the final encounter as particularly monumental, even in non-orchestral soundtracks such as that of DEUS EX: HR. Another element used to achieve this effect are powerful guitar riffs that draw on the tradition of heavy metal music, exemplified in the score of the final encounter of PERSONA 3 (Atlus 2006) that contrasts with the game's overall soundtrack, which is dominated by funky pop music with jazz and hip-hop elements.

A well-known closural signal surfaces when ludic finales refer back to or re-use themes from the game's opening, such as the piece titled "The Extreme" during the final phase of the encounter with Ultimecia in FINAL FANTASY VIII, that begins with a distorted version of the game's intro theme "Liberti Fatali" – which, incidentally, is easily recognisable by its distinctive choir part. Music, as has been mentioned, is also part of the series-encompassing, metareferential net of the final encounter in METAL GEAR SOLID 4. The musical references to previous instalments are made explicit, even for players unfamiliar with the predecessors, when the game displays the title and source of the soundtrack in the left bottom corner of the screen at the start of each phase (see Figure 3.6).

Other musical means emphasise the urgency and threat of the situation to the avatar and, in extension, the player, rather than the monumentality of the encounter. For example, the propulsive beats that are frequently part of the score for dangerous and time-critical situations in ludic finales can be interpreted as mimicking a fast heartbeat. By creating similarities to bodily sounds, music and sound in audiovisual media can, following Arnie Cox's "mimetic hypothesis" (Cox 2001), "encourage[] us to equate a fictional character's endangered corporeality with an awareness of our own sense of bodily precariousness" (Winters 2008, 4; see also 11–3, referring to Cox 2001). While Cox and Winters discussed the effect with reference to film music, Summers acknowledges its applicability to digital games (see Summers 2016, 68). Since the rules of the vast majority of narrative digital games imply the avatar's endangerment, which is conventionally maximised during the finale, this musical effect is particularly useful to strengthen the final sequence's impact.[25]

As a means to further set the score of the finale apart from that of standard encounters in a game – which are typically also designed to evoke a sense of pressure, and even a degree of spectacle in the case of midgame boss encounters – the propulsive and monumental parts are often alternated with calm segments and softer sounds such as that of a piano. This method is most likely to be used in encounters of an expectably long duration, such as that of PERSONA 3 or FINAL FANTASY VIII, both to ease the – potentially even physiologically manifest (see Winters 2008, 5) – stress of players and to induce a moment of concentration that also symbolises the heroes' determination before or during the fight.

The combination of compositional strategies that either focus on spectacle, a sense of danger, or gathering focus results in what Summers describes as "epic texturing" (Summers 2016, 63). Assuming that the epic – a term used "by players and reviewers, but [also] game audio practitioners" (Summers 2016, 63f.) alike – emphasises "the 'narrative vertigo' between the intensely personal [...] and the broader spatio-temporal and societal/contextual considerations" (Summers 2016, 64f.), Summers identifies epic texturing as an effective and frequently used strategy to musically "immerse[] the player through heroizing them" (Summers 2016, 83). Although epic texturing certainly is not limited to ludic finales, its dramatic effect is obviously well-suited for this kind of climactic sequences.

Occasionally, music in ludic finales deliberately avoids urgency and spectacle, even though the sequence appears to follow the conventions of a final challenge. This appears to occur most frequently in games with a high degree of narrativity such as THE LAST OF US and BASTION. While the escape sequences of both games are not particularly challenging, their deceleration of both gameplay and music evokes a strong sense of closure. In both cases, movement is slowed down because the avatar carries another character, which simultaneously marks a crucial moment in the game's story that is intensified by the musical texturing. The music in BASTION is particularly remarkable, as it adapts to player choice: If players decide to leave NPC Zulf to die, the avatar stays in possession of the final weapon, the ram, that allows him to fight opponents in the following sequence, accompanied by the propulsive track "Terminal March", which is known from other combat-focused sequences during the game. In contrast, if players choose to help Zulf, leaving their avatar defenceless in carrying his friend, the score is Zulf's theme "Mother, I'm Here", a slow guitar tune accompanied by nostalgic lyrics that intensifies the tragedy of the situation, in which the same opponents that players fight in the other option finally stop mercilessly shooting the avatar to just watch him slowly carry their former comrade away.

Regarding non-musical means of auditory closural signals in ludic finales, a remarkable element is that of "urgency signals" (Jørgensen 2009, 92), which are particularly typical for games with final time limits or even only narratively evoked temporal pressure. Urgency signals generally fulfil

an informative function, attracting attention and "pointing towards emergency situations" (Jørgensen 2009, 92). As they are "separated into different priority levels", not all urgency signals "demand immediate action" from players but can also just serve as information about the general situation (Jørgensen 2009, 92). For example, during the climax of RESIDENT EVIL an alarm sound alternates with a spoken warning about the facility's activated self-destruction mechanism in a constant loop. The actual demand for fast player actions, however, only starts with the ludic time limit of three minutes that is initiated shortly before the final encounter, regardless of the time players took to get to this point. No time limit at all is set at the end of the final main mission of FALLOUT 3, during which there is also a constant alarm that is narratively explained with the nearing destruction of the building.

The looming destruction of the final setting is indeed a transmedial narrative ending trope, as is demonstrated by the collapse of the temple in the movie INDIANA JONES AND THE TEMPLE OF DOOM (Steven Spielberg 1984), to give only one popular of countless possible examples. Making the space of the climax inaccessible for characters by its destruction is a downright physical signal of closure. The more clearly the imminence of this signal is communicated the stronger its evocation of a sense of an ending.

Just as the temporal pressure communicated by sound design, the bulk of audiovisual spectacle for all kinds of ludic finale concerns the setting. The previous section on the beginning of game endings already referred to the potential closural function of specific settings. Depending on the ending's length and structure, the spectacular impact of the closure-initiating change of location is even surpassed in the ludic climax, which frequently takes place at the centre or otherwise most significant place within the wider setting such as Bowser's gigantic castle in the final lava world of NEW SUPER MARIO BROS. WII, or the White Witch's throne room in the Ivory Tower in NI NO KUNI. The examples indicate that this convention, again, is particularly relevant for final boss encounters. While the ludic limitation to a confined, arena-like space is typical for any kind of boss encounter, the settings of final encounters gain their closural function from their audiovisual (and narrative, see the following section) extraordinariness.

Just as for the change of location marking the beginning of the ending, the most conventional audiovisual cues in the ludic finale are those that evoke a sense of awe or danger. While awe is primarily evoked by size (both of the location itself and of the potential boss opponent), dangers divide into "mundane" hazards, such as natural disasters (including fire, lava, and storms) or height (e.g. a place on top of a mountain), and fantastic or otherworldly dangers such as alien dimensions and distorted realities. Often, several of these criteria are combined, such as during the final encounter of TOMB RAIDER (Crystal Dynamics 2013), which takes place on the rooftop of a burning monastery high up in the mountains during a blizzard. Although vast size is a prevalent spatial convention for final locations, high

up places in ludic finales rarely share the dizzying height of the monastery in TOMB RAIDER. However, due to its symbolic meaning, reaching the top (of a building, mountain, and so on) at the ludic climax is probably one of the most conventional spatial tropes of digital game endings. Among the numerous examples substantiating this claim are the top of the radio tower in METRO 2033 (4A Games 2010), the roof of the Lakeview Hotel in SILENT HILL 2, or the dwindling top of the other-dimensional Tartarus Tower in PERSONA 3.

An interesting fact about otherworldly final locations, in contrast to other forms, is that they are often not explained narratively. While this is expectable in games with an overall low degree of narrativity such as SUPER MARIO KART (Nintendo 1992) – with its final race taking place on a "Rainbow Road" in outer space – this trope is also found in games with a high degree of narrativity. Although players can certainly come up with their own interpretations, a game's refusal to provide a clear explanation despite its former practice of explicating any situation marks the otherworldly dimension as a distinctly visual element without a (predominant) narrative meaning. The multiphase final encounter of FINAL FANTASY VIII serves as a pertinent example, as its location changes from the narratively well-explained (although already otherworldly) throne room on top of sorceress Ultimecia's castle into, first, an open space of barren land, and, finally, into the vast nothingness of space that does not even provide ground for the characters to stand on (see Figure 3.8).

In contrast, the otherworldly locations during the ending of LIFE IS STRANGE (Dontnod Entertainment 2015) – which are, by the way, framed by a scene playing out during a storm on top of a hill – are narratively sufficiently explained as the reality-distorting side effects of protagonist Max's power of rewinding time. Yet, they still stand out for their audiovisual design that contrasts with the game's overall realistic (i.e. here: not fantastic) representation of a small American town and art college. Although all of the locations (as well as most scenes playing out in them) are familiar from the game up until then, they are distorted, both by being incoherently connected to each other and by prominent visual changes. For example, during the stealth sequence, which comes closest to a final ludic challenge in this highly narrative game, places with no direct relation in the game's diegetic "real" world are linked; yet these links and, most importantly, the boundaries of these places are obscured in darkness, which emphasises the setting's detachment from reality. The auditory design of the ending is equally distorted, most significantly during the beginning of the sequence which largely reproduces the expositional scene of the game that introduces Max's school after she leaves her classroom. In the ending's distorted reproduction of the scene, the conversations and the song that Max is listening to, as well as her own thoughts are heard in reverse. Thus, beyond fulfilling the closural convention of referencing the game's beginning, the sequence provides a climactic reflection of its central theme of rewinding time and how this power can distort reality.

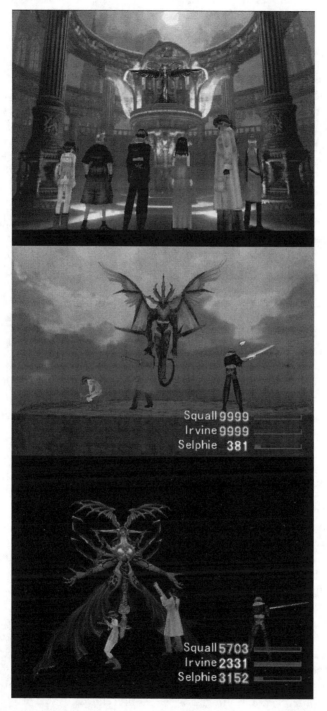

Figure 3.8 Setting change during final encounter of FINAL FANTASY VIII.

In final encounters, apart from the setting, the gravity of the ludic climax is, naturally, also communicated by the audiovisual representation of the final boss itself, with an increasing degree of spectacle if the encounter is spread over multiple phases during which the boss, or at least its appearance, changes. Again, the effect of the audiovisual representation depends on the game's overall context. Opponents that seem extraordinary in game worlds that are designed to closely resemble the real world can appear insignificant in games with fantastic storyworlds. Vice versa, a seemingly spectacular opponent in these games might turn out to be a common occurrence, so that the design of the final boss might turn out downright excessive and exaggerated to conform to the ending convention of maximum spectacle. An example is PERSONA 5, in which all encountered enemies are diegetically located in a purely cognitive realm that allows all sorts of abnormal and physically impossible shapes and figures. Although the game freely indulges in this narrative *carte blanche* for its enemy design, it also ensures the maximum monumentality of its final boss in relation to previous opponents. Hence, during the game's final encounter, the already impressive "Holy Grail"[26] transforms into the (previously mentioned) "God of Control, Yaldabaoth", a metallically shining, winged deity the size of a skyscraper that does not even fit on screen, although the camera in the following battle sequence is zoomed out to a point where the characters themselves are tiny in comparison to previous battles.[27]

To re-use the distinction between "mundane" and "fantastic" forms of extraordinariness, the audiovisual spectacle of final bosses is largely dominated by the latter, i.e. representations that have no equivalent in the real world. While representations of realistic opponents, i.e. beings that conform to the rules of our reality, also abound in final encounters, they gain their significance – and, hence, their closural effect – rather from narrative cues, as will be shown in the following.

Extraordinariness via narrative context

As the three dimensions of designing the ludic finale are deeply interconnected, many cross-references to the narrative meaning of ludic finales were already given in the previous sections. To avoid confusion that can accompany the discussion of multimodality on different levels, I would like to stress again that the strategies discussed here only refer to the narrative elements during the ludic phase(s) of the ending, i.e. framings that are narrative on a micro-level, while the sequence as a whole is predominantly ludic. The same element in a game may gain a different modal predominance in different phases: During the ludic finale, the avatar serves predominantly as a tool of the player who tries to overcome the final ergodic challenge. During the narrative finale, the same character predominantly signifies the protagonist of a story that is about to come to an end. Yet, in both phases, the subdominant modal dimension is still present.

Admittedly, the narrative information provided during the ludic finale itself is rarely sufficient for marking the events playing out as narratively significant, let alone evoking a sense of an ending. Those framings that do suffice as narrative closural signals during ludic finales are typically straightforward verbal utterances by either narrator figures or characters, mostly the antagonists themselves, who announce "the ultimate test" (narrator in the dream world of CATHERINE), proclaim that "this world will soon be at an end" (final boss Zodiarchy in NI NO KUNI), or tauntingly ask the avatar to "prepare to join your species in extinction" (SHODAN in SYSTEM SHOCK 2).

Most conventionally – just as is the case for most closural signals on the level of story – the narrative elements in ludic finales gain their closural effect largely from their relation to the whole. Hence, the ludic finale usually marks an important event in the game's story, representing, for example, the antagonist's defeat or the protagonist's achievement of their personal goal (which usually coincides with the goal given to the player) such as arriving at a certain location, surviving a dire situation, saving the world, and so on. Typically, the ludic finale's degree of narrativity is proportional to the game's overall degree of narrativity. Hence, the final challenge of a fighting game like TEKKEN 5 (played in story mode) has much less narrative impact than, for example, the final decision of the narrative-driven adventure game THE WALKING DEAD, or even the humorous showdown between greenhorn pirate Guybrush Threepwood and ghost pirate LeChuck in THE SECRET OF MONKEY ISLAND. While TEKKEN 5 indeed provides a story that even spans the whole series, the narrative impact of the final battle against Jinpachi, the revenge-seeking head of the series protagonists, the Kazama family, is largely obscured depending on the player's choice of avatar, as the characters' relations to the main plot vary considerably.[28] In contrast, the ludic finale of THE WALKING DEAD – which culminates in the decision to let the little girl Clementine shoot the protagonist, and her father figure, Lee, or, alternatively, spare her the heavy weight of the deed, but let Lee turn into a mindless "walker" (i.e. a zombie) as a consequence – is not even playable in a meaningful way without taking the narrative level into account.

The fact that events playing out during the ludic climax mark an important plot point does not only make the ludic finale narratively relevant in context of the game's story but, moreover, bestows significance to the challenge itself. As players become attached to the unfolding events (at least if they were attached to the narrative dimension of the game in the first place), the narrative elements of the ludic finale increase suspense and pressure on players and evoke a sense of an ending by signalling the narrative climax. This effect is best singled out in games that opt for a subtle audiovisual representation of their ludic finale instead of a glaring spectacle.

The rather ordinary, human appearance of the final boss "Gehrman, the First Hunter" in BLOODBORNE (FromSoftware 2015), for example,

contrasts with many of the otherworldly and nightmarish opponents encountered throughout the game. Although undermining the strong convention of an audiovisually spectacular final opponent might also be a means of increasing suspense by suggesting that the opponent's extraordinary powers are merely hidden behind a modest appearance, Gehrman's significance is already given in narrative context. The character plays a crucial part in the game's obscure story that is only fully revealed when players choose to defy him right before the final encounter. Before that, Gehrman accompanies players as a constant guiding figure and seemingly harmless old man in a wheelchair, who resides in the hub world "Hunter's Dream" and introduces himself as "Gehrman, friend to you hunters". The location of the encounter adds to its meaning, as it takes place inside the hub world itself, although in a formerly inaccessible part of it – a place that is supposed to be the game's only battle-free zone, a safe haven in a world full of lethal dangers. A large part of the conventional spectacle of the ludic finale is, hence, produced by narrative context.[29]

Similarly, the ludic finale of ASSASSIN'S CREED II (Ubisoft Montreal 2009) stands out for its narrative meaning: Although fighting Pope Alexander VI – an evil Templar mastermind in the game's story – inside the Vatican might sound spectacular on its own, the significance of the encounter does not primarily result from audiovisual – or even ludic – spectacle, but from the meaning that both the character and the location gain from the game's narrative content as well as from the broader context of the connotations of their real-world counterparts. Probably more often than not, extraordinary narrative significance and audiovisual spectacle occur simultaneously in ludic finales. Even the encounter with Gehrman is not free of visual extraordinariness, as the bright and soft look of the white flower field that serves as the battleground contrasts with the sinister locations that dominate the game. As has been occasionally hinted at, nearly all examples mentioned in the previous section combine audiovisual spectacle during the ludic finale with heightened narrative significance.

As the example of Gehrman in BLOODBORNE shows, narrative meaning is not generated during the ludic finale itself, but built up continuously throughout the whole playing process, and maximised shortly prior to the final encounter. Just as the ludic challenge gains impact via the opponent's narrative meaning, the encounter of avatar and final boss forms a decisive piece in the puzzle of the game's story. SILENT HILL 2 presents another example of a final encounter that largely gains its significance through narrative context, which is further strengthened by the encounter's symbolic visuality: The design of the boss, a distorted, caged version of avatar James' late wife Mary, is reminiscent of Mary's confinement to bed due to illness during the last months of her life, as seen in the following closing cutscene (see Figure 3.9). Furthermore, the cruel necessity to violently defeat her reflects how James felt himself driven to finally kill his wife, not only to end her suffering but also to free himself from the threat she posed to his own

Figure 3.9 SILENT HILL 2, Mary in final encounter and final cutscene.

life, preventing him to move on while she was neither fully alive nor dead –
a deed that eventually left him ridden with a guilt that comes to life in the
horrors of the town Silent Hill.

Closural conventions of the ludic finale – Summary

In summary, design strategies characteristic of the ludic finale focus on
creating a sense of spectacle, urgency, and significance of the last (pre-
dominantly) ergodic sequence in a digital game. This sense is conveyed via
at least one, but most conventionally all three of the dimensions of ludic,
audiovisual (or descriptive), and narrative (i.e. mainly story) elements. For
players, rendering the final challenge as extraordinary in one way or an-
other potentially increases both the pressure to overcome it and the satisfac-
tion in case of success. A challenge that is difficult to overcome furthermore
emphasises the medium's controlled access in a particularly effective way,
as it denies inapt players the satisfaction of the narrative desire to know the
ending – at least in the case of games that fulfil their promise of closure only
in the narrative phase following the ludic finale. Of course, players accept
the risk of their narrative desire remaining unfulfilled as soon as they be-
gin playing a game, since they accept the media artefact's ergodicity.[30] On
the contrary, many contemporary games move away from the convention
of maximising difficulty as a way to stimulate their narrative reception or
to generally cater for the players' desire for completion.[31] Although this
applies mostly to highly narrative games, the degree of narrativity does
neither determine the level of difficulty nor the spectacularism of the ludic
ending phase in general.

The conventions apparent in ludic finales reveal that the medium indeed
possesses its own traditions of staging endings. Although the representa-
tional strategies used are often informed by closural signals known from
other media, such as film, the unique combination of ergodicity and narr-
ativity in digital games at least bestows them with new functions in the

context of the ludic climax. Neither does the medium simply borrow from traditional non-digital games, as these typically show cyclical structures that show no increase of difficulty or any climactic event near the end of a match (see Backe 2008, 321). In digital games, these latter features are conventional because of the progression structure of digital singleplayer games, which repeat their challenges in increasingly difficult variations to maintain the interest of players who are constantly improving their playing skills, rather than to conform to any demands of the combined narrative frame – proven by their existence in non-narrative games like SOKOBAN (see Chapter 2.2). The structural elements and representational strategies of digital game endings that are, obviously and undeniably, informed by the frame narrative are those discussed in the following section.

3.4 "It's over. We can go now."[32] – The narrative finale

Distribution of narrative closure in digital game endings

The ending of a digital game usually encompasses more than one predominantly narrative sequence, depending on the game's length and where the ending's beginning can be located. Most conventionally, games frame the ludic finale with narrative segments, setting the stage for their climax with a non-ergodic sequence, such as a cutscene that establishes or re-emphasises the narrative weight of the upcoming final challenge. If that challenge is segmented into multiple phases, those might be interlaced with more predominantly narrative sequences, such as the one that establishes how the avatar in PERSONA 5 gains the power of the final attack. After the ludic finale, in case of success, the narrative consequences are shown in another sequence that either focuses on immediate consequences (such as the defeat of the villain), long-term consequences (such as the fate of the storyworld), or both in two distinct phases, the latter of which typically constitutes an epilogue.

The epilogue can also be merged with the following paratextual phase, as a cutscene playing alongside or in the background of the conventional credit roll (see Chapter 3.5). Such fusions of narrative and paratextual ending phases are facilitated by both being typically non-ergodic. Occasionally, a separate narrative sequence follows a non-narrative paratextual phase, potentially opening up a new narrative thread to hint at a possible sequel, such as in DEUS EX: HR and METAL GEAR SOLID, which both reduce the representation in this phase to the auditory dimension with spoken dialogue that is visually accompanied only by the game's title or logo. Most narrative post-credits sequences, however, take the form of conventional cinematic cutscenes. Just as any other predominantly narrative segment of a digital game ending – as will be exemplified shortly – post-credits scenes can also include ergodic elements.

Overall, the bulk of the narrative finale in terms of closural signals takes place after the ludic climax and before the closing paratext. The typical

absence or severe reduction of ergodicity during this phase increases the distance between player and game before the playing process is finally terminated.[33] Yet, just as the ludic finale has been shown to also include narrative elements, a complete lack of player agency is not mandatory for a sequence to predominantly function as narrative. Still, non-ergodicity prevails in narrative sequences, so that the representation of narrative finales is likely to adapt closural conventions from other narrative, particularly audiovisual media.

The degree of closure in narrative digital games is typically strong, regarding both aspects of content and form. In particular, high-budget games (just like most mainstream media artefacts, equivalent to high-budget movies) and games with a long duration are prone to provide full closure, leaving as few narrative gaps as possible. This convention probably results from the fact that in narrative digital games, "parallel to solving puzzles or overcoming challenges, a story is being told that the player expects to be concluded with overcoming the final challenge" (Backe 2008, 324, my translation from the German). Narrative closure, thus, constitutes a reward for triumphant players, a function that Sallge acknowledges for narrative sequences in digital games in general (see Sallge 2010, 98). The argument is supported by games that grade closure according to ludic effort, for example by revealing some (occasionally crucial) narrative information only to players that find and defeat a hidden final boss, or that explore all possible ending variations (see Chapter 4.3). Open endings or the actual denial of closure are most likely to occur in games that deliberately end with a cliffhanger to tease their upcoming sequel, or in independent games in which the story remains rather obscure and which generally demand more elaborate acts of interpretation from players to unveil their narrative meaning such as LIMBO (Playdead 2010). The subsequent section will explore common closural signals in narrative finales of digital games both on the level of story and discourse, followed by a discussion of their ergodic aspects.

Closural use of content narremes

Throughout the narrative finale's different stages, there are some common tropes and closural signals on the level of content. The conventional story elements during the finale's main phases, i.e. those occurring after the ludic climax and before the closing paratext, can be grouped into those that provide resolution with immediate reference to the story's finale – which usually includes the events happening during the final ludic challenge – and those that provide additional information about the fate of the storyworld and its characters in an epilogue. This conforms to David Bordwell's distinction of the "two concluding phases" of "resolution", or "untying", and "epilogue" in classical Hollywood cinema, with the former encompassing "the overcoming of the obstacle, the achievement of the goal, the solution of the problem", and the latter "function[ing] to represent the final stability achieved by the narrative: the character's futures are settled" (Bordwell

1982, 4). This twofold structure is not only common to film but seems to be inherently transmedial, as Bordwell already refers back to Aristotle's poetics (see Bordwell 1982, 40), and epilogues and phased endings prevail in other narrative media as well, even appearing as a strong convention, for example in 19th-century literary fiction (see Goetsch 1978, 243).

Just as in classical Hollywood cinema, the stages of resolution and epilogue in digital games can range from long and distinctly separated sequences to short scenes that merge the essence of both phases (see Bordwell 1982, 4). The elaborateness of the narrative finale largely depends on the game's overall degree of narrativity and, perhaps most importantly, length. While it seems almost self-evident that shorter narrative media artefacts have shorter endings, scholars have emphasised that length affects more than the time needed for the reception process, as it has "repercussions on textual structure" (Fludernik 1996, 348). These repercussions can cause the same representational strategies (including closural signals) to have different effects in artefacts with strikingly differing lengths such as novels and short stories (see Krings 2003, 14). Hence, the RPG – as the genre with the most elongated examples among narrative digital games – tends to include extensive epilogues that tie the story's loose ends and allow players to bid farewell to all characters, often including minor characters, as is the case in PERSONA 5. In contrast, an FPS – as a typically fast-paced and short genre – usually ends with a single narrative cutscene, even for highly narrative examples like HALF-LIFE. In SYSTEM SHOCK, the final cutscene is not even one minute long and summarises both resolution and epilogue in six frames accompanied by three written sentences.[34]

As noted in my initial digest of ending conventions across media (see Chapter 2.1), content closural signals are probably the category with the most variations and, thus, most difficult to summarise in terms of conventions, since even similar types of events can have strikingly different meanings in the context of different stories. The most conventional closural events are marriage and death, both because they – traditionally or inevitably – mark a distinct change in life that leads to a certain stability, which bestows it with a "natural" sense of an ending. Narrative digital games, however, reveal another set of conventional closural events. Since avatar and player goals are typically meant to correlate, games give a clear, explicit goal to their protagonists more often than other media. The variety of plausible narrative goals that coincide with the inherent ludic drive for success is limited. Consequently, and because failure is conventionally not considered a viable option for a digital game to conclude (see Chapter 4.4), the most common content closural signals of the medium are events related to the achievement of these goals, comprising the following (not necessarily comprehensive) list:

- The protagonist's eventual escape out of a life-threatening situation. Examples are Lara Croft leaving the island of Yamatai in TOMB RAIDER (2013), and the survival of the protagonists at sunrise in UNTIL DAWN (Supermassive Games 2015).

- The rescue of an important character, mostly the protagonist's love interest, such as in most instalments of the SUPER MARIO series, in which protagonist Mario's goal is to save Princess Peach from Bowser. Another example would be Leon Kennedy saving the US President's daughter in RESIDENT EVIL 4 (Capcom 2005).
- The protagonist(s) saving the world or a significant part of it from evil forces such as the unnamed space marine in DOOM II: HELL ON EARTH (id Software 1994) saving Earth by closing the gates of hell. This trope is extremely common in RPGs, such as FINAL FANTASY VII, where the defeat of Sephiroth prevents the planet's destruction.
- The quest for a certain item or treasure. While this is a common goal for many digital game heroes who classify as typical adventurers – such as Nathan Drake in the UNCHARTED series (Naughty Dog 2007–2017) – it often entails narrative twists that finally lead to the protagonist's escape or saving the world. For example, Drake's quest to find the El Dorado, a statue, in the first UNCHARTED game (Naughty Dog 2007) is overruled when he discovers that the statue is cursed. Nevertheless, the protagonists return from their perilous journey with a load of other treasure, as is seen in the final cutscene. An example that fulfils the trope more clearly is the obtainment of the Apple of Eden in ASSASSIN'S CREED (Ubisoft 2007).
- The unveiling of a mystery, or the dénouement. This is a trope well-known from detective stories in any other medium but is not limited to this narrative genre. Examples in digital games include the unearthing of the numerous secrets surrounding protagonist Eike's own death in SHADOW OF MEMORIES (Konami 2001), the classic reveal of the killer's identity in DEADLY PREMONITION, and the origin and meaning of the mysterious "Zone" that is the setting of S.T.A.L.K.E.R. SHADOW OF CHERNOBYL (GSC Game World 2007).

Not just the latter, but all of these types of events are transmedially common narrative tropes; yet the modal hybridity of narrative digital games that links protagonist and player goals arguably results in their higher prominence at the endings of this medium. Often, several of these tropes provide goals and, on their achievement, a sense of an ending in a single game, as the example of UNCHARTED shows, in which Drake's successful escape from the curse of the El Dorado is combined with his obtainment of treasure.

Despite the conventional correlation of success and ending as well as the alignment of player and avatar goals, a large number of digital games refuse to provide their stories with a thoroughly happy ending. Although these games act against ludic conventions of the medium, they maintain those of the frame narrative, within which an unmotivated (happy) ending rather questions conventionality, stimulating meta-narrative reflection (see Bordwell 1982, 6; Christen 2002, 41f.). Backe mentions the ambivalent endings of MYST (Cyan 1993) as an early example of a game demonstrating that ludic success and a satisfactory narrative ending are generally independent

of each other (see Backe 2008, 325). Other examples include HALF-LIFE (see also Backe 2008, 325), which spoils the protagonist's seeming victory against the alien invaders by revealing the mysterious and shady "G-Man" in control of the supposedly sealed-off otherworldly dimension, and DEUS EX: HR, which lets players decide to take control of the media and manipulate public opinion, or to destroy all manipulators and sacrifice avatar Jensen's life in the process. Thus, although the combination of ludic success with clearly positive narrative events and developments promotes ludonarrative synergy, a deviation from this norm does not necessarily disrupt the player's experience or cause dissatisfaction, given an adequate narrative context and, of course, depending on individual "playing style and expectations" (Iversen 2012).

Closely following established narrative ending conventions, the most frequent story event occurring in "bad" digital game endings that do not qualify as failure on the ludic level is the protagonist's death. Since avatar death usually results in a failure sequence that enables the player to retry the failed challenge, the final, unavoidable death of this character is prone to cause frustration as it re-establishes some of "the real-world, negative connotations of death" (see Härig 2013, 386, my translation from the German) within the safe space of the medium in which death is never final and serves an ergodic function (see Neitzel 2008, 90; Chapter 4.4). Yet, exactly because of this, it can be an effective closural signal on the level of content, since irrevocable protagonist death severs all ties between player and avatar, unmistakably communicating the end of the playing process. Consequently, the death of Shepard in most endings of MASS EFFECT 3 (BioWare 2012) ends not only this game but also the whole storyline of this character, who served as protagonist of the trilogy.[35] Just as MASS EFFECT 3, most tragic game endings couple protagonist death to a sacrifice that gives the seemingly negative event a positive, heroic twist. PERSONA 3, for example, has the avatar die in its final cutscene, as he gives up his life to seal away the dark entity that was trying to extinguish humanity.[36]

In addition to the goal-related and consequential ending events mentioned up until now, there are some smaller, yet remarkable content closural markers frequently appearing during narrative finales that contribute to a sense of an ending. Usually, these are not linked to the game's goals and have rather emotional meaning. One such closural signal is prominent in games with large character ensembles, including a range of characters that can be (partly) controlled besides the main avatar, as is the standard case in RPGs. Such games typically offer players the option – or make it mandatory – to have the avatar talk to their companions, usually before the final ludic challenge such as in MASS EFFECT 3 or LIFE IS STRANGE. Alternatively, attention might be drawn to each character in between the phases of the ludic finale, for example in form of the motivational phrases given by the protagonist's friends in a cutscene right before the final special attack in PERSONA 5.

Similarly, epilogues usually address the fate of each important character, as is the case in the extensive ending cutscenes of METAL GEAR SOLID 4, which span almost one hour in total. The point is to give each character a moment of spotlight that prepares players for parting with them or that ties the loose ends of their storyline in a narratively traditional manner. FINAL FANTASY XV gives a twist to this conventional element with a cutscene presented *after* the (first) credit roll that shows a heartfelt and serious conversation between the four main characters, which diegetically takes place *before* the final ludic challenge, and gains impact as players already know that this challenge ends with avatar Noctis giving his life for saving the world – another example for the closural protagonist sacrifice.

The basic function of providing a stage to say goodbye to characters is often fulfilled in a non-narrative manner by images or short cutscenes in the paratextual ending phase. During credit rolls in particular, the paratextual and epilogical narrative ending phases often overlap (see Chapter 3.5).

Audiovisual closural signals during the narrative finale

Many audiovisual closural signals in the final narrative sequences of digital games are familiar from other audiovisual media. On the one hand, this is due to the predominant non-ergodicity of these sequences that puts them closer to the affordances of film and TV series. On the other hand, there seem to be many inherently transmedial representational strategies among these closural signals, which also appear in yet another set of narrative media that might share only one of the sensory modes – such as the comic, which addresses visual, but not (at least not immediately) auditory perception – or which can only evoke virtual audiovisuality such as written literature.

Notwithstanding their contemporary prevalence, not all final narrative sequences in digital games are cinematic cutscenes. Aside from moving images, it is also common to present narrative finales as (a succession of) still images combined with music and, potentially, spoken dialogue or narration (e.g. FALLOUT 3 and BASTION). The latter can also be provided without any visual accompaniment (i.e. to a black screen, as in the post-credits scenes of METAL GEAR SOLID and DEUS EX: HR) or in written text (often in addition to sound, depending on the player's choice to turn subtitles on or off). Purely written text is rarely used as the exclusive means of representation in contemporary digital games, but might be more focused than in mere subtitles such as the letter presented in both written and spoken form at the end of SILENT HILL 2. Following Thon, I will still use the term cutscene to refer to all of these kinds of predominantly narrative, "noninteractive elements of video games" (Thon 2016, 108) in which "the player's opportunity for participation usually does not extend beyond the decision to cancel the cutscene" (Thon 2016, 108) or, one might add, to advance the scene by simply pressing a button, which is often required when narration or dialogue is presented in written form.[37]

Calleja suggests to consider even sequences with slightly more opportunities for participation as cutscenes if ergodicity is reduced in comparison to predominantly ludic sequences, and if "story elements are imposed upon the player" (Calleja 2011, 123). For example, in ASSASSIN'S CREED, the player has limited control over the camera in dialogue sequences, and HALF-LIFE even allows avatar movement, which is "restricted to the space where the cut scene is taking place" (Calleja 2011, 123). Similarly, the player can take control over cameras and move around as a small robot during the mission briefings of METAL GEAR SOLID 4. Even just semantically, it makes little sense to call these examples "cutscenes", since they are often closer to the form of "scripted events or sequences of events" (Thon 2016, 109), which are "predetermined representations of events that occur during the interactive simulation of the actual gameplay" (Thon 2016, 368), usually triggered by a certain action such as reaching a specific point in the game space. Yet, with their more or less distinct differences from the prevalent ludic sequences of the game in question, the given examples reflect the variety of non-ergodic and partly ergodic sequences that Thon points out in his analysis of THE WITCHER 2: ASSASSINS OF KINGS (CD Projekt Red 2011), highlighting the "diversity of marginal forms [orig. 'Randformen'], which at least partly undermine the differences between cutscenes, scripted events, and interactive gameplay sequences" (Thon 2015, 117, my translation from the German). While such forms can impede a thorough classification, the given examples should still be distinguished from other predominantly narrative sequences with a low degree of ergodicity as they are not actually ergodic: All actions offered to the player are completely optional, and the events of the sequence unfold in the same way and in the same amount of time with or without any player activity. They also need to be distinguished from cutscenes, however, as player control over perspective and camera can decisively affect audiovisual factors. Entirely non-interactive "cut scenes have the advantage that their narrative purpose (conveying specific information) cannot be thwarted by the player's *tmesis*, her freedom to chose[!] what to perceive" (Domsch 2013, 33).

Endings, being a crucial part of the narrative prototype, tend to uphold firm restrictions over player agency, so that even minor interactive options are prone to be withdrawn from the player during the narrative finale. For example, ASSASSIN'S CREED ends with an ergodic sequence – with a limited set of available actions, which are, however, equal to those in all ludic sequences of the game's present-day setting – that finally changes to a brief cutscene – with the aforementioned option for camera control only – as soon as the player discovers hidden cryptic markings on a wall. Yet, ultimately, the player is deprived of all control once the protagonist's monologue is over and the view inevitably zooms in on the centre of the markings as the last image before the credit roll.

The ending of ASSASSIN'S CREED is rather unconventional not only for its long-lasting ergodicity but also for its abruptness, its audiovisual signals and narrative context, which all match the trope of the cliffhanger that is occasionally found in endings of serial games. The cliffhanger contrasts with the

convention to bring the sense of an ending to a maximum in the very final moments of the narrative finale. The audiovisual representational strategies typically used in these moments gain their closural function either from evoking an impression of standstill, increasing distance (from the player to the characters, the storyworld as a whole, and the activity of playing), referring to the game's beginning, or from general closural allusions. Mostly, all these strategies are used to convey a positive mood that matches with the ludic success, as happy endings still prevail in the medium. Yet, many games combine this positive mood with a sense of melancholy or nostalgia to underscore the equivocality of finishing a game which always entails "the death of [the player's] pleasure" (Salen and Zimmerman 2003, 258), even if it is a thoroughly happy ending in terms of content. A different approach is often taken by games that are deliberately designed for narrative serialisation: As their endings only mean a temporary parting, serial games focus less on happy endings and the melancholy of farewells and are instead prone to increase suspense and hint at upcoming adventures such as in ASSASSIN'S CREED.

The closural effects are best to discern visually in the very final shot of the cutscene right before the (conventional) credit roll. The effect of distancing in particular shows itself in visual form, although it can also be conveyed verbally, as is the case in FALLOUT 3, which closes with a narrated summary (and moral evaluation) of the avatar's deeds during the game, referring to this customisable character – which is, hence, prone for players to identify with – simply as "the Lone Wanderer", like the hero (or villain) of a distant legend. The sequence's visuality – a series of still images that changes together with the narration depending on previous player choices – strengthens this distance, with several images showing the protagonist walking away from the camera (see Figure 3.10). The very final image of the game then evokes nostalgia by emphasising standstill and referring back to the beginning, as it shows a deserted room with a framed photograph of the protagonist as a child with their father (see Figure 3.11).[38] Another reference to the game's beginning is the overall audiovisual style of the cutscene, which is else only found in the opening sequence. Thus, the main storyline of FALLOUT 3 is placed inside a distinct narrative frame that enhances the closural effect.

Among the numerous closural signals employed by FALLOUT 3 the visually most conventional might be that of characters – or vehicles – facing or actually moving away from the (immobile) camera. Even only within the pool of games that have been previously used as examples in this chapter, this representational strategy appears frequently, e.g. in BASTION, MASS EFFECT 3, PERSONA 5, or UNCHARTED. Just as in film, the distance-increasing movement can also be executed by the camera, most commonly by zooming out, as is the case in TOMB RAIDER (2013). In this scene, however, protagonist Lara Croft does not turn her back to the player, but faces the camera sideways, as do the characters in NI NO KUNI when they are flying away to the left on their dragon in the game's final shot. Having the characters face sideways, or even towards the camera, as in NEW SUPER MARIO BROS. WII or PERSONA 4 (Atlus 2008), is a slightly less distancing, gentler way of leaving

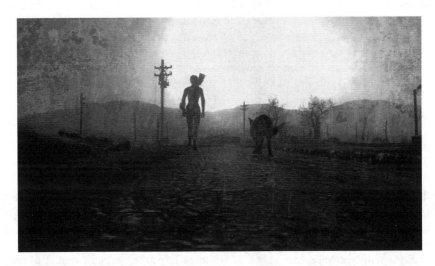

Figure 3.10 FALLOUT 3, the Lone Wanderer in the distance.

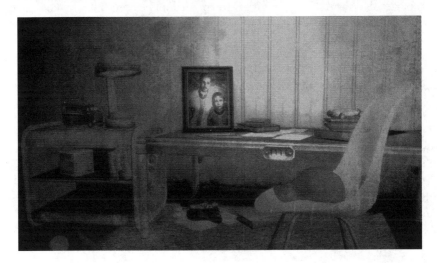

Figure 3.11 FALLOUT 3, family photograph in the final frame.

the player, indicating a lasting (emotional) bond established between player and game that foregrounds the nostalgia of a goodbye (see Figure 3.12).

While all these examples still manage distance by using long shots, close-ups are also a field size common in final cutscenes. Mostly, they are used to intensify the distancing effect as the starting point of a shot that continues with either the characters or the camera moving out such as in FINAL FANTASY VIII – which is also a prime example of the typical feature that characters facing the camera in final shots usually wear relaxed and happy

faces, as protagonist Squall is shown with a smile for the first time in the game. In contrast, a close-up as the very last frame can be used to convey an ambiguous feeling, as the connection between player and protagonist is disrupted rather abruptly. This is particularly effective if there remain open questions in the story, lowering the overall degree of closure of the game's ending. For example, both THE LAST OF US and THE WALKING DEAD end with a close-up on their young female protagonist, whose survival in both cases is linked to sacrifices that overshadow the supposedly happy outcome (see Figure 3.13). However, a close-up as the final frame

Figure 3.12 Characters facing the camera in final distancing shot of PERSONA 4.

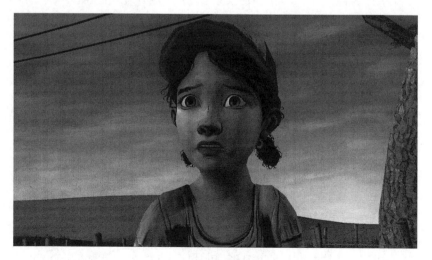

Figure 3.13 THE WALKING DEAD, final close-up on Clementine.

does not necessarily entail such an ambiguous ending but can also be used to convey an impression of openness that hints at the protagonist's upcoming adventures such as in THE SECRET OF MONKEY ISLAND, which shows avatar Guybrush and his love interest Elaine, finally together, heroically gazing into the distance.

The fireworks complementing this final scene of MONKEY ISLAND reveal another range of frequently used representational strategies during final shots that centre around extraordinary lighting. While fireworks imply a cause for celebration in the storyworld that meta-narratively refers to the player's success, they are also a form of audiovisual spectacle (although their actual representation may not be that spectacular, depending on the game's audiovisual design). Rather than success and celebration, the even more common visual trope of a sunset – an outright cliché closural convention in film, particularly in the Western genre (see Strank and Wulff 2014, 23) – focuses on imparting a sense of farewell and closure. Examples of games that leave players with the last light of the day can be found in TOMB RAIDER (2013) or UNCHARTED. In contrast, a sunrise emphasises a new beginning and a brighter future after successful survival in games like RESIDENT EVIL or UNTIL DAWN. Regardless of the state of the sun, wide and calm sceneries including blue skies (MASS EFFECT 3 and PERSONA 5), the open sea (TOMB RAIDER and UNCHARTED), or large meadows (FINAL FANTASY VIII) are used to visually convey the state of peace and equilibrium reached in the storyworld that – ideally – allows players to freely leave without any regrets. Occasionally, narrative finales also employ distinct closural allusions such as the closing of a door like in one of the endings of DEUS EX: HR.

DEUS EX: HR demonstrates another way of distancing that involves leading players back to their own reality, in this case by using real-life footage instead of the animated computer graphics used in the game's cutscenes prior to the ending. Narratively, the game upholds the intradiegetic level, primarily via the protagonist's voice-over narration, which only loosely relates to the depicted footage. Another example is METAL GEAR SOLID, which directly refers to real-world states and events with written information about worldwide nuclear disarmament plans and the still existing number of nuclear warheads at the time of the game's production. Arguably, the screens bearing this information belong to the paratextual, rather than the narrative ending phase.

Up to this point, this section has focused on the latter half of the audiovisual. Closural signals on the auditory level in narrative finales generally pursue the same effects as those on the visual level. For example, the usage of voice-over narration by either an intradiegetic character or an extradiegetic narrator – such as in FALLOUT 3, DEUS EX: HR, METAL GEAR SOLID, or SILENT HILL 2 – indicates the upcoming parting of player and storyworld, especially if it is the only occurrence of this representational strategy in the game, such as is the case in MASS EFFECT 3.[39] Naturally, the content of

the narration can increase its closural effect if it helps to tie loose ends of the story (SILENT HILL 2), gives direct closural allusions (FALLOUT 3), includes musings about the storyworld's future (DEUS EX: HR), or addresses general philosophical problems (METAL GEAR SOLID), which can be another way of leading players back to the real world.

The music during narrative finales most conventionally combines or rather goes through different stages of celebrating the happy outcome – if applicable – and expressing soft sorrow for the upcoming farewell. Hence, there are, for example, orchestral finales of increasing intensity as well as solemn and melancholic strings and piano tunes. While the latter follows the former in MASS EFFECT 3, which ends generally good, but almost un-avoidably with the protagonist's sacrifice, NI NO KUNI and TOMB RAIDER (2013) musically emphasise the full positivity of their endings by finishing on a climactic high note, and DEUS EX: HR matches its narratively more ambiguous ending with an ethereal soundtrack accompanied by a lament-ing chant. Similar to movies, some games use music to lead softly over to the paratextual ending phase by fading in a song that further accompanies the credit roll, e.g. PERSONA 5 and BASTION.

Agency and ergodicity during the narrative finale

The previous section already established that narrative finales – just as pre-dominantly narrative sequences in general – are not necessarily completely devoid of ergodicity. One factor in determining the priority of narrativity in a digital game sequence is how narrative information is communicated. Following game designer Ken Levine, Gordon Calleja distinguishes be-tween "push narrative and pull narrative" (Calleja 2011, 122), the former being a sequence in which "[t]he information the game designers wish to impart is literally pushed at the player" (Calleja 2011, 123), while the latter "embed[s] the narrative elements in the world, [...] rely[ing] on the player to pull the narrative to them" (Calleja 2011, 123). Since the focus on narrative elements is predetermined in the push variant, the narrative mode always dominates, while the pull variant is modally undecided until players choose a predominant mode via their individual playing style.

I previously pointed out that, since the ending is a prototypically crucial part of the narrative frame, push narrative is the prevalent design choice for the narrative phase of most digital game endings. Although push narrative does not preclude ergodicity, it at least entails a distinct reduction of player agency, unless the game is designed as a push narrative throughout with an overall low degree of ergodicity such as many adventure games in the manner of THE WALKING DEAD, or visual novels and visual novel hybrids like the ZERO ESCAPE series (Spike Chunsoft / Chime 2009–2017). Games like these often compensate their lack of ergodicity with a ludification of the narrative mode that requires players to make narrative choices, usually on behalf of the protagonist.[40] The finales of games that focus on narrative

agency usually culminate in a climactic choice that often confronts players with a moral or ethical dilemma. For example, LIFE IS STRANGE forces its protagonist Max – and with her the player – to either let her hometown be destroyed by a storm, or to sacrifice her best friend Chloe, whose life she saved over and over again during the course of the game. Although final sequences like this would have to be considered predominantly narrative in general, they also belong to the ludic ending phase since they form a ludic climax in the specific context of the overall highly narrative game.

In contrast, sequences that I would like to call ergodic epilogues offer more options for player agency than to be conventionally expected from narrative sequences, but are also clearly distinguished from a game's ludic finale, making up a form of ludic anti-climax. Despite acting against more traditional conventions, this design strategy is no longer uncommon in contemporary digital games, so that it might well be considered an alternative convention that does not generally disrupt player expectations. Rather, an ergodic epilogue generally serves two functions: First, it gradually leads players out of the ludic experience that is otherwise prone to abruptly stop after the ergodic climax of the final challenge. Second, it emphasises the game's narrative level in two ways, while players are still being actively engaged in the game: On the one hand, players can focus on story elements as they need to pay less attention to the timing and precision of their own actions in comparison to sequences that combine ludic and narrative climax. On the other hand, ensuring a minimum degree of player attention for a predominantly narrative sequence by demanding action reacts to the long-prevailing prejudice that narrative elements in games are either outright superfluous or instrumental at best, which often condemned purely narrative sequences to be skipped or ignored by players. A minimum degree of ergodicity in narrative sequences can help to keep players engaged even if agency is not required, but optional, such as avatar movement in HALF-LIFE and camera movement in ASSASSIN'S CREED.

Ergodic epilogues not only vary in length and degree of agency but also in narrative impact, since they can either serve an actually epilogical purpose in the narratological sense of the term or still belong to the resolution phase of the ending. By definition, the former takes place after the story's main conflict is resolved. Elaborate examples can be found in the PERSONA series, which include rather extended ergodic epilogues that can span days or weeks of diegetic time, allowing players to lead final conversations with various characters and to pay final visits to the game world's central locations before the protagonist's inevitable departure at the end of the school year.

More frequently, ergodic epilogues are still part of bringing closure to the game's central narrative conflict. They most often involve spatial progression through a mostly unknown location, but without the threats or challenges that accompany other levels during the game. For example, the final avatar change of THE LAST OF US occurs in a short level in an unfamiliar environment in which players have to simply follow a path without being

threatened by any enemies. During the sequence, protagonists Joel and El-
lie hold a mostly one-sided conversation that culminates in a key narrative
moment in the following non-ergodic cutscene. The avatar change marks
a shift in the player's perspective, or rather: proximity from Joel to Ellie,
strengthening the impact of the final scene, which shows Ellie ultimately
building her trust in Joel on his severe lie about how and why he saved her
life during the events that made up the ludic finale. Other examples for
ludic anti-climaxes with narrative importance for the game's main plot are
found in ALAN WAKE or BIOSHOCK INFINITE.

It is important to distinguish between post-climactic ergodic epilogues
like these and the option to continue playing in an open game world. While
the former is still narratively relevant to the game's (main) story, the latter
distinctly takes place after the ending and fulfils a predominantly ludic
function, offering an opportunity to complete open side quests or tackle
new ergodic challenges. Such a *post-ending phase* (see Chapter 4.2) is usu-
ally only loosely related to the main story and, most importantly, has no
bearing on the former's closure. A remarkable exception is found in RED
DEAD REDEMPTION, the actual ending of which is, arguably, related to
the completion of what is ludically signalled as a side mission called "Re-
member My Family". After protagonist John Marston has been killed in a
climactic sequence, the game jumps forward in time, putting the player in
control of Marston's now adult son Jack. Among the side quests available
after these events, "Remember My Family" sticks out for its objective to
avenge the death of Jack's father. The quest is ergodically ordinary and not
challenging; yet it offers both narrative and ludic satisfaction to the player,
who was left in a state of defeat after the unwinnable fight of the ludic
finale with avatar John Marston. Most remarkably, the game's credit roll
only runs after the completion of this particular side mission, thus paratex-
tually rendering the seemingly optional mission as an indispensable part of
the game and a narratively essential piece of the puzzle to get full closure.
This substantial closural power of paratextual signals is the focus of the
following section.

3.5 "Turn your computer off and go to sleep!"[41] – The paratextual ending phase

The closural effect of paratext

"The only thing more final than your own funeral is the credit roll"[42] –
although this quote, coming from a YouTube compilation of fake endings,
refers to a premature credit roll (that of HITMAN: BM) that undermines
precisely this sense of finality (see Chapter 4.1), it perfectly demonstrates
the significant closural power commonly ascribed to this form of ending
paratext, which has also been noted academically both in film and TV
studies (see Christen 2002, 60–2; Mittell 2015, 27). While media artefacts

that are perceivable as a whole throughout the reception process due to their material constitution – such as books – permanently expose their remaining amount of text, paratext gains importance as a closural signal in media artefacts that progress in time without necessarily disclosing their remainder of text.

A large part of the closural effect of paratext results from its mostly extradiegetic nature. Similar to the use of real-life footage or references in narrative finales, paratext leads players back to their everyday reality by reminding of the game's fictionality and artificiality. Not all paratexts fulfil this function, however, as there are various conventional closural signals, which can either lean towards the narrative, or the ludic mode, or be neutral to both (for example operating in the descriptive or argumentative mode). Among these signals are the credits and the game's logo, which are typically modally neutral unless they are specifically amended by ludic or narrative elements. The end title is arguably closer to the narrative mode as it is a traditional paratextual way of signalling narrative closure. Paratext with ludic relevance is the one which is most unique to the medium. It encompasses forms like gameplay evaluations, trophies and achievements, gameplay-related rewards that can be used in a second playthrough as well as information about or the option to create a save file of the game in the state of completion. These meta-ludic references most commonly occur at the very end of the paratextual phase. Thus, players are given time for the narrative closure maximised right before the paratextual phase to settle cognitively, before they are reminded of the ergodicity of their activity – unless they actively seek it by, for example, skipping the credit roll (if possible). Both conventional and unconventional representations and arrangements of paratext, and how it can be both narrativised and ludified, will be discussed in the following subsections.

Game logos and end cards

A typical paratextual ending phase either begins with a credit roll, an end title, or the game's logo. While credits, arguably, are the most established form of paratextual closure in audiovisual media in general, the logo is probably just as frequently used in digital games. Mostly, the logo is displayed before or at the start of the credit roll, in order to anchor the media artefact's identity in the player's mind at one of the peaks of its reception such as in BASTION, THE SECRET OF MONKEY ISLAND, TOMB RAIDER (2013), or XCOM: EU. Since credit rolls can often be skipped at the press of a button, the logo is less effective at the end of this paratextual sequence. Still, logos can be found after the credits as well, such as in RESIDENT EVIL, or during or after a post-credits sequence such as in SUPER METROID, the METAL GEAR SOLID series, or DEUS EX: HR.[43]

As they disturb or at least weaken the definite sense of an ending that is given by the typical credit roll, which solely focuses on the extradiegetic real

world by listing the names of the production team, post-credits scenes and epilogical credits (see below) seem particularly prone to be closed off with a final title, which is either the game's title / logo, a generic end title, or both. Often, the title is superimposed on the final shot of the sequence that usually shows conventional visual closural signals, such as a radiant blue sky (Ni No Kuni), or a still image portraying main characters as a form of memento to bid them farewell (Persona 4, The Legend of Zelda: Majora's Mask [Nintendo 2000][44]).

Some games make smooth transitions from the final narrative cutscene to paratext by transforming the final shot into the game's logo, such as when the futuristic cityscape at the end of System Shock is illuminated to form the game's title. Final Fantasy XV makes an elaborate, narrativised use of a logo transformation: The final, post-credits cutscene shows protagonist Noctis sitting on his throne, with his bride Luna by his side. When both character and camera movement stop in a state of peacefulness, the image of Luna is replaced with a drawing of her that is an essential part of the game's logo, which is familiar to players from the main menu. The full logo is then shown on screen for some seconds, until it is suddenly amended by a drawing of Noctis beside that of Luna, matching the couple's position in the final cutscene. Thus, the sense of an ending is perfected as the two characters, who were painfully separated throughout most of the game, are united in this altered paratext. From then on, the altered version replaces the previous logo in the main menu as a permanent closural signal and reminder of the open world game's narrative completion (see Figure 3.14).

The credit roll

Both in contemporary non-ergodic audiovisual media and in digital games, the credits are by far the most influential paratextual closural signal – a convention that is not imperative, as the prevalence of the insert "The End" over credits in film endings before the 1970s proves (see Bordwell et al.

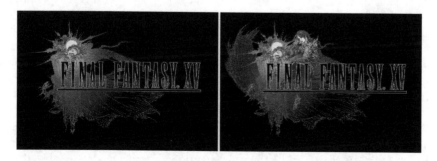

Figure 3.14 Final Fantasy XV, game logo before and after the ending.

[1985] 2005, 35). Similar to how logos are not always employed in a simple and blunt manner, the design and function of credit rolls often goes beyond the conventional, minimalist sequence of text that plainly documents the production team's names. Even this simplest visual form of the credits, however, can gain a memorable impact from the music that accompanies it. The conventional importance of closing a game with appropriate music during the credit roll is exemplified by the horror adventure SILENCE OF THE SLEEP (Jesse Makkonen 2014), which adheres to the convention despite being a one-man production. After being stretched with acknowledgements and a metaleptic joke, most of the sequence shows an empty screen, save a vaguely visible gramophone to the left. The gramophone further highlights the significance of the music, which is also strongly implied by the creator's musings that verbally conclude the credit roll: "Ah damn, I need to hire some people so I don't need to fill the ending credits with stuff like this... I'll be quiet now, sit back and relax!" The remark not only implies that the text – which is just written, not spoken – disturbs the player's enjoyment of the music on an auditory level but also a felt necessity for a musically aided, final reflection on the game experience.

Just as the music of narrative finales, the scores of credit rolls cover a range of moods, depending largely on the tone of the game's narrative coda, although they seem to be most prone to focus on melancholic aspects that emphasise a feeling of farewell. Examples can be heard in the soundtracks of NI NO KUNI, PERSONA 5, SILENT HILL 2, or THE WALKING DEAD. More propulsive scores, occasionally interspersed with musical climaxes, often accompany the credits of games that end on a dramatic high note, especially if they clearly hint at a sequel, e.g. SYSTEM SHOCK, TOMB RAIDER, or DEUS EX: HR. While nostalgic undertones are still present in the latter two, they tend to be absent in games with cliffhangers, such as ASSASSIN'S CREED or HALF-LIFE, where vigorous, driving music hints at the action yet to come.

Obvious references to a game's narrative level are made by credit songs with lyrics that reflect general themes of the story – e.g. in BORDERLANDS 2 or THE WALKING DEAD – or that are even set on an intradiegetic level such as in BASTION or PORTAL. Such songs superimpose the narrative ending phase on the paratextual one, thus either intensifying the narratively established sense of an ending or questioning it. The latter is the case with "Still Alive" (composed by Jonathan Coulton), the song sung by supposedly defeated antagonist GLaDOS during the credits of PORTAL, in which the A.I. reflects the game events, mocks the protagonist, and muses about its future research.

Narrative references also occur on the visual level of the credits, occasionally going as far as to merge narrative and paratextual ending phase. These references can serve an epilogical purpose, such as is the case in PORTAL, where the lyrics of the aforementioned song are also displayed in writing, designed as an experiment protocol by GLaDOS and accompanied

by a few illustrations in ASCII code, while the actual credits (introduced as "list personnel") occupy merely a quarter of the screen. A more obvious example of a credits-accompanying epilogue is the video in FINAL FANTASY VIII that shows the characters celebrating their victory in the style of a private video filmed by them. The epilogical credit roll of UNTIL DAWN even adapts to the game's individual outcome, with interviews of the surviving characters reflecting some major player choices and which characters did not make it through the night, which is also documented in a replay of all death scenes (see Figure 3.15).

Probably the most common visual closural signal during credit rolls of digital games, which can have both narrative and ludic relevance, is a form of reminiscence of the game events. This reminiscing function is akin to those closural signals during the narrative finale that let the protagonist share a parting moment with a range of important NPCs. Accordingly, one type of reminiscing credit rolls focuses on characters too, as is also exemplified by the credits of UNTIL DAWN, or those of PERSONA 5, which alternate character portraits and character-related snippets of cutscenes known from the game. FINAL FANTASY XV individualises this reminiscing process with pictures out of the fictional photo album that players compile throughout the game. Apart from recalling characters as a form of farewell, the embedding of partial cutscenes (usually without the corresponding audio) or still images in the credit roll accentuates important fictional events in a way of briefly reviewing the game's story.

Matching the importance of space in most digital games, reminiscing credits can also focus on the game world itself. While showing both locations and the characters inhabiting them, the credit rolls of GRAND THEFT AUTO V (Rockstar North 2013)[45] and MAJORA'S MASK emphasise the

Figure 3.15 Police interview in epilogical credit roll of UNTIL DAWN.

places visited during the game. In fairly linear games of progression, spatial reminiscences like these are typically organised in reverse order from how the settings were encountered during play. This is vividly demonstrated by the credits of JOURNEY (thatgamecompany 2012) that follow a shooting star (arguably a transformation of the avatar) from the snowy summit of the game's finale back through all previously visited locations to the exact spot in the desert at which the player's journey once began, thus neatly tying ending and beginning of the game in a full circle (see also Chapter 4.1).

Overall, however, the most powerful closural effect of the credit roll still stems from the paratext's transitional stage between the game world and that of everyday life (see Christen 2002, 62). As the example of SILENCE OF THE SLEEP has already indicated, some games emphasise the latter by giving additional insight into the production such as photos of the production team in the credit rolls of TOMB RAIDER (2013) and VANQUISH (PlatinumGames 2010). The lengthy credit roll of BIOSHOCK INFINITE not only contains individual messages by the production team, but even a video clip documenting the two protagonists' voice actors practicing a song that is featured in the game. Not incidentally, the song – a version of the Christian hymn "Will the Circle Be Unbroken?" – both reflects the central theme of the game's story and fits the conventional criteria of a credits song's nostalgic but hopeful atmosphere. Thus, the credits of BIOSHOCK INFINITE remarkably make use of paratext's transitional stage by combining its ostensibly diametrical forms of closing, i.e. either prolonging the sense of an ending or leading over to the outside world. As the clip finishes with the game's director giving instructions to the actors after their musical performance, the practical aspects of the production process, which ideally reconnect players to everyday life, prevail over the emotional impact of the song – at least until the following narrative post-credits scene turns the tide yet again. Hence, the game shows that both closural signals within one ending phase, as well as the parts of different ending phases can be combined in various ways, potentially even evoking conflicting, or at least competing, cognitive frames.

Another potential for competing cognitive frames evoked by the paratextual ending phase can be found in credits that directly activate the ludic mode via ergodic aspects. In games, conventional credit rolls are not only of "non-diegetic nature, thus signalling a breach in, or at least a disruption of the diegesis" (Christen 2002, 60, my translation from the German) but also of non-ludic nature, terminating the ergodic experience together with the narrative one. While epilogical credits and post-credits sequences attenuate the impact of this disruption narratively, "ludified" credits – although quite rare – keep players engaged ergodically. Usually aiming at the player's entertainment, ludified paratext offers the opportunity to either play a game alongside the credit roll – e.g. a simple shooting gallery in the classic adventure SAM & MAX: HIT THE ROAD (Lucas Arts 1993) – or play *with* the credits themselves, for example by destroying the letters to gather coins in NEW SUPER MARIO BROS. WII, which even has a competitive aspect if

more than one player participates. While the former largely allows players to ignore the production information given in the credits, some cases of the latter specifically draw attention to it, combining the prolonged player engagement via ludic features with the paratext's function of referring back to the outside world. For example, THE TYPING OF THE DEAD (Smilebit 2001) allows players to type out the developer names displayed to free some dancing zombies, and in VANQUISH, players gain points by shooting asteroids showing developer photos, upon which the person's name, position, and picture appear at the bottom of the screen (see Figure 3.16).

ASSASSIN'S CREED II employs a more complex form of ludified credits, which defies the traditional closural power of this paratext, appealing to both the player's narrative and ergodic attention. After the seeming conclusion of the narrative finale that however posed more questions than it answered – an impression accurately reflected in protagonist Desmond's final exclamation "What the fuck?" – the game's credit roll is accompanied by cutscenes and ergodic sequences that seamlessly continue the story. As the protagonists have to flee their headquarters, the sequence matches the escape type of ludic finales, even without considerable gameplay reductions, as combat action is also necessary (although failure is not possible). Upon successful escape the screen finally fades to black, but the characters can still be heard discussing their next steps, and the game narratively ends in another cliffhanger while the increasing volume of the music finally drowns the dialogue. Although narrative continuations during – but most commonly after – credit rolls might be familiar and, hence, less surprising to most players, the demand for player action in ASSASSIN'S CREED II certainly undermines expectations and obstructs the evocation of closure. Only as the credit roll continues for a while in the most conventional

Figure 3.16 Developer information in playable credit roll of VANQUISH.

manner after the last, auditory cliffhanger, players are finally given a moment to relax and process a sense of ending. The example perfectly demonstrates both the potential multimodal range of any part of a digital game, and how even high-budget productions occasionally use this potential to break convention and undermine expectations.

Evaluation, ranking, and other meta-ludic information

The oldest examples of paratext with ludic references at the end of a digital game, however, are gameplay evaluations, the most traditional form being tables showing the highest scores or shortest time of completion for all playthroughs of a particular game on a particular machine. This was and is the norm for arcade games, such as Pac-Man or Donkey Kong, but remained in use in many home computer and console games with improvement goals, especially in those with a low degree of narrativity.[46] Even the simplest highscore table can potentially evoke a (non-narrative) sense of an ending, for example, if the recent playing session results in a new record that satisfies the player's chosen goal (e.g. of getting the number one spot on the table). Since these simple forms of evaluation that characterise the arcade era in particular, there has been a range of complex closing paratext with similar functions. It is worth mentioning that the implementation of gameplay evaluation in the paratextual ending phase is not necessarily related to the game's overall degree of narrativity. Although there seems to be a general tendency of evaluations being used more frequently in non-narrative, or marginally narrative games, highly narrative examples, such as Metal Gear Solid or Silent Hill 2, make use of this paratextual convention as well. Both of these games give detailed statistics about the playing process, including the chosen difficulty setting, playing time, covered walking distance, the number of saves, items used, enemies defeated, and more in Silent Hill 2. Based on these statistics, the game also calculates a rank – displayed as a number of stars that is higher, the better the player's performance – which adds a basic competitive dimension to an otherwise entirely uncompetitive game.

Ranking systems like this generally offer an easy way for players to compare themselves with others (or previous own playthroughs), a traditional social aspect even for singleplayer games, considering the scores provided in singleplayer arcade games. With the growing availability of online features, digital games started to include statistics that directly compare a player's performance with data automatically collected from other players. For example, the detailed "game summary" at the end of XCOM: EU gives all of its stats for both the current player and the "world" average. Similarly, contemporary adventure games that ergodically focus on narrative choices, such as Life Is Strange and The Walking Dead, complement their closural summary of the player's decisions with a percentage showing the average distribution of choices for all players combined (see Figure 3.17). As the

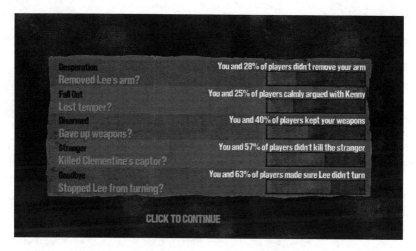

Figure 3.17 Player choice statistics in THE WALKING DEAD.

choices' options are usually not evaluated as good or bad, the social aspect of statistics in these games feeds the player's curiosity rather than their desire for competition. Another rare example of gameplay-related paratext with a social function unrelated to competitiveness is the list of player IDs in JOURNEY that gives names to all the anonymous player characters encountered during a playthrough.[47]

Even ranking systems without immediate social functions often go beyond a mere rating of a playing performance on a scale from bad to good, whether measured by a simple score or a more complex formula. For example, the whole METAL GEAR SOLID series bestows a "code name" upon players in its evaluation, based on individual playing style. The system reflects the game's design intention to accommodate different gameplay preferences, from risky, action-oriented rushes to slow and stealthy progression. While the code names – almost exclusively animal names such as leopard, whale, or tarantula – resonate with the game's military espionage theme, they are of limited use for performance comparison, since their meaning is not made transparent in the game itself and can only be inferred from common connotations of the animal, or looked up in contextual paratext. Hence, the code names also function as an incentive for replaying the game, as players might be interested in uncovering further names and how to influence the outcome with different playing styles.

GTA V obscures the ludic meaning of its evaluative paratext by narrativising it as a psychological evaluation "from the office of Dr. Isiah Friedlander", the therapist of one of the game's protagonists. The 15 bullet points on the report are rather conventionally based on gameplay data such as the time taken to complete the story or the time spent on various

minigames. Yet, the data are camouflaged as tongue-in-cheek assessments of the player's behaviour and psyche, such as "very large ego", which are often difficult to interpret without further explanation. While the evaluation of GTA V, as any conventional paratextual evaluation, is clearly addressed at the player (the patient's name on top is the player's username), its design bestows it with a distinct, metaleptic narrative meaning, since the issuing therapist is known from the game's storyworld.

More commonly, narrative references in evaluative paratext concern player choice, such as in the examples of LIFE IS STRANGE and THE WALK-ING DEAD, since their evaluations clearly relate to diegetic events. Similarly, but less straightforwardly, evaluative paratext refers to the narrative mode when it relates to a game's multiple endings, such as the statistics of SILENT HILL 2, which display the name of the achieved ending alternative and how many of them the player has obtained in total.[48] While the specific ending is only one of several aspects mentioned in the evaluation screen of SILENT HILL 2, it is the sole focus of the evaluative paratext in both SHADOW OF MEMORIES and ZERO TIME DILEMMA, with the former even including a picture and a short text that hint at the ending's narrative meaning, thus serving as much as an epilogical end card (see Figure 3.18).

Evaluative paratext gains most of its closural effect by convention, i.e. from the fact that its occurrence is conventionally reserved to the final position, so that its sheer appearance signals the end of the playing process, regardless of its contents. It further confirms the sense of an ending by leading players out of, first, the fictional storyworld and, second, the confinement of their solitary playing process.[49] While the former is an effect of all means that draw the player's attention away from the narrative

Figure 3.18 "EX ending" end card in SHADOW OF MEMORIES.

mode, the latter is achieved by any representational strategy that refers beyond the individual playthrough. Thus, evaluative paratext reconnects players to the world outside the game, just as the credit roll does by giving information about the artefact's production. Yet, although a summary of the ergodic experience can intensify the sense of an ending, evaluations also work against closure, especially those that give an incentive to either increase in rank, explore a different playing style, or that reveal the existence of other endings.

A similar effect is achieved by other meta-ludic messages, which inform about a post-completion save state (created either automatically or as an option for players) or the unlocking of new content such as a higher difficulty level, a new game mode (often called "New Game Plus"), or new items available to be used in another playthrough. Most commonly, such messages are displayed at the very end of the paratextual ending phase, right before the player is taken back to the main menu. In BORDERLANDS 2, the information about a new playing mode that is unlocked with the completion of the game's main story missions even appears twice: once before the paratextual ending phase, triggered together with the final cutscene right after the final ludic action; and once after the credit roll. The latter, more elaborate message explicates what the name of the new mode already indicates: "True Vault Hunter Mode is where the REAL game begins. You'll fight new, tougher enemies, earn better loot, and gain even more levels!" Thus, the game clearly emphasises its replay value instead of equating narrative with ludic completion, so that the narrative sense of an ending is not questioned or diminished. Narrative and ludic mode are, hence, distinctly separated at the end of BORDERLANDS 2. This is, in fact, the case in most games that include paratextual incentives for another playthrough, since the changes promised by additional difficulty settings and other forms of "New Game Plus" content rarely ever affect any narrative aspects. Significant exceptions to this rule are games with multiple endings, which invariably interconnect ludic and narrative mode (see Chapter 4.3).

There is, however, also a form of meta-ludic paratext that reinforces closure by applauding the player for completing the game with a congratulatory message such as BAYONETTA. FINAL FANTASY XV even bestows the player with a "Certificate of Completion", which also functions as a basic evaluation, as it includes the time until completion and the avatar's level (see Figure 3.19). The certificate prolongs the game's efforts for individualising the player's experience beyond its actual ergodic sequences by including a photograph from the game, which the protagonist, and hence the player was asked to choose right before the ludic finale.

This chapter has shown that closing paratext in digital games comes in a wide variety of forms, potentially pertaining to or at least referencing both the narrative and the ludic mode, leading to possibly strikingly different effects. Rather than preventing it, the conventionally strong closural effect

Figure 3.19 FINAL FANTASY XV, "Certificate of Completion".

of the paratextual ending phase enables unconventional and playful modal experiments, as the meticulously listed names of the production team always confirm the sequence's ultimate sense of an ending.

The following section will further explore the digital game's potential for modal playfulness beyond the paratextual ending phase by analysing the highly metareferential use of closural signals in THE STANLEY PARABLE, which expose and undermine many of the local conventions and structures of digital game endings that have been identified so far.

3.6 "The end is never the end is never the end" – Undermining micro form conventions in THE STANLEY PARABLE

The metaleptic set-up of THE STANLEY PARABLE

Upon starting THE STANLEY PARABLE, players are confronted with the phrase "the end is never the end" on the game's loading screen in infinite repetition (as suggested by the letters being cut off at the sides of the screen), with each "the end" marking both beginning and end of the phrase. It is only interrupted by one outstanding word in white (instead of grey), which combines with what is to its left to the phrase "the end is loading". In the metareferential manner that is characteristic for the game as a whole, the loading screen hints at one of its core themes (which happens to reflect one of the main arguments of this study), namely how the integration of narrative and ludic mode can expose the arbitrariness of endings and threaten the conventional narrative quest for closure by multiplying this traditionally singular element for the sake and by the means of ludic choice-making. With its multiple endings – adding up to about 20, depending on how the

term is defined – THE STANLEY PARABLE suggests itself easily to be addressed within the context of the overarching structures that endings form on a macro-level in relation to the game as a whole (see Chapter 4). Yet, the endings of THE STANLEY PARABLE are unusual since they are, at least on a superficially narrative level, largely unrelated and differ so radically from one another that they can hardly be interpreted as the narrative alternatives that multiple endings in games typically are. Rather, they form a compilation of the medium's closural tropes and conventions. While freedom of play, player choice, and its consequences are also frequently addressed by THE STANLEY PARABLE, and certainly make up one of its major meta-poetic and meta-ludic interests, the multiplicity of endings most notably enables a reflection on a maximum number of conventional closural signals in one single game. By simultaneously adhering to some conventions, completely undermining others, or just blatantly spelling them out in the narrator's witty commentary, THE STANLEY PARABLE exposes the inner workings of digital game endings.

In the centre of the metaleptic narrative that fuels the game's humorous metareferentiality are protagonist Stanley and a nameless narrator. At first, the relationship between the two seems fairly conventional: In the introductory cutscene, the narrator presents Stanley as an average but content office worker whose life is about to change drastically as "one day, something very peculiar happened", marking a breach in order within the storyworld that is common for narrative beginnings. Without any instructions coming in for Stanley and all of his co-workers having disappeared, the implicit goal given at the game's beginning is to reveal the truth behind this mystery. Players control Stanley as their avatar in first-person perspective, able to perform simple actions like walking and interacting with objects such as doors or buttons. The narration provides more immediate goals, or better: implicit instructions, during ergodic sequences, as the narrator often describes Stanley's actions even before they are performed – such as: "he got up from his desk and stepped out of his office". Herein lies the foundation for the game's metaleptic twist, since the player is (mostly) given the choice to conform to or go against these instructions – in this case: closing the office door instead of leaving. As the narration (mostly) uses the past tense, any disobedience on the player's part creates a paradox that exposes the conflict between prototypical narrative pastness and the (immersive) presentness of the ergodic activity (see Wolf 2013, 253). The clash of preconceived narration with ludic freedom opens up a vast range of opportunities for metareferential reflections, many of which are directly related to the issue of closure.[50]

Happy ending? – The Freedom Ending

Most of THE STANLEY PARABLE's endings provide a strikingly low degree of closure. The sense of an ending is systematically kept to a minimum via the loading screen's paratextual framing and the fact that the game

automatically restarts after each ending, straightforwardly urging players to explore a different path and with it a different outcome. In some cases, this plain refusal of closure matches the openness of the ending the player just passed, while in others, it contrasts strikingly with the sense of closure the narration and the audiovisual representation are trying to convey. One example for the latter is the game's Freedom Ending.[51] The Freedom Ending occurs if players thoroughly follow the path suggested by the narration, which leads to an underground "mind control facility" that, according to the narrator, reveals the company's evil, big-brother-like intentions. His emphatic commentary repeatedly stresses the magnitude of the company's atrocities and Stanley's horrified reactions to them (e.g. "And as the cold reality of his past began to sink in, Stanley decided that this machinery would never again exert its terrible power over another human life"). By deactivating the facility once and for all, Stanley supposedly achieves his freedom, as the player steers him outside into a peaceful scenery.

At first glance, the happy ending is perfectly implemented by the use of closural conventions on nearly all levels: The final change of location from the dark halls and corridors of the underground facility into a calm, sunny landscape evokes "the feeling of liberation" that the narrator ascribes to Stanley at this moment, matching the narrative trope of successful escape after the defeat of a superior evil. The verbal narration conforms to literary conventions of closure, for example that of starting the final sentence with a conjunction (a closural signal used in many of the game's endings): "And Stanley was happy" (see Korte 1985, 158–60). Furthermore, the distance between game and player is increased when ergodicity stops as soon as the avatar leaves the building. The camera, no longer controlled by the player, finally pans upwards to a typical view of a blue sky, which then fades to white, positively contrasting with many of the game's narratively bad endings that culminate in a black screen. The slow, minimal piano tune that accompanies this final non-ergodic sequence matches musical ending conventions, conveying the soft nostalgia typically connected to leaving a game.

And yet, the closural effect of all these conventional signals is doomed to failure as they lack sufficient contextualisation. Throughout the path to the Freedom Ending, narrative information given by both the environment and the narrator is kept to a minimum, apart from the latter's overdramatic descriptions. The whole sequence is uneventful both narratively – as neither what supposedly happened in the company building nor the evil mastermind behind it is shown, and Stanley himself remains silent – and ergodically, given that the final "challenge" of dismantling the facility is achieved by simply pressing an "off"-button. As such, the narrator's attempt at building suspense falters, and the happy ending remains largely unmotivated, failing to produce any effect of triumph or relief. The short duration of the playing process does not help either in evoking any sense of accomplishment, as it takes just under ten minutes from beginning to end if players strictly follow

the path. Even the final sentence, which would conventionally intensify closure by referring back to the game's beginning, in which the same phrase is used, rather adds uncertainty: Not only does the narrator first use "And Stanley was happy" in the introduction to describe a state of *false* happiness (because Stanley is supposedly being mind-controlled at this point), but it appears right before the breach in order that narratively sets the game in motion, thus suggesting another turn of events coming up when it is re-used in the Freedom Ending. Apart from these rather subtle signals, the Freedom Ending more explicitly encourages players – who might be still unfamiliar with the game's metareferential workings, if they got there in their first playthrough – to try another path, as, in the final cutscene, the narrator mentions the "puzzles still [...] unsolved", asking "what other mysteries did this strange building hold?"

Tragic endings? – Avatar death and defeat

Some of the twists and turns that the story of THE STANLEY PARABLE can take result in a bad ending, culminating in Stanley's death. One of these endings has the protagonist breaking down from insanity on a sidewalk, which is noteworthy for being a rare incident of the character shown on screen (see Figure 3.20). The non-ergodic sequence demonstrates the closural principle of distancing, both visually, as the camera zooms out, and by changing an important content element, as the narrator now tells "the story of a woman named Mariella", who stumbles upon Stanley's body. The distance to the previous protagonist is maximised as the narration is focalised through Mariella, who does not even know "the strange man" lying on the sidewalk. Matching the story's ironic twist, the majority of

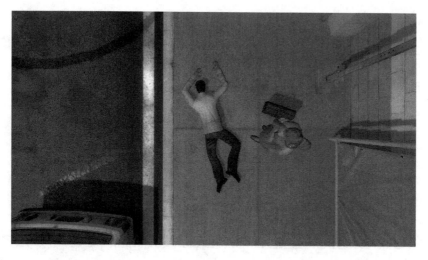

Figure 3.20 THE STANLEY PARABLE, Mariella Ending.

the closural signals of the Mariella Ending evoke a positive atmosphere of departure – e.g. via the final sentence: "And then she turned and ran", and via the subtly propulsive score of radiant high notes – rather than one of sadness and defeat. Just like Stanley, the player is left powerless and abandoned by the narrator, since the sudden change of protagonist does not entail a change of avatar but instead ends the ergodic experience (until the inevitable automatic restart).

Other instances of avatar death in THE STANLEY PARABLE are more directly linked to failure and predominantly refer to the ludic mode. The ending which most directly undermines player expectations of winning and losing is the Explosion Ending. This ending is a close alternative to the Freedom Ending, but instead of deactivating the mind control facility, players turn it back on. This act of revolt upsets the narrator so much that he initiates the building's self-destruction. Mocking Stanley's, or the players', attempt to get in control by making their own choice, the narrator proves his superiority by altering the events at will and even pretending to contemplate the length of the time until detonation: "Hmm... let's say, um... two minutes." A matching countdown appears in large numbers on the wall of the arena-like control room that is lined with workstations equipped with various screens and buttons (see Figure 3.21). The setting clearly conforms to the ludic closural convention of a final encounter, although there is no physical combat against the supposed boss, the narrator. Rather, the consoles filling the room suggest that there is a final puzzle to solve in order to either escape the facility or prevent the detonation. The sense of a conventional final challenge is intensified by the temporal pressure of the countdown and supported by the forcefully propulsive score that contrasts strikingly with the absence of music in most parts of the game. The narrator continuously feeds

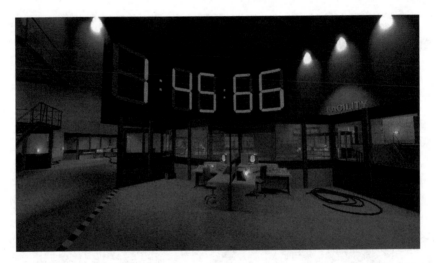

Figure 3.21 THE STANLEY PARABLE, countdown sequence in Explosion Ending.

his new image of the malicious antagonist as he admits having "erased" Stanley's co-workers, torturing Stanley again and again in each repetition of the game and even "laughing at every second of your inevitable life".

Thus, every detail in this sequence suggests a predominantly ludic interpretation, which imposes itself more, the more familiar the player is with the medium in general. The narrator even spells out the ergodic suggestiveness of the sequence due to its use of representational strategies with a conventionally ludic function:

> Did you just assume when you saw that timer that something in this room was capable of turning it off? I mean, look at you, running from button to button, screen to screen, clicking on every little thing in this room! "These numbered buttons! No! These colored ones! Or maybe this big, red button! Or this door! Everything, anything, something here will save me!" Why would you think that, Stanley? That this video game can be beaten, won, solved?

Yet, the same narrator has just shortly before proven his fundamental unreliability by initiating, and later even manipulating the timer. Without a look into the black box that the game's program code is for most players, they are trapped in a dilemma between believing the potentially deceiving words and trusting in their experience with the medium's conventions (see Bojahr and Herte 2018, 246f.). While it usually suffices "to watch a program's effects and extrapolate potential approaches or problems [...] in its code" (i.e. a "*black-box* analysis") (Bogost 2007, 62), the countdown sequence of THE STANLEY PARABLE prevents reliable extrapolation, as the screens and buttons suggest the existence of a solution by giving audiovisual reactions to input, leading players to assume they only need to find the right sequence of actions to solve the puzzle. Only a "*white-box* analysis", i.e. actual insight into the code (see Bogost 2007, 62f.), can prove that the narrator speaks the truth when he says: "This is not a challenge." THE STANLEY PARABLE *Wiki* refers to the felt need for and actual performances of such an analysis within the doubtful player community:

> Several players have decompiled the map to figure out what the buttons are and what they do. They have no entities tied to them that would stop the countdown. In other words, despite player folklore, the countdown cannot be stopped in any way [...]
> (http://thestanleyparable.wikia.com/wiki/Explosion_Ending)

The Explosion Ending, hence, disguises its narrative finale in a conventionally ludic outfit, drawing attention to the multimodality of digital games by undermining expectations of modal predominance. The narrator admits that the same sequence could have been completely non-ergodic: "You're only still playing instead of watching a cutscene because I want

to watch you for every moment that you're powerless." Yet, the sequence does not feed any sadistic desire of the narrator – or even the developer. Rather, its whole metareferential effect depends on the conflict of expected consequential ergodicity and the actual futility of all available actions. Despite the reversal of typical modal dominance, the sequence retains a certain closural effect, since it still clearly *is* a finale, albeit not a ludic, but a (meta-)narrative one.[52] Hence, although closural signals provide the frame for the sequence, its metareferential focus is, arguably, more on modal confusion in general than on conventions of digital game endings in particular.[53]

During his monologue in the Explosion Ending, the narrator touches the question whether failure can be considered a viable outcome in a digital game when he claims that there is "no ending here, just you blown into pieces". The question of failure's potential closural effect will not be discussed in detail until Chapter 4.4; yet some of the failure sequences of THE STANLEY PARABLE – if they even constitute a case of failure at all – deserve a closer look in the context of this chapter. It should be noted that all scenarios in which avatar death is possible or even required to proceed in THE STANLEY PARABLE lead to the same restart sequence as any other path. While the narrator negates the acceptability of a bad outcome, i.e. Stanley's death, in the Explosion Ending, it has already been mentioned that it is not only accepted, but even enriched with narrative closural signals in the Mariella Ending. The Suicide Ending provides another representation of avatar death, which also differs strikingly from its most common representation in the game, i.e. a sound designating the cause of death (such as the impact of a body hitting the ground) and a cut to black. During the Suicide Ending, players need to let Stanley fall from a high staircase four times before he finally dies, which foregrounds the active choice of death as an end to enable a new beginning. Although the avatar death itself does not constitute player failure, as it is caused deliberately, the sequence as a whole is thus marked as the dead end of a failed attempt. The audiovisual representation – which reverberates the game's origins as a modification of HALF-LIFE 2 (Valve Corporation 2004) – supports this interpretation by reproducing the conventional failure screen of Valve's games, with the screen rotated by 90° and covered in a transparent shade of red. The game restarts a few seconds later. This distinct representation prolongs and foregrounds avatar death as an outcome compared to the simple cut to black of most of the game's other death scenarios. The importance of this difference will become clearer in this study's chapter on the premature endings of failure.

Paratextual detours and endings that refuse to stop

Although it ultimately conforms to the game's "conventional" representation of avatar death, the Museum Ending adds another layer to it. Having

deviated from the narrator's intended path just shortly before the mind control facility, this ending leads the player into a deadly machine. Just a moment before Stanley is trapped in its "enormous metal jaws", a narreme-related change occurs as the male narrator is replaced by a female one, who vividly describes how "in a single, visceral instant, Stanley was obliterated as the machine crushed every bone in his body, killing him instantly". Yet, the game does not restart here. Instead, the avatar is released from the machine's grip and players stay in control as they are being led to a museum filled with paratextual information about the game, ranging from the credits displayed on a wall, to narrator outtakes, to marketing material, to pictures, videos, and 3D-models of earlier versions of some of the game's contents. With this paratextual overload, the sequence reflects the closural power of paratext that is intensified as players enter the museum through a black void in which the game's title is displayed in large, white letters, conforming to the game logo convention. Although the sequence could thus be understood as a form of ludified paratext, the game simultaneously undermines this closural power, as it actually continues while players are free to explore the new area. The game explicitly states that it was never even stopped for this paratextual detour in a room labelled "EXIT", which, again, bears only the game's title and a switch showing that THE STANLEY PARABLE is still "on".

Interacting with the switch takes players back to the moment before Stanley is eventually crushed by the machine. The female narrator implores them to "press 'escape,' and press 'quit' [...] to beat this game". Evoking philosophical questions about free will and responsibility, she emphasises that "stop[ping] now [...] will be your only true choice". Although the consequences of the choice, i.e., restarting, seem to be identical with those of Stanley's death, the game refuses to restart automatically even after the narrator's words are cut off and the screen turns to black, implying Stanley's demise. In order to proceed, the player *has* to take another paratextual detour – this time via the "actual" paratext of the game's menu – to initiate another playthrough, or maybe even quit the game.

Although no other ending leaves players ergodically paralysed in avatar death, there are several other paths that refuse to stop and rather require manual restarting, such as the Window Ending, which occurs after players crawl out of the building via a seeming glitch, or the Heaven Ending, which places Stanley in a bright space with ethereal music and an infinite number of buttons to push. In all of these cases, THE STANLEY PARABLE reflects the question if closure presupposes a fixed termination on part of the media artefact, or if it rather relies on the conscious choice of the player/recipient, as it has been discussed with reference to hyperfiction (see Chapter 2.1). The sequences differ from the (ideally) open-ended nets of hyperfiction, however, in that they form dead ends in which there is nothing left to do. A player staying there would rather be comparable to a reader blankly staring at the last page of a novel instead of putting away the book.

However, as this is the core of the question of closure being a conscious choice or evoked by signals within the media artefact, the refusal of restarting also draws attention to the difference between the ending signifying conclusion instead of mere cessation. The issue is brought up frequently by other representational characteristics before many of the game's automatic restarts. For example, the narrator's words are cut off abruptly not only in the Museum Ending but also in the Explosion Ending, the Suicide Ending, and a range of others. The interruption of verbal narration is particularly noticeable and effective for metareferential reflection because it addresses *the* prototypical form of narration. While the degree of closure might be debatable in other modal domains, the incompleteness of a sentence is unmistakable – especially if that sentence is spoken out aloud, with intonation further indicating the interruption.

Indeed, true to the initially quoted claim of the game's loading screen, perhaps none of its so-called endings meets the fundamental criterion of evoking an expectation of nothing. The game outright mocks the term "ending" in itself in several ways, for example with the "Whiteboard Ending", which is simply a text found on a whiteboard hanging on the wall of an otherwise empty room (see Figure 3.22). After being familiarised with the game's branching nature, which leads to strikingly different stories and metareferential topics, it is indeed unlikely that players will be convinced to have completed the game by following any one path. In this sense, THE STANLEY PARABLE resembles ideal hyperfiction which refuses traditional closure, leaving the user with the task to exhaust either the text or themselves trying (see Chapter 2.1). It also serves as a perfect example of games that employ narrative branching and multiple endings to encourage completist play (see Chapter 4.3).

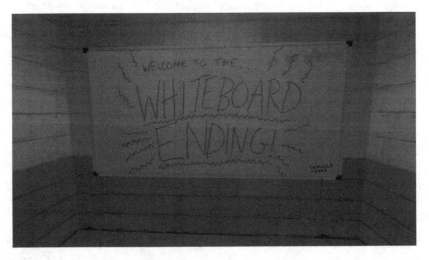

Figure 3.22 THE STANLEY PARABLE, Whiteboard "Ending".

Confusing expectations, and closure, after all?

THE STANLEY PARABLE even plays with the expectations it teaches to players after they have discarded their conventional expectations of closure, most notably in its Confusion Ending. On the path to this ending, the game restarts several times; yet these restarts clearly mark no new beginnings, since the narrator, in contrast to all other restarts, remembers the previous playing sequence.[54] Finally, players reach a small room with a text projection detailing the course of "The Confusion Ending", which is structured into nine phases interrupted by eight restarts. Players can easily find their current location on this path in the middle of the projection as part of the fifth phase. The narrator refuses to acknowledge the chart, unwilling to restart the game again and again, and yet, this is exactly what automatically happens shortly after. It is crucial that the chart describes the first element of the next phase as "Narrator forgets about previous restarts". Since this is what happens in any "conventional" restart of the game, players are prone to believe, at least for a while, that the Confusion Ending path – the name says it all – is still ongoing, while it, in fact, is not, since the discovery of the chart is its final event – an event that denies and disguises its sense of an ending.

Arguably, there is one ending in THE STANLEY PARABLE that evokes a sense of closure strong enough to mark it as the game's "true" ending, at least according to the related page of THE STANLEY PARABLE *Wiki*.[55] The closural effect of this ending is heightened by signals on all levels relevant for the sense of an ending. Although the ludic mode only slightly partakes in this, it is still noteworthy that the decisive player action leading to the "Not Stanley Ending" requires more effort or, at least, attentiveness than most other paths of the game: After an early deviation from the narrator's intended path, players arrive in a room with a ringing telephone. Instead of picking up the receiver (which is also possible), the Not Stanley Ending requires players to pull the phone's plug. The action is not obvious but subtly suggested by the shine of a single light bulb swinging back and forth between the telephone and the plug in the wall.

On the narrative level, closure is communicated much clearer and more efficiently than in the Freedom Ending, for example, because all diegetic levels and their metaleptic connection are an integral part of it. According to the narrator, pulling the telephone plug results in a narrative paradox, as this choice was not supposed to be even possible. He "realises" that the player is a real person, and not Stanley, able to make actual choices. As the narrative paradox threatens to destroy the game world, the narrator urges players back to the first choice in an attempt to re-establish the game's teleology and to free them from the task of playing: "You take the door on the left. The story will have resolution again and you'll be home free in the real world." Yet, it is too late. After the narrator is forced to restart the game because the only action he requires from the player (i.e. speaking

into a microphone) is simply not possible with the given game mechanics, players suddenly find themselves avatar-less above the ceiling of the room that marks the game's most prominent choice of taking the left or the right door. Below stands Stanley, motionless, and the voice of the narrator is heard as if from a distance, urging Stanley to do just anything. Yet, as the protagonist is but a mere shell that cannot move without a controlling player, his attempts are in vain. Both narratively and audiovisually, the distance between player and both Stanley and the narrator is thus maximised (see Figure 3.23).

While the player is free to move around like a ghost on top of the ceiling, an end title ("The End!") and the message "Thank you for playing THE STANLEY PARABLE" appear briefly before a credits start to roll, marking the paratextual closural phase of this ending. The closural effect of this credit roll is particularly strong as all the game's other endings lack paratextual closural signals.[56] The closural power of this conventional paratext is briefly highlighted at the beginning of the path when the narrator is reviewing the script for the (non-existent) ending that was supposed to be triggered by picking up the phone and finished like this: "Music comes in, fade to white, roll credits."

It is remarkable that the game restarts after this strong closural paratext rather than discharging players from the game by terminating the program or leading back to the main menu as would be most conventional. Yet, in spite of the continuation of the restart logic, the sense of an ending evoked by the Not Stanley path is apparently intersubjectively intense enough for it to be discussed as the game's true ending without any further cues from authoritative sources. The fact that paratext, however, is not necessarily a reliable signal of closure is briefly touched during the Confusion Ending – not

Figure 3.23 THE STANLEY PARABLE, Not Stanley Ending.

only in its ending chart but also long before it, when both the player and the narrator get lost. Disoriented, the narrator decides to just let Stanley win the game, which prompts a loud cheering noise and the message "You win!!" on screen. Yet, victory does not last long, as the narrator admits that, ergodically, it is completely unmotivated: "I don't feel right about this at all. We both know you didn't put in any actual work for that win. Some people win fair and square and this was not one of those situations." As a consequence, he initiates another restart of the game – a restart that, however, does not mark an ending, as it does not finish but continues the Confusion Ending path.

THE STANLEY PARABLE *and closural conventions – Conclusion*

Despite its exorbitant branching, THE STANLEY PARABLE takes only two and a half hours to complete for the average player.[57] In this short time frame, it constantly alternates between evoking and denying a sense of an ending, of spreading closural signals and either directly turning their conventional effect upside down or undermining it shortly after. Within the continuous cycle of happy endings and victories, bad endings and failures as well as sudden cessations, representational strategies, and their ludic and narrative functions are exposed, questioning their proper effectiveness against their conventionality. Although the lines between rules and fiction – to use Juul's only approximately equivalent terminology for the ludic and the narrative (see Juul 2005) – are often blurred in the metaleptic set-up of the game, the ludonarrative dissonance in moments like the underwhelming ludic finale of the Freedom Ending or the feigned ergodicity of the Explosion Ending makes THE STANLEY PARABLE a prime example for how "jarring mismatches between [rules and fiction] [...] can still generate a positive effect, working as a way of playing with the player's expectations, [and] as a way of creating parody" (Juul 2005, 163).

The density and exposure of micro forms enable the game to effectively address ending structures on a macro-level as well, as has been repeatedly pointed out. Although this study will move away from THE STANLEY PARABLE to discuss these macro forms of endings, using other examples in the following chapter, the reader will find some of them familiar from here, as local and global forms of closure are eventually interconnected. Since the density of closural signals is crucial for identifying endings, knowledge of the micro forms and functions compiled in this chapter is essential for the following analysis of ending structures that mostly differ significantly from the narrative prototype of beginning, middle, and end.

Notes

1 As has been briefly mentioned in Chapter 2.1 the Proteus Principle designates the fact that different contexts can bestow different functions on the same form (see Sternberg 1982, 145).

2 Whether just unknown to the recipient or truly unrelated to the narrative conflict, endings are generally meaningless on the level of story if they do not relate to the whole. Compare Bunia's assessment of the ending of Italo Calvino's *If on a Winter's Night a Traveler*:

> When Calvino's novel leaves aside all events contributing to a logical solution of a conflict, it becomes manifest that the last events can be interpreted as the final decisive step in a chronological sequence only if they *are* embedded into the development. The marriage at the close of *If on a Winter's Night a Traveler* simply is not functional as it does not refer to any conflict.
> (Bunia 2006, 367, original emphasis)

3 For example, NIER (Cavia 2010) uses a variety of visual perspectives in both predominantly ludic and predominantly narrative scenes. While the game is mostly played in a 3D environment with a controllable camera at a fixed distance from the avatar, there are sideways, 2D sequences without camera control in both narrative-focused dialogue and action-focused ergodic sequences. A variety of visualisations – with only the narrative scenes ranging from textbox-based dialogue to fully animated cutscenes – is also common in RPGs such as the PERSONA (Atlus 1996–2017) and FINAL FANTASY (Square / Square Enix 1987–2016) series.

4 Kill screens – a problem largely limited to arcade games – occur when an unexpectedly far progress of a player causes an error in the game program. The most prominent example is PAC-MAN (Namco 1980), in which, broadly speaking, an overflow of the level counter variable causes severe graphical glitches that make level 256 unbeatable. Other examples include DIG DUG (Namco 1982), which causes an instant "game over" in level 256, or DONKEY KONG (Nintendo 1981), in which an algorithm eventually produces an unbeatable time limit. It could be argued that these accidental cessations indeed supply a sense of closure, or better: victory, for players, which is otherwise denied in games with mere transient goals. Yet, this feeble sense of an ending solely relies on the knowledge that a technical error is preventing further play, rather than on actual closural signals. Moreover, even the kill screens usually culminate in a "game over", as the glitches do not overrule the game's fundamental transient goal principle, but rather just set a limit to the possible highscore.

5 Message displayed at the point of no return in BASTION (Supergiant Games 2011).

6 Note that there can be other types of endgame triggers in MMOs, just as there might be no endgame at all.

7 In the following abbreviated as DEUS EX: HR.

8 Strictly speaking, the points of no return in DEUS EX: HR fulfil a closural function as well, since they are placed at chapter endings, which belong to the form of interim endings common to serial narrative artefacts.

9 The final mission of MASS EFFECT 2 actually and unconventionally includes a "victorious" ending in which the avatar dies, although their survival is also possible and, arguably, much more probable (see Herte 2017).

10 In the following abbreviated as XCOM: EU.

11 Thon points out that such breaches of narrative plausibility are generally not perceived as problematic by players, since they are used to applying a "medium-specific charity" to ludonarrative dissonances, "based on knowledge about contemporary video games' representational conventions" (Thon 2016, 106).

12 Arguably, the change to a spectacular, formerly inaccessible or otherwise extraordinary setting forms a transmedial closural signal as well. Especially the finales of blockbuster movies frequently take place at special locations, such as the factory at the end of TERMINATOR 2: JUDGMENT DAY (James Cameron

1991), or the volcanic planet Mustafar in Star Wars: Episode III – Revenge of the Sith (George Lucas 2005), which both represent the trope of a lava-infested environment. However, the closural signal of a change in setting has not yet been recognised by research on endings in other narrative media. Probably, its significance is more apparent in digital games because of the medium's overall emphasis on spatial phenomena, which is due to the fact that players can and have to navigate this space. This general importance of space conceivably supports a higher degree of conventionality for spatial closural signals in the medium.

13 Players are, at first, quite literally taken back to the 1998 game, as Act 4 of Metal Gear Solid 4 reproduces its predecessor's beginning sequence, using the same graphics and game mechanics. Shortly after, the sequence is revealed as a dream of Snake, protagonist and avatar in both games, and Shadow Moses is then recreated with the graphics and mechanics of the fourth instalment. The sequence has a nostalgic, rather than a closural effect, and powerfully demonstrates the metareferential potential of digital games.

14 The changes amount to slight differences in combat in Hotline Miami (fixed weapon, faster movement), Bayonetta (increased damage, a range of other minor effects), and Deadly Premonition (change of weapon), while the new avatar in L.A. Noire merely has no accompanying partner and cannot change outfit.

15 This change of events that follows a diegetic temporal setback (the biker surviving the encounter instead of the previous avatar) turns the story of Hotline Miami into a unilinear forking-path narrative (see Chapter 4.3).

16 It should be noted that the ending sequence of Hotline Miami is extremely unconventional, as the flashback follows a sequence that actually already fulfils a range of conventional closural signals (see Chapter 4.1).

17 The table of contents as a part of a book's paratext is also discussed in Genette's chapter on intertitles (see Genette [1987] 1997, 316–8). Yet, a striking difference between the chapter titles hidden in some digital games' save/load menus to those of non-procedural media is that they usually only appear after the player has proceeded far enough to begin this segment of the game. In contrast, the table of contents of a book is always completely accessible, although sometimes deliberately put after, rather than before the text.

18 In the following abbreviated as Hitman: BM.

19 Intradiegetic narrator/game master Tiny Tina at the start of the final encounter of the Borderlands 2 (Gearbox Software 2012) DLC Tiny Tina's Assault on Dragon Keep (Gearbox Software 2013).

20 In case of New Super Mario Bros. Wii, the escape sequence could be classified as a second phase of the boss encounter. After defeating series villain Bowser in the first phase, he transforms to giant size and chases avatar Mario. With the change from combat to chase, the sequence's goal and the only option to survive the passage is spatial progression.

21 Players not necessarily aim at making the ludic finale easier by investing time and effort like this, but may simply follow their preferred playing style and interest in thoroughly exploring the game world.

22 Although the abbreviation HUD stems from the term "head-up display", it is used for any on-screen ludic information given, such as health bears, mini-maps, equipped items, regardless of any relation to a supposed head-up display used by an avatar in a game with first-person perspective.

23 Occasionally, the strategy of reduction is found not during the ludic climax itself but at the beginning of the ending. For example, Metal Gear Solid 2: Sons of Liberty (Konami 2001) bereaves players of their entire equipment near the game's ending, forcing them to proceed with a visibly vulnerable,

naked avatar before retrieving their gear. Reductions like this can gain a closural effect as an unexpected breach in order; yet it should be noted that they are equally employed during other phases of a game as, for example, a similar temporary loss of equipment during the first METAL GEAR SOLID shows.

24 What players don't know in their first playthrough is that even without the weapon there is no failure in the following ludic sequence, in which the defenceless avatar carries his unconscious friend. Despite enemy attacks going on for a while – just as when the player chooses to proceed with the weapon – the depletion of the avatar's health does not trigger the game's failure routine. Instead, he – still controlled by the player – carries on against all, both narrative and ludic, odds.

25 Another, straightforward method of conveying urgency via sound is conventionally employed by the SUPER MARIO series, where the music speeds up whenever a level's time limit reaches a certain minimum. As it occurs in all levels of the series' typical platforming games, it is not a closural signal per se. Yet, it is still worth noting due to its close connection to both approaching the end of a level – which might be understood as an interim ending of a digital game – and potential failure, the closural implications of which are discussed in Chapter 4.4.

26 Although the Grail is not exceptional in height compared to previous bosses, it stands out (besides its narrative connotations) for its pure golden colour, and for being an immobile vessel, its immobility suggesting an invulnerability and calm supremacy that is also communicated by dialogue.

27 Although obvious from the visual representation, the characters even point out Yaldabaoth's extraordinary size in dialogue, e.g. "This is crazy! It's like a building!"

28 However, the implicit goal of a fighting game like TEKKEN 5 includes playing through arcade mode with every single character for full completion of the game, so that players ideally encounter all possible fragments of the story (with as many different developments and endings as there are characters).

29 Note that Gehrman is not the definite final boss of BLOODBORNE, as the game includes multiple endings that differ in their ludic finale (see Chapter 4.3). Apart from the option to simply not fight Gehrman (and sacrifice the avatar's life), players can fight the "Moon Presence" after defeating Gehrman, if they invested additional effort before the encounter. The strange creature's nightmarish appearance makes up for Gehrman's lack of audiovisual extraordinariness. Neither does it lack narrative significance, as it is the hidden force that controlled Gehrman, and with him the Hunter's Dream. Both encounters are designed as ludic finales and, thus, fulfil a closural function.

30 This risk has been reduced, historically, not only due to the arguably low difficulty of most contemporary narrative digital games but also because it is now easy to access any segment of a game in a non-ergodic way by watching other people play online such as on platforms like YouTube or Twitch.

31 While this study is not the place to further elaborate on this issue, it should be noted that digital games that are too easy to complete also frequently gain criticism. Due to the hybrid nature of narrative digital games, a narrow focus on fulfilling one player desire (e.g. the narrative desire to know how it ends) often goes at the expense of another (e.g. the ludic desire for overcoming a challenge).

32 Lara Croft in the final narrative sequence of TOMB RAIDER (2013).

33 A similar process, but in reverse direction, typically happens at the beginnings of games, where ergodicity is gradually increased from non-ergodic cutscenes to ludic sequences in which game mechanics are often enabled step by step to slowly introduce players to the game (see also Thon 2015, 116–8).

34 However, the sequence gains crucial significance for being one of only three narrative cutscenes in SYSTEM SHOCK, apart from the game's beginning and failure sequence. The seemingly extreme lack of elaborated, non-ergodic narrative sequences in SYSTEM SHOCK furthermore results from the technical limitations in the game's release year 1994 in contrast to more recent examples.

35 There is a way to save Shepard's life in the game's ending. However, it requires additional player effort in the game's multiplayer mode, thus not only forcing some players to leave their comfort zone of singleplayer mode but also relying on an active player community to be achievable at all.

36 The avatar's sacrifice is only explicitly revealed in the game's expanded version PERSONA 3 FES (Atlus 2007), which includes an epilogical episode titled "The Answer". Even without this additional knowledge the character's death and sacrifice are the most likely interpretation suggested by the game's ending.

37 The visual novel genre often lets players choose between manual and automatic text progression, making a point for not distinguishing between purely non-interactive cutscenes and those that require such trivial player actions.

38 The photograph is meaningful in the narrative context of FALLOUT 3, because the game begins with the birth of the protagonist. Players even have to play through some crucial moments of the character's childhood themselves, and a large part of the game's main story is devoted to finding their father.

39 In MASS EFFECT 3, the narrating voice or better: voices, since the sequence turns out to be a dialogue, are actually seen as characters on screen. Yet, these characters are seen only from behind from a far distance, and just roughly identified as "Stargazer" and "Child" in the (optional) subtitles. "Stargazer", thus, functions as an unspecified, intradiegetic narrator, whose temporal distance to the events he is talking about (i.e. the story of the game) conveys a strong sense of closure, as it transforms these events, which are still very much present to the player, into remote legends.

40 Note that this perceived narrative agency does not necessarily affect the objective course of events – which would entail multiple endings – but can have a more subtle, moral, or ethical impact (see Chapter 4.3).

41 Message displayed at the end of the credit roll of THE SECRET OF MONKEY ISLAND.

42 Andy Farrant in a YouTube video titled "7 Times It Wasn't Actually Game Over and You Totally Fell For It", channel *outsidexbox*, released June 23, 2016, https://www.youtube.com/watch?v=ptGYTr519xE (timecode 2:28–2:31).

43 DEUS EX: HR displays the logo both at the start of the credits and after the post-credits scene.

44 In the following abbreviated as MAJORA'S MASK.

45 In the following abbreviated as GTA V.

46 Note that not all games that record scores include a highscore table, or even keep track of score records in the first place. For example, SUPER MARIO BROS. (Nintendo 1985) does not.

47 Although JOURNEY is basically a singleplayer game, it became partly famous for its online feature of letting players randomly meet in the same instantiation of the game world. As all avatars look exactly the same and there are no options to communicate via speech or text, the identity of the other person remains completely obscured during play.

48 As will be explained in Chapter 4.3, any information on multiple endings during the paratextual phase always refers to both the ludic and the narrative mode, as multiple endings fundamentally function as a ludification of the latter.

49 It seems appropriate to note that, despite this study's general exclusion of multiplayer games, some of the examples mentioned here have multiplayer aspects, so that the playing process is not always that solitary. For example, in JOURNEY,

players randomly meet other, anonymous players during a game, and BOR-
DERLANDS 2 can be played cooperatively with up to four players who pursue
the story together. In both games, there are no or just marginal effects on the
ending. (By these multiplayer aspects, I am explicitly not referring to distinct
multiplayer game modes such as the online modes of THE LAST OF US or RED
DEAD REDEMPTION.)

50 Note that this "ludic freedom" is generally restricted to the limits predeter-
mined by the game designers, and "unforeseen" player actions that go against
the narration only trigger another set of fixed, pre-recorded reactions by the
narrator.

51 Where available, the names for the endings are taken from the game itself
such as from its in-game museum that is filled with paratextual information.
Other names are taken from THE STANLEY PARABLE *Wiki*, to conform to estab-
lished discourse about the game (see http://thestanleyparable.wikia.com/wiki/
Category:Endings).

52 Just as in the Freedom Ending, the degree of narrative closure is still weak as
there is not much context given. However, considering the Explosion Ending's
metalepsis, this lack of context is less relevant here, as the story is revealed to
be but the malevolent narrator's fantasy.

53 I have previously analysed this and other instances of modal confusion in THE
STANLEY PARABLE in a different context (see Herte 2016).

54 In between these restarts, the loading screen also differs from the one men-
tioned at the beginning. Instead of the quoted phrase, only the word "loading"
is repeated over and over again at the bottom of the screen. The same loading
screen occurs regularly upon a significant change of place, e.g. when taking an
elevator.

55 See http://thestanleyparable.wikia.com/wiki/Not_Stanley_Ending. The mean-
ing of "true" endings is discussed with reference to ending hierarchy in Chapter
4.3.

56 Only the Museum Ending also provides credits; yet it does so in form of a
diegetic display that players can simply pass by, while the credit roll in the Not
Stanley Ending is presented in the traditional manner of white text scrolling
across the screen.

57 This average is given on the Website *HowLongToBeat.com*, a platform that col-
lects individual game completion times. As players can freely input their times,
the data are not exactly reliable, but useful as an estimate, especially since the
platform records different stages of completion, e.g. finishing only the main
story versus thorough completion. Thus, it should be noted that the average
of 2.5 hours does not reflect thorough completion of THE STANLEY PARABLE,
as most players do not attempt to finish its Art Ending, which requires at least
four hours of playing an extremely simple and repetitive "art game" (see https://
howlongtobeat.com/game.php?id=14083 [accessed June 25, 2018]).

4 Ludic and narrative macro functions

The ending as part of the entire playing process

4.1 Beginning, middle, end? Digital game endings in context

Structural ending variations in digital games

So far, this study has focused on the inner structure of digital game endings, which typically begin with a (both ludically and narratively) marked breach in order that leads to a ludic finale, followed by a narrative finale, and a phase of paratextual closure, with some room for variation particularly in the latter two parts. The phases are marked by a range of closural signals that contribute to a varyingly strong sense of an ending. The intersubjective closural effect of these signals mostly results from their conventionality and their reference to transmedially valid closural principles but is also relative to the context of the game as a whole (e.g. regarding ludic, audiovisual, or narrative extraordinariness). Beyond single closural elements, this context, which Krings – with regard to literature – calls the "residual text" (Krings 2003, 11), determines the overall structure of the narrative media artefact and the ending's function within it.

Following Aristotle, the relation between ending and residual text should be fairly simple, as the end is "that which itself naturally (either of necessity or most commonly) follows something else, but nothing else comes after it" (Aristotle 2008, 14). Yet, the structure of narrative media artefacts is not always this straightforward, as my discussion of position as a supposedly exclusive and unmistakable closural signal exemplified (see Chapter 2.1). The ludonarrative hybridity of digital games significantly increases the potential for structural deviations from the Aristotelian prototype. While some of these structural variations still stand out as deviations, others have established a strong conventionality of their own. As this chapter will demonstrate, a common denominator of most of these variations is a distinct pluralisation of the ending that contrasts with its traditional singularity in a narrative structure. By continuing after what seems to be the end or by offering various ending alternatives, these structural variations from the prototype undermine closural expectations and question the ending's finality.

Closed circles and endless cycles

Among the macro-structural deviations of digital games that influence the ending's effect, there is one that does not involve ending pluralisation and entails an ambiguous effect on the sense of an ending: circularity. Albeit far from conventional, circular structures are well-known from other narrative media. They maximise the closural principle of referring back to the beginning by closing the story in a loop. While, thus, any form of returning to a story's beginning might be considered circular – such as is commonly the case when narration on a second diegetic level frames the main story – a complete narrative circle strictly exists only if the events lying behind in the story are the same as those lying ahead, forming the temporal paradox of a constant cycle of repetition. Although repetition implies movement, it is a movement without change (see Christen 2002, 72), so that the perfect knowledge of what lies ahead ultimately triggers the closure-defining expectation of nothing. Hence, the sense of an ending is typically strong in circular narrative structures (see also Hock 2015, 75), although its effect differs strikingly from non-circular means of closure.

Digital games add another layer to circularity that can be used to disturb this closural effect. Games are traditionally designed for repetition, as they can be played again and again, following the same rules that determine their basic structure. For Backe, as mentioned in Chapter 2.2, this prototypical element of ludic artefacts contrasts with narrative artefacts that prototypically foreground teleology (see Backe 2008, 165f.). Indeed, the cyclical structure of games does not evoke any sense of an ending because it operates on a metalevel, i.e. it is hardly relevant for the outcome of a single match or playthrough that the game can be played again. While repeatability is also a general feature of non-ludic narrative artefacts – a book can be read again and again – the ludic variability of outcome adds an incentive to repetition that is decisive for the prototypical cyclical structure of non-narrative games. Yet, contrary to Backe's conclusion, the meta-ludic cycle of repetition does not generally impede or lower the sense of an ending of a single match. This can change if the procedurality of the computer is used to automatise the cycle of repetition, de facto leading players back to the game's beginning after they reached the final goal.[1] While such a design would have no special meaning in a non-narrative game (merely being a quicker way to begin another match), it can have a striking effect for a game's narrative level, being the literal implementation of the full circle that is merely delineated in non-procedural and non-ergodic narrative artefacts with circular structures.

JOURNEY exemplifies how seamlessly digital games can implement circularity on both the narrative and ludic level. The game begins in a desert near a small, prominently marked hill, a scenery that is presented as the background of the game's main menu even before the playing process begins (see Figure 4.1). The menu is minimalist, offering only the option to start a "new journey" at the press of a button, which triggers a brief

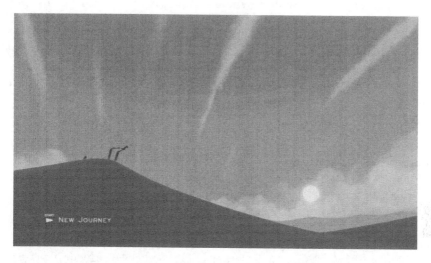

Figure 4.1 JOURNEY, menu screen and starting point of the game.

cutscene of a glowing object falling down in the desert at a spot where, next, the mysterious, cloaked avatar awakes. Upon climbing the distinctive hill, the player sees a shining light at the top of a mountain in the distance that implicitly suggests the goal of going there. As soon as players achieve this goal at the end of their journey through various locations, the avatar disappears into the light and the game ends with a credit roll that is accompanied by a cutscene showing another glowing object emerging from the mountain top and passing through all previously visited places. Eventually, the object drops down close to the distinctive hill in the desert, with the camera stopping at the same position as the title screen. As the sun slowly rises to the right, the minimalist main menu appears, allowing the player to, again, start a "new journey".

As JOURNEY uses only non-verbal means of communication, its story largely remains mysterious and obscure. Matching the game's meditative atmosphere, the arrival at the top of the mountain and the indicated metamorphosis of the avatar into a ball of light suggest a process of spiritual revelation. As this spiritual voyage leads nowhere but back to the familiar beginning, it becomes clear that the goal – or the destination – of JOURNEY is indeed the journey itself. The (player's or protagonist's) awareness of this revelation is symbolised by the distant mountain, which is now visible in the centre of the screen, in contrast to its – in retrospect remarkable – absence in the same scenery before the first playthrough. Simultaneously, since the discovery of the mountain at the horizon initially communicated the game's goal, its visibility now also serves as a tacit reminder of this goal, a subtle incentive to follow the screen's implicit invitation to begin a new journey. This ambiguous interpretation of the mountain matches the

game's ambiguous sense of an ending, which is highlighted by an abundance of closural signals before and during the credits, but partly revoked by the game's ergodically seamless circularity.[2]

The example demonstrates that, while narrative circularity commonly entails a strong closural effect, ergodic circularity can act against this, as it implies a demand for action rather than inducing players to part from the game that they just completed. In general, the defining uncertainty of a game's outcome also refutes the perfect knowledge of what lies ahead that is usually implied by narrative circularity. The play-stimulating effects of ergodic circularity prevail in games that only remotely imply a narrative cycle, such as in DARK SOULS (FromSoftware 2011), which promptly restarts the game after the credit roll, but clearly offers further incentives for playing with a difficulty increase in "New Game Plus".[3]

Overall, ludic and narrative circularity are rarely combined in digital games. Most examples with narrative circularity such as LIMBO and BASTION (depending on the player's final choice) distinctly interrupt the playing process after closing the narrative circle. Even the procedural circle of JOURNEY is, strictly speaking, not completely seamless, since players need to manually restart the cycle. A noteworthy exception is THE TALOS PRINCIPLE (Croteam 2014) that indeed seamlessly restarts the game in one of its three endings. Within the game's storyworld, androids are supposed to gather insight by solving puzzles in a virtual reality, overseen by an artificial intelligence called Elohim that disguises itself as God. The player controls one such android and can choose to either defy or abide Elohim's spiritual guidance. In case of the latter, the game ends with the avatar "ascending to heaven" to achieve eternal life. Yet, in fact, Elohim absorbs the android's memory and re-initiates it as a new version to repeat the same process of puzzle-solving. While the android's memory has been turned into a blank page and the game world is reset to a completely fresh start, players realise that they are trapped in an endless cycle. The seamless procedural integration of this cycle is all the more striking in comparison to the game's two other endings, in which the android either transforms into a guiding figure itself or transcends from virtual reality into the diegetic real world. Accordingly, the game does not initiate a restart in both cases.

As THE TALOS PRINCIPLE effectively proves, there are no factors (technological or otherwise) that prevent a direct, continuous restart of a game after it ended other than the convention to provide a sense of an ending as a reward for completion.[4] Even art games – a label frequently used to describe LIMBO and JOURNEY – seem reluctant to contest it entirely. A more common way of challenging closural conventions goes in the opposite direction, as the following section about fake endings will demonstrate.

Don't trust the credit roll – A false sense of an ending

Among the structural variations that entail a pluralisation of endings in digital games, there are those that deliberately evoke a false sense of an

ending at any point in the game. Seamlessly continuing after the fake closure, games that employ such a structure purposefully cheat the player's expectation of nothing to a surprising effect, ultimately drawing attention to the arbitrariness of endings. In contrast to the endings of open world games (see Chapter 4.2), which commonly terminate the story but not the playing process, closure effectuated by a fake ending is subsequently revoked as the ending is unveiled as a bluff.

A false sense of an ending is created by a premature accumulation of closural signals or the use of only a few, but highly effective closural signals such as a credit roll. In general, fake endings are most effective if they employ all conventional ending phases, although the paratextual phase seems to be most important. The closural power of paratext is not relative to context to the same degree as ludic and narrative closural signals, as its main function is to lead back into the real world outside the fictional and ergodic experience. Admittedly, both story and gameplay lend themselves easily to a premature evocation of closure, since narrative endings are arbitrary on the level of content to a significant degree, and the maximum difficulty towards which the ludic level of a game gradually progresses can neither be anticipated nor rated intersubjectively in the first place. Yet, the same reasons inhibit these closural dimensions from an effective evocation of a false sense of an ending on their own, as continuation always seems possible, or even likely. While the likelihood of continuation decreases with an increasing amount of closural signals on all levels, paratextual closural signals can be effective on their own, even when they come as a surprise.

Accordingly, minimal fake endings, which are mainly employed for a humorous effect, such as in DONKEY KONG COUNTRY (Rare 1994), or THE CURSE OF MONKEY ISLAND (Lucas Arts 1997), are largely based on paratextual signals. The former feigns a slightly premature ending during its ludic finale with obviously fake and brief "kredits" that list names of antagonistic characters in lieu of the production team and roll between two phases of the final boss encounter, which continues after the paratext finishes with the caption "the end?".

The metaleptic joke in THE CURSE OF MONKEY ISLAND is more elaborate, and part of the solution to a puzzle for which series avatar Guybrush needs to enter a crypt. After players make Guybrush consume a "possibly lethal" drink in a bar, he collapses and the screen fades to black. In the following cutscene his body lies unmoving at the same spot, while the bartender and an undertaker utter their surprise about Guybrush's death "with him being the main character and all". As the undertaker voices the doubts that any player familiar with the game studio might have at this point – "Funny, I didn't think you could die in LucasArts adventure games" – the bartender acknowledges the possibility of a bad ending by suggesting that "maybe they're trying something different". Finally, the undertaker entombs Guybrush in the crypt and the words "The End" appear on screen, followed by the fake meta-ludic message "You scored 0 of 800 points" (there is actually no score in the game) and a beginning credit roll. Just then, Guybrush starts

to complain about the closing paratext: "Hey! I'm not really dead!" As if giving in to the protagonist, the credit roll quickly rewinds, and players can finally interact again via the point-and-click adventure's familiar cursor symbol. Rather than a serious attempt at fooling players – assuming most are familiar not only with the no-failure-policy of LucasArts adventure games but also with their metaleptic humour – the fake bad ending in this sequence is a witty and entertaining way to embellish this unconventional step of feigning the protagonist's death for the sake of a puzzle.

To properly revoke a sense of an ending that has been substantiated by paratextual signals, a metaleptic twist seems almost inevitable. At least it is the most logical consequence for facilitating a meaningful interpretation of deceptive closural signals as the game continues. While in THE CURSE OF MONKEY ISLAND it is the protagonist who cancels the fake ending, KID ICARUS: UPRISING (Project Sora 2012) has the antagonist interrupt the premature credit roll and with it the optimism of the seemingly triumphant protagonists. Here, the credits roll after (seeming) main antagonist Medusa is defeated and the protagonists revel in how they saved the world, providing additional narrative closural signals. Yet, the true villain, Hades, only reveals himself as his big hand tears apart the credit roll (see Figure 4.2).

Figure 4.2 KID ICARUS: UPRISING, Hades tearing apart the fake credit roll.

The following segments until his eventual defeat even make up more than half of the game in total, proving that the position of a fake ending is flexible.

Rarely, fake endings are employed in a more serious way, without a metaleptic reference to their occurrence and without completely revoking the sense of an ending. Rather, closure is either delayed or put into perspective by a change of narrative point of view. For example, in KILLZONE SHADOW FALL (Guerrilla Games 2013), avatar Kellan is shot in a cutscene at the end of the game's penultimate chapter and the credits begin to roll. Yet, the paratext is interrupted by a static interference and the player is taken to "Chapter 10: The Savior", in control of a different avatar to finally defeat the villain and avenge Kellan's death. The chapter's brevity and the fact that the ludic and narrative climax occurred in the previous chapter characterise it as an epilogue following the ending's resolution phase. Thus, what is revoked is not the sense of an ending itself, but a negative outcome that seemed to have been confirmed by the credit roll. Although the ergodic epilogue does not twist this outcome into a thoroughly happy ending, it still intensifies closure by allowing the player to take revenge for their avatar's killer.

A change of perspective allows a game to partially sustain the prematurely evoked sense of an ending despite its continuation because the given closure is revealed as insufficient in the now bigger picture. The game's subsequent content, thus, can get the connotation of a secret being revealed, of a truth that lies beyond conventional closure. This is the case in HOTLINE MIAMI, where false closure occurs much earlier than in KILLZONE SHADOW FALL. Although the story of HOTLINE MIAMI is riddled with many questions that remain unanswered, the degree of closure given in its fake ending seems conventionally convincing enough due to a range of signals: First, on the level of content, the protagonist finds peace as he defeats the syndicate that (seemingly) orchestrated the killings he was forced to commit. The final cutscene shows him performing symbolic closural acts: He steps outside – facing his back to the player – throws away the mask that identified him as a killer, lights a cigarette as if to relax and contemplate, and finally throws away what seems to be a photograph. The camera follows the picture blowing away in the wind, hence leaving the protagonist and conforming to the closural convention of increasing distance. The following credit roll is short but complete, as the game's production team consists of no more than four people. Thus, there is no interruption of the credits as in the other examples of fake endings. Moreover, players can expect the ending beforehand since the game gives a preview of all chapters yet to come in the menu, with the one leading to the fake ending being labelled "final chapter". In contrast, the four chapters that, surprisingly, still await players in the following "Part V" are not revealed in the menu beforehand. Closure is, thus, solely questioned by the game's continuation, and the new part's title, "Answers", explicitly promises to enhance the previously given degree of closure by tying some more loose ends.

However, part V does not continue the game's story, but jumps back in intradiegetic time and simultaneously changes focus to another character. This new avatar is familiar to the player as an unidentified biker they had to kill earlier in the game. Part V shows an alternative path of the story in which the biker kills the former protagonist and subsequently uncovers the people truly responsible for orchestrating the assassinations, who are part of an even bigger scheme than the syndicate. While the first ending mainly provides a sense of an ending for the protagonist – who, arguably, is tricked by this fake closure as much as the player, since it is based on a false belief about his manipulators' identity – the second ending provides closure on a larger scale, revealing not only the true manipulators, but even giving insight into their motives. Hence, the first ending sustains its closural meaning as it truly concludes the main character's storyline, but not that of the overarching scheme of the orchestrated killings, which is then provided – to a certain degree – at the end of part V.

It should be noted that fake endings, especially fake paratextual closural signals, are not unique to digital games. Yet, they are more likely to occur in media that can obscure the artefact's length or duration. The digital game maximises this quality due to its immateriality and its ergodic duration relativity. In Chapter 2.1, I mention how the rare example of a literary fake ending in Fowles' *The French Lieutenant's Woman* can easily be identified as false by the remaining pages of the book. In contrast, the example of the chapter previews in HOTLINE MIAMI shows that even if there *is* information about what is yet to come in a digital game, it might be deceiving, thus contributing to the potential false sense of closure provided by the fake ending.

The medium's ergodicity opens another dimension for revoking a false sense of an ending as the task can be handed to players themselves. This is aptly demonstrated by HITMAN: BLOOD MONEY. At first glance, the game's final mission, "Requiem", seems to lack any ergodic quality. Although it opens with a narrative cutscene just as any of the game's prior missions, what follows is not a mission briefing, but another cutscene and a credit roll. The meaning of the mission's title becomes clear as contract killer and avatar Agent 47 is betrayed by his handler Diana, who poisons him by order of a rivalling organisation. The organisation's head and henchmen watch as the lifeless agent lies in state, about to be cremated, and the credits roll in front of the scenery (see Figure 4.3). After a while, the body is let down into an opening in the floor, and the screen turns to red, visually matching the game's regular representation of avatar death upon player failure, as a series of single dots concludes the credit roll, before the player is taken back to the main menu. Certainly, this ending provides a reasonable degree of closure, as Agent 47's death was foreshadowed in prior narrative sequences. However, not only is the death of the betrayed protagonist prone to be dissatisfying, but players are also defrauded of a ludic finale in this seemingly non-ergodic final "mission".

Figure 4.3 HITMAN: BM, premature credit roll.

Yet, there are hints that players can, indeed, revolt against this bad out-come by intervening during the credit roll. First, it seems conspicuous that the player is still in control of the camera. More importantly, other signals suggest that the avatar might not be dead after all: In slow intervals, the blurry vision briefly clears, a heartbeat sounds and a small red bar flickers in the bottom left corner of the screen, matching in size and position the avatar's health bar on the game's regular HUD. Moreover, the visual resemblance of the beginning cremation to the game's failure design suggests that allowing the credit roll to finish matches defeat. Even on the level of story there is reason to believe in Agent 47's return: In the cutscene immediately prior to the credit roll, Diana gives two guns to the protagonist as a seeming parting gift, as well as a kiss goodbye, probably delivering an antidote to awaken the agent from what turns out to be a Juliet-like fake death. To un-veil this truth, or rather, to actualise this event, players need to apply effort beyond merely pressing a button, as the avatar does not immediately react to any input. Only pressing the buttons for moving left and right elicits a faint reaction: The red bar is now constantly visible, but is depleted once the player stops interacting. A fast and steady alternation between left and right is necessary to fill the health bar, abort the credit roll, and make Agent 47 get up from his bier, weapons ready to take revenge on the organisation that tried to get rid of him. Thus, the ludic part of the final mission "Requiem" finally starts, and the credits are interrupted, as in most of the other examples of fake endings – yet this time, players need to actively trigger the interruption.

HITMAN: BM is one of the examples in which the fake ending occurs so late that it structurally belongs to the game's actual ending. It is remarkable

because it requires players to act during the paratextual phase without explicitly conveying this demand. As closure is not revoked without the player's effort, Agent 47's cremation might even be regarded an alternative ending, a path in which Diana failed to resurrect the protagonist. Although the red tint of the screen at the end suggests understanding this outcome as a failure scenario, the fact that what follows this scene is simply the main menu, and *not* the regular "mission failed" screen, opposes this interpretation.[5] Ultimately, the fake ending's closural effect remains ambiguous, emphasising the player's role in determining the narrative outcome, albeit less straightforwardly than is the case in the typical final choice in many games with multiple endings (see Chapter 4.3). Thus, the example of HITMAN: BM shows that differences between the unconventional structure of fake endings and more conventionalised structures like multiple endings are often merely gradual.

While most simple occurrences of fake endings such as in THE CURSE OF MONKEY ISLAND and KID ICARUS: UPRISING leave no doubt about their status as a mere bluff or joke without any lasting closural effect, changes of perspective, such as in KILLZONE SHADOW FALL or HOTLINE MIAMI, and ergodic interventions, such as in HITMAN: BM, reveal a first glimpse at one of the consequences of a plurality of endings that will continually resurface in this chapter: The ending's finality is questioned as the multiplication of this traditionally singular element of the narrative prototype challenges its ultimate meaning-making function.

4.2 Open worlds – The post-ending phase

"Enjoy everything this world has to offer!"[6] – Ludic openness and completionism

Similar to games with fake endings, open world games often continue after their endings that are complete with a ludic, a narrative, and a paratextual phase. In contrast to the former, however, the provided closure in open world games is neither revoked, nor enhanced by a later ending. Thus, what follows the ending in these games can more aptly be called a *post-ending phase*.[7]

Generally, the attribute "open world" has no bearing on a game's ending, as it merely describes the design principle of a seamlessly explorable game world, in contrast to games segmented into a level succession and tightly structured spaces that enforce linear progression. As the spatial design of open game worlds promotes certain play styles and gameplay features – e.g. free exploration, non-linear progression, and quest structures (with quests of varying priorities and narrative relevance) – these features are generally associated with the genre called "open world games" such as FALLOUT 3, GTA V, or FINAL FANTASY XV. Although not at all compulsory for the genre, the freedom of play that is suggested by these open worlds – which

are frequently referred to as "sandboxes"[8] – often leads to "open-ended gameplay" (Domsch 2013, 72), i.e. the continued availability of play after the completion of the game's main quest line, or story. Accordingly, Domsch describes open world games as follows:

> Most actual cases do contain a narrative telos in that they set the player a number of tasks constituting a main quest, the completion of which equals a 'solving' or 'beating' of the game, but then allow the player to continue playing. In this case, there is simply put a possibly perfectly uni-linear narrative that is followed by the absence of a commanding objective.
>
> (Domsch 2013, 72)

Hence, games that leave their world open to explore in such a post-ending phase are geared towards perpetuating the enjoyment of the ergodic experience and that of generally being immersed in a fictional world, rather than providing additional information for strengthened closure (as is the case in some "serious" fake ending games) or offering narrative individualisation (as most games with multiple endings do).

Despite lacking the clear commanding objective of the previous main quest, the post-ending phase of an open world game usually offers many activities to the player apart from simply wandering around, such as finding and collecting items, defeating powerful enemies, and completing side quests, which might explicitly encourage one of the former. Beyond the purely paidic enjoyment of the still playable world, the implicit given goal is always that of completion, i.e. the exhaustion of all activities until all rewards are obtained, all item collections complete and no (given) challenges left. In Fassone's terms, the post-ending phase only allows the completist, horizontal mode of play and not the teleological, vertical mode (see Fassone 2017, 51; Chapter 2.2). Note that it would be false to conclude that completist play *replaces* teleological play after the ending of an open world game, as players usually can freely choose between both styles and pursue other activities besides the main quest throughout the entire playing process. Teleological play, however, is no longer possible in the post-ending phase beyond potential vertical progression through complex side quest lines.

Occasionally, games inspire completist play paratextually, for example, with a percentage indicating the progress of completion, both during and before the post-ending phase. METAL GEAR SOLID V: THE PHANTOM PAIN (Kojima Productions 2015) does this straightforwardly by displaying the percentage of "overall completion" in its main menu screen, while the "progress report" of NI NO KUNI is more hidden within its menu tree, but also more detailed (see Figure 4.4). To be sure, such documentation of completion is not at all unique to the open world genre. For example, the platformer SUPER MEAT BOY shows a progress percentage on the game's map screen, and the FPS DOOM (id Software 1993) even offers a more detailed

Figure 4.4 Detailed progress report of NI NO KUNI.

look at the degree of completion at the end of each level, separated into stats for kills, items, and secrets found. While the term "secrets" alone reveals that there can be optional tasks even in extremely linear games like DOOM II, what is unique about completist play and its encouragement in open world games is, precisely, that it is still available *after* finishing the linearly progressing main quest.

Most contemporary open world games with post-ending phases distinctly highlight the possible continuation of play. NI NO KUNI even prompts the message "Enjoy everything this world has to offer!" in place of the current objective after the story's completion. More importantly, however, the game adds "a range of post-completion features" (as highlighted in a meta-ludic message during the paratextual ending phase), i.e. new tasks and challenges as an incentive for post-ending play even for players who might have thoroughly pursued a completist goal before finishing the story. However, even with completion given as a goal as explicitly as in NI NO KUNI, exhausting the activities of an open world game does not produce any message-based framings that might trigger any further sense of an ending apart from the player's personal feelings of accomplishment and satisfaction. Upon achieving full completion, there is no accumulation of closural signals, and no final acknowledgement beyond, potentially, a paratextual gauge reaching 100%, or an achievement or trophy obtained in the metagame. Since related messages only appear in passing, i.e. without interrupting the playing process – as, for example, a credit roll would – the event triggering completion not only constitutes no ending, but it does not even cause a stop or cessation, as the program continues running and the world remains open to be used as a playground.

The more open a game world and the more diverse the activities that it offers, the more reasonable it is for a game to actively encourage completist play. Although "the paradigm of reading it all [...] still reigns" (Eskelinen 2012, 85) in both non-ergodic and ergodic media artefacts (here, Eskelinen refers to hyperfiction), the ludic frame essentially works against it:

> In literature, theater and film everything matters or is conventionally supposed to matter equally – if you've seen 90% of the presentation that's not enough, you have to see or read it all (or everything you can) because every part of the presentation carries irreducible expressive value that is at least potentially crucial for the spectator's or reader's interpretation of the work. [...] In contrast, in games some actions and reactions in relation to certain events and challenges will bring the player more quickly to a solution or help him reach the winning [...] situation sooner or more effectively than others. Therefore the player either can't or doesn't have to encounter every possible combinatory event and existent the game possibly contains or could generate [...] as these differ in their ergodic importance.
>
> (Eskelinen 2012, 278)

Hence, from a purely goal-oriented, ludic point of view, there is nothing like "missing" something in a game if the goal can still be achieved without it. In fact, even achieving full completion does not nearly equal the exhaustion of all the game's combinatory possibilities. Rather, their differences in ergodic importance result in a hierarchy of events and existents in digital games from a pool of minor ones that largely define the player's action space to major elements that will be encountered by each player of the game. In between lie all the events and existents related to optional goals that are encouraged, but not required to finish a game. By actively commending completion, digital games aim to present seemingly negligible content as worthwhile tasks even for players who prefer focused, teleological over broad, completist play.

Apart from encouraging play, the documentation of the completion progress in a game with a post-ending phase provides orientation for when to finally leave the game. Since the game world remains open and explorable even after exhausting all challenges, players without completion guidance might be uncertain about their progress and either lose interest early or continue playing in search for something that does not exist.[9] In open world games that do not keep explicit track of completion, the extent of a player's exploration of the game world might serve as an alternative indicator, since side quests and secrets are typically scattered throughout the world to reward spatial exploration in a genre that emphasises space even more than the medium generally does.[10] Even without any hidden quests, full spatial exploration can become a completist player's goal, as John-K. Adams describes in an anecdote about him marvelling at his son, who replayed a

game he had already finished, mainly to visit locations he had missed during his first playthrough (see Adams 1996, 201). Although a player's proactive completist approach is to distinguish from a game's encouragement of completist play, the difference often is merely gradual, as games differ strikingly in the level of detail with which they present remaining challenges and completion progress. Even if a single game does not explicitly encourage completion, medium conventions can easily induce players to assume this goal. Yet, with regard to closure, it is important to distinguish games that use representational strategies to actively encourage completion from those that do not. While neither the mere fact of full exploration of every nook and cranny of a game world nor the completion of all available challenges constitutes a closural signal, the explicit documentation of progress serves this function – at least rudimentarily and for the ludic mode, exclusively – if, for example, a percentage meter reaches 100.

It is worth noting that, ever since online features and digital distribution of games became common, completion has increasingly become a transient goal, not only in the open world genre. It is common practice by now to enhance a game with downloadable content (DLC) after its release. Usually, players need to actively acquire and pay for a story DLC, which is then distinctly marked as separate from the original game content as it takes place in a new setting and follows its own storyline, which is usually shorter than that of the main game but more extensive than conventional side quest lines (e.g. the DLC of BORDERLANDS 2 or FALLOUT 3). Most DLCs do not require players to finish the main quest line first but can be played anytime as soon as the content is installed.[11] Occasionally, new content is added automatically with free updates. While these are prone to include only minor changes and additions, they can still be relevant for completist interests.

Some games such as RAYMAN LEGENDS (Ubisoft 2013), METAL GEAR SOLID V, FINAL FANTASY XV, or MONSTER HUNTER: WORLD (Capcom 2018) even include events or quests that are only playable at certain dates, either just once, or (more commonly) as part of a recurring cycle. Either way, time-exclusive challenges are designed to long-term bind players to a game, changing the typically end-oriented singleplayer experience into a habitual ergodic practice, at least if players take the bait. As an incentive to participate in timed events, there are rewards which are otherwise unobtainable. For example, in FINAL FANTASY XV players get a certain amount of "Quest Points" for each successfully finished "Timed Quest", which can be accumulated and exchanged for special items.

Open worlds and narrative closure

The ludic openness of the post-ending phase can have negative repercussions on any established narrative sense of an ending, since the fact that "the end of the main objective does not provide gameplay closure potentially echo[es] the fact that no narrative closure is ever completely final"

(Domsch 2013, 72). Because open world games usually do provide teleological stories as their main quest, the question remains of how the continuation of play after reaching the goal relates to the story. Presumably, it seems most likely that the storyworld simply moves on after the narrative finale, yet with no more drastic changes to come. Although side quests, including those that are activated after the ending, are usually framed narratively, they affect only small parts of the storyworld, if they have a lasting effect at all. Thus, the ludic mode clearly dominates the post-ending phase, even if it is framed as a narratively coherent continuation of the storyworld.

Yet, the predominance of the ludic is even more striking if the post-ending phase causes ludonarrative dissonance, as in, for example, FINAL FANTASY XV or NI NO KUNI. Exemplifying a quite common design strategy, both games set their post-ending phase narratively *before* the finale, while maintaining all ludic progress players made during the ending such as experience points and items collected.[12] Observing the same strategy in FINAL FANTASY XIII (Square Enix Product Development Division 1, 2010), Domsch concludes that with allowing this kind of ludonarrative dissonance "the game switches modes in a way that cannot but devalue the striving for closure" (Domsch 2013, 74). However, according to the principle of "medium-specific charity" (Thon 2016, 106), with which players typically handle even severe occasions of ludonarrative dissonance (by recognising them as conventions of the medium), the post-ending phase is most likely to be recognised as a predominantly ludic segment of the game that does not affect or directly relate to its narrative segments, which are accepted as finished with the end of the main quest line. Hence, medium-specific charity allows players to prescind the ludic from the narrative mode, if necessary, to preserve a narratively established sense of an ending despite the ludic openness of a post-ending phase.

In the case of both FINAL FANTASY XIII and XV, the narrative leap backwards is almost a necessity to continue, as main characters die during the finale, including the avatar himself in FINAL FANTASY XV. RED DEAD REDEMPTION, in contrast, demonstrates that even the protagonist's death can be handled in a narratively coherent way for the continuation of post-ending play by changing the avatar from gunslinger John Marston to his son Jack – after leaping forward in time for Jack to be old enough to fully follow in his father's footsteps, both metaphorically and to guarantee coherence of avatar-related gameplay features (see Chapter 3.4). Domsch refers to this and other examples as games that "have started to reflect more successfully on the significance of narrative closure and continuation" (Domsch 2013, 74). While there certainly is some truth to this, RED DEAD REDEMPTION does not simply avoid ludonarrative dissonance to sustain closure, but unconventionally postpones a significant part of its sense of an ending to the post-ending phase.

Several factors contribute to the denial of full closure in the game's finale. On the one hand, players are prone to be dissatisfied with the impossibility

of winning the final ludic encounter against an outnumbering enemy force, which inevitably results in the tragic outcome of a story that seemed to have been resolved happily when John Marston was reunited with his family, only to be killed shortly after. Although these negative aspects of the finale contradict medium conventions, they do not generally obstruct the sense of an ending, as tragic protagonist death is a traditional closural convention in a range of media. More importantly, on the other hand, the game's finale denies closure by the absence of paratextual closural signals. These are provided belatedly with the completion of the post-ending quest "Remember My Family", in which Jack avenges his father's death. Before a (skippable) credit roll, finishing the mission triggers a display of the game's logo, together with a freeze-frame close-up of Jack's sternly resolved face, thus providing both paratextual and audiovisual closural signals in the final frame (see Figure 4.5). By interweaving conventional ending phases and post-ending content in such a way, RED DEAD REDEMPTION adds a narrative motivation to the game's continuation, softly leading over from teleological to completist play. Although its post-ending phase is, thus, narratively coherent, there is still a (less common) form of ludonarrative dissonance in this dragged-out ending of RED DEAD REDEMPTION in the mismatch between narrative and ludic importance of the quest: Although "Remember My Family" completes the story's closure, it is merely presented as a side mission (as can be inferred from visual signals such as the purple question mark designating the location of the mission objective), matching the convention that post-ending phases do not include main quests.

The post-ending phase of FALLOUT 3, another example that involves avatar death, takes yet another approach. FALLOUT 3 is remarkable for being an open world game that originally had no post-ending phase, but was

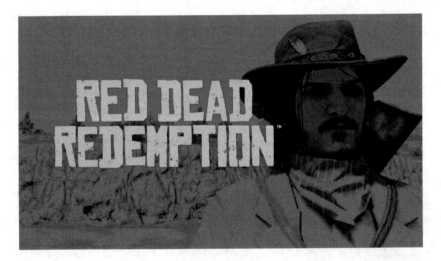

Figure 4.5 RED DEAD REDEMPTION, end title.

opened with the addition of its third DLC, titled Broken Steel (Bethesda Game Studios 2009), which amended the main quest line and added further side quests as well as a range of other additional features. The DLC and its repercussions on both the game's story and playability are, thus, suited for an in-depth discussion of the relation of openness and endings.

The open world roleplaying game (RPG) is set in a post-apocalyptic future that is suffering from the effects of nuclear war. Its customisable protagonist roams this wasteland in search for their father, ultimately learning of his dream to provide the land with purified water. Originally, Fallout 3 ended with the final mission to activate the Purifier that cleans water from radiation after the father gave his life for the cause. Yet, recent events turned the facility's activation into a deadly task, which players can either bestow on an accompanying non-playing character (NPC) or perform with their own avatar. The choice is morally evaluated by the narrator in the final cutscene, who either praises the protagonist for their selfless sacrifice, or condemns their cowardice for not performing the action themselves.[13] Beyond rendering the protagonist as morally good, the self-sacrifice option also has higher narrative impact as it marks the fulfilment of the father's dream and constitutes a conventional closural signal. On the ludic level, the choice has no consequence as the game stops either way after the final narrative cutscene and the ensuing credit roll. Without any meta-ludic messages – such as a post-completion save option, which is conventional in more recent open world games – Fallout 3, originally, simply leaves players at this point, leading them back to the main menu.

The addition of the DLC Broken Steel distinctly alters the ending's closural effect.[14] The only actual change of the ending itself is the lack of credits after the final cutscene. Given the conventional closural power of the paratextual ending phase, this removal significantly lowers the sequence's sense of an ending. Arguably, the effect is even stronger than in the example of Red Dead Redemption, because the lack of paratextual closure is even more striking in comparison to its inclusion in the original ending. The only paratext given is a clear signal of the story's continuation: an intertitle announcing a narrative time gap of two weeks after which the avatar wakes up again. The following dialogue with a familiar NPC reveals that, against all odds, the protagonist did not die while activating the Purifier, but merely fell into a state of coma.[15]

In general, narrative continuity is emphasised throughout the contents of Broken Steel, as the DLC's main quest line directly relates to the story of the main game, and players can observe the effects of purified water being spread across the world. The latter include the effects of another choice made in the finale to either complete or ignore the mission of a dubious quest giver, who wishes to poison the water with a virus that would kill all mutated and contaminated creatures and people of the wasteland to purge the fallout's survivors. In the original version, this choice, again, only affects the moral evaluation by the narrator in the final cutscene. In the DLC's

post-ending phase, players who chose the water's contamination will repeatedly encounter mutated people badly suffering from the virus. Despite all these effects, BROKEN STEEL is not an exclusively narrative enhancement, as most narrative elements are ultimately tied to ludic features, such as quests, while other additional features have no narrative bearings at all. In a telling detail, the ludic freedom of the post-ending phase is highlighted narratively in the dialogue that occurs at its beginning: If the player chooses to ask: "So what happens now?", the NPC replies with "Well, that's really up to you, isn't it?" Even the DLC's main quest is, hence, narratively framed as an optional course of action. In conclusion, just like the main game and the four other DLC for FALLOUT 3 (MOTHERSHIP ZETA [2009], OPERATION: ANCHORAGE [2009], THE PITT [2009], and POINT LOOKOUT [2009]), BROKEN STEEL upholds an overall fair balance of narrative and ludic mode, while it is remarkable for being the only enhancement with a fixed relation to the original game's main storyline and its ending.

Yet, although BROKEN STEEL withdraws part of the ending's original closural effect by removing the paratextual phase and (potentially) annulling the protagonist's self-sacrifice, it does not compensate for this reduction of closure at its own completion. While the end of the DLC's main quest does provide many closural signals – including a spectacular orbital missile strike – there is no further non-ergodic cutscene as in the game's beginning and original ending, nor a credit roll, which is, hence, never triggered in the game itself with the addition of BROKEN STEEL. Thus, despite being a rather uncommonly close and coherent follow-up to the game's main story, the post-ending phase provided by BROKEN STEEL remains conventionally focused on completist, rather than teleological play – not least because it allows the player to complete any unfinished side quests beyond those added with the DLC. However, the previous reduction of a sense of an ending leaves the game in a narratively more open state than is usually the case for an open world game. While the story of the Lone Wanderer, as the protagonist of FALLOUT 3 is called by the narrator, seems to have been closed in the main game, the DLC ultimately acts against this prototypical narrative closure, highlighting the arbitrariness of the ending in terms of content.

In the wide range of potentially narrative media, it is not uncommon that seemingly closed stories are continued, or that a protagonist whose fate seemed to have been settled reappears (as is famously the case with the return of Sherlock Holmes after his death). However, this strategy usually involves serialisation, i.e. the story is continued in a sequel that is a self-contained media artefact, autonomous in all matters apart from those of content. As DLC are always enhancements which technologically depend on the original game to be playable, examples like BROKEN STEEL appear as another form of continuation that is still a step away from serialisation.[16] Moreover, even if (unexpected) narrative serialisation retrospectively diminishes the closural effect of an antecedent media artefact's ending, it bears no material effect on this ending.[17] In contrast, the

enhanced version of FALLOUT 3 actually takes away closural signals such as the credit roll.

Strictly speaking, there usually is no pluralisation of endings in open world games with post-ending phases, at least not in a narrative sense. While they provide maximum ludic openness, their stories typically still conform to the Aristotelian structure. Yet, a post-ending phase inevitably diminishes the sense of an ending of the game in its hybrid entirety. The diminishing effect increases if the post-ending phase is distinctly narrativised, preventing a ludonarrative dissonance that would call for the application of medium-specific charity. Furthermore, post-ending phases entail ending pluralisation in a broader sense, i.e. if completion is acknowledged as a predominantly ludic form of ending, marked by closural signals like percentage gauges and detailed completion reports. In this sense, rather than a separation of ludic and narrative closure, there is a pluralisation of ludic endings, exclusively, although the ending provided by full completion differs strikingly from what has been discussed as the ludic finale in Chapter 3.3. The following section will, instead, examine a form of ending pluralisation in digital games that conforms to its strict narrative meaning.

4.3 Parallel potentialities – Multiple endings in digital games

Narrative branching and player agency

The most obvious and most common form of pluralisation of endings in digital games is the implementation of multiple endings, which can transmedially be defined as several segments that evoke the sense of an ending within one media artefact which act as alternatives to each other. While games prototypically feature variable outcome, only "differences in final states that are narratively relevant" (Domsch 2013, 77) constitute multiple endings in digital games that have both ludic and narrative characteristics. Hence, multiple endings imply narrative branching and are mostly limited to a variation of the narrative finale, although ludic variation occasionally accompanies it. The different forms of multiple endings, their functions, (hierarchical) structures, as well as the representational strategies and design principles by which they are constructed will be discussed subsequently.

While any narrative situation is generally indeterminate and open to be continued in various ways, prototypically "the working out of plot [...] is a process of declining possibility. The choices become more and more limited, and the final choice seems not a choice at all, but an inevitability" (Chatman 1978, 46). Although such sense of inevitability is surely an extreme case of strong closure, which even the most conventional and traditional narrative media artefacts rarely provide, the subsequent narrowing down of possibilities marks an important difference between unilinear and branching, multilinear stories. Strictly distinguishing between the two types of narrative, Bode defines the "minimal units" of "Future Narratives"

(i.e. media artefacts with narrative branching in his terminology) as "nodal situations" or, in short, "nodes", which differ from events, the minimal unit of "Past Narratives" (i.e. unilinear narrative structures) (see Bode and Dietrich 2013, 1f. and 16f.). A node is a point at which branching occurs, a "situation that allows for more than one continuation" (Bode and Dietrich 2013, 1) in a factual, not abstract sense, i.e. "from the nodal situation, each of these mutually exclusive states is possible to be actualized" because the aspects of "potentiality, openness or indeterminacy [...] are actually present in a nodal situation, they are staged by the structure of the narrative" (Domsch 2013, 1). Although Bode's concept of Future Narratives may have its flaws (which cannot be broached here), this ontological difference of potential branching situations in unilinear and multilinear narrative artefacts cannot be overestimated, at least not if the focus of analysis is on the intra-compositional features of media artefacts such as in this study. Therefore, I will review the implied differences in more detail.

In unilinear media artefacts, the different possible continuations of a narrative situation are merely conjectural, as only one of the options is found in the text itself, while the recipient is still free to imagine any other kind of continuation. In multilinear artefacts, multiple options are integrated, yet with a difference between artefacts that allow user agency (ergodic artefacts) and those that do not. In non-ergodic media artefacts like RUN LOLA RUN or *The French Lieutenant's Woman*, different continuations of the same situation are presented in succession. They are all actualised within the media artefact and will all be encountered in a conventional reception process. In an ergodic media artefact, users choose (intentionally or unintentionally) which option to actualise in their individual reception or playing process. Yet, users do not *create* the chosen continuation, but select it from a given range of options, which are, hence, each part of the actual media artefact. For example, a player of BASTION can choose to activate the Bastion to either undo the Calamity or depart from the known world, but they cannot make the protagonist commit suicide or any other conceivable continuation of the situation at the game's end. While recipients are still free to imagine any other continuation, these conjectural options are irrelevant for structural analysis.

The potential of agency has prompted doubts about the narrative identity of the stories of a game that noticeably differ with each individual playthrough "depending on player decisions, gameplay performance, and comparable parameters" (Thon 2016, 117; see also Backe 2008, 355). Although it would be preposterous to deny the differences of the actualised stories of an ergodic, multilinear narrative artefact, they are still all based on a common ground that contributes to the media artefact's identity. Backe notes that the variations between different playthroughs are usually severely limited on the level of story, so that a basic narrative identity is still given (see Backe 2008, 355). Even if this was not the case, the game system itself ensures at least "a machinic identity, as cybertexts [to which narrative digital

games belong; MH] are machines for producing variety of expressions" (Eskelinen 2012, 70).[18] In the closer context of multilinear narrative arte-facts, Bode formalises the vague idea of identity in a way useful for analysis by distinguishing "between the objective structure of a FN [i.e., Future Narrative] – its *architecture* – on the one hand and any concrete and par-ticular path or *run* through that structure on the other" (Bode and Dietrich 2013, 19). As long as the game's code is not modified, both its ludic and narrative architecture are the same for each playthrough. In contrast, each run differs, either just on the ludic level of player actions without narrative consequences or concerning the development and outcome of the story, de-pending on which kinds of agency the game allows. Note that *architecture* and *run* are generally transmedial terms, although they are most useful for ergodic media artefacts, because

> [i]f the FN does not provide any agency [...], the protocol (the way that the run looks) will not differ from the way that the architecture looks. This is, for example, the case in films or novels with multiple endings that necessarily show all of their endings
>
> (Domsch 2013, 49).

With reference to games, it is important to note that not any type of player agency causes branching, or, in Bode's terms, qualifies a choice as a nodal situation. Games often allow a situation to be solved or overcome by vari-ous means (e.g. many contemporary RPGs allow to finish a quest in a vio-lent or a non-violent way) or in even just slightly different ways (e.g. a player of SUPER MARIO BROS. might defeat an enemy by jumping on it or by shooting it with a fireball), while all successful action sequences still lead to the same result (e.g. obtaining the quest reward or points for defeating the enemy). Even if the actions performed do result in different ludic outcomes (e.g. the reward for a quest might differ depending on the means used to complete it), this is not considered branching, as the term refers to narrative consequences alone. However, this narrative exclusiveness does not at all mean that multiple endings are ludically irrelevant – quite the contrary, as the upcoming discussion of strategies to integrate multiple endings in digi-tal games and of their functions will show.

It should also be noted that branching does not necessarily result in multiple endings. In *Narrative as Virtual Reality*, Marie-Laure Ryan doc-uments the variety of narrative structures in non-unilinear artefacts (see Ryan 2001b, 246–58). Although her presentation focuses on how users can traverse the text (rather than the plain narrative architecture) and the nodes pictured by her do not always symbolise narrative branching in Bode's sense, it seems worth noting because her diagrams demonstrate the ending variety of non-unilinear structures that ranges from one, to multiple, to no endpoints at all. Similarly, not all digital games that advertise narrative choice as one of their features include multiple endings. First, genuinely

open-ended games, such as the simulation games of the SIMS series, might focus their narrative level on the player's individualised characters and their development. Although the lack of an intracompositional story sets severe limits to the possibility of meaningful narrative choice in this kind of game, the overall low narrativity results in a potentially significant impact of any action within the confined space of the game and the player's individual interpretation of its rudimentary narrative framings. Second, just as is the case with different gameplay options that lead to the same ludic outcome, narrative branches can be reunited at a "point of convergence", so that "all lead to the same final state or ending" (Domsch 2013, 77). For example, although THE WALKING DEAD starts with the promising paratextual message "This game series adapts to the choices you make. The story is tailored by how you play", there is, arguably, only one ending. Due to the game's narrative bottleneck structure, previously made choices bear no consequence on its finale, and even the final choice – to make Clementine shoot protagonist Lee or let him turn into a zombie – fails to make a difference at the final narrative state because, either way, Lee is lost (dead or undead), and Clementine wanders the post-apocalyptic world alone in a post-credits scene.

Points of convergence are a double-edged sword, since they facilitate the game's design at the potential expense of the player's feeling of agency and narrative impact. In Ryan's words,

> [t]his architecture prevents the combinatorial explosion of the tree-shaped diagram [i.e., the potentially exponential growth of the number of endings with every choice, MH], but when the choices occur in the middle exclusively, it trivializes the consequences of the user's decisions
> (Ryan 2001b, 252).

Domsch similarly notes that "[a] complete point of convergence effectively functions as a negation of multilinearity, since it neutralises the consequence (in the sense of a variation of outcomes) of earlier choices" (Domsch 2013, 79). Indeed, frustration and the feeling of being tricked by game developers – especially in cases of overt advertising of consequential narrative choice such as in THE WALKING DEAD – often seem to dominate public discourse about games with bottleneck structures. Yet, it would be wrong to jump to the conclusion that all choices before a point of convergence are insignificant. For example, the moral weight of a choice alone can be more relevant than its actual narrative consequences (see Schmidt 2017, 227–9), and, fundamentally, each choice becomes part of the individual playing process, "procedurally entering and changing the narration and the playing experience as well as [...] the tone of the narration" (Unterhuber and Schellong 2016, 26, my translation from the German). Hence, even though the outcome of bottleneck-structured games with a single ending appears to be the same for each player, the protocols of the individual runs would show different narrative representations.

Usually, games try to disguise their narrative bottlenecks, or at least to avoid any narrative incoherence at the point of convergence, by plausibly rendering it inevitable within the greater context of the storyworld, or even unquestionably desirable for the avatar (see Sallge 2010, 96). Thus, players ideally do not even notice the factual narrative inconsequence of their choices, since what matters, cognitively, is not agency itself, but the perpetuated illusion of it (see e.g. Backe 2008, 397; Bryan 2013, 8–18). While "[t]he expectation of consequence is what keeps players motivated to make choices", the procedural nature of digital games enables them to "withhold clear information about consequences" (Domsch 2013, 137). Hence, "the ratio of actual consequence and experienced potentiality can vary dramatically. By far the most common occurrence in video games is the attempt to merely create the illusion of agency" (Domsch 2013, 140). Bode calls situations that evoke a false sense of agency "mock nodes" or "pseudo nodes", which present different options that have identical consequences, so that no actual branching occurs (see Bode and Dietrich 2013, 49f.). However, such "arbitrary choice opportunities [...] only function toward agency once" (Bryan 2013, 14), i.e. the strategy of illusion fails if players choose to test the consequences of their actions by replaying the game, or parts of it, to make different decisions.

Although the actual existence of different outcomes in a game's architecture is, clearly, required to speak of multiple endings, it is not reversely true that multiple endings are essential for giving the impression of meaningful choice in a digital game. In fact, even games that branch into multiple endings after a point of convergence are not exempt from being accused of a "lack of substantial consequence" as is shown by the example of the MASS EFFECT trilogy, which "became the poster child for this sort of [feigned, MH] dramatic agency" (Bryan 2013, 11). Although the final choice in MASS EFFECT 3 entails major consequences for the storyworld, the different endings were broadly perceived as "a few banal options, each of which result in what is effectively the same conclusion, differentiated by recolored visual effects" (Bryan 2013, 11). Before I further elaborate on the reasons for this effect, it is necessary to understand how multiple endings are implemented in digital games in the first place. Thus, to properly identify the consequentiality of player agency and the functions of multiple endings in digital games, the following section will discuss the means by which players can influence narrative outcome, and how the program determines which one of a range of alternatives to present in an individual playthrough.

On the path to multiple endings – Choice and consequence

For players, it can be difficult to assess agency, i.e. the actual consequentiality of player actions. On the one hand, they can only ever choose one option at a time, so that testing out consequences requires additional effort, the amount of which mainly depends on the design of the game's save and

load options. On the other hand, moments of choice are not always apparent and consequences not always immediate. While apparency describes an effect on players, namely their cognitive response to a choice situation, immediacy or prolongation of consequences relates, first and foremost, to the game system itself. Typically, if not inevitably, if consequences occur immediately after the node, the moment of choice itself is also apparent to the player, and vice versa.

Digital games owe their potential to obscure and prolong consequences to their procedurality, which allows temporal flexibility when effectuating user input. Backe describes this property of the medium in a technical manner:

> Digital games possess selectors, which are bound to locations, points in time, events or player decisions; if a selector is triggered by the bound element, there is either an output of previously stored information, or new information is being stored.
>
> (Backe 2008, 373, my translation from the German)

Regarding narrative branching, he concludes that there are, hence, immediate branching, in which selection and branching occur at the same moment, and "effect structures", in which selection and branching occur separately (see Backe 2008, 373). With a particular focus on endings, Domsch similarly distinguishes between multiple endings that are based on a "last minute decision", in which "there is a rather obvious choice situation close to the end of the game", and "passive multiple endings" that follow "long-term consequences", i.e. "decisions throughout the gameplay will (sometimes covertly) influence which of the possible endings the player will reach" (Domsch 2013, 77). Domsch's rather unfortunate use of the term "passive" for the latter refers to the fact that the choices leading to long-term consequences are often not perceived as such, as either their range of influence or even the nodal situation itself is obscured, so that "the change to the gameworld is not reflected in the presentation of the gameworld for an extended amount of time" (Domsch 2013, 77).

The low perceptibility of "prolonged causality" or "substructural decision-making", as the phenomenon is alternatively termed (see Ascher 2016, 46 Baumgartner 2016, 253), certainly partakes in its marginalisation in discourse about digital games among both players and academics (see Baumgartner 2016, 253f.). Obscured choices are also less commonly used for the integration of multiple endings in digital games, although it should be noted that a single game can include different types of choices. For example, FALLOUT 3 combines the outcome of two final choices with a range of prolonged consequences for its ending sequence, and METRO 2033 offers its final choice only as a prolonged consequence of previous obscured choices.[19] Furthermore, player awareness or the apparency of a nodal situation is not directly linked to the temporal distance of choice

and consequence, as choices with immediate consequences can be covert just as choices with prolonged consequences can be overt.[20] While player awareness itself – being an individual cognitive state – cannot be appropriately assessed in a study focusing on intracompositional aspects of media artefacts, it is still possible to identify representational strategies used to make a choice more or less discernible on a spectrum of fully transparent to fully obscured.

Examples that use prolonged consequences for the choice of ending include SILENT HILL 2, BIOSHOCK (2K Boston and 2K Australia 2007), S.T.A.L.K.E.R.: SHADOW OF CHERNOBYL, FALLOUT 3, METRO 2033, and CATHERINE, which vary considerably in types of player actions bearing consequences for the ending, number of choices being made throughout the game, apparency of choice situations, narrative impact of consequences, and number of available endings. These factors are strongly interrelated, as, for example, the type of action affects the choice's degree of obscurity. They can be divided into aspects related to the design of the actions with influence on the narrative outcome, and aspects related to the ending itself. To begin with, the following section will primarily address the former.

Out of the given examples, the simplest approach of integrating prolonged consequences on a game's ending is taken by BIOSHOCK and CATHERINE. Both games include a highly limited range and number of player actions to affect the ending, whilst maintaining a relatively high degree of transparency in choice situations. BIOSHOCK even employs only one type of player action to determine its ending: the player's decision to either "harvest" (i.e. in consequence, kill) or "rescue" the so-called "Little Sisters", sinister-looking, genetically modified girls whose purpose it is to collect energy from corpses, which the avatar can, in turn, harvest from them. Although its consequences on the game's ending are obscured, the choice situation itself and its immediate consequences – either obtaining gameplay relevant energy or not – are obvious: The game is paused as the options are presented to the player and the pitiful creature cowers in visible fear before them, strongly implying a morally right way of choosing (see Figure 4.6). In total, there are 21 Little Sisters in the game, so that there is a fixed maximum number of choices, although players do not automatically encounter all of them. Yet, finding all Little Sisters is necessary in order to obtain either the best or the worst ending, since they require all of the girls being rescued or harvested, respectively.[21] The game helps players towards this cause by marking the current location of any Little Sister on the map, thus further decreasing the choice's overall degree of obscurity.

The actions with prolonged consequences in CATHERINE are slightly more varied than those in BIOSHOCK; yet they are simultaneously more restricted as players automatically encounter all of them in each playthrough. The game's ending is determined by a combination of three final choices and a moral evaluation that results from up to 114 decisions during the game with two or three options each, divided into 86 nightly confessionals

Figure 4.6 BIOSHOCK, harvest or rescue a Little Sister.

in the protagonist's dreams, and his replies to up to 28 text messages.[22] Just as in BIOSHOCK, nodes are obvious, and the game will only move on once the choice is made. At first glance, CATHERINE seems to be an example of immediate consequences since each choice is directly followed by the reaction of a morality meter moving into the direction of devil or angel. Yet, this is but a visual communication of the decision's effect on the information stored by the program to be evaluated for the later choice of ending. While the meter, thus, gives valuable feedback to players by facilitating control over the avatar's moral development, there are no immediate consequences and the story unfolds in exactly the same way until the total sum of all choices determines the ending.

Like CATHERINE, both FALLOUT 3 and METRO 2033 bind the game's outcome to a moral evaluation, based on the sum of negative and positive morality or Karma points that players accumulate throughout the game. Yet, they include a considerably larger variety and number of actions, which are often optional, such as stealing or helping NPCs in need. In METRO 2033, not least due to the first-person shooter's linear progression structure, all potentially relevant actions are predefined and, hence, fixed in number. In contrast, the open world of FALLOUT 3 makes little restrictions on how often players can get into a potentially morally relevant situation, so that the number of actions determining the ending is, technically, indefinite. The degree of obscurity of an action's moral effect differs slightly between both games, as well as between different types of actions within them. Generally, narrative context is reliable to form expectations about positive or negative effects. For example, when the player is asked by different characters to either disarm or detonate the dormant atomic bomb in the town Megaton near the beginning

of FALLOUT 3 – either saving the population from the danger of explosion or intentionally wiping out their lives in the blink of an eye – the respective effect on the avatar's Karma level is quite expectable. FALLOUT 3 also clearly communicates moral effects after and potentially even prior to an action: While good and evil actions trigger a message about the effect on the avatar's Karma accompanied by a distinct sound (see Figure 4.7), the game also highlights potential loss of Karma for some actions, such as stealing, as the HUD signals the possible action in red instead of the usual blue-green.

METRO 2033 is less transparent, both with regard to an action's expectable consequences on the morality score and to the communication of these consequences as well as the morality system itself. Relevant actions range from obvious choice situations – e.g. donating ammunition (the game's currency) to a poor NPC – to vague actions of showing attention and, arguably, caring for the avatar's environment, e.g. by touching the guitar in his room or listening to conversations. If an action led to an increase in morality, this is signalled by a dripping sound and a brief flash of light, which are both distinct and easily recognisable as soon as players are familiar with them; yet neither are these explained nor are they particularly striking within the setting. This obscure strategy matches the game's overall high degree of representational realism that facilitates immersion by, for example, avoiding a conventional HUD.

Further up the scale of obscurity there are S.T.A.L.K.E.R. and SILENT HILL 2, which differ in their approach of implementing prolonged consequences: S.T.A.L.K.E.R resembles FALLOUT 3 in that the number of actions influencing the avatar's reputation is virtually limitless, and the current state of reputation (ranging from "terrible" to "excellent") is transparent, as it is accessible in a menu screen. Yet, it is not clearly communicated which actions influence the level of reputation, besides what can be inferred

Figure 4.7 FALLOUT 3, messages signalling moral effect of player action.

from context (e.g. completing or failing a mission raises and lowers reputation, respectively). Moreover, the prolonged consequences on the endings of S.T.A.L.K.E.R. are not limited to reputation, but also factor the avatar's accumulated wealth, the survival of two important characters, and a certain optional quest line. Apart from the latter's narrative context, the game gives no information at all about the potential effects of these factors on its ending. This is what S.T.A.L.K.E.R. fundamentally has in common with SILENT HILL 2, which involves both an indefinite number of player actions counting towards the narrative outcome and the complete obscurity of these actions' effects, including the mere fact that they do influence the ending.

Other than many of the aforementioned examples, SILENT HILL 2 does not employ any morality system. Instead, certain actions add or subtract points to the individual score of all ending options, tracked in secret by the program. Hence, each action only counts for one ending, and the one with the highest score is shown after the ludic finale. Among the factors influencing the ending scores is one that even reaches beyond the individual playthrough, as points are added depending on which endings were previously unlocked. This leans towards Bode's type of extradiegetic "preparatory nodes", i.e. consequential choices that are made outside the actual playing process (see Bode and Dietrich 2013, 50). Mostly, however, the ending scores of SILENT HILL 2 are affected during play, by actions which might not even suggest themselves to the player. For example, checking the photograph of avatar James' deceased wife Mary in the inventory affects the score, as does going into the wrong direction for an extended amount of time at certain parts of the game, taking a closer look at writings on the wall and certain items, "over-healing" the avatar (i.e. using more health items than necessary) or, conversely, keeping his health dangerously low for an extended amount of time. Remarkably, there is narrative meaning behind which action influences which ending of SILENT HILL 2 and in which way. For example, the player can choose to treat the protagonist's temporary companion Maria either particularly well (e.g. by protecting her from monsters or trying to speak to her repeatedly) or particularly bad (e.g. by trying to attack her), respectively, influencing the score of the "Maria" ending, in which James and Maria leave the town of Silent Hill together.

Yet, the narrative meaning of such influential actions in SILENT HILL 2 is not as obvious as, for example, the moral choices in previous examples, and their consequentiality is completely obscured. Especially actions with direct ludic consequences such as keeping the avatar at low health – which might be the result of a lack of resources rather than intentional – are hardly perceived as narratively relevant. However, the consequence of this action (or, rather, lack of the action to heal) shows a remarkable example of ludonarrative synergy, as it adds points to the ending in which James commits suicide. As trauma, denial, and mental instability are central narrative themes of the game, it is only fitting that the player's intentions – which one

might be inclined to translate as the protagonist's intentions in terms of player and avatar identification – are secondary to the action's effects: Just as James is in denial of the circumstances of his wife's death, he – and, by extension, the player – is not fully in control of his actions and their consequences. In conclusion, the strategy of total obscurity of choice situations with prolonged consequences in SILENT HILL 2 reflects the game's dark and mysterious narrative layer, since the player's narrative influence is as much rooted in uncertainty and disorientation as the protagonist's behaviour throughout the game.

Although making sense in the narrative context of the game, the prolongation of consequences and obscurity of choice in both S.T.A.L.K.E.R. and SILENT HILL 2 perfectly demonstrate how this type of organising narrative branching is "virtually the antithesis to the concept of agency" (Baumgartner 2016, 260, my translation from the German). Just as a sense of agency can be feigned by a game, the concealment of choices and delay of consequences can completely undermine any sense of agency and even make an ending seem completely arbitrary (see Baumgartner 2016, 254f.): "[S]ince the effect of a decision is so far removed, it might not even feel like a relevant decision at all" (Domsch 2013, 147). At least in the final part of its paratextual ending phase, SILENT HILL 2 compensates for a lack of perceptible agency by highlighting the existence of its multiple endings on the evaluation screen, which reveals the title of the ending just obtained, and even the number of endings cleared out of a maximum of four. As Baumgartner concludes, it is not surprising that prolonged consequences are rare and, hence, unconventional, because, although they can be "intellectually stimulating", they are "diametrically opposed to the conventionalised perception of the digital game as an instrument of satisfying self-empowerment" (Baumgartner 2016, 269, my translation from the German).

Depending on the employed design strategy, however, prolonged causality does not necessarily counteract a sense of agency, as the previous examples have shown. Compared to choices with immediate consequences, it can positively affect the meaning of decisions "because they cannot simply be undone at will and the player has to accept the consequences of their actions" (Ascher 2016, 46, my translation from the German). In contrast to non-digital games, which rely on the players' attentiveness and willingness to always adhere to the rules, the computer's procedurality ensures that consequences are invariably executed by the game itself. Yet, digital game conventions, which include flexible re-entry for repeating previously played sequences, also render consequences reversible. Within the resulting process of the medium "constantly negotiating between enforcing and reducing consequence" (Domsch 2013, 141), the deliberate obscurity of nodal situations clearly contributes to the former, since

> [b]y the time that the consequences manifest themselves, the player will have already invested too much gameplay effort to be willing to return

to the initial decision with the help of an earlier savegame, but will
instead accept the consequences

(Domsch 2013, 147).

Player acceptance is, thus, more likely, the higher the uncertainty about a
choice's consequences and the longer the temporal delay between cause and
effect. One narrative purpose of this design strategy, which could negatively
be labelled as coercive and manipulative, is to prevent players from deliber-
ately following a path of pure success in games that attempt to convey mor-
ally nuanced storyworlds, breaking the cliché of the avatar as the perfect
knight in shining armour (see Domsch 2013, 147).

Another aspect of limiting player control while still allowing for nar-
rative branching concerns the specificity of information about the nodal
situation and expectable consequences (see Bode and Dietrich 2013, 49).
Basic information about the existence of several options to continue is the
prerequisite for player awareness of a node that enables "informed (or con-
scious) choice" (Domsch 2013, 113). With increasing specificity of informa-
tion, the nodal situation is increasingly more likely to enable a "motivated
choice" (Domsch 2013, 113). Hence, "[a] motivated choice must also be a
conscious choice, but not vice versa" (Domsch 2013, 113). In a similar con-
text, Ryan distinguishes between "random selective interactivity", in which
the user is aware of the choice without knowing which outcome to expect,
and "purposeful selective interactivity", in which the user chooses the out-
come from several given alternatives (see Ryan 2001b, 205). To illustrate
the concepts with an example, imagine a player encountering a fork on a
previously unilinear path. The mere existence of the options to go left or
right suffices to make the situation a conscious choice. Yet, without any fur-
ther information on where the paths lead, the choice cannot be motivated,
and only random selection is possible. In contrast, the first forking path
situation in THE STANLEY PARABLE, where players choose to take the left or
the right door, qualifies as a motivated choice, since the narrator instructs
the player to take the left door. Thus, the selection becomes purposeful,
both because players know (or believe to know) what can be expected at
the end of at least one of the paths (i.e. the meeting room Stanley should be
heading to) and because of the choice's additional meaning of either obey-
ing or rebelling against the narrator's instructions.

Somewhat unfortunately, Domsch ties his category of motivated choice
to the prerequisite that "one outcome must [...] be valorised higher than at
least one other" (Domsch 2013, 114). While he concedes that "[i]n normal
life, the valorisation, if it is in fact motivating, is always ultimately based
on some emotional preference" (Domsch 2013, 114), he does not grant a
similar subjective potential to choice in digital games. Although he sup-
plies a detailed and nuanced discussion of moral and ethical applications
of "valorisation rules" – i.e. the rules that determine which outcome of
a game is desirable – he fails to mention games that employ purposeful

selective interactivity without any clear valorisation. Games like this either present complex ethical problems and refuse to present their options as distinctly morally right or wrong, or a choice's consequences are, in fact, only relevant to the player's personal preferences. Such refusal of giving valorisation can, arguably, be found in the following examples, which also demonstrate that narratively purposeful selective interactivity is common in final choices with immediate consequences on the ending, in contrast to games that rather employ prolonged consequences.

In the case of final choices, the game or characters in it usually paraphrase and assess the expectable consequences of the given options beforehand. For example, before the final choice of LIFE IS STRANGE, protagonist Max and her best friend Chloe discuss Max's options to either sacrifice Chloe's life or let her hometown Arcadia Bay (and the people living there) be destroyed in a storm. Similarly, the NPCs Rucks and Zia in BASTION give their own opinion on the final choice's options, i.e. either activate the Bastion to reset time in order to retroactively prevent the known world's destruction, or use it as a vessel to leave the ruined land and move on. Both games briefly summarise the expected consequences at the moment of choice (see Figure 4.8). The information clearly enables a purposeful choice; yet there is no distinct valorisation of the outcomes other than ethical principles or the player's personal preferences. A more nuanced choice is offered by the four options given in DEUS EX: HR, which, according to the media-controlling A.I. Eliza Cassan, will crucially influence public opinion. Thus, the choice is presented as determining the world's fate regarding body augmentation technology, the game's central narrative motif. The examples demonstrate that anticipation of consequences usually serves to enhance a choice's moral weight. However, this potentially goes at the expense of the

Figure 4.8 BASTION, final choice.

finale's dramatic effect, as any information facilitating purposeful selection makes the ending predictable to a degree.

While choices with prolonged consequences are often conscious, and even motivated – as the example of harvesting or rescuing the Little Sisters in BIOSHOCK shows – the choice's purpose is usually limited insofar as the specificity of information does not allow conclusions about the game's ending. Generally, the delay of consequences is rather intended to prevent purposeful selection. Yet, if choices are assigned a moral value – as is the case in BIOSHOCK, CATHERINE, FALLOUT 3, and METRO 2033 – players can at least pursue an elementary, long-term purpose even in games with prolonged consequences. Although moral evaluation gives no information about the choices' actual influence on the narrative outcome, it at least entails the expectation that the story will conclude in a correspondingly good or bad manner.[23]

Having assessed the representational and structural variety of paths leading to multiple endings and the expectations (e.g. of agency) they evoke, it is finally time to focus on the endings themselves. While it cannot be evaluated how likely endings are to satisfy player expectations within the scope of this study, intracompositional differences in story, audiovisual representation, and even gameplay, as well as general narrative relations between the endings of a single game can provide clues to their closural effectiveness, besides revealing the structures and functions of multiple endings in digital games in general.

Making a difference? Narrative, audiovisual, and ludic variation

Multiple endings are defined by significant narrative differences in a game's outcome, as has been stated at the beginning of this chapter. These differences are, first, a matter of degree, i.e. how similar do the endings appear and how big are the narrative consequences they entail? Second, there are differences in the interrelations of endings, i.e. if they are incompatible with or build upon each other, and if they amend each other's closural information. Despite the narrative predominance of the phenomenon itself, all aspects of digital game endings, i.e. aspects of gameplay, audiovisual representation, and narrative content, can contribute to these differences, as will be shown in the following.

Differences in narrative content are, certainly, the most prominent distinguishing feature of multiple endings. Most conventionally, alternatives are strictly mutually exclusive, as they present different versions of how the protagonist's life and/or the whole storyworld changes. This is particularly evident in games that employ a final choice to determine their narrative finale such as LIFE IS STRANGE or BASTION. Final choices usually show what Bode calls strong "nodal power" (Bode and Dietrich 2013, 47), a feature of narrative branches that "is measured in the differences in the possibility

space constituted by the edges of its [i.e., the node's] various continuations" (Bode and Dietrich 2013, 48). Nodal power evaluates the potential effects of a choice both on events and existents of a storyworld. While the concept is useful for assessing the narrative impact of a single choice, it should be noted that it is of limited use for describing variation in multiple endings, since these might depend on more than one node, especially in the case of prolonged consequences.

In both LIFE IS STRANGE and BASTION, the final choice has extensive consequences on the fate of the storyworld, which are made clear prior to the choice, enabling purposeful selection. Although players can, of course, repeat the choices by playing the sequence again, they are explicitly staged as final and life-changing for the protagonist. In LIFE IS STRANGE, if Max uses her power to alter the past one last time to save her hometown, she has to accept the death of her friend Chloe, and if she chooses Chloe, the town and all its inhabitants are doomed to drown in a storm. In BASTION, the protagonist can either take the titular device as a vessel to search for new horizons with his friends, forever leaving their home in its state of destruction after the Calamity. Alternatively, he can activate the Bastion to reset time, including the characters' memories, so that they cannot spend a future together.[24] Arguably, both games push the degree of narrative difference between endings to a maximum, since the choice does not only trigger changes in the storyworld's future but potentially also in its past, due to the rewinding of time in one option.

While differences in events are conventionally deemed more important than, for example, changes of a character's mental state or the state of character relationships, the latter should not be underestimated. As Schmidt notes, even choices without distinct effects on events in the storyworld – which can be classified as "quasi-choices" (Aarseth 2004b, 366) – entail consequences and, hence, narrative differences, which foreground characters and questions of ethics and morality (see Schmidt 2017). The strong nodal power of the final choices in LIFE IS STRANGE and BASTION, arguably, results from them bearing extensive consequences on both events and characters, including moral questions. Sometimes, however, differences are much less pronounced. For example, two of the three endings of BIOSHOCK differ just slightly in the tone of voice of the narrating character, a difference so small that it hardly warrants speaking of two alternative "bad" endings. Indeed, the variation seems as insignificant as, for example, representational differences in final cutscenes that result from character customisation (e.g. the avatar's clothes). While it can, thus, be argued that BIOSHOCK has only two major endings, the tonal difference does imply a moral evaluation – with the speaking character either pitying the protagonist or being outraged at his cruelty – that, applying Schmidt's line of argumentation, might be worth considering. Instead of trying to find a definite conclusion, I propose that the desired level of detail and analytical scope of a study should decide if such "minor" differences are relevant

or not. However, there should be a clear distinction between differences located on the representational level of the media artefact and differences inferable only from interpretation. For example, there is a minor, but distinct intracompositional change on the auditory level between the two bad outcomes of BioShock. In contrast, in case of The Walking Dead, it is reasonable to assume that it would make a huge (mental) difference for the girl Clementine if she shot her father figure Lee as a result of the player's final decision, or if she left him to turn into a zombie. Yet, there are no intracompositional changes whatsoever in the game's final cutscene that briefly and vaguely hints at Clementine's fate.

BioShock already indicates that the perceived degree of difference in endings is not simply equivalent to variations on the level of story. The example of Mass Effect 3 makes a good case for the assumed importance of differences in audiovisual representation. As briefly mentioned earlier, the game caused an outrage of many dedicated players who felt that the three basic ending options did not do justice to the Mass Effect series and its complex storyworld. Apart from issues relating to the story, critic Sparky Clarkson remarks that "[t]he choice only determines the primary color and some other minor details of an ensuing cutscene. This denies the player any meaningful feedback about [the final] decision" (Clarkson [2012] 2013). As Clarkson is not alone in mentioning the difference in colour as the disappointing main variation between the final cutscenes (see e.g. Bryan 2013, 11), the poor reception of the endings of Mass Effect 3 seems to result (partly) from a lack of representational variety.[25] A closer look at the endings themselves is due to verify this hypothesis.

In the game's final choice, the player is presented three options to prevent the destruction of all organic life in the universe by a powerful synthetic species known as the Reapers. All options involve avatar Shepard activating an ancient device called "the Crucible". The device grants Shepard the power to either merge their mind with the Reapers to subsequently exert control over them, or to wipe out any synthetic life from the galaxy (eradicating another, now friendly synthetic race together with the Reapers), or to initiate a synthesis of organic and non-organic life by which every living being changes into a new form of existence with unknown consequences. As a means of enabling purposeful selection for the player, these options and their expected effects are lengthily explained prior to the choice by an entity called "the Catalyst". While the choice is thus staged as epic and consequential for every living being in the galaxy, both organic and synthetic, the ensuing, comparatively short cutscene fails to convey this impact, at least if the alternatives are seen in comparison. To be sure, the vastly different consequences for the storyworld are clearly implied in the corresponding cutscenes; yet their most striking difference lies in the colour of the light emitted by the Crucible on its activation, which visually dominates the following scenes in either red, blue, or green. At first glance, this prominent visual element might appear as an appropriately strong signal

to differentiate the endings on the level of representation. Yet, the effect of this straightforward variation largely backfires as it turns out to be nearly the *only* representational difference, since large parts of the alternative final cutscenes are otherwise identical. Arguably, a greater representational variety, combined with more insight into the consequences on the storyworld – i.e. an expanded epilogue – would have prevented the player community's backlash. Just as the closural effect of any ending (when seen in isolation) depends on its audiovisual representation as much as on content features, so does the perceived consequentiality of player agency when different narrative outcomes of a game are being assessed against each other.

While this study does not aim to make claims for production strategies, the homogeneity of the endings in Mass Effect 3 seems to stem from a design principle that is guided by economic efficiency. Since the creation of each cutscene in such a high-budget game requires a large amount of resources, it makes sense to use the medium's technological affordances to minimise this effort with a modular approach. That is, instead of producing three entirely different final cutscenes, a maximum number of segments are reused in all endings, with variations made by adjusting only a few parameters such as colour. Production efficiency might also contribute to the fact that ludic ending variation rarely occurs, since it also requires additional resources to design and program different ludic finales, which are secondary to the implementation of multiple endings, as these are primarily characterised by narrative variation.

Consequently, the rare occasions of ludic variations in multiple endings are particularly noteworthy. One such example is GTA V that places its final choice *before* its final mission, which then leads to three completely different finales. One of the unusual characteristics of this open world game is that it has three protagonists who alternatingly serve as avatar. Narratively, the game's finale is centred on avatar Franklin, who can choose to kill either one of the other two protagonists, or to save both and, against all odds, confront the people that want them dead. The three corresponding missions differ both in length and gameplay: The mission to kill Trevor mostly involves a car chase, while the mission to kill Michael adds a shootout between the two protagonists to a similar car chase sequence. In both missions, players stay exclusively in control of Franklin. In contrast, "The Third Way", as the mission for the final option is aptly titled, involves several avatar changes, both during the initial, large-scale shootout with the "FIB" (the game's version of the FBI), and in the ensuing missions of getting rid of certain criminal kingpins. Ludic and narrative mode are tightly intertwined in these three different endings.

A less diverse, but no less remarkable case of ludic variation is found in the finale of Silent Hill (Konami Computer Entertainment Tokyo 1999). All four endings of the game ludically culminate in a final boss encounter at the same location with the same narrative outset; yet the boss itself is different, depending on previous player actions. If players followed an optional

quest line during the second half of the game, the shady Dr. Kaufman will appear in a cutscene prior to the ludic finale, throwing an unidentified liquid at the possessed girl Alessa to expel the demon from her body. In this case, players fight the demon in the ensuing encounter, while otherwise the possessed Alessa makes the final opponent, with the latter both looking more harmless and being easier to defeat than the former. The optional quest is a typical case of obscured prolonged consequences, as it appears like a mere detour in terms of ludic progression until Kaufman's appearance in the finale reveals its effect on the ending, which further extends into the narrative phase if the boss is successfully defeated.

In both cases, ludic variation further highlights the narrative differences between the outcomes, either in addition to or instead of distinct representational differences: While the variations in GTA V involve elaborate event sequences happening at different locations in the game world, which alone entails representational differences, SILENT HILL features less distinct finales, as the final encounters and ensuing cutscenes invariably happen at the same place, and because the narrative finales are relatively short, including only brief epilogical phases.

A different form of ludic variation occurs in games that structure their potential ludic finales in succession, rather than presenting them as equal alternatives. Similar to SILENT HILL, such games require additional player effort to obtain endings that typically grant a higher degree of closure. I will further elaborate on this in the subsequent section on multiple ending structures and hierarchies. Prior to that, let me conclude the question of making a difference with a closer look at numbers.

In general, despite the abundance of multiple endings in the medium, the total number of ending alternatives in a single digital game is usually remarkably low. This results mainly from the problem of manageability, which concerns both game designers and players. In case of the former, manageability relates to both production cost and narrative plausibility. Although the computer's procedurality allows for flexible, almost unlimited variation of non-narrative aspects of outcome, "[a] structure with multiple branching paths that leads to an indefinite number of endpoints would not be programmable" (Neitzel 2014, 614) in a way that grants narrative coherence, at least not by today's technological standards. For players, manageability is relevant mostly in case of overt choices and immediate consequences, as meaningful and purposeful selection is more difficult the more options are given. Hence, final choices are typically limited to four (e.g. DEUS EX: HR), three (e.g. GTA V), or, most conventionally, even only two options (e.g. BASTION, LIFE IS STRANGE). Because purposeful selection is commonly not possible in games with prolonged consequences, manageability on the part of the player is not an issue here, so that a higher number of outcomes is more likely, as witnessed by the seven endings of S.T.A.L.K.E.R. and the eight endings of CATHERINE. Apart from manageability of choice, prolonged consequences can also increase the narrative plausibility of more options, since

the outcome results from long-term effects and more than one choice. Yet, overall, fewer ending options are equally common in games with prolonged consequences, as demonstrated by METRO 2033 (two endings), BIOSHOCK (two or three endings, depending on the definition, as discussed earlier), and SILENT HILL 2 (four regular endings[26]). Thus, narrative player agency does not open up a space of infinite possibilities but amounts to a finite number of outcomes with more or less distinct variation. As other narrative media, digital games largely conform to Bordwell's observation that "[i]n fiction, alternative futures seem pretty limited affairs" (Bordwell 2008, 172), because "instead of the infinite, radically diverse set of alternatives evoked by the parallel universes conception, we have a set narrow both in number and in core conditions" (Bordwell 2008, 173; see also Ryan 2001b, 242).

A modular design, as in MASS EFFECT 3, might be able to counter these conventional limitations. Indeed, the game's endings vary in more aspects than those mentioned, although most of them are representationally hardly more significant than the variation in tone of voice between the two bad endings of BIOSHOCK. In contrast to the prior example, however, the increased number of variations in the modular approach of MASS EFFECT 3 vividly demonstrates how complicated it can be to (numerically) differentiate and classify multiple endings in digital games, which is reason enough to discuss them in more detail here.

The additional variations between the endings in MASS EFFECT 3 result from long-term consequences. On the one hand, as a rather minor detail, the avatar's interactions with squad members throughout the game determine which NPCs are shown at the beginning of the final cutscene, symbolising the avatar thinking of those most important to them in their (most probably) final moments of existence. On the other hand, both the number of available options in the final choice and some of the final story events are determined by the player's score of "effective military strength". Military strength can be increased with the completion of optional missions and via the game's multiplayer feature. The additional player effort is rewarded with an increasing number of final options that entail increasingly better outcomes. Thus, at the lowest level, there is no choice at the game's ending as only the destruction of all synthetic life is possible, resulting in the vaporisation of Earth and the deaths of both Shepard and their squad. While the choice is subsequently amended with the options for control and synthesis, the highest level of military strength also leads to the survival of Earth, the squad, and potentially even the protagonist.[27] The differences considering the final choice, the state of the Earth, the squad, and the protagonist add up to seven possible combinations. Despite their narrative significance regarding content – e.g. the survival of major characters – these variations, again, largely fail to produce any striking representational differences. For example, the state of the Earth being devastated or saved is merely inferable by the presence or absence of a fire and soldiers celebrating victory in a few corresponding shots during the final cutscene.

As another example with a modular ending structure, FALLOUT 3 shows even better that the range of segments, which are treated equally by the program, can differ strikingly in their consequences for the game's narrative layer in general, and for the ending's closural effect in particular. The game's final cutscene – a slideshow accompanied by voice-over narration – is compiled out of 29 available building blocks, which are selected based on various factors such as the avatar's appearance, Karma level, the completion of certain side quests, and two final choices. While some of the related variations are clearly minor, such as the avatar's appearance, others entail a significant narrative difference, such as good or bad Karma, which influences the narrator's moral evaluation of the protagonist's life and, by extension, the playthrough. Although it would be possible to calculate all plausible combinations of building blocks to define the number of endings in FALLOUT 3, it should be clear by now that it is debatable or, rather, depends on the context of analysis, which differences qualify as significant and which do not. Thus, instead of prompting an attempt to categorise these variations, both MASS EFFECT 3 and FALLOUT 3 are given as examples to further highlight the potential nuances of multiple endings in digital games, showing that they might even resist simple enumeration.

It should be noted that these nuanced differences are, potentially, ontological, in contrast to similarities in the multiple endings of non-procedural narrative media artefacts. For example, if a unilinear movie employs an identical shot in several of its otherwise separate ending sequences, these exist more than once during the reception process, as a copy of the shot is included in each ending sequence. Before the age of digitalisation, the repeated use of a shot would have been materially manifest in the film strip. In contrast, when different final cutscenes of a digital game with modular ending structure are actualised, they can each use the same piece of data, or file, if the ending is being compiled during the playing process.[28] Granted, this medial idiosyncrasy is hardly relevant for recipients and the evocation of a sense of an ending. Yet, it is still worth mentioning as a fundamental difference between procedural and non-procedural media, which helps explain further characteristics of multiple endings in digital games.

In summary, although digital games are technologically prone to include a variety of multiple endings due to the computer's procedurality and the largely modular structuring of software in general, the vast majority of multiple endings in games are both ontologically and representationally distinct and allow clear identification of a finite number of endings. While the multiple endings of digital games seem to be similar to those of other narrative media in this respect, both their structures and functions are strikingly different, as the following sections demonstrate.

All endings are not equal – Ending arrangements and hierarchies

As I pointed out in my discussion of the ending's position (see Chapter 2.1), non-ergodic narrative media artefacts are bound to a unilinear arrangement

of multiple endings, which, if included, necessarily succeed one another in a single reception process "[d]ue to the exigencies of telling in time" (Bordwell 2008, 182). Linear succession, however, inevitably implies a hierarchy of the given alternatives because of the recency effect, which causes a particularly high cognitive impact of the last segment encountered during a reception process, giving the last ending presented the highest value. Hence, multiple endings in unilinear narrative artefacts always at least imply a hierarchical order, as the narrator of *The French Lieutenant's Woman* bemoans with reference to "the tyranny of the last chapter" (Fowles [1969] 1996, 408). Less dramatically, Bordwell identifies this tyranny as one of the "conventions of forking-path tales" (Bordwell 2008, 174) in film: "All paths are not equal; the last one taken, or completed, is the least hypothetical one" (Bordwell 2008, 183).

The media modalities of the digital game create a completely different outset for the integration of multiple endings. While all alternatives are encountered in a single reception process of non-ergodic media artefacts, players conventionally encounter only one ending in a single playthrough of a digital game because only one path following a nodal situation is actualised at a time. All the examples discussed in the previous section employ such a parallel structure of multiple endings, in which one option acts as a direct alternative to another. The withholding of all other alternatives is enabled by the medium's ergodicity and facilitated by its procedurality (see Wolf 2002, 108).[29] Therefore, a parallel ending arrangement suggests itself easily for digital games, while it is impossible in unilinear media artefacts. It allows for a structural equivalence of all multiple endings, with no hierarchy being evoked, such as in LIFE IS STRANGE or DEUS EX: HR.

Yet, games are not confined to non-hierarchical structures: "Even the design of a nonlinear structure can still force the user toward a more linear progression, and a certain ending can be designated as the 'right' one which the player is directed to attain" (Wolf 2002, 108). While the medium's technological affordances enable and facilitate outcome equality, the cognitive ludic prototype contributes to ending hierarchisation, as it features outcome valorisation, meaning "that some of the possible outcomes of the game are *better* than others" (Juul 2005, 40). Although there are also many representational strategies to implement outcome valorisation in games with parallel ending structures (see below), other games arrange their endings in a way that even structurally implies hierarchy, thus approximating a unilinear approach. In such an arrangement, if certain conditions are fulfilled, endings are "stacked" upon each other as another ludic sequence follows the sequence that serves as the ludic finale in another ending. The additional effort thus required for longer endings is typically compensated by additional narrative information that entails a higher degree of closure.

For example, BLOODBORNE, the ending of which is decided by both a final choice and prolonged consequences, puts several "final" bosses in succession for its more elaborate endings. In the final dialogue, players can either choose to accept Gehrman's offer to submit the avatar's life – which

leads to a final cutscene without any further ludic sequence – or to refuse and fight the previously mentoring character. Success in this encounter will either lead to another cutscene finishing the game or to another boss fight against the demonic "Moon Presence", if the avatar has previously consumed three special items that are scattered throughout the game world. The result is a quick succession of the encounters, and although additional narrative information is revealed with each stacking sequence, the cutscenes are short and the narrative meaning remains obscure, or at least subject to interpretation, matching the overall vague style of narrative communication in BLOODBORNE.

The stacking endings of PERSONA 4, in contrast, are considerably more expanded and detailed, both ludically and narratively. Here, two subsequent binary choices either directly lead to a narrative ending sequence or continue the game. First, a distinctly bad outcome is triggered if players wrongly convict a suspect for the game's central murder case, who the protagonist then executes in a rash of vigilante justice. In the other option, the true murderer is eventually revealed and posed as a final opponent at the end of an extended dungeon full of monsters to defeat. After the villain's arrest, in what appears to be a playable epilogue, players are offered to revisit the town's department store, a seemingly insignificant option. If they decline, the sequence maintains its epilogical status and the game finishes with a cutscene in which the characters say their farewells to the protagonist, expressing relief over having found the culprit, but also slight doubts concerning the yet inexplainable supernatural events that enabled the murder spree in the first place. If, on the other hand, players revisit the department store, the choice leads to another whole dungeon that culminates in another, this time truly final, boss encounter against the goddess who is revealed as the source of said supernatural events. The following epilogical cutscene is highly similar, even partly identical, to the previous ending option, save the characters' doubts.

It is important to note, however, that there is a significant difference between such stacking structures and the succession of multiple endings in unilinear artefacts, because still only one ending is ever completely actualised in a single playing process.[30] In PERSONA 4, players can pursue the latter, "true", ending, which ties all the story's loose ends, only after encountering large parts of the previous, "neutral", ending. Yet, the choice to pursue the true ending interrupts the latter during the narrative phase, so that the final cutscene and the paratextual ending phase do not play out. Stacking endings, thus, do not simply succeed one another, but – under certain conditions, which are determined by player actions – the higher valorised ending interrupts the one with lower value to further expand the game.

As the higher valorised alternative builds upon the progress of a lower one, stacking endings literally conform to another of Bordwell's rules for forking-path tales: "All paths are not equal; the last one taken, or completed,

presupposes the others" (Bordwell 2008, 181). Yet, unlike in unilinear narrative artefacts with multiple endings, this presupposition involves no narrative setbacks (neither for the protagonist nor for the player) because the preceding path is replaced before its ending is fully completed. In games, narrative setbacks that invariably occur during the reception of a unilinear artefact only happen outside the playing process, i.e. if players pursue full exploration of all endings, deliberately deciding to reload a previous game state to take a different course of action.[31] Endings organised in a stacking structure, hence, still form narrative alternatives to each other, which, however, are not equal in length and degree of closure. In conclusion, digital games can use a fundamentally wider repertoire for organising multiple endings than unilinear media artefacts.[32]

While hierarchical differences are already implied in the structural design of stacking ending arrangements, parallel structures can equally evoke hierarchy by other factors such as length, amount and detail of closural information, and ludic effort. For example, although the endings of SILENT HILL are structurally equal in their parallel arrangement, they still differ in effort, both during the final encounter and prior to it, via the optional quest line that is the prerequisite for the change in finale. However, the difference in effort only becomes apparent in comparison of all alternatives, while the succession of finales makes it obvious in a stacking arrangement.

The factor of additional ludic effort is taken to an extreme in endings that are only available in a second (or even later) playthrough, demanding repetition of the whole game. SILENT HILL 2, for example, has three endings that cannot be achieved in a first run, as the items needed to complete these paths are only placed inside the game world after any of the other endings is unlocked. While the hidden "Rebirth" ending still provides a plausible conclusion to the dark and serious story of the psychological horror game, the "DOG" and "UFO" endings each have a clearly joking quality, with the former revealing the story's events to be orchestrated by a dog, and the latter finishing with protagonist James being kidnapped by aliens.[33] The additional effort required for these endings prevents players from accidentally stumbling upon them in their first playthrough, which would most likely cause confusion and break immersion, influencing the player's interpretation and potential closural satisfaction with one of the other endings.

With only one ending to get in a first playthrough, the game NIER even hides most of its four outcomes for first-time players. Yet, unlike SILENT HILL 2, it openly communicates that another outcome, "Ending B", has become available with a meta-ludic message in the paratextual ending phase of the first. While players need not repeat the full game for a second playthrough, as it restarts from about halfway through, further ending options in a third run require considerably more effort as is explicated by another meta-ludic message that promises the addition of "one final decision that affects the story", but only if players "obtain all of the weapons in the game". Remarkably, this ludic prerequisite for the unlockable final choice

is completely unrelated to the game's narrative level, as there is no reasonable clue to why only a complete weapon collection would allow the protagonist to sacrifice himself for his companion at the end. In contrast, the actions required for the "Rebirth" ending in SILENT HILL 2 are narratively motivated, as the instructions for a ritual to bring someone back from the dead are scattered in the game world, explaining why avatar James would collect the required items to revive his deceased wife. Thus, while attentive players of SILENT HILL 2 can – and must, unless they resort to contextual guides – gather the clues for the "Rebirth" ending by themselves, players of NieR would be lost without the paratextual message that openly states the requirement of the weapon collection for the new ending. Since the hidden endings' unavailability alone is narratively inexplicable in both cases, ludic and narrative mode are clearly detached, potentially evoking a feeling of ludonarrative dissonance that is increased if the ludic requirements for the new ending are narratively meaningless.

With regard to hierarchy, the required effort of playing the game (at least) twice indicates a considerably higher value of the endings in question. Yet, the hierarchical status of the hidden endings of SILENT HILL 2 is not as clear, as a higher value is neither supported narratively nor paratextually. Both narrative context and paratextual evaluation are, however, typically important indicators of ending hierarchisation. In the example's predecessor, SILENT HILL, the hierarchy is explicitly stated in the final paratextual evaluation, which labels the available endings "GOOD+", "GOOD", "BAD+" and "BAD". While such unequivocal paratextual communication is rare, narrative context often leads to a similarly clear hierarchisation, as both the degree of narrative closure (i.e. the amount and detail of narrative information) and the positivity of outcome (i.e. most conventionally, if the story ends in a way favourable for the protagonist) increase with the ending's hierarchical status. In PERSONA 4, for example, the true villain is only revealed in the ending that requires the highest effort, and shorter paths leave more loose ends in the story. Accordingly, the doubtful remarks of the protagonist's friends in the narrative finale of the game's neutral ending highlight this outcome's closural deficiencies by drawing attention to the story's unanswered questions, arguably to encourage players to look for the true ending that provides the answers.

The hierarchising effect of narrative context is not new to digital games. The final outcome of "forking-path" type films, such as RUN LOLA RUN or SLIDING DOORS, is usually the happiest, or at least the morally "right" one (see Bordwell 2008, 183), and gamebooks typically present one positive outcome as the "real" ending (see Bode and Dietrich 2013, 21).[34] While the principle of high valorisation of outcome positivity is easy to observe in gamebooks, which are prone to adhere to a simple worldview as they are usually aimed at children, matters are not always that easy.[35] For example, *The French Lieutenant's Woman* presents the less positive outcome – judging by love story conventions – last, potentially creating a conflict of the hierarchising factors of position and outcome positivity in this unilinear

narrative artefact. Yet, this structurally "privilege[d] [...] unhappy, 'existentialist' ending, which shows the male protagonist alone and forsaken, not happily reunited with the love of his life and their common daughter (as is the case in the second ending)" (Bode and Dietrich 2013, 26) fits the zeitgeist – and, thus, ensuing new conventions – of the novel's postmodern origin better than any traditional happy ending. Hence, factors like "positivity" or "morally right" always need to be put into perspective.

It could be argued that the distinctly clear ending hierarchisation in gamebooks can be attributed to their ludic form rather than to a narrative simplification that is aligned to the age of their target audience. After all, I previously pointed out how outcome valorisation, particularly in form of separating positive from negative outcomes (i.e. winning or losing), is a prototypical feature of games. Yet, contemporary digital games prove that there is no compelling link between ludic success and positive narrative meaning, although the bigger the divergence between these two factors the higher the risk of disappointing conventional player expectations.[36] It is still common that winning, or rather, successful completion, coincides with a positive outcome while failure equals a negative narrative outcome. Yet, an increasing number of digital games give up on this rule (see Domsch 2013, 179), not only by presenting a distinctly bad or tragic ending but also by rendering outcome positivity rather ambiguous, which, respectively, affects potential ending hierarchies. For example, the effort required for the "Rebirth" ending in SILENT HILL 2 indicates its high hierarchical status. The ending also provides more insight into the game's storyworld than the other outcomes by revealing the possibility of the ritual.[37] However, although the protagonist is supposedly to be reunited with his wife (yet, neither the ritual's outcome nor the process itself is shown in the ending), the sequence's dark and solemn atmosphere and the moral ambiguity of James' rejection to accept Mary's death cast doubt on the desirability of this outcome. In contrast, a more mature alternative, in which James finds peace by accepting both his wife's death and his partial responsibility for it, is provided by the "Leave" ending, which is available in a first run of the game, i.e. without additional effort. Hence, there is no definite ending hierarchy in SILENT HILL 2 and the example shows that the factors of ludic effort, general length of the ending (or the path leading to it), amount and detail of closural information, and positivity do not necessarily correlate. Yet, besides merely communicating "success" on a narrative level, if narrative positivity is aligned with ludic success, it strongly contributes to a basic functionality of ending hierarchies in digital games that will be discussed in the following.

Gratification and canonisation – Why games employ ending hierarchies

It might seem curious that narrative digital games employ ending hierarchies in the first place, considering that they do it not out of necessity but

by (designer's) choice, in contrast to unilinear media artefacts. What, then, are the functions or benefits of ending hierarchies in digital games?

Most importantly, hierarchisation contributes to the complexity of a game's challenge and reward system. Since closure can be regarded as a form of reward for players who invest their time into finishing a narrative digital game, a gradation of closure according to player effort can enhance this reward function. Moreover, clearly communicated ending hierarchies can increase a game's replay value, as the existence of a "better" outcome can motivate another playthrough by challenging the player's ambition, just as a highscore or ranking system does. For example, if a player obtains a "BAD" ending in SILENT HILL, the confrontation with this outcome evaluation in the paratextual ending phase might induce the wish to do better (or it might simply evoke frustration, to a reverse effect).

The reward function of reaching a game's goal – which in most narrative singleplayer games is equivalent to reaching the end – also has a social dimension. After all, "whoever reaches the end of a game will be recognized as a good player" (Frasca 2003, 232), implying that the better or harder to achieve an ending, the more recognition the player will get. Hence, ending hierarchies contribute to a meta-competition between players if they share their experiences and compare outcomes. Alternatively, discourse can be more productive if players rather choose to exchange tips for how to get a better ending, which might become a necessity in games that conceal their best outcome. For example, although the important moment of choice that leads to the true ending in PERSONA 4 comes in the disguise of a seemingly trivial question, it is still rather obvious when compared to the obscure side quest that leads to the good endings of SILENT HILL. If there are no obvious clues for how to get the best outcome in the game itself, trying to find the best solution, or any hidden ending, can become a form of meta-game for the player community. Thus, by stimulating player exchange, ending hierarchies potentially contribute to a game's overall public attention and reputation, especially ever since online resources have been facilitating communication.

The use of additional endings for publicity and marketing purposes is obvious in DLC or complete remakes that add further outcome possibilities. For example, promotional material for the 3DS remake of DRAGON QUEST VIII: JOURNEY OF THE FIRST KING (Square Enix 2017, originally on PS2 [Level-5 2006]) highlights that "[t]his updated classic also includes new dungeons, bosses, items, quests, scenes, and a new possible ending!"[38], thus actively advertising the ending variety as a feature. DLCs, in contrast, seem less prone to add new outcome alternatives, since they, unlike enhanced reissues or remakes, are not full games but mere enhancements of a game that players, presumably, already completed when they purchase the additional content. Instead, story DLC (i.e. DLC with a narrative focus, in contrast to, for example, additional playable characters or cosmetic enhancements) typically fills story gaps such as a character's

backstory (e.g. THE ASSIGNMENT [Tango Gameworks 2015], which tells the story of the secondary protagonist of THE EVIL WITHIN) or literal gaps in the original game's main story (e.g. THE MISSING LINK for DEUS EX: HR, which is nearly seamlessly integrated at the appropriate point in the main plot if the game is purchased and played for the first time in the "Director's Cut" version).

Yet, occasionally, DLC is narratively set after a game's ending such as the previously discussed BROKEN STEEL DLC for FALLOUT 3 or AWAKENED (Visceral Games 2013), the story DLC for DEAD SPACE 3 (Visceral Games 2013). Amending story DLCs like these occupy a state somewhere between a "true" ending, which stacks upon and overrides the game's original outcome, and a sequel which, following established principles of narrative seriality, continues the story without completely negating the closural effect of the original ending. A rare example of a DLC ending with a high hierarchical status, comparable to that of the true ending of PERSONA 4, is ASURA'S WRATH's (CyberConnect2 2012) "episode pack" PART IV: NIRVANA (CyberConnect2 2012), which amends the original game's eighteen with four additional episodes that continue the story. The paratext in the menu screen for the DLC's first episode, "Episode 19: The One Behind the Curtain", clearly reveals the content's purpose of providing a true ending: "It was not the end. There was still an enemy left to defeat. [...] Asura and Yasha prepare to face the mastermind behind it all." The example also shows that the economical exploitation of the narrative desire for closure by DLC is highly controversial among players, while a story's completion via serial release is more widely accepted.[39]

The contribution of ending hierarchies to the reward function and their stimulation of social engagement in player communities are also relevant for secret endings, or Easter egg endings, which also require additional effort but are located rather at the hierarchy's narrative bottom. Secret endings are usually well hidden and finding them is either the result of meticulous detective work on part of the player or happens by coincidence. In contrast to high-value endings, secret endings are usually unrelated to the main story or provide narrative information only as a joke. They are a closural variation of the hidden and mostly humorous content in digital games (and other media) that is known as Easter eggs. Since "[p]art of the pleasure of finding an Easter egg is a sense of transgressive discovery", they "violate the otherwise internally consistent world of a game" (Salen and Zimmerman 2003, 279) but have no bearings on the game's main gameplay or story. Rather, they give a nod to inquisitive and explorative players by letting them "see or experience something that more lawful players would not" (Salen and Zimmerman 2003, 279), without punishing the latter for less deviant styles of play. Beyond violating the game world's consistency, Easter egg endings undermine both ludic and narrative ending conventions and closural expectations, mainly for (the player's) fun. Their joking quality makes them easily identifiable as special or bonus endings.

The "DOG" and "UFO" endings of SILENT HILL 2 are famous examples for this low hierarchy but high effort type of multiple endings (in contrast to the transient fake endings). Apart from their narrative hilariousness, the special status of the DOG and UFO endings is further confirmed in the paratextual ending phase: In contrast to the uniform credit roll of the other alternatives, both Easter egg endings have their own credit rolls that audiovisually match their theme, so that the DOG credits roll in front of a dog picture and the clownish musical tune is accompanied by barking (see Figure 4.9). Moreover, the game's final evaluation screen highlights the special status of these endings by protocolling them separately in brackets behind the number of endings achieved out of the regular four, so that a completion of all options would be displayed as "4/4 (+2)".

The issue of narrative plausibility, which is typically lacking in Easter egg endings, leads to the general problem of ending canonisation. Closely related to hierarchy, canon determines which, if any, ending can be assumed to be the "right" one, i.e. commonly, the official outcome of the story as declared by the authority of the producers. The canonising function of hierarchisation is clearly implied in the term "true ending", which is more prevalent in the discourse about games than intracompositionally. Explicit declarations of one canon ending within the game itself are rare. Most commonly, the canon ending is implied by a combination of detail of resolution, positivity of outcome, and effort necessary to reach the ending. In other words the ending with the highest value can be assumed to be canon. Arguably, however, the most reliable factor for ending canonicity is applicable only for serial games, because the continuation of the story in a sequel on the basis of a particular outcome equals a confirmation of this

Figure 4.9 SILENT HILL 2, DOG ending credits.

outcome as canon on part of the producer. Hence, serialisation can either acknowledge or overrule the canon established by intracompositional factors of hierarchy.

The SILENT HILL series shows an example of how an intracompositional high-value ending is confirmed as canon by a sequel, as the good endings of the first instalment are the prerequisite for the continuation of the story in SILENT HILL 3 (Konami Computer Entertainment Tokyo 2003). While the two good endings of SILENT HILL – which differ from each other only in a minor aspect as far as the story's continuation is concerned – are suggested as canon by the game itself (via the narrative positivity of outcome, the additional effort required to get there, and the game's paratextual evaluation), this status is confirmed in the narrative sequel, since SILENT HILL 3 avatar Heather is the baby that SILENT HILL avatar Harry receives in the good endings, exclusively.

In contrast, the METRO series exemplifies the rejection of an intracompositional high-value ending as canon: METRO 2033 has a distinctly morally positive ending, achieving which requires additional player effort to prove avatar Artyom's high moral standing, which allows him to choose a path of peaceful coexistence between humanity and the seemingly hostile, mutated race called the "Dark Ones". Yet, this positive outcome is clearly not the basis for METRO: LAST LIGHT, in which Artyom encounters the last survivor of the Dark Ones one year after the race's supposed extermination by the missile strike he himself initiated in the bad ending of METRO 2033. The bad ending serves as a plausible basis for the story's continuation, because it allows the extension of the first instalment's central conflict with the increased moral weight of Artyom's questionable choice. In this case, however, canonisation also results from a higher authority than that of the sequel, since the games are adaptations of a novel series by Dmitry Glukhovsky. His novel METRO 2033 ends in the same way as the bad outcome of the game (see Glukhovsky [2007] 2012), which was, hence, declared canon within the franchise's transmedial storyworld even before the production of METRO: LAST LIGHT. Although adaptations are not strictly bound to adhere to their source material, there is a strong conventional power of the original which asserts its authority in questions of canonisation.[40] Yet, as intracompositional hierarchisation and authoritative canonisation diverge in METRO 2033, its two possible outcomes compete in terms of hierarchy, depending on whether the interpreter's focus lies on canon or (moral) value.

In conclusion, there is no uniform relationship between hierarchisation and canonisation. Just as a distinct, intracompositionally evoked hierarchy can be used to indicate a canon ending, ending canonisation via serialisation can retrospectively put the previous instalment's endings in a (different) hierarchical order. No matter the nature of their relationship, however, both hierarchisation in general and canonisation in particular minimise narrative ambiguity and counteract the ending's loss of finality that is conventionally effectuated by multiple endings in digital games. Usually, they

do so at the expense of the player's potential for meaningful choice. By authoritative enforcement of one outcome as the "right" one, hierarchisation and canonisation condemn all other potential endings to ultimately remain in "the subjunctive mode" of possible worlds (Neitzel 2014, 617) – despite them being realised in some individual playthroughs.

The designers of DEUS EX: MANKIND DIVIDED (Eidos Montréal 2016)[41] intended to avoid this authoritative impetus of serialisation for the sequel of DEUS EX: HR, the four endings of which are intracompositionally arranged in a flat hierarchy. One of the sequel's writers, Mary DeMarle, describes their intention of preventing retroactive hierarchisation and canonisation in an interview prior to the game's release:

> [Prescott, the interviewer:] There was a huge morally ambiguous decision at the end of Human Revolution, with several different outcomes that dramatically affected the story's close. Where does Mankind Divided pick up? Which of those endings is 'true'?
>
> [DeMarle:] A lot of people ask which ending we settled on to grow from, and the answer I give is 'which one did you choose?' Everyone chose their ending and it was a big decision. [...] We don't want to rob that from anybody. We realised that there are three people in the world who know what decision was made: Adam Jensen [i.e., the protagonist and avatar], Eliza [i.e., an NPC A.I.], and you, the player.
>
> (Prescott 2015)

Both the interviewer's question and the writer's answer suggest that players largely feel the need for ending canonisation, particularly in case of serialisation.[42] Coming from the dilemma between answering this need and trying to uphold the value of a player's personal choice, which producers of a sequel to a game with multiple endings invariably find themselves in, the writers of DEUS EX: MD chose the unconventional path of rejecting canon. Yet, DEUS EX: MD, arguably, fails to deliver the intended effect of valuing player choice, since it mainly just avoids addressing the outcome of DEUS EX: HR. Although the final choice of the earlier game was presented as so consequential as to determine the fate of the whole world (at least with regard to humanity's overall stance towards technological augmentations of the human body), the sequel implies that it was completely irrelevant. After A.I. Eliza dramatically asked avatar Jensen (and, by extension, the player) right before the final decision if he has "the wisdom to choose an appropriate future for mankind", it turns out in DEUS EX: MD that the news broadcast sent out by her according to Jensen's choice had no power to affect mankind at all, as DeMarle implicitly confirms: "[T]he message has gotten out but by the time anyone is ready to hear it, there are a lot of competing messages. [...] [T]here are plenty of messages, plenty of false reports and rumours" (DeMarle in Prescott 2015). While this turn of events might not lack narrative plausibility, it clearly robs all consequence from the player's

choice of ending. Worse yet, even out of the only "three people in the world who know what decision was made" (Prescott 2015), as DeMarle clearly emphasises, Jensen himself, the avatar in both games, does not remember the choice due to a (convenient) partial amnesia at the beginning of DEUS EX: MD. Arguably, Jensen's memory loss adds insult to injury for players who were invested in their choice at the end of DEUS EX: HR, strikingly against the writer's declared intention of preserving the value of this "big decision" (DeMarle in Prescott 2015). While canonisation always entails an authoritative impetus that undermines individual choice, the example of the DEUS EX series shows that the reverse does not simply entail a reverse effect.[43]

With canonisation, the present discussion of multiple endings has left the boundaries of the single game. Although there would be much to say about the endings of game series as a whole (in comparison to other serial media artefacts), the interim endings of episodic games (e.g. LIFE IS STRANGE), as well as those of games with internal serial structures (such as the world and level structure in the SUPER MARIO BROS. games), there is not enough room in this study to thoroughly cover these aspects, which all entail another form of ending pluralisation that is characteristic for seriality (see Grampp and Ruchatz 2013, 10f.). Instead, the following section will, finally, discuss the fundamental functionality of multiple endings in digital games, which is governed by two competing principles.

A ludification of the narrative mode

Even though the frequency of branching narratives has generally increased in popular culture since the 1990s (see Bordwell 2008, 187), multilinear stories and multiple endings are nowhere as common as in digital games. While "[n]ot all the story-driven genres of video games put the same emphasis on multiple endings, [...] it is a feature that is becoming more and more standard" (Domsch 2013, 78). Considering the resulting conventionality of multiple endings in digital games, they hardly function as the postmodernist narrative experiment as which they, arguably, first appeared in other media with a tradition of unilinear narrative structures such as the novel. Neither can their prevalence be ascribed to the medium's ergodicity per se. Although ergodicity, with its condition of non-trivial user activity, undoubtedly supports diverging narrative paths that are actualised by the user, the lack of multiple endings in most hyperfiction compared to their abundance in game-like narrative artefacts – such as gamebooks of the "Choose Your Own Adventure" kind – suggests that a ludic quality is more relevant to the structural pluralisation of the ending.[44] Indeed, multiple endings in digital games are intricately linked to their ludic nature regarding their frequency as well as their forms of implementation and their functions.

I propose to understand multiple endings in games as a narrative realisation of the prototypically ludic feature of variable outcome. Just as

non-narrative outcome differences can either be strictly distinct (e.g. victory versus defeat) or gradual (e.g. a highscore), multiple endings can differ completely or just gradually (e.g. in the modular implementations of MASS EFFECT 3 and FALLOUT 3). Essentially, multiple endings, thus, constitute a ludification of the narrative mode. In fact, this function applies to narrative branching in digital games in general, irrespective of its relevance for the ending, especially in highly narrative games with marginal gameplay.[45]

There are two fundamental principles governing this ludification of the narrative mode: either it emphasises selective individualisation of a story, or it facilitates the exploration of various continuations. Accordingly, it predominantly serves to enhance either narrative or ludic features. For example, choices in THE WALKING DEAD are designed to be made once – the game does not particularly facilitate re-entry for trying out other options – and have a final, potentially lasting narrative impact, for example, on NPCs who "will remember this", as the game repeatedly emphasises. In contrast, the protagonist's power to reverse time in LIFE IS STRANGE shows a more playful approach, not only allowing but also occasionally explicitly demanding players to explore different options and the NPCs' corresponding reactions without having to reload a previous game state – only to increase the crushing effect of a choice's finality in those situations in which Max cannot use her power.

It should be noted that, although individual games usually accentuate one of the two principles via representational strategies and context, players are likely familiar with both conventions. Therefore, they might be inclined to evaluate a game's multiple endings according to both principles, i.e. judging the consequentiality of choice for individual endings, as well as how the game facilitates and motivates exploration of different outcomes. Presumably, player preference for one principle over the other is more important for their expectations than the focus communicated by the game itself, which still can affect player satisfaction and the perceived sense of an ending in a game with multiple endings. While the latter is an empirical matter, the two principles governing the ludification of the narrative mode have intersubjectively distinct effects on closure and the degree of finality of one single ending.

First, following the principle of individualisation, multiple endings offer a tailored conclusion to a story that, ideally, matches players' personal closural expectations, since the outcome is based on their own (purposeful or unconscious) choices. If communicated beforehand, the promise of multiple endings adds further incentive to the narrative reception process by making it more diverse and personal, consequently enhancing player immersion via the promise of agency. Despite their potential awareness about alternatives, players are more likely to accept the ending as a consequence of their personal choice. Rather obviously, the best-suited organisation of multiple endings to support the principle of individualisation is a parallel arrangement with no implications of hierarchy.

Even more than in endings with striking plot variations, individualisation is clearly the idea behind nuanced narrative outcome differences such as the variation of NPCs in the final cutscene of MASS EFFECT 3 that reflects the avatar's relations to the characters based on prior interactions. Such small nuances are often the sole focus of narrative individualisation, which, hence, not necessarily affects a game's ending. This is, famously and controversially, the case for most adventures by Telltale Games which begin with the promise that "[t]he story is tailored by how you play" (e.g. THE WALKING DEAD), but often end in a narrative bottleneck. It is debatable if Telltale's promise was ever as empty as critics have repeatedly pointed out, since "[t]he choices you make in Telltale games have limited consequences for the plot, it's true. But they have massive consequences for the characterization and theme" (Macgregor 2015). Yet, according to the effectiveness of feigned agency, the debate is irrelevant in the context of a single first playthrough, i.e. if the player is not aware of their actions' actual consequentiality. In contrast, it surfaces in the question of canonisation, as has been shown by the aforementioned example of DEUS EX: MD and the somewhat feeble attempt of its designers to honour the players' final choice of ending in DEUS EX: HR.

Ideally, following the principle of narrative individualisation, players would be completely content with their achieved ending, not even inclined to further test potential consequences of their actions. Famously, game developer David Cage insisted on this ideal scenario for both his games HEAVY RAIN (Quantic Dream 2010) and BEYOND: TWO SOULS (Quantic Dream 2013) with the maxim: "Play it once and then don't replay it" (Cage in Kelly 2012). In an interview, Cage declares the principle of individualisation as

> the right way to enjoy HEAVY RAIN [...] because it's going to be your story. It's going to be unique to you. It's really the story you decided to write, and that will be a different story from someone else. And, again, I think playing it several times is also a way to kill the magic of it.
>
> (Cage in Berghammer 2009; quoted from
> Alvarez Igarzábal 2019, 133)

He later confirms that the same holds true for BEYOND: TWO SOULS, adding that the individualising aspect can enhance the social dimension of playing singleplayer games, by motivating exchange: "[Y]ou can talk to other people and see their versions, and compare what you did, what you missed, what you saw, but never know what would have happened if... I think that's the beauty of the thing" (Cage in Kelly 2012).

Yet, Cage's ideal is countered by the second principle at the heart of the ludification of the narrative mode, which promotes exploration of all available content. In this pure sense of narrative's ludification, uncovering story variations becomes a ludic goal. This is reminiscent of the narrative

outcome valorisation that characterises ending hierarchies as discussed earlier. Thus, hierarchisation also supports the explorative principle. Yet, its replay incentivising effect, arguably, only works until players achieve the "best" possible outcome, which does not necessarily equal narrative completion.[46] With the exception of clearly hierarchised ending options, then, multiple endings that accentuate the principle of exploration are similar to the post-ending phases of open world games in that they encourage completist play. While the former open a vast game world to exhaustive horizontal exploration of simultaneously available challenges, multiple endings bind horizontal completion to vertical setbacks, i.e. the game – or at least parts of it – needs to be played repeatedly, with the player making different choices each time, to uncover all available content. From an economical perspective, multiple endings increase a game's replay value as several playthroughs are required to truly complete the game (while open world games with post-ending phases can be completed within one single playthrough). Consequently, each ending loses the sense of finality that this structural entity prototypically holds, even if a single ending provides a maximum degree of closure. Coincidental to the instrumentalisation of the narrative mode for ludic purposes – since it is used to create occasions for player agency – the ending's pluralisation, hence, fundamentally rejects the supposed, prototypical inevitability of narrative endings, presenting them as exchangeable.

Naturally, multiple endings can encourage completist play only if their existence is apparent to players, which games achieve by a range of representational strategies. If and how a game exposes or hints at its multiple endings can, hence, indicate which of the two principles of ludification dominates. Note, however, that the obviousness of multiple endings does not generally rule out a focus on narrative individualisation, as is often the case in games with final choices that are based on moral or ethical questions, in which players can choose the option closest to their personal beliefs such as in MASS EFFECT 3 or DEUS EX: HR (which both combine some prolonged consequences with the final choice to further individualise the outcome).

A final choice always entails the overtness of multiple endings, yet at the same time deprives completist play of its appeal, since full narrative exploration is nearly trivial if the ending is solely determined by one choice. Therefore, prolonged consequences seem to provide a better foundation for successful encouragement of completist play. Yet, as these are often covert, they carry a high risk of leaving players unaware of both the consequences of their actions for the ending and the existence of multiple narrative outcomes in general. Baumgartner notes that, in this case, players either need to blindly test a game's outcome variability with another playthrough or to resort to contextual paratext, e.g. in online walkthroughs, message boards, or fan-wikis (see Baumgartner 2016, 261).[47] Although Baumgartner's observation occasionally holds true – such as for S.T.A.L.K.E.R.[48] – there

are also intracompositional signals for multiple endings that appear even in games with covert prolonged consequences. Mostly, these are meta-ludic messages during the paratextual ending phase. In these, endings are counted (such as in SILENT HILL 2), or the ending just obtained is labelled, either in a neutral way (such as the alphabetically numbered endings of SHADOW OF MEMORIES), evaluatively (such as the "GOOD" and "BAD" endings of SILENT HILL), or with narrative connotations (such as the endings of SILENT HILL 2: e.g. "Leave", "In Water", or "Maria"). Although labelling does not give away the means of how to get different endings, it encourages another playthrough and thorough exploration by implying the existence of alternatives.

In addition to closural evaluation screens, some games keep track of the completion process in the game menu, similar to corresponding records in completion-encouraging open world games. SHADOW OF MEMORIES, for example, reveals the existence of its five endings (labelled A to E) in its "Extras" menu, where the end cards, if unlocked, can be reviewed; and ZERO TIME DILEMMA points at its major endings with seven question marks in its load/save screen, which are replaced by specific symbols as soon as the corresponding ending is unlocked. The effect is stronger in the latter example, as players of ZERO TIME DILEMMA are confronted with their degree of completion each time they load or save a game state, while the "Extras" menu in SHADOW OF MEMORIES is, as the label suggests, completely optional to encounter. This matches the complex integration of multiple endings in the narrative design of ZERO TIME DILEMMA, which will be the sole subject of the following section, as the game's outright indulgence in multiple endings serves to recapitulate and conclude the preceding discussion of their various aspects, from basic narrative branching to the ludification of the narrative mode to hierarchisation and canonisation.

Multiple ending excess in ZERO TIME DILEMMA

The opening cutscene of ZERO TIME DILEMMA begins *in medias res* with nine people who find themselves trapped in an isolated facility somewhere in the Nevada desert. A mysterious, masked person enters, giving a vague and ominous speech. He takes a coin from his pocket – blue on one side, red on the other side – and flicks it. If his prisoners can guess which colour is facing up, he promises, they will be free. Otherwise, they "will have to stay in the game until at least six of [them] are dead". The masked person designates a man called Carlos the leader of his captives, forcing him to make the decision for them all. Or rather, he forces the player, as the game then switches from non-ergodic cutscene to a choice situation, prompting players to pick blue or red. Chances are fifty-fifty, and, indeed, the correct answer is not scripted by the game. What is scripted, however, is that whichever choice players make on their first try will be the right one. In the following cutscene, Zero, the masked person, fulfils his promise for

freedom. After the characters have been drugged, they awake in the desert outside the facility, puzzled, with only vague memories of what happened. The camera zooms out, the screen fades to black, and, slowly, the credits begin to roll, followed by an end card reading "CQD-END:1" and a sun symbol (see Figure 4.10). The whole sequence takes under 15 minutes.

The beginning of ZERO TIME DILEMMA, hence, already presents an ending, foreshadowing the abundance of multiple endings in the game, as well as their ludic and narrative importance, a feature established throughout the ZERO ESCAPE trilogy, which the game concludes. Although "CQD-END:1" superficially seems like a happy ending, since the characters escape a scenario of certain death for the majority of them, a sense of closure is largely prevented by both the sequence's shortness and the complete lack of closural information – open questions include but are not limited to: Who is Zero? Why did he trap these nine people? Why did he let them go so easily after such an elaborate setup? What did his mysterious speech about the fate of the world mean? – Hence, when players encounter "CQD-END:1", they are probably as puzzled as the characters standing in the desert. Yet, in the save game screen that automatically follows, the first of seven question marks displayed below the save state's name changes to the same sun symbol as seen in the end card (see Figure 4.11). The implications are clear: There are at least six other outcomes, represented by six remaining question marks, which can and, hence, should be replaced with corresponding symbols by exploring alternative narrative branches. As in the series' previous instalment, ZERO ESCAPE: VIRTUE'S LAST REWARD (Chunsoft 2012),[49] exploration is further encouraged by a detailed flowchart accessible in a menu, which shows all paths that were already taken, as well as potential continuations (see Figure 4.12).[50] The flowchart is an important feature of both games' mechanics, as it allows players to go back to any previously

Figure 4.10 ZERO TIME DILEMMA, end card.

Figure 4.11 ZERO TIME DILEMMA, save state after first ending.

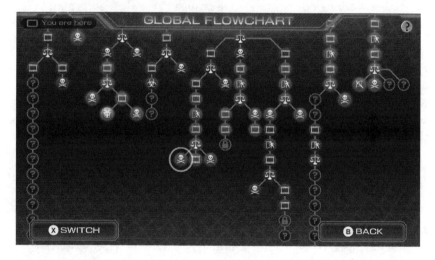

Figure 4.12 ZERO TIME DILEMMA, part of the flowchart mid-game.

unlocked scene by choosing it from the chart. Since the first encounter with the first choice in ZERO TIME DILEMMA invariably leads to "CQD-END:1", these mechanics are learned from the start, as players need to navigate back to the coin toss decision to progress the game.

Only upon guessing the wrong colour will the game actually begin, as only then the intro sequence plays, showing stills from the game, selected credits, and, finally, the game's logo.[51] The story continues with the characters being locked up in an underground shelter, divided into three groups of three people each, doomed to play Zero's cruel escape game,

which demands at least six of them to die. Remarkably, diegetic failure, i.e. guessing the wrong colour, in this case leads to ludic progress. Thus, the game's initial setup suggests that information and insight into the storyworld are more important than positivity of outcome for the game's ending hierarchy.

The games of the ZERO ESCAPE series are highly narrative, and unsurprisingly so, since they belong to the visual novel genre (see Lebowitz and Klug 2011, 192–6), which they combine with that of escape puzzle games. Visual novels often hardly qualify as games as they barely include any ludic elements. As the name suggests, their focus is on verbally delivering a story, similar to a traditional novel, but enhanced with dynamic visualisation. Their dominant gameplay feature is that of player choice in nodal situations. The ludification of the narrative mode that is characteristic of multiple endings is, thus, an important function for visual novels. In contrast to many representatives of the genre, the ZERO ESCAPE series offers frequent opportunities for choice, which are rooted in the games' narrative design of nine people having to engage in a potentially deadly game that forces them to pair up, work together, or conspire against each other, according to very specific rules that require momentous decisions. While both predecessors, NINE HOURS, NINE PERSONS, NINE DOORS (Chunsoft 2009) and ZERO ESCAPE: VLR, put the player in the position of a single avatar, ZERO TIME DILEMMA alternates between three avatars, one for each group, dubbed C-Team for avatar Carlos, D-Team for Diana, and Q-Team for the boy Q. As all three games focus on nine major characters, the increase in player-controlled characters plausibly increases the number of nodal situations (from 18 in ZERO ESCAPE: VLR to 30 in ZERO TIME DILEMMA).[52] In all three games, the decisions determine which direction the story will take, whereas the interspersed escape puzzle sequences predominantly determine if the game advances at all, as players are stuck in a puzzle sequence until they solve it.[53]

The nodal situations in ZERO TIME DILEMMA are diverse, both regarding their representation and the number of options given. What unites them is that they are all introduced by the message "Time to decide!", shown in red in front of a freeze frame of the scenery or characters in inverted colours, accompanied by a distinct sound. In the coin toss situation, the decision is binary, and the odds are even (i.e. they were even in principle, although implemented differently in the game's code, as players always win in their first attempt), with both options leading to different outcomes. The game also includes nodal situations with uneven odds, e.g. when the characters need to roll a sequence of 1–1–1 with three dice at their first try, or to choose one out of ten lockers, only one of which contains a life-saving gas mask. Other choices let players freely input text, for example to state a suspicion for murder, with several input options leading to several different outcomes. Just as in the previous instalments, most nodal situations branch into two paths, but some result in up to four.

The branching in ZERO TIME DILEMMA follows a typical tree structure without bottleneck situations, i.e. all paths lead to a unique outcome (see Ryan 2001b, 248f.). Both the tree structure and its visualisation in a flowchart that encourages the exploration of alternative paths are not particularly unusual for digital games.[54] Rather unique about the ZERO ESCAPE trilogy, however, is that the exploration of alternative paths itself has narrative meaning, since the continuation of some paths is influenced by information given in others that seem unrelated in the flowchart. This information transfer between branches is not only relevant for players, but for characters as well. Hence, the ZERO ESCAPE games require to account for a factor of narrative branching that is mostly not important in digital games, while it is typically crucial for forking-path tales in, for example, film, namely, whether characters are aware of the branching and whether the branching is intradiegetically coherent (see Schmöller 2012, 78–82). As Schmöller notes, character awareness of the successive actualisation of multiple alternative paths requires a "supernatural" narrative setup (see Schmöller 2012, 78).[55] In the ZERO ESCAPE series, this setup uses the science fiction trope of parallel universes that draws on the many-worlds idea of quantum theory (see Ryan 2006, 637–40).

Ryan identifies several criteria for a narrative media artefact "to impose a multiverse cosmology" (Ryan 2006, 656). First, and maybe obviously, the text "must be based on a decision tree or on a diagram with parallel branches" (Ryan 2006, 656). Yet, this is not sufficient, as branching can imply that only one of the paths gets actualised, or in the terms of Possible Worlds theory: one branch constitutes the actual world (AW), while all other branches are alternative possible worlds (AWP) (see Ryan 2014b, 726f.), for example belonging to the realm of a character's imagination (see Ryan 2006, 668–71). This would be the standard case in most fictional worlds, including those of ergodic media artefacts with narrative branching that allow only one path to be taken per run. According to the concept of parallel universes, however, all worlds constitute the AW, i.e. all paths are actualised, "and all the branches must possess equal ontological status" (Ryan 2006, 656). Arguably, this entails the consequence that all paths are, generally, equal, ruling out hierarchisation. Yet, while narrative artefacts can perfectly present several alternative worlds as equal possibilities, the ontological status of the alternatives is only relevant in case of interferences.[56] Hence, "the text must not only move up and down along the branches, it must also perform lateral jumps from branch to branch, and there should be a consciousness within the narrative multiverse that is aware of the jumping" (Ryan 2006, 656). This is clearly the case in the ZERO ESCAPE trilogy, and, arguably, even constitutes the series' most defining narrative element.

Broadly speaking, the trilogy's narrative background revolves around the looming end of humanity following the intentional release of a lethal virus. While ZERO ESCAPE: VLR is set decades after humanity's near extinction,

ZERO TIME DILEMMA plays shortly before this event, and the main motivation of the game's supposedly evil mastermind Zero is ultimately revealed to be the outbreak's prevention, which he himself initiated in a parallel world. The potentially deadly game, which he forces the characters to play, turns out to be an elaborate setup to facilitate this cause, as crisis and lethal danger enable certain characters to switch consciousness with their alter ego in another timeline via a supernatural ability called "SHIFTing".[57] Intradiegetically, the strictly controlled environment of Zero's "Decision Game" ensures that choice situations are limited to guarantee the desired outcome of the characters' SHIFTing. In terms of game design, this narrative restriction plausibly counters the danger of "a combinatorial explosion" that accompanies the parallel universe concept and logically follows from the tree structure's exponential growth, which is incompatible with the design of a (coherent and manageable) narrative game (see Ryan 2001b, 248).

The accessibility of parallel universes in the ZERO ESCAPE series is explained by the so-called "Morphogenetic Field", an invisible, holistic energy that permeates and, thus, connects all parallel realities. At the beginning of ZERO TIME DILEMMA, the protagonists, i.e. the characters serving as avatars, do not know about the Field, conceiving their present timeline as the only AW, while players are likely to know of the game's narrative premise of parallel universes from previous instalments. The concept is also ludically suggested by the game's requirement to actualise (parts of) different branches to proceed in the story before the concept of the Morphogenetic Field is narratively explained. Once characters obtain knowledge about the Field and use it intentionally to transfer information or their own consciousnesses, their private worlds (i.e. their view of the world) change to encompass the multitude of different timelines into their perceived AW (see Ryan 2006, 649). In total, six of the nine major characters of ZERO TIME DILEMMA can actively access the Field via the ability to SHIFT, including all three avatars. Thus, all cases of information transfer between different branches of the game's story are narratively explained, and the key ludic element of exploring narrative branches by jumping back in the flowchart and making different decisions is turned into a key narrative element.

It is finally time to examine how this ludonarrative setup affects, or, more generally, relates to the game's multiple ending design. Although the mastermind's plan is unknown to both the characters and the player for most of the playing process in ZERO TIME DILEMMA, its narrative context clearly implies a goal: Try to find a way out of the shelter with as many, preferably all, people alive as possible. Most characters share this goal, as suggested by their utterances of aversion and objection to Zero's Decision Game. On both the narrative and the ludic level, the subsequently revealed option to transfer to a different timeline, particularly in lethal situations, suggests that failure scenarios, or, more generally, outcomes that deviate from the ideal goal, can and should be avoided. In other words ZERO TIME DILEMMA suggests that there is one "true" ending. Both previous instalments of the

series support this assumption with their own endings of maximum hierarchical status, that each form the longest of all available paths (visually easy to observe in the completed flowcharts), provide the highest degree of closure, present the most positive outcome for the characters, and are marked as canon by the sequels. Save the latter, the same criteria apply to the "true" ending of ZERO TIME DILEMMA, as will be explicated shortly.

Yet, not nearly all branches in the game's story are disrupted by the characters SHIFTing, which terminates the branch without providing an end to it, although these cessations (in contrast to closures) do indeed exist, as is observable from the flowchart on branches that end in a filmstrip icon.[58] Instead, ZERO TIME DILEMMA distinguishes several types of closing a branch, so that the narrative idea of ontologically equal parallel realities is, at least to a certain degree, taken seriously by the game's structure and its representation (during the narrative ending phase, as well as in the flowchart and the save screen). While both endings and mere branch interruptions, ultimately, lead back to the menu, in which the player can choose how to continue the game (either by navigating the flowchart or via a not chronologically ordered "Fragment Select" menu that is grouped per team), endings are paratextually pointed out by an end title screen and by leading to the save menu and its display of ending symbols encountered so far. The explicit suggestion of saving the game indicates that the discovery of an ending of any kind is considered progress, which further emphasises the exploration-encouraging function of multiple endings.

In total, there are three types of endings in ZERO TIME DILEMMA, which all imply a different hierarchical status. First, there are "game over" endings, designated as such verbally in a paratextual message visually equivalent to the end cards of the game's other endings. Both on this end card and in the flowchart, game over outcomes are marked with a skull symbol. There are altogether 23 game over scenarios, which all entail the current avatar's death. Since there are different avatars, some branches in the flowchart are continued even after a game over. For example, D-Team's "Transporter" fragment chronologically connects to a failure scenario of C-Team's "Monty Hall" fragment. Remarkably, the game over in "Monty Hall" invariably occurs after the player's choice for one of ten lockers, one of which contains a gas mask. As there is only a single mask, which can save only one of the three present characters, even the correct choice here leads to avatar death, since in the ensuing cutscene avatar Carlos chooses to protect Akane, the only female character present. Akane's survival is, in turn, crucial for the events in D-Team's connecting "Transporter" fragment. This fact is worth mentioning, since it points to a remarkable difference between the failure sequences of ZERO TIME DILEMMA and those of ZERO ESCAPE: VLR: While in the latter, game over always equals no progress, the former has several situations in which the path to failure is the direct prerequisite for other branches, or contains information that is, ultimately, crucial for the path to the true ending.

The second type can be called the game's "main" endings, as they are hinted at and subsequently protocolled in the game's save and load screen. These endings are designated by individual symbols, which are – just as the skulls of the game overs – shown in white on coloured ground, with the colour signalling the team (red for C-Team, green for Q-Team, blue for D-Team, and cyan in case all nine characters are present). While the ending titles refer to the affected team (i.e. "CQD-END" means that all three teams are present and alive), the symbols themselves are loosely based on a key narrative element of the sequence. For example, the sun in "CQD-END:1" refers to the characters being released into the blazing sunlight of the open desert, while the ending labelled "D-END:1" shows a biohazard symbol, as this timeline – which forms the basis of the events of ZERO ESCAPE: VLR – leads to the fatal release of the virus. "D-END:1" also demonstrates that neither this major type of ending inevitably terminates a timeline in the flowchart, since "C-END:1", symbolised by a moon, directly connects to it. Hence, despite the parallel display of these endings in the save and load screen, they do not form parallel alternatives in terms of mutually exclusive timelines. Rather, they are focused on characters, just as the game over endings. In contrast to the latter, these seven individually labelled endings all involve the survival of the current avatar and the termination of the Decision Game, mostly by their escape. Survival and positivity of outcome, thus, seem to be the main factors differentiating these outcomes from the game overs in terms of hierarchy, although they usually also contain more detailed information about certain aspects of the storyworld, some of which are, again, prerequisites for the actualisation of other branches. The increased hierarchical value of the seven main endings is confirmed by the paratextual ending phase, which includes a credit roll before the end title screen.

The third type of endings in ZERO TIME DILEMMA is hierarchically vague, although clearly lower than the seven main endings. There are two endings of this type, both located in Q-Team fragments, but shown in yellow (instead of green) in the flowchart: First, there is the "HAPPY END", marked with the symbol of a gift, in which robot boy Q's mind is transferred into a virtual reality where it lives happily ever after. As in the main endings, the avatar here escapes the Decision Game, but the virtual reality bestows it with a different ontological status compared to other branches of the multiverse. Second, there is the "Perceptive End", marked by an arrow hitting the centre of a triangle, which refers to a plot twist that is revealed only after several crucial bits of information have been obtained in several fragments. The twist, thus, occurs quite late in the playing process, while the fragment leading to the "Perceptive End" is available at an early stage.[59] Essentially, it concerns a tenth character, a supposedly blind and deaf old man in a wheelchair, who accompanies all teams. His existence is known to the player only after the twist, which also reveals that he is the mastermind Zero himself, and his real name is Delta. In the choice situation of the

Q-team fragment "Triangle", the player can freely type in a name to decide which character to shoot during an escalating conflict. The situation either leads to a main ending ("Q-END:1"), one of two game overs, or, finally, to the "Perceptive End", if the player inputs "Delta". While the following shot is clearly directed at the old man on the level of story, it seems equally directed at the player, as avatar Q fires towards the camera, which had switched to Zero's point of view without the player being aware of it.[60] The screen briefly turns white and then the camera keeps shaking, reflecting the dying man's motions. Although his voice can be heard in the cutscene, he is not shown here at all, so that the characters' gaze – directed both at the player and the dying man – and the dialogue – e.g. Mira saying to Q: "Out of all your choices, you kill him" – gain a double meaning that gives a metareferential dimension to the "Perceptive End".

Narrative context is necessary to understand the special status of the "yellow endings" and why they are not on par with the seven main endings. Although both do not entail the avatar's death, and, hence, do not qualify as a game over, they neither progress the plot nor reveal any crucial information. Consequentially, while positivity of outcome (for the current avatar) features as the main difference between game over and the seven main endings, the "yellow endings" are clearly set apart in hierarchy by their failure to provide additional insight into the storyworld, i.e. by the amount of closural information given. Thus, the two endings rather function as bonus, or Easter egg endings. Yet, they neither demand significant additional ludic effort nor are they particularly hard to find, since the number of possible outcomes to a fragment is always visible in the flowchart even before its completion (signalled by question marks). Their relevance is mostly ludic, pertaining to the game's explicit encouragement of exploration, as full completion cannot be achieved without them.[61] In general, they demonstrate that endings can be assigned different statuses beyond clear hierarchisation, depending on narrative and ludic context, for which explicitly joking Easter egg endings, such as those of SILENT HILL 2, are only one example within the diversity of multiple ending types in digital games.

In contrast, the hierarchical status of the game's true ending, "CQD-END:2", which belongs to the seven main endings, is clear. First, this outcome provides the aspired survival and escape of all characters, which also applies to "CQD-END:1". Yet, second, "CQD-END:2" also resolves the central narrative conflict, giving detailed information about Zero and his motivation, including the purpose of the Decision Game. Thus, the closural effect is maximised on the level of story. Paratextual details further confirm the ending's hierarchical supremacy, as it is (1) represented by an eye symbol that connotes knowledge and insight, (2) positioned at the far right of the ending list in the save and load screen (i.e. holding the final position), complementing the frame that was opened by "CQD-END:1" on the far left, and (3) the only main ending where the credit roll cannot be skipped, the paratext's persistence implying the outcome's definitiveness. The most

remarkable aspect of "CQD-END:2", however, which combines two closural signals that seem incompatible, is that it directly connects to both the game's longest and shortest branches. On the one hand, as has been noted in the discussion of stacking endings, the outcome of the longest branch is conventionally the ending with the highest hierarchical value, a convention that has been confirmed in the tradition of the ZERO ESCAPE series itself. On the other hand, a reference to the beginning is a conventional closural signal that is here implemented in a literal way, although not in form of a circular structure, as it was discussed with reference to JOURNEY.

The ending's twofold connection to both branches is, of course, enabled via the narrative key feature of SHIFTing, which all characters use after the detailed revelation of Zero's plan in the invariably final fragment, appropriately titled "Final Decision". This fragment concludes the longest branch in the flowchart and requires a variety of crucial information that is successively revealed in other timelines, mostly during the segments of other main endings. In the final SHIFT that concludes the fragment – which results from a final choice that conforms to the ludic finale's convention of urgency by giving a time limit of ten seconds – the characters switch consciousness with their alter egos from "CQD-END:1".[62] Apart from the true ending's reference to the beginning, this jump backwards in time also re-evaluates the apparently low-value "CQD-END:1" – which contains no closural information and is obtained without any player effort – by revealing it to be a crucial prerequisite for "CQD-END:2".

Yet, this re-evaluation comes at the price of "CQD-END:1" losing even more of its already low sense of an ending, since it retrospectively marks a mere interruption before the story's final continuation in the true ending. Similar situations during the game simply cause the fragment to stop due to a lack of information to proceed, requiring the player to choose another fragment to continue the playing process. Accordingly, the segment known as "CQD-END:1" could simply have been marked as a cutscene (i.e. a filmstrip symbol in the flowchart). Yet, obviously, its representation as an ending, which is, moreover, acquired even before the game's intro sequence, entails a distinct dramatic effect and serves to introduce players to the key element of ending exploration. Structurally, however, "CQD-END:1" conforms to the criteria of fake endings due to the retrospective revocation of its (low) closural effect. Indeed, the segment narratively continues exactly from where "CQD-END:1" broke off, implying that there is no direct alternative for this timeline, as it is also implied by the flowchart, in which "CQD-END:2" directly follows "CQD-END:1" without another branch leading from it (see Figure 4.13). Hence, within the game's multiverse storyworld, there is no timeline in which the unsuspecting characters simply return home after winning their freedom in the coin toss.

ZERO TIME DILEMMA is a game that clearly emphasises the completion-encouraging aspect of multiple endings over their function of individualising outcome. With its distinct declaration of one true ending and its requirement

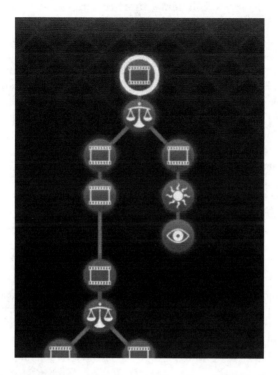

Figure 4.13 ZERO TIME DILEMMA, first and "true" ending (sun and eye) connecting in flowchart.

to obtain most other endings to achieve this goal, the game's choices, as diverse as they are, never involve actual agency with reference to the choices' outcome. While some nodal situations outright deny freedom of choice insofar as there is a correct answer to them that contrasts with failure upon the wrong decision, others at least initially suggest the possibility of choosing an individual preference. Yet, either progress in the story or the game's paratextual stimulation of completist play asks the player to eventually try out all available options in one playthrough. Is choice, thus, ultimately irrelevant and insignificant in the ZERO ESCAPE series? Not at all, as I would like to argue. Rather, the game's ludonarrative setup makes a metacommentary about both freedom of choice and its consequentiality. While the player continuously makes and remakes choices to explore branches that are objectively equal (considering their ontological status regarding both ludic and narrative mode) but subjectively unequal (considering their positivity for the characters and their potential to satisfy the player's demand for closure), the game narratively constantly addresses questions of cause and effect, choice and consequence, and human motivation for choice, provoking reflection of these topics in comparison to the player's own actions in the game.

Arguably, the most prominent cause for reflection occurs right at the game's final moment, as "CQD-END:2" culminates in a choice situation that is not seen through: Standing in the desert, the characters again face their tormentor Zero, now fully aware of his identity and his plan. Both characters and player know that Zero's goal was to save humanity from the virus; yet he condoned and even wilfully set into motion a game that mentally and physically tortured the protagonists, even leading to the deaths of their alter egos in several timelines. Zero himself acknowledges in the final cutscene that the protagonists are fully entitled to hate him for this torture. Handing a gun to Carlos, he offers them revenge, while his concurrent monologue increasingly raises expectations for a choice to come. With his gaze being mostly directed at the camera, his speech seems equally addressed at the characters and at the player. He promises that "you will be able to choose whether to kill me now, or allow me to leave", finally announcing that "this", again, "is the decision game". Indeed, following this monologue, Carlos points the gun at Zero and the frame briefly freezes, just as in each choice situation throughout Zero Time Dilemma. Yet, instead of the expected message "Time to decide!", the credits appear. As the choice is withheld, the game not only questions the morality of revenge but also the meaning of choice itself. The game's narrative context suggests two conflicting interpretations of this question, as the plot has shown both that a simple choice can decide the fate of the world and that choice is ultimately insignificant, since all alternative versions of the world exist in parallel equality. The answer, hence, remains for the player to decide – or not.

4.4 Game over? The closural potential of failure sequences

Failure and punishment

In Zero Time Dilemma, as argued earlier, game over scenarios appear as one type of ending, designated as such via their representational similarities to the game's other endings, although not all of these "bad" outcomes equal failure, since some need to be completed to unlock the path to the game's "true" ending. Thus, Zero Time Dilemma integrates game over sequences in an unconventional way, since the iconic phrase is most commonly triggered by the player's shortcomings, punishing failure with a state that may or may not qualify as an end state. While failure, in the sense of losing, traditionally signifies a game's outcome – albeit one that is undesirable for players – the phenomenon underwent a particular development in digital singleplayer games that strikingly distinguishes it from a classical state of defeat. Most importantly, failure has been conventionalised as a transient state, always implying the option to try again. Even Zero Time Dilemma – due to its specific ludonarrative setup – clearly incites players to go on and try a different action after being confronted with a "game over" screen.

Yet, the diversity of failure sequences in digital games still encompasses variations that resist failure's conventional transiency. As existing research reveals discordant opinions on the game over's status as an ending, this section will explore the potential closural effect of failure in detail, tracing the following questions: Which are the meaning and functions of failure in digital games? How are failure scenarios implemented and represented? In which ways does the ludic element of failure relate to the narrative mode, if at all? Finally, how are failure and the sense of an ending related in digital games?

Failure is both essential and unique to games. As "the art of failure" (Juul 2013, 30), digital games have implemented the repetitive process of failure and re-entry as a structural principle (see Nohr 2014, 262). While similar forms of repetition are exceptional in other media, they are the rule in digital games, affecting both their ludic and narrative design (see Nohr 2014, 263). With its (still to be debated) power to terminate the player's medial experience (i.e. in the case of games, the playing process), the game over is, furthermore, unique because it represents a "prescribed ending, one that is not present, in this form, in any other medium" (Fassone 2017, 54). While player effort is implicit in the medium's ergodicity, the potential of this effort to result in failure further highlights the conditional relationship between player and game, with each relying on the other to proceed (see Eskelinen 2012, 311f.). It follows from this conditional relation that, particularly in games of the progression type – to which most narrative single-player games belong – "there are more ways to fail than to succeed" (Juul 2005, 73). Yet, not only are there many ways to fail in a single game, there are also many ways of implementing failure, not all of which equal what is commonly understood as a game over.

To be precise, it is not failure itself that might or might not qualify as an ending but the event that it triggers. Failure itself is the inadequacy of a player to successfully perform a task, which games can handle in various ways, ranging from game termination to giving no punishment at all (see Eskelinen 2012, 289f.). Apart from extent, punishment also varies in representation, which is crucial for any potential closural effect. In the following, I will use the term *failure sequence* for the representation of the taking effect of punishment. Another prerequisite for the evocation of any sense of an ending is that the punishment "lead[s] to discontinuity" (Eskelinen 2012, 290), i.e. that it causes a distinct interruption in the playing process. While this is the case for both game termination and setback punishment – i.e. punishment that forces the player "to replay part of the game" (Juul 2009) – other types such as "energy punishment" (Juul 2009) occur seamlessly during play (see Eskelinen 2012, 289f.). According to Juul's brief definition of game termination, this type of punishment equals the well-known "game over" (Juul 2009); yet many occurrences of this phrase in digital games link to setback structures, coupled with the option to try again from a set checkpoint or load a save state (see, for example, Figure 4.14). Arguably, setback

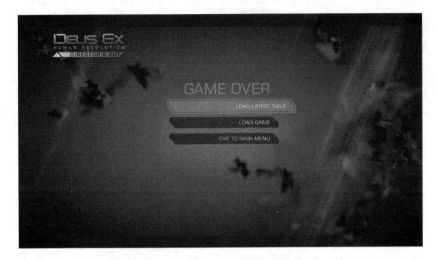

Figure 4.14 Game over screen with different load options in DEUS EX: HR.

punishment historically evolved from game termination punishment, and the boundary between the two types is rather blurry.

In early arcade games, game termination punishment was the prevailing convention of dealing with failure. It was even essential to games with improvement goals, which have no end and, hence, include no event triggering termination other than player failure (see Juul 2013, 29). Furthermore, game termination punishment was economically motivated, as players had to pay for each playing process. Technological developments, such as home consoles and affordable personal computers, fundamentally changed both the economic circumstances of digital games and some of their established conventions. Increasing memory capacity (among other factors) enabled different types of games that were longer and often involved reaching a designated goal, which sparked the desire of keeping progress – both in the case of failure and in order to be able to interrupt play and continue the game at a later time – which game developers answered by introducing save mechanics (see Backe 2008, 305). Save mechanics enabled setback punishment, which, in time, largely replaced game termination punishment.

As much as some players mourn "the evolution of game over from full stop to a more nuanced interpunctuation between different phases of gameplay" (Fassone 2017, 57, in reference to Orland 2007; see also Juul 2013, 29), this was, arguably, already implicit in the economic model of the arcade. After all, even in the medium's early days, game termination was never meant to stop players from playing but to induce them to spend more money. Thus, "ever since arcade games enticed their players to continue a failed game by inserting another coin, games have mostly treated the 'game over' state as unacceptable" (Domsch 2013, 68). What has changed since

then are mostly the routines by which continuation is encouraged, or even automatically effectuated, and the extent of the setback, since game termination, which forces players to restart the game from the beginning, is, in principle, simply a maximum form of setback.[63] After all, transiency is

> one defining characteristic of game over [...]. It is never definitive and its reiteration creates a looping play experience, that is constantly interrupted and resumed [...]. Few games can be traversed without ever encountering a game over in one of its forms, since failure and success [...] are at the core of the experience of playing a rule-based game.
>
> (Fassone 2017, 59)

Accordingly, although the game over in its original sense might be "dying" (see Orland 2007), "failure is actually becoming more common, with infinite retries and smaller punishments lowering the cost of failure" (Juul 2013, 87). The decrease in punishment follows a change in the medium's conventions, which now include "the promise that almost all players will be able to complete them [i.e., the games]" (Juul 2013, 29). While games can, and occasionally do, completely avoid failure sequences,[64] the enduring prevalence of (albeit less consequential) failure directly results from its ludic functionality. Since "players learn how to interact with video games through trial-and-error processes" (Alvarez Igarzábal 2019, 138), failure sequences serve "as a pedagogic feature of video games" (Fassone 2017, 54). They clearly communicate a game's rules and goals and offer "a tool for players to monitor and reflect upon their performance", with the interruption of play giving them "an opportunity to rethink and adjust their strategy" (Fassone 2017, 56).[65] Players, thus, conform their actions to the medium's structural principle of repetition in order to succeed, willingly submitting themselves to the game's demand of constant self-optimisation (see Nohr 2014, 253). As long as setbacks still occur, slighter punishment for failure, first of all, simply makes this process of self-optimisation more agreeable and easier to endure.

Against the contemporary trend of games becoming easier, Fassone observes "the adoption of more experimental and, at times, openly nostalgic practices of game design", particularly in the "diverse scene of independent developers between 2008 and 2010" (Fassone 2017, 59). Many of these experimental and nostalgic practices are aimed at making games more difficult again, such as roguelike games, which need to be restarted from the beginning after failure and which, furthermore, change with each playthrough, as their game worlds are generated procedurally (see Fassone 2017, 59). As another example, Fassone mentions SUPER MEAT BOY, the "infamous, tough-as-nails platformer"[66], which "mimick[s] the unforgiving design practices of early platform games" (Fassone 2017, 59). Yet, the contemporary trend of more agreeable punishment still prevails in this game: While the challenges of SUPER MEAT BOY are undeniably difficult

to overcome, punishment for failure differs strikingly from early platform-ers as players have an unlimited number of lives, i.e. attempts to complete a level. Moreover, re-entry happens seamlessly, as the avatar immediately reappears at its starting position after its death and the screen briefly fading to black, the whole process taking less than one second. In contrast, most classic platformers demanded player input to restart a level, such as SUPER MARIO BROS. 3 (Nintendo 1991), where players had to manually re-enter a level from the world map after losing one of a limited amount of lives. Even DARK SOULS, popularly praised for bringing back difficulty into the action adventure and RPG genres, is more forgiving than some earlier games, as progress is never completely lost, and the avatar respawns after death. Just as in SUPER MEAT BOY, albeit slower, the respawning process itself occurs automatically at a predefined location and players never need to manu-ally save the game. Although all previously defeated enemies respawn as well, and the avatar loses all collected "souls" (i.e. the game's experience points), players get one chance to retrieve them at the spot of their failure. While DARK SOULS and SUPER MEAT BOY are indeed less forgiving than many other contemporary games, they still conform to some of their con-ventions of player convenience.[67] Hence, difficulty does not directly corre-spond to neither the extent of punishment nor the dramatic effect of failure sequences. Before discussing the aspects that *are* essential to this dramatic effect, I will review some of the general arguments for and against regard-ing the game over as an ending.

Failure sequences with a sense of an ending?

While no game scholar denies the game over's transiency that resides in its (implicit or explicit) invitation to try again, opinions differ about whether this transiency contradicts the interpretation of failure sequences as end states. In general, since failure ultimately boils down to the player's insuffi-ciency, it clashes with closure's basic requirement of "allow[ing] the reader [or player, MH] to be satisfied with the failure of continuation" (Herrn-stein Smith 1968, 34). Rather than evoking "the expectation of nothing" (Herrnstein Smith 1968, 34), failure sequences conventionally evoke the expectation of getting another chance. Although this expectation is con-ventionally met in contemporary digital games, the traditional ludic mean-ing of failure as a loss state is still the most common argument for a sense of an ending surrounding game over. Yet, if a game's regular ending is determined by winning, or, more generally, by reaching the game's goal, game over only elicits a sense of an ending in negative relation to the desired outcome (see Neitzel 2000, 99). Thus, failure, in general, cannot be defined positively, but only as the negation of success, as *not* reaching a goal. Still, this negation is in the realm of possible outcomes, as a prototypically ludic, "pervasive sense of the ending that is to be avoided" (Brown 2014, 165). As Fassone remarks, "[g]ame over is indeed an end state, but one that differs

essentially from those found in other media" (Fassone 2017, 54). The main factor preventing failure states from providing closure, thus, seems to be their lack of acceptability.

The sense of an ending that Fassone attributes to the game over is fundamentally different from closure, which he calls "its polar opposite" (Fassone 2017, 53). Instead, he describes it as "the machine's complete and final opposition, a form of cybernetic caesura in which interaction is suspended and usually can only be resumed at the price of reverting to a previous state" (Fassone 2017, 54). Thus, game over demonstrates "the presence of digital authority" (Fassone 2017, 55) that is normatively "imposed upon the player by the game" in form of "a non-negotiable full stop" (Fassone 2017, 56). To be sure, not all failure sequences in digital games – not even all that cause an interruption in the playing process – conform to Fassone's concept of a "prescribed ending" that "derives from a precise design strategy being implemented in the game" (Fassone 2017, 55). Yet, even the automatic re-entries of, for example, SUPER MEAT BOY – which can hardly be understood as a full stop – demonstrate the same "authorial (or even authoritarian) strength exercised by the game over its player" (Fassone 2017, 55), since they are non-negotiable. Yet again, the non-negotiable execution of rules by the system is inherent to all aspects of digital games, so that it can hardly be taken as a factor that specifically contributes to the game over's potential sense of an ending. Rather, the degree of execution of authorial strength (i.e. the extent of the punishment) and its communication (i.e. the game over's representation) do. [68]

One of the most powerful arguments against understanding failure sequences as endings is their narrative meaning, or, rather, lack thereof. Although game over mostly correlates with avatar death, it is an event that predominantly triggers the ludic frame and is mostly understood as narratively irrelevant, as empirical data confirm (see Sallge 2010, 90). The story actualised during the playing process of a narrative digital game is retrospectively reduced to the successful segments of the process, and any mistakes and failures are at most viewed as delays without any narrative consequences (see Engelns 2014, 145 and 214f.). Nohr even notes the perceived narrative irrelevance of failure sequences as crucial to the structural re-entry logic of digital games, which "is only possible because the player leaves the ostensible diegesis of the game and turns to the interface" (Nohr 2014, 266, my translation from the German). As, on the one hand, death is functional in games for the process of trial and error, and, on the other hand, progression would be difficult if players would constantly have to fear losing their avatar for good, games rid death of its finality (see Neitzel 2008, 88). Furthermore, completable goals lead players to expect that a game has an endpoint coinciding with the goal's achievement and narrative framing suggests the existence of a satisfying resolution according to narrative conventions, so that players are aware of avatar death being only a symptom of ludic failure rather than the story's conclusion (see Backe 2008,

323), at least if the event occurs in predominantly ludic sequences. The recency effect adds to this by retrospectively lowering the impact of failure sequences, because a game over is most likely not the last outcome players encounter (except in case they actually discard a game after failing). Consequently, due to failure's conventional transiency, the strong knot between protagonist death and ending, which is an established part of prototypical narrative closural signals, becomes loose in digital games (see Neitzel 2008, 84), and the player's awareness of this substantially lowers any game over's potential closural effect. Considering the transmedial interest of this study, it is remarkable how ludic conventions can thus affect or even override narrative conventions.

Games with "permadeath"[69] – such as The Binding of Isaac (Edmund McMillen 2011), a representative of the briefly mentioned roguelike genre – reject the conventional transience and inconsequentiality of avatar death. These games present "[c]ases of non-transient game over" (Fassone 2017, 55) by punishing failure with the permanent loss of all progress, which can be interpreted as the player character's permanent death, although in most cases, the same character can be used as avatar again in another playing process.[70] Not all occurrences of this permanent failure mechanic narratively involve death, however. In the turn-based strategy game Renowned Explorers: International Society (Abbey Games 2015), failure is instead narrativised as the player-controlled group of explorers losing their resolve for continuing their expeditions. Similarly, XCOM: EU includes game termination punishment if the player, in the fictional role of XCOM's commander, fails to make sufficient progress in the fight against the alien invaders, so that the world council finally withdraws its support for the XCOM project. Involving death or not, such forms of game termination punishment increase the corresponding failure sequence's closural effect – particularly if they are distinctly narrativised as further discussed below.[71]

Nevertheless, albeit maximising punishment, even games with permadeath are prone to being restarted upon failure. They also mostly conform to the convention that "all game over situations are identical" (Domsch 2013, 36), or at least nearly identical, accounting for, for example, minor variations in setting or cause of avatar death (e.g. getting shot versus falling from a cliff). The sequences' lack of individuality prevents them from being "regarded as valid branching options" (Domsch 2013, 36) in the sense of multiple endings. Thus, game over conventionally is signalled as but "a pause in the path" and "the failure state is not an actual path available" (Bryan 2013, 16). In this sense, the validity of the negation of success as an outcome is neglected – emphatically so by Jeffrey S. Bryan: "No, having the ability to lose isn't an end to the path on its own" (Bryan 2013, 16).

However, Bryan goes on to describe the bad endings of Castlevania: Symphony of the Night (Konami 1997)[72] as "a wonderful example of loss states that form new paths" (Bryan 2013, 16), implying that there is a potential for closure or at least a sense of an ending in failure sequences.

Yet, Bryan's terminology here is somewhat misleading, since what he calls the game's "end states [...] B and C" (Bryan 2013, 16) are rather low hierarchy endings than failure sequences. Although they do imply the failure to find and defeat the true villain, Dracula (and almost half of the game's overall content), these endings occur after the *successful* defeat of another, seemingly final boss. As they do not entail any punishment, are narratively framed, and paratextually complete with a credit roll, they contrast strikingly with the game's regular failure sequence that occurs upon depletion of the avatar's health and presents a simple game over screen. Hence, the bad endings constitute "loss states" primarily on the narrative level, as they represent the protagonist's failure to uncover the truth – although this is, of course, the result of player actions. The game over screen and the bad endings of CASTLEVANIA: SOTN, thus, result from two different kinds of failure, with the former arising from the player's inadequacy of overcoming skill-based challenges, and the latter relating to the failure to find and correctly apply a special item. Moreover, the bad endings do not involve avatar death. As stated in the previous chapter, ZERO TIME DILEMMA makes a similar distinction between game over and other types of ending by the main factor of avatar death. Following the imperative of the game over's transiency that deprives protagonist death of its narratively traditional sense of an ending, the events leading to the bad endings of CASTLEVANIA: SOTN provide an overall more acceptable basis for closure. Both the example and Bryan's debatably broad notion of failure demonstrate that the concept of failure is not clear-cut per se, with different kinds of failure in one game possibly resulting in different kinds of punishment, different narrative consequences, and different degrees of closure, suggesting that no simple yes or no can answer the question whether game over qualifies as an ending.

The PERSONA series provides further examples that are both similar to and different from that of CASTLEVANIA: SOTN. As outlined in my discussion of multiple endings, PERSONA 4 has three endings arranged in a stacking structure with increasing length, ludic effort, and degree of closure. Since all these provide a basic closural frame with a final cutscene and a credit roll, they are comparable to the ending variety in CASTLEVANIA: SOTN. Yet, PERSONA 4 includes failure sequences that definitely have a lower closural effect than those endings, but clearly evoke a higher sense of an ending than its regular game over scenarios. The game's regular failure sequences occur if players lose a fight, implying the death of the avatar and other party members. An ensuing cutscene takes player and protagonist to the otherworldly "Velvet Room", a location visited many times during the game, for both ludic and narrative purposes. A solemn and gloomy text is displayed, before the scene vanishes and the player is presented the choice to re-enter the game at a save state or quit.

The other, more elaborate type of failure sequences is triggered if players fail to complete a dungeon in time. It is a core feature of the series that

players manage the protagonist's everyday life, which progresses according to his high school schedule, besides exploring dungeons and fighting monsters in a parallel dimension. Events in the diegetic real world set a time limit for the completion of each dungeon. If the crucial date is not met, unique expanded failure sequences are triggered. In PERSONA 4, the person to be rescued from the dungeon is found dead and the bad news leave the protagonist in despair, unable to continue his quest. Just as in regular failure sequences, the scene then changes to the Velvet Room, but instead of a text being displayed, the room's master explains the impossibility of continuing the protagonist's quest. Although the sequence is, thus, distinctly narrativised, it is, ultimately, marked as a transient game over state in contrast to the game's main endings, as there is no credit roll, but players are, again, given the option to retry or quit. In the game's sequel, PERSONA 5, the narrative setup of these special failure sequences is even more elaborate, both regarding length and individual design. Yet, they also employ the most effective convention of game over, namely avatar death, as the protagonist is, ultimately, killed in the epilogues of these sequences. Overall, both games show deliberate effort to increase the closural effect of their extended failure sequences, hierarchically locating them somewhere in between regular game over and their major bad endings.

Again, these examples show that the potential sense of an ending conveyed by failure sequences is highly dependent on representational strategies and context, particularly in the light of a game's other outcomes that might include distinctly bad endings. Although a lack of acceptability largely prevents game over from providing closure, it is important to note that "the success state doesn't necessarily involve a positive outcome, but simply signifies the completion of a path" (Bryan 2013, 16). Negative outcomes that seem unacceptable to players who expect the success state to align with a happy ending not only feature as lower hierarchy alternatives in games with multiple endings but also occur in the tragic finales of some games without alternative outcomes, such as RED DEAD REDEMPTION, which even aligns the bad narrative outcome with ludic failure with its unwinnable final ergodic sequence.

Apart from intracompositional factors, external aspects, such as genre, can influence the acceptability of a negative narrative outcome. For example, although the "In Water" ending of SILENT HILL 2 involves the protagonist's death in suicide, the horror genre – in addition to James' morally ambiguous backstory – renders this outcome acceptable, since entirely positive closure is not part of generic conventions. While a decisive factor of an outcome's acceptability surely is the player's sense of having succeeded or failed, games might not always communicate this directly. For example, players of CASTLEVANIA: SOTN might be satisfied with a bad ending if they never know about the item needed to continue on the path to the true ending, since there is no intracompositional signal of the bad outcome's low hierarchy.[73] In contrast, the abruptly initiated regular failure sequences

clearly signal the player's insufficiency with the iconic phrase "game over" and because players know about having caused the interruption by letting the avatar's health drop to zero. Analogous to the classification of narrative branching, it could be said that regular failure sequences equal immediate consequences, while extended failure sequences and bad outcomes are the result of prolonged consequences.

In the following, I will further discuss representational strategies used to narrativise failure sequences to elicit a closural effect that defies their ludic transiency.

"As a cyborg, you will serve SHODAN well"[74] *– Narrativisation of game over*

On a quest to stop the rogue A.I. SHODAN, the protagonist of SYSTEM SHOCK explores a space station roaming with hostile robots and cyborgs, which were formerly part of the station's human crew. If players fail in an encounter, the protagonist's fate is even worse than death, as his body is turned into a cyborg as well, forced to switch sides. Wrapping up the game's central narrative conflict in a negative outcome, the brief cutscene showing this process adds a sense of mockery to this ultimate defeat ("you will serve SHODAN well"). Players are then taken to the main menu screen. Yet, SYSTEM SHOCK has another way of dealing with failure. On each level of the space station, players can find a device which performs the cyborg conversion on a dead body. The device's function can be changed to instead revive the avatar upon death, so that the narrativised game termination punishment is replaced by an equally narrativised, seamless re-entry sequence.

Thus, as early as 1994, SYSTEM SHOCK shows two strikingly different ways of dealing with avatar death, both of which address a narrative paradox that Alvarez Igarzábal (2019) calls the Groundhog Day Effect (GDE), referring to the movie GROUNDHOG DAY, in which protagonist Phil is forced to relive the same day over and over again. Accordingly, the GDE describes how the conventional re-entry logic of narrative digital games "generates a gap between the knowledge acquired by the player from previous attempts, and the player character's knowledge, which is reset along with every other element in the gameworld every time the player loads a saved state" (Alvarez Igarzábal 2019, 138). The Restoration Bays in SYSTEM SHOCK represent the respawn mechanics that Alvarez Igarzábal lists as one of the "'solutions' to the paradox", in which "the act of spawning (and respawning) is integrated into the fictional world, avoiding the need to load saved game states" (Alvarez Igarzábal 2019, 123). The respawn strategy is a narrativisation of failure sequences that rejects any sense of ending, since there is no stop after failure, even on a narrative level, just as the deaths of Phil in GROUNDHOG DAY do not actually end his life, as he always wakes up unharmed on the morning of the titular date, with his memory of previous iterations

of the day fully intact. In contrast, the game termination punishment in
SYSTEM SHOCK, which shows the protagonist's cyborg conversion, provides
a narrativisation that highlights the closural potential of the failure event.
Although re-entry is still possible by manually loading a (manually created)
save state, it is not directly encouraged during the game over sequence and
the re-entry would not be part of the avatar's fictional memory. Yet, upon
reloading, the paradox still occurs – or does it?

Arguably, the narrative paradox of the digital game's re-entry logic can
be rationalised with parallel worlds theory, as journalist Ben Croshaw pro-
poses in his article "Death in Videogames":

> In terms of the many-worlds interpretation of quantum mechanics, we
> are stepping into a different universe where events can occur slightly
> differently. That death we suffered still stands back in the old timeline.
> In that universe, the goodies will fail, a superior officer brings tearful
> news of your death to your parents in what little time remains before
> the bad guys' doomsday weapon detonates. We, the player, opportun-
> istically hopping into the body of our player character's quantum clone,
> are the only ones who remember the old timeline, but it will still exist
> somewhere, and that will weigh heavy on our minds for eternity. When
> we finally beat the game, we are playing as the one Gordon Freeman
> or Sam Fisher or Lara Croft that got enough lucky breaks to see things
> to the end, while the multiverse at large is riddled with the corpses of
> our failures.
>
> (Croshaw 2011)

Alvarez Igarzábal's visualisation of the GDE's temporal structure matches
the concept so affectively outlined by Croshaw by arranging fictional time
in parallel timelines with varying (premature) endpoints (e.g. effectuated
by player failure), while playtime progresses unilinearly towards one end-
point (see Alvarez Igarzábal 2019, 119). Similarly, Hitchens points out that
"the personal experience of time for the player is *linear*" (Hitchens 2006,
45, original emphasis), whereas "Game Progress Time" includes setbacks
that lead to branching with premature endpoints for any unsuccessful path
taken (see Hitchens 2006, 47). As this study has shown, this concept is
fictionalised, i.e. part of the game's diegesis, in the ZERO ESCAPE series. In
ZERO TIME DILEMMA, each termination of a path – be it one of the major
outcomes or a game over – constitutes an ending, while there is only one
ending that solves the central conflict of the game and provides maximum
closure, and that is encountered after players uncovered (nearly) all other
outcomes. Even besides the fact that many of these outcomes are distinctly
labelled "game over", the general similarity to the conventional re-entry
structure of digital games is undeniable, and the parallel timelines of var-
ying length in the game's flowchart are reminiscent of the visualisation of
the GDE.

In contrast, the failure sequences of METAL GEAR SOLID 3: SNAKE EATER indirectly refer to the multiverse theory by rejecting alternative timelines: Narratively, the game is a prequel to the series, so that the death of protagonist Snake is not compatible with the story of previous instalments. Consequently, the event is presented as unacceptable when the game over message "Snake is dead" slowly transforms into "time paradox" (see Figure 4.15). Thus, instead of providing a coherent solution to the ludonarrative dissonance evoked by the GDE, METAL GEAR SOLID 3 rather confirms the paradox on the narrative level, insisting that players find the one correct timeline to ultimately prevent it.

Admittedly, it may seem futile to attempt a narrative explanation for the GDE with multiple worlds theory, since failure and re-entry are predominantly ludic features that require no narrative explanation. Hence, if the existence of a fictional multiverse is not evoked by the game itself – such as in the ZERO ESCAPE series – it is irrelevant for narratological analysis. Although various contemporary games try to coherently integrate re-entry structures into their narrative level (e.g. ASSASSIN'S CREED, BIOSHOCK, or

Figure 4.15 METAL GEAR SOLID 3, transformation of failure message.

BORDERLANDS 2), even the ludonarrative dissonance otherwise produced by the paradox is just one more digital game convention that players easily accept following the principle of medium-specific charity (see Thon 2016, 106). Yet, the application of multiple worlds theory is interesting in the light of the closural potential of failure sequences, since it facilitates an understanding of game over as a possible narrative end state despite its ludic transiency. The plausibility of such an interpretation is particularly important for games that deliberately highlight the narrative impact of their failure sequences such as in the cyborg conversion of SYSTEM SHOCK.

In general, game over narrativisation covers a wide range of representational strategies, from basic representation of avatar death to epilogical wrap-ups of the game's story. Certainly, most of these forms are not particularly aimed at evoking a sense of an ending. First and foremost, the narrative representation of failure, for example a dying protagonist, facilitates the player's comprehension of the ludic mechanics of failure and punishment. Yet, any representation of avatar death still heightens the event's narrative impact compared to an immediate transition to an extradiegetic game over screen, linking the player's insufficiency to consequences in the storyworld. Accordingly, Mark J. P. Wolf traces the beginnings of game over narrativisation back to PAC-MAN: "[W]hen Pac-Man died, he did not merely vanish, as other characters did, but instead shriveled up with an accompanying sad musical flourish as if soliciting sympathy from players and bystanders" (Wolf 2002, 97). According to Neitzel, the general rise of narrativity in digital games and the medium's technological advances led to an increasingly diverse repertoire of narrativised death sequences (see Neitzel 2008, 85).

Like PERSONA 4 and 5, THE LEGEND OF ZELDA: MAJORA'S MASK shows two variations in one game. First, the game's regular failure sequence, which occurs if avatar Link loses all health, simply shows Link breaking down, accompanied by a sad tune (just like Pac-Man). The game then automatically resumes from the player's last point of entry to the current location. Second, players can fail to meet a time limit that structures the whole game: Within three days, thus the game's narrative setup, the sinister-looking moon will crash down on the world, leading to its destruction. It is Link's and the player's quest to prevent this from happening. Yet, since players find a device to rewind time, the (constantly visible) time limit, albeit some remarkable effects on gameplay, is not as threatening as the narrative level makes it seem. However, if players fail to rewind in time, or are simply curious what might happen when time runs out, the apocalypse indeed happens: A cutscene shows the moon crashing down and, subsequently, Link screaming and trying to shield himself from the blast, but to no avail (see Figure 4.16). A single sentence closes the sequence: "You have met with a terrible fate, haven't you?" The punishment for this failure is not game termination, since the last save game is automatically loaded. Yet, the extended representation of the moon's impact and the focus on

Figure 4.16 Majora's Mask, Link dying in the apocalypse.

Link's horrified expression when he meets his demise put an emphasis on the event's narrative consequences that strikingly contrasts with the much shorter regular failure sequences of Majora's Mask, in which Link is seen in gameplay perspective, i.e. usually from behind.

Another elaborate example of avatar death narrativisation is found in Metal Gear Solid 4. The failure sequences of the series in general are famous for being accompanied by NPCs desperately trying to contact the protagonist and crying out his name, unwilling to accept his demise. While still including this iconic feature of the series, Metal Gear Solid 4 takes narrativisation one step further: When avatar Snake's health bar depletes, he breaks down with a painful death cry, and his fall is intercut with a quick succession of frames from cutscenes witnessed during the prior playing process. As the scenes adapt to the player's progress in the game, they symbolise the protagonist's life flashing before his eyes in his final moments before his body stops moving and the screen fades to white noise. The following "mission failed" message, however, instantly diminishes the briefly heightened closural effect of the death sequence by giving the conventional options to continue or exit the game.

It should be noted that, apart from emphasising the narrative impact of protagonist death, elaborate death sequences can also function "as a spectacular device" (Fassone 2017, 61) that compensates the player's loss of control upon failure with viewing pleasure (see Fassone 2017, 64f.). Arguably, this function applies to the game over sequences of Metal Gear Solid 4, which offer players the pleasure of discovering references to previous scenes, including some of a rather funny nature such as a cutscene in which Snake witnesses a soldier having digestion issues. Usually the spectacle of game over death sequences is more of a gory nature, "fascinat[ing] through the immediate joyful discomfort of witnessing (bodily) destruction" (Juul 2013, 100).[75] Using the example of the particularly graphic failure sequences of Dead Space 2 (Visceral Games 2011), Fassone traces their pleasurable viewing experience back to formulas established in horror movies, especially those of the slasher genre, which present spectacular death sequences in a modular fashion similar to that in which players witness the repeated demise of their avatar (see Fassone 2017, 62–5).

To be sure, spectacular audiovisual representation does not necessarily contribute to narrativisation or closure. For example, while UNTIL DAWN even repeats all violent character death sequences triggered during a play-through in direct succession at the beginning of its credit roll, the first encounter with these sequences during play does neither terminate nor interrupt the game as there is no re-entry in UNTIL DAWN. If an avatar dies, further scenes with the character will be skipped and play contin- ues seamlessly with the player controlling one of the other protagonists, who can all die or survive the night, depending on player performance and choice. In contrast, death of any of the three avatars of NIGHTCRY (Nude Maker 2016) – another horror game that, just as UNTIL DAWN, draws on many conventions of the slasher film – leads to a "dead end" that terminates play, taking players back to the main menu. Both the sequences' function of a pleasurable viewing spectacle and their role as bad outcomes are high- lighted paratextually, as finding a dead end is rewarded with a meta-ludic trophy and the game keeps track of the player's progress in completing a collection of game overs (25 in total) in a separate menu. As the menu dis- tinguishes these dead ends from eight available main endings, the failure sequences of NIGHTCRY appear as low hierarchy endings with marginal closural effect, similar to the game overs of ZERO TIME DILEMMA, albeit without the additional ludic functionality of the latter.

Compared to mere death scenes, failure sequences with an epilogical function usually provide a stronger narrativisation and closural effect, since they give information about the consequences of the event that caused fail- ure on the storyworld, just as it is the case in the extended failure sequences of PERSONA 5. A more rudimentary representation is found in FALLOUT 2 (Black Isle Studios 1998), where avatar death is followed by a picture of the protagonist's remains and varying phrases uttered by a narrator, which are determined partly by progress and by way of dying. Many of these phrases fulfil a basic epilogical function such as "You have died. Your village is lost, doomed to die of starvation", or, more consequentially: "Your death has sealed the fate of everyone else on Earth. The Enclave triumphs, releasing the FEV virus into the atmosphere. Millions die, and the Earth falls silent… again." However, the use of such content closural signals is not consist- ent in all failure sequences of FALLOUT 2, since some are rather neutral ("You have perished"), while some rare occurrences even aim at mocking the player for a particularly bad performance ("Boy, are you stupid. And dead.").

In contrast, each failure sequence of FAHRENHEIT (Quantic Dream 2005) is epilogical, narrated by one of the avatars, even if the event leading to failure entails their death. A common scenario in the game is that protag- onist Lucas gets arrested for a crime he did not commit, with the failure sequence playing out a short cutscene of the event. The final frames of these cutscenes usually conform to an established visual closural signal such as increasing distance between the camera and the characters (see Figure 4.17).

Figure 4.17 Example of a final frame of a failure sequence in FAHRENHEIT.

The voice-over narration is often detailed and contains evident closural signals, particularly in a first sentence that openly declares the end of the story. For example, during an early possible arrest, Lucas narrates his fate as follows:

> And that's how my story ends. The cop, who thought at first that I was injured, opened the door to the toilets and found the body. I'll be spending the rest of my days rotting in some prison somewhere. I'll never know exactly what happened to me that cold night in January in the toilet of an East End restaurant, because as far as everyone else is concerned, I'm just a killer.

Remarkably, as soon as the narration begins, the options to "continue from last save" or "stop" appear in the centre of the screen, ludically diminishing the sense of an ending that the sequence evokes audiovisually and by narrative content. Yet, even narratively, the sense of an ending is kept low as the narration hints at some of the story's loose ends.

"Wait! That one doesn't count!"[76] *– The acceptability of failure*

In conclusion, the sense of an ending evoked by failure sequences is at best ambiguous. Even games that deliberately emphasise the closural potential of their game over scenarios are still subject to the dominant conventionality of failure's transiency. Yet, the boundary that distinguishes failure sequences from bad endings is blurry, so that it is not always clear why "the 'game over' outcome is usually not counted as an ending [...] although 'bad endings' are" (Domsch 2013, 77). There is no universal answer to this

classification problem, as it ultimately depends on the representation and context of the sequences, which are unique to each game. The decisive role of differences in representation and context has been shown in the previous discussion of CASTLEVANIA: SOTN and the PERSONA series. While these examples provide some helpful clues for classifying their bad outcomes – because "regular" failure sequences that occur upon avatar death are distinct from the games' more narratively focused bad endings – the issue is more difficult in games that do not include typical game over scenarios. For example, Janet Murray classifies the bad endings of the classic adventure MYST as loss states (see Murray 1997, 141). Indeed, the game includes no variations of failure other than the avatar getting trapped inside one of the storyworld's magical books if players fail to help the benevolent Atrus, or foolishly choose to trust one of Atrus' malevolent sons instead. According to Backe, rather than representing acceptable narrative outcomes, these bad endings designate narrativised and emotionalised failure sequences without a game over screen that "only exist to motivate the player to search for the positive ending" (Backe 2008, 325, my translation from the German). Backe's reasoning alludes to the principle of exploration that is encouraged by multiple endings in digital games, especially if they are distinctly valorised, forming an outcome hierarchy (see Chapter 4.3). Despite their overall low closural effect, failure sequences are clearly part of such hierarchies, as losing is essentially a low-value outcome. Since games are challenging and enjoyable partly because "[p]ositive outcomes are usually harder to reach than negative outcomes" (Juul 2005, 40), failure sequences are necessarily located at the bottom of ending hierarchies.

The ambiguous closural effect of loss states is not unique to digital games. A similar classification issue occurs in unilinear narrative artefacts with "forking paths" (Bordwell 2008), which often include re-entry structures that oppose an understanding of their multiple paths' end points as multiple endings. For example, films like GROUNDHOG DAY, RUN LOLA RUN, or EDGE OF TOMORROW show their protagonists failing and re-entering until they achieve a certain goal. While the re-entry sequences are increasingly quick and seamless in GROUNDHOG DAY and EDGE OF TOMORROW, RUN LOLA RUN puts emphasis on the outcomes of Lola's two unsuccessful "runs", even framing them with obscure dialogue sequences that seem as distant from the diegetic real world as the Velvet Room scenes in the game overs of the PERSONA series. The closural ambiguity of failure and re-entry, thus, has a transmedial scope, although structurally, it is most important, even defining, for the digital game. Hence, its comparatively rare occurrences in other media might qualify as intermedial references rather than indicating the phenomenon's transmedial range (see Rajewsky 2002, 16f.; Leschke and Venus 2007, 17).

While loss states have always been undesirable to players, the social dimension of most traditional games enforces their acceptance to a certain degree. As non-digital games are usually played against others, there is

always a winner and a loser, and even a rematch can at most shift the burden of accepting a bad outcome to another player. While the same principle holds for digital multiplayer games, singleplayer mode facilitates the process of dismissing a bad outcome to strive for success in another attempt, as there is no need for negotiating the repetition with other players. The ludic unacceptability of a loss state and the general pluralisation of endings – witnessed by various phenomena discussed in this study – effectuate the game over's conventional transiency and diminish its potential sense of an ending despite its conceptual function as an outcome.

The structural principle of re-entry in singleplayer games can have both motivational and straining repercussions on players. While the chance to retry a task encourages players to view failure, in general, as a mere setback, a non-fatal, minor step back in a continuous path to success, it also implies the pressure to take this path and the constant demand to improve, especially if re-entry sequences occur seamlessly, without even giving players the option to quit. This implicated pressure might be a reason for many games to still uphold the established convention of a game over screen, which offers players both a distinct break and the choice of taking another attempt or not. Overall, the historical changes in failure sequences did not affect their closural ambiguity, as they resulted in a diversification of conventions rather than their replacement. There have been both trends to diminish (e.g. via automatic re-entry sequences) and to increase (e.g. via narrativisation) failure's outcome acceptability, as well as measures countering these trends (e.g. permadeath, or the narrativisation of re-entry). The variability of failure sequences, both regarding representation and gameplay, offers a new perspective on outcomes and endings that allows their playful consideration but ultimately rejects a fatalistic understanding of the end.

4.5 The end… or is it? – The pluralisation of endings in digital games

This section was guided by the hypothesis that narrative digital games, despite mostly conforming to the prototypical narrative structure of beginning, middle, and end, include a vast variety of ending forms and functions that lead to a distinct pluralisation of this traditionally singular structural element, even within the bounds of single media artefacts. The phenomena supporting my hypothesis range from less frequent occurrences of fake endings, to a multiplication of ludic endings (i.e. ludic finale and completion) in open world games, to the various forms of narrative multiple endings, to the potential bad outcomes of failure sequences. Most narrative digital games employ at least one of these phenomena. While their potential sense of an ending varies significantly according to individual design, it still seems safe to say that ending pluralisation is the rule rather than the exception in digital games. Predominantly, this pluralisation serves ludic functions, for

example prolonging the playing process or fulfilling the prototypical ludic quality of variable outcome. Yet, as ludic and narrative mode in digital games are often tightly intertwined, not only has this ludic functionality repercussions on the game's story and narrative representation, but the phenomena are often used for narrative purposes as well, such as when choice and multiple endings become a narrative leitmotif as in ZERO TIME DILEMMA, to only mention one of the most striking examples.

Since most forms of ending pluralisation have been identified as distinctly medium specific, as they are born from the specific ludonarrative hybridity of digital games, they do not demand an adjustment of the concept of the cognitive narrative prototype. Yet, due to their remarkable conventionality in the medium, they still significantly question the finality traditionally associated with any sense of an ending. While the ending's arbitrariness and equivocality have been occasionally problematised both in narratology and fiction, narrative digital games routinely expose them as part of some of their most conventional structures. These structures also offer yet a new perspective on possible alterations of prototypical narrative elements that still allow the intersubjective cognitive understanding of the media artefact in question – i.e. in this case, a narrative digital game – as narrative, while also pertaining to other discursive macro-modes, e.g. the ludic. Hence, digital game endings, both regarding their inner structures and their pluralisation on a macro-level, vividly demonstrate the medium's discursive multimodality, which can result both in synergies and dissonances – with the latter being as potentially fruitful as the former: While the benefits of synergies are obvious as they are likely to increase immersion and closural satisfaction – e.g. if alternative outcomes allow the ending's individualisation – dissonances are not merely disruptive, but prone to encourage reflection about the player's own behaviour, medium conventions, and even broader questions such as freedom of choice.

Notes

1 Note that there is a distinct structural difference between such circular ludic structures, which provide a sense of an ending or beating the game before leading back to its starting point, and net-like structures which might include paths that lead the user back to the beginning without reaching any goal or encountering any sufficient amount of closural signals.

2 Examples for closural signals in JOURNEY are the visually spectacular location of the snowy mountain top, the camera zooming out as the avatar proceeds into the light, and the reminiscing credits that revisit all prior locations.

3 The disclosure of a "New Game Plus" mode in the paratextual ending phase has been noted to potentially disrupt the ludic, but not the narrative sense of an ending (see Chapter 3.5). As such a mode usually not only offers a new challenge to the player but also retains some progress (such as avatar level and equipment) from the first playthrough, the ludic circle here is not complete – "New Game Plus" is not a fresh start, but a reiteration with variations based on the previous playing process.

4 The automatic restarts in THE STANLEY PARABLE basically work to the same effect. Yet, the game hardly fulfils the criteria of narrative circularity and its multiplicity of (strikingly different) narrative branches and endings alone contradicts a circular structure (see Chapter 3.6).

5 Also, as Chapter 4.4 will show, failure sequences cannot simply be judged as bearing no sense of an ending.

6 Extradiegetic message after the ending of NI NO KUNI.

7 As noted in the beginning of Chapter 3.2, the term endgame might also be used to designate such post-ending phases. Yet, applying it here would risk confusion due to its generally broader meaning and its prevalent use in other contexts. Furthermore, the term post-ending phase is useful to highlight the – in relation to the narrative prototype – paradoxical quality of this kind of openness after finishing a story.

8 Note that the term "sandbox" is also used for games that differ strikingly from the open world genre, in which players control an avatar to explore the game world with a main (story) goal at hand. For example, simulation games like SIMCITY or the crafting game MINECRAFT (Mojang 2011) are also referred to as sandbox games since they allow and encourage the free, paidic play that is associated with children playing in a sandbox.

9 It should go without saying that, in general, there is nothing like leaving a game "early" or "late", as players are free to decide for how long to play a game and which goals to strive towards. Here, I am merely judging the termination of play with reference to the (implied) given goal of completion. Naturally, there are many individual reasons – chosen goals – to prolong play without any given incentive.

10 According to Espen Aarseth, "[t]he defining element in computer games is spatiality. Computer games are essentially concerned with spatial representation and negotiation" (Aarseth 2001a, 154). Among others, Rolf Nohr confirms Aarseth's notion by ascribing a spatial fetish to the medium (see Nohr 2007).

11 Note that games are often available for purchase in a bundle with all existing DLC after their release. In this case, the DLC status of some missions might not be clear for new players, depending on how the content is integrated into the game. For example, the DEUS EX: HR DLC THE MISSING LINK (Eidos Montréal 2011) is chronologically situated in between other segments of the game. While it still takes place in a setting unfamiliar from the main game – which just skips this part of the story – the smooth integration of the DLC at its designated point in time of the story in the "Director's Cut" of the game makes it less apparent as additional content.

12 It seems worth noting that players of FINAL FANTASY XV are, at this point, rather used to a peculiar ludonarrative dissonance that involves temporal paradoxes, as the game's open world is only accessible via a magical time travelling device from about two thirds into the playing process onward. While all events happening in these optional open world parts are narratively set in the past, they can lead to ludic progress (such as levelling up).

13 With the DLC activated, there is also the option to send one of three optional companion characters into the activation chamber, who are immune to radiation and, hence, survive the task easily. Yet, the choice bears no consequences, and the narrator still shames the protagonist in the ensuing cutscene.

14 The DLC of FALLOUT 3 can be manually activated and deactivated in the game's launch options, so that players who own it can still choose to play the unenhanced version.

15 Remarkably, even if the player chooses to ask the originally present NPC to perform the task, the avatar still suffers the same two weeks of coma, while the NPC dies in the activation process.

16 The sequel-like character of the DLC can even be completely lost if the game is first played with all enhancements already released and active.

17 The closure-diminishing effect of serialisation occurs most likely if there is no hint at a sequel in the series' first instalment or its contextual paratext (such as producer interviews). In media artefacts that are designed for serialisation, the sense of an ending is usually weaker anyway. Examples that prepare players for narrative serialisation range from obviously open stories that stop in a cliffhanger to those that merely hint at potential future adventures, such as UNCHARTED, which finishes with reporter Elena cheekily telling protagonist Drake: "There'll be other stories. You still owe me one."

18 Here, Eskelinen refers explicitly, and almost literally, to Aarseth's definition of cybertext as "a machine for the production of variety of expression" (Aarseth 1997, 3).

19 A final choice entails immediate consequences per definition, as it occurs during a game's ending, i.e. any further delay of consequences is simply not possible, at least within the confines of a single game.

20 I adopt the terms "overt" and "covert" from Bode, who uses them to scale the "obviousness", i.e. the apparency, of a nodal situation (see Bode and Dietrich 2013, 49).

21 This prerequisite for the outcome can be known to players only after several playthroughs, or from contextual paratext, such as online walkthroughs. Note that there are technically three different endings to BIOSHOCK. However, the two "bad" endings are hardly separable since the final cutscenes of both only slightly differ in tone of the narrator's voice.

22 As, in total, 13 of these text messages require a certain type of reply to a previous message, these are not automatically encountered in each playthrough.

23 It seems due to note that CATHERINE refuses the stereotypical evaluation of choices as good or bad. Although the options given in the game's choices as well as the visual design of the meter clearly match the common connotations of the morally good and bad, the questions posed by the game, which centres around the conflict between commitment to a romantic relationship and individual freedom, often rather address societal norms and conformity such as "Which makes you more nervous?" with the possible answers being "being alone" and "being with others".

24 Within the storyworld of BASTION, it is conceivable that history would repeat itself, so that the characters would meet again, and the choice would have to be made again as well. In this hypothetical scenario, the Bastion's activation would, ultimately, not have been able to prevent the Calamity.

25 A quick and illustrative overview of this lack of representational variety in all the endings of MASS EFFECT 3 can be enjoyed in parallel cuts of the final cutscenes such as this comprehensive video by YouTube user Crosscade: https://www.youtube.com/watch?v=rPelM2hwhJA (accessed January 27, 2019). The video correctly implies that the endings are also nearly identical on the auditory level.

26 The two other possible outcomes of SILENT HILL 2 classify as Easter eggs, as is further explained below.

27 The maximum level of military strength can only be achieved if the player ventures outside the singleplayer experience via the game's multiplayer mode. However, only the protagonist's survival in the Destruction ending is affected by this. All other aspects and all other endings remain the same as with the next lowest level of military strength, which can be achieved with singleplayer missions alone.

28 This does not apply if ending segments are saved as separate, pre-rendered files. The ontological difference, thus, depends on the program's design. Yet, it is a potential of the medium that is likely to be used if players are allowed

to customise characters and make a range of consequential choices such as in
FALLOUT 3.

29 While all ergodic media, including non-digital media, can employ narrative
branching that is designed for the actualisation of only one path in a single run,
procedurality ensures the automatic execution of this rule, i.e. the program
relieves users of the responsibility of actualising the chosen path. In contrast,
Choose Your Own Adventure books, for example, rely on the reader to con-
tinue at the corresponding page after a choice. At a first glance, the difference
might seem negligible, at least in non-empirical studies, assuming an ideal user
who always adheres to the rules. Yet, procedurality does not only help prevent
cheating but also enables more complex structures of narrative branching. Pro-
longed consequences, for example, are difficult to implement in non-procedural
media since users would be required to keep track of their actions and choices –
which, furthermore, largely precludes obscured prolonged consequences.

30 The closest digital game equivalent of unilinear ending succession in non-
ergodic media is the fake endings discussed earlier. Just as the first ending to
The French Lieutenant's Woman, which the narrator subsequently declares as
false (see Fowles [1969] 1996, 342), the fake endings of digital games clearly
take a bottom position in any conceivable ending hierarchy, as they play with
closural expectations and lose their sense of an ending at the moment their
deception is unveiled.

31 Alvarez Igarzábal points out the peculiarity of player-induced iterations in
contrast to intracompositional narrative setbacks in the context of failure and
re-entry sequences that are often compared to the main plot device of the movie
GROUNDHOG DAY (see Alvarez Igarzábal 2019, 115f.).

32 Of course, this repertoire is not an exclusive feature of narrative digital games,
but generally available in all media with similar affordances that enable
non-unilinear storytelling.

33 Joking UFO endings are a convention of the series, including a certain narrative
continuity between the UFO endings of different instalments.

34 Bode's example shows that several factors of hierarchy indication usually coin-
cide, as the happy ending in his example *Der Tempel des Schreckens* (THiLO
2005) is further confirmed by its position at the material end of the book and a
reference to the story's beginning, i.e. an additional closural signal, in only this
outcome (see Bode and Dietrich 2013, 21).

35 Indeed, target audience seems to be the decisive factor for the complexity of nar-
rative structure and ending hierarchies in gamebooks. Michael Tresca notes that
beyond the simplistic children's gamebooks, there are many that include several
successful outcomes, forming parallel alternative endings (see Tresca 2011, 106).

36 A divergence from player expectations does not invariably lead to frustration
but might fruitfully be used to induce meta-ludic and meta-narrative reflection.

37 As one of the few occult elements in the game, which otherwise focuses rather
on psychological themes and symbols, the ritual links SILENT HILL 2 to the
storyworld of its predecessor, which revolves around a cult.

38 Promotional text on the publisher's official website: www.nintendo.com/
games/detail/dragon-quest-viii-journey-of-the-cursed-king-3ds/ (accessed May
9, 2020).

39 Regarding the controversy around the DLC for ASURA'S WRATH, see, for ex-
ample, the outrage of *CinemaBlend* author William Usher, which is evident in
the title of his news post "Want The Real Ending To Asura's Wrath? Cough
Up $6.99" (https://www.cinemablend.com/games/Want-Real-Ending-Asura-
Wrath-Cough-Up-6-99-40917.html, accessed November 13, 2018).

40 Adaptation studies have made continuous effort for eliminating questions of
fidelity that potentially imply the normativity of an adaptation adhering to the

plot of its source. Although fidelity studies can avoid such a normative impetus, evaluative practices, which measure an adaptation against its source, are certainly inherent in the question. Evaluation, furthermore, implies a hierarchy of media artefacts that can be transferred to their endings. On the issue of fidelity and its pros and cons, see Johnson 2017.

41 In the following abbreviated as DEUS EX: MD.

42 This need fits the general observation that "[a] large part of fan activity [...] is devoted to protecting the canon" (Ryan 2017, 531, with reference to Saint-Gelais 2011, 423).

43 I have previously discussed the issue of ending canonisation and DEUS EX: MD's debatable strategy of canon refusal in the context of endings and serialisation in digital games in the German journal *PAIDIA* (see Herte 2017).

44 Bordwell suggests that even media with unilinear narrative traditions, such as film, saw an increase in "forking-path tales" (his term for narrative branching) less due to a postmodern impetus but as a result of an intermedial influence of ludic media artefacts such as digital games or gamebooks (see Bordwell 2008, 187). The 21st century's advancement of digital technologies promotes this influence as digital production and distribution – of, for example, films and TV series – facilitates the use of ergodic features, which, in turn, enables ludic forms. One example is the Netflix production BANDERSNATCH, which not only translates the mechanics of gamebooks into an interactive film (including the convention of failure scenarios) but also reflects the process of ludic remediation in its story, which focuses on the adaptation of the fictional "Choose Your Own Adventure" book "Bandersnatch" into a digital game.

45 For example, adventure games like THE WALKING DEAD or LIFE IS STRANGE allow few actions besides narrative choices that are overtly presented as nodes (even if they only feign consequences). In both examples, the avatar's confinement to rather small areas in each segment of the game even reduces the conventional ludic potential of spatial exploration to a minimum. The marginality of spatial exploration, in turn, accentuates the ludic importance of the offered narrative exploration, e.g. by dialogue options.

46 Even in games with clearly communicated hierarchies, players might wish to feed their curiosity by exploring the "worse" alternatives, so as to fully understand the consequences of the game's narrative branching, or to prolong their involvement with the fictional storyworld by learning how it would change and how characters would react in different situations. Games might even reward such an approach by scattering closural information over different endings, so that even bad outcomes offer some unique insight. An example is found in the supernatural murder mystery story of SHADOW OF MEMORIES.

47 Strangely enough, Baumgartner only mentions "digital" paratext for this purpose, although there is a long tradition of print strategy guides which also contain this kind of information, even for Baumgartner's main example SILENT HILL 2 (see Baumgartner 2016, 261).

48 S.T.A.L.K.E.R. includes seven endings in total, a variety which is not indicated by the game, except for two endings which act as direct alternatives to each other in a final dialogue choice. Yet, the game demands additional effort from the player to even uncover the path that leads to this secret final choice.

49 In the following abbreviated as ZERO ESCAPE: VLR.

50 The series' first instalment, NINE HOURS, NINE PERSONS, NINE DOORS (Chunsoft 2009), was given a similar flowchart in its remastered iOS version 999: THE NOVEL (Chunsoft 2013) – which lacks the escape puzzle parts – and the multi-platform edition ZERO ESCAPE: THE NONARY GAMES (Chunsoft 2017), which contains the first two instalments.

51 While the logo has been mentioned as a common paratextual closural marker earlier in this study, it is just as conventional for marking a game's beginning, usually embedded in a cutscene, as it is also the case here.

52 To be sure, there are many other reasons for the increase of nodal situations, potentially even the designer's specific intention to make the playing process even more interesting for players accustomed to the series. The design of the different *intradiegetic* games in the instalments also contributes to the plausible increase of choices.

53 In ZERO TIME DILEMMA, there are no game-interrupting failure scenarios in the puzzle sequences, except from one in the story fragment titled "Outbreak". Here, if players fail at disarming a bomb, they trigger a traditional failure screen with the option to continue or exit the game. Remarkably, this failure does not prompt a "game over", which is used quite differently in ZERO TIME DILEMMA, as described in the following.

54 Outside the visual novel genre, flowcharts are included in, for example, the hack and slash game DYNASTY WARRIORS 8 (Omega Force 2013) and the adventure game DETROIT: BECOME HUMAN (Quantic Dream 2018).

55 Accordingly, other digital game examples for narrative branching with character awareness also involve a supernatural setup such as the protagonist's ability to turn back time in LIFE IS STRANGE.

56 An example of a non-ergodic media artefact that presents its paths as equal alternatives is the two-part movie SMOKING / NO SMOKING (Alain Resnais 1993), which shows 12 variations of the continuation of a couple's life after the wife's seemingly insignificant choice to smoke or not to smoke.

57 The capitalisation of "SHIFT" matches the use of the term in the game, where it is explained as an abbreviation for "Spacetime Human Internal Fluctuating Transfer".

58 The filmstrip icon that designates cutscenes is one of the three major icons for "midgame", i.e. not ending-related, symbols in the game's flowchart, together with a scale icon for choice situations, and an icon of a person going through a door for escape puzzles.

59 Players who know the crucial information from a previous playthrough or other context can, in fact, use it to unlock the "Perceptive End" even prior to obtaining the information in the current playthrough.

60 The same visual trick is used in the chronologically later sequence that leads to the described twist.

61 Apart from the save and load screen, which focuses on exploration of the main endings, completion is further encouraged by the question marks in the flowchart and the message "COMPLETED" that is shown whenever the player explored all the segments of a fragment.

62 The player can, alternatively, either choose "DON'T SHIFT" or let the time run out, which, in both cases, leads to another game over as all characters die in the shelter's detonation.

63 The conception of game termination as the ultimate setback relies both on the conventionality of taking another attempt and on the availability of the game after failure. However, it is conceivable that a game makes itself unavailable for repeated playing. This is the case in the art game LOSE/LOSE (Zack Gage 2009), a SPACE-INVADERS-like "video-game with real life consequences" (from the developer's official website, www.stfj.net/art/2009/loselose/), which deletes itself upon player failure.

64 For example at first contrasting with the abundance of failure sequences in point-and-click adventures, especially in those by the studio Sierra On-Line, the Lucasfilm Games (later: LucasArts) adventures in the early 1990s established the absence of game over screens in the genre. The only possible type of

failure in a game like MONKEY ISLAND is not being able to find the solution to a puzzle and, hence, to get stuck. Another way of avoiding failure scenarios is to adapt the course of the game to the player's insufficient performance, possibly punishing failure with a bad narrative outcome, as is exemplified by HEAVY RAIN (see Alvarez Igarzábal 2019, 132f.). Hence, failure in specific tasks can be used to effectuate prolonged consequences.

65 The pedagogic function of repetition in form of a setback is also present in multilinear plots in film, such as GROUNDHOG DAY or RUN LOLA RUN, in which characters often learn from previous paths, although often this learning process appears narratively inexplicable (see Bordwell 2008, 181f.).

66 Quoted from the Steam store (https://store.steampowered.com/app/40800/Super_Meat_Boy/, accessed December 10, 2018).

67 Note, however, that player convenience is not generally maximised by automatic re-entry sequences. Depending on genre, goals, and gameplay, it might be more convenient for players to choose one from a range of previous save states. For example, players might want to rewind further than an automated checkpoint in turn-based tactical games like XCOM: EU, or stealth-based games like DEUS EX: HR, if they recognise undesirable consequences from an earlier action.

68 Thus, games that implement narratively coherent failure routines, such as BIOSHOCK (see Alvarez Igarzábal 2019, 124f.), can be understood as the system avoiding an authorial gesture by perpetuating the player's fictional immersion, although the setback itself still marks the non-negotiable execution of the system's authority.

69 Remarkably, the term *permadeath* itself proves that the concept is an exception within the medium, as it demonstrates the necessity to re-associate (ludic) "death" with "permanence", a notion that would make sense neither in the real world nor in most fictional setups.

70 Narratively, the permanence of "permadeath" is more impactful in games that let players control several characters at once such as the XCOM series, HEAVY RAIN, or UNTIL DAWN. In these games, character death does not trigger a failure sequence. Instead, play continues without the character in question, with their death being reflected by other characters or entailing bigger narrative consequences.

71 As a remarkable example for undermining expectations regarding failure, HELLBLADE: SENUA'S SACRIFICE (Ninja Theory 2017) intentionally misleads players into believing that it features permadeath. When the titular protagonist first "dies" early in the game – an inevitable, scripted event – she is revived on the spot, but players are told that a disease called the "Dark Rot" is spreading through her body every time Senua's energy depletes. Once it reaches her head, so the message, "her quest is over" and "all progress will be lost". Indeed, following failure sequences show the disease spreading further. Yet, in fact, it will never reach Senua's head until the game's finale. Hence, permadeath in HELLBLADE is merely a bluff to make failure seem more consequential than it actually is.

72 In the following abbreviated as CASTLEVANIA: SOTN.

73 On the contrary, the true ending of CASTLEVANIA: SOTN is even paratextually concealed by the game's completion meter. Upon thorough exploration of the castle, the meter nearly reaches 100% right before a bad ending occurs. On the subsequent path to the true ending, the castle is duplicated in an upside-down version, and the meter simply exceeds 100%, up to 200.6% for complete exploration. As a percentage gauge contributes to managing player expectations for completion and closure, the bad endings of CASTLEVANIA: SOTN, thus, gain acceptability via paratext.

74 Final line in the game over sequence of SYSTEM SHOCK.

75 Juul makes this statement in reference to the gory deaths in SUPER MEAT BOY.

76 NPC Junpei of ZERO TIME DILEMMA, after a failed dice roll that leads to a game over screen.

What makes an ending an ending? Conclusion

This study has been guided by the question of what endings are and how we identify them in a narrative media artefact. Its analytical focus on digital games was encouraged by the medium's fundamental multimodality and hybridity that promised to be fruitful for identifying transmedial signals of closure, and whether these signals are essentially narrative or transmodal, pertaining to abstract principles that are, for example, also relevant for a ludic form of ending. Vice versa, a detailed analysis of digital game endings offered a way of highlighting some of the specific qualities of digital games without attempting the impossible task of covering the medium in all its aspects, while simultaneously filling a gap in the field of game studies that stood out in comparison to, for example, literary and film studies.

In a narrative media artefact, the ending is the part that signals the upcoming termination of the reception process, ideally by evoking the expectation of nothing that is closure. Depending on the artefact's length or duration, these signals are communicated in more or less distinct phases (resolution, epilogue, and paratextual phase), and they operate on different dimensions, namely the intratextual level of story (content closural signals), the intratextual level of discourse (formal closural signals), and the paratextual dimension (paratextual closural signals). The representational strategies that function as closural signals are highly dependent on the affordances offered by media modalities and further vary according to medium and genre conventions. Moreover, closural conventions – like all conventions – are relative to historical and cultural context and subject to at least gradual changes.

Both ending phases and dimensions are equally essential for the structural texture of endings in digital games, which further add a ludic phase and ergodic dimension (ludic closural signals). Besides the latter, many of the prototypical closural signals identified in previous narratological research refigured in the present analysis of the endings of narrative digital games, confirming their assumed transmedial range. The modal heterogeneity of the representational strategies used for a closural effect requires

abstraction to identify the ending's "transmedial core". There appear to be three abstract principles governing the closural signals mentioned in this study:

1 The completion of a process or action;
2 An increase in distance (between the artefact and the recipient or player);
3 The exceptionality of the closural signal in context of the whole.

It should be noted that single closural signals can pertain to more than one principle at once, and that the overall sense of an ending is most likely stronger, the more principles are at work.

The first principle, the completion of a process or action, is already established in Aristotle's *Poetics* (see Chapter 2.1). It is most obviously manifest in content closural signals that solve narrative conflicts and tie the loose ends of a story. However, it is also present on other dimensions such as in closural allusions (e.g. the image of a door closing) or in the paratextual aspect of reaching the artefact's material delimiters. A notion of completion is also evoked by patterns of repetition and symmetry, especially in closural signals that refer to the artefact's beginning. For the principle to work, the moment of completion needs to be anticipatable, i.e. there has to be prior information about the relevant action or process running towards an end (e.g. the awareness that organic life ends in death, while there is no expectable terminus of the existence of lifeless things such as stones). Such information might be given by convention (e.g. the convention that narrative artefacts end; or more specific conventions such as romantic comedies culminating in a happy ending), or explicitly stated, for example in form of a goal.

In this study, the second principle, that of increasing distance, appeared most frequently on the level of discourse. Mostly, the distance evoked is one between recipient, or player, and storyworld. It is communicated, for example, visually (e.g. the camera zooming out), verbally (e.g. creating a temporal distance with phrases such as "and then they lived happily ever after"), or metareferentially (reminding the player of the storyworld's fictionality). The latter is also related to the principle's realisation in paratextual closural signals, which evoke distance almost by default by referring to production context and, thus, extradiegetic reality (e.g. production information given in a credit roll). On the level of story, the principle primarily refers to a distance between characters, marked by events such as death or farewells.

The third principle, the closural signal's exceptionality within the context of the artefact as a whole, seems particularly relevant for digital games, which conventionally show various kinds of spectacle in their finales (see Chapter 3). Yet, exceptionality does not always entail spectacle but refers to any kind of closural signal that breaks the artefact's established pattern or flow. For example, Wenzel's pattern of contrast (Wenzel 2015, 25),

which refers to any sudden change or surprising introduction of something new, conforms to this principle, as does diegetic reduction (e.g. time being stopped in a freeze frame). In the paratextual dimension, the principle is ubiquitous, since any paratextual means disrupt immersion, particularly if they cannot be exactly anticipated – for example, paratextual closural signals of a book are foreseeable, while only the fact of their eventual occurrence but not their exact timing can be anticipated by players of a digital game. The principle of exceptionality is also particularly relevant for the beginning of endings, as it fundamentally governs the concept of a breach in order.

In their abstractness, these three principles are certainly not exclusive to the narrative mode. They define the forms and functions of actualisations of the ending in its role as a prototypical narreme as much as occurrences of closure and conclusion that predominantly pertain to other discursive macro-modes such as the argumentative or the ludic.

Overall, the endings of digital games show many similarities to those of other media in their inner workings, which were discussed in detail in Chapter 3. While most of the medium's unique conventions concern the ludic mode, even ludic closural signals are governed by the same ending principles: For example, the prototypical reduction of ergodicity in the narrative finale conforms to the principle of increasing distance, and multi-phase final encounters, urgency signals, or unique final weapons address the principle of exceptionality. Remarkably, however, it is also the ludic mode that is mostly responsible for any representational strategy that denies or revokes a sense of an ending in digital games, e.g. in playable credit rolls or evaluations that are prone to motivate another playthrough rather than to discard the game in full acceptance of the ending's finality. Furthermore, the example of protagonist, or avatar, death has shown that ludic conventions can superimpose the effect of established narrative closural signals. Ultimately, individual ludic and narrative framings of the event determine whether the anti-closural effect of ludic transiency or the closural effect of narrative finality of death dominates.

Probably the most profound structural difference between game endings and those of other narrative media artefacts is the additional ludic phase that conventionally precedes the narrative finale. By providing a final challenge that ideally culminates the ergodic experience, allowing players to prove their mastery of the game, the ludic finale fulfils a function that is simply not relevant to non-ludic media artefacts. Yet, it is not a mere prefix to the other ending phases, since ludic and narrative finale can functionally overlap, just as they both employ closural signals which, in themselves, predominantly pertain to the respective other macro-mode. For example, the confrontation with the main antagonist is not only a ludic convention, present in most games with fighting mechanics and corresponding final encounters, but also a typical event in the resolution phase of narrative media artefacts. The narrative impact of such an encounter is, accordingly, framed

by narrative signals in the ludic phase, and its ludic outcome is, usually, reflected during the subsequent narrative finale, so that the resolution spans both phases.

Particularly with regard to the historical difficulties of digital game studies to reconcile ludological and narratological approaches, it cannot be overemphasised that ergodic features and ludic specificities are not isolated within digital game endings, but have repercussions on the narrative mode, and vice versa. For example, due to the prevalence of progression structures in narrative singleplayer games, that conventionally involve a continuous increase in difficulty, their endings seem exceptionally prone to be climactic and spectacular on all levels. Although climactic finales are certainly not unique to digital games, they appear to be more common than in other media, especially across genres. Similarly, the content closural signals prevailing in digital games are typically connected to the ludic mode, as they relate to objectives that align player and protagonist goals. While goal-oriented stories frequently occur in other media, their relevance to gameplay gives them another, non-narrative meaning in digital games.

The functional interrelations of ludic and narrative mode in digital game endings are even more striking on the macro-level. The analysis in Chapter 4 has shown that prototypically ludic features, such as variability of outcome, effectuate ending structures that form strong medial conventions such as multiple endings and failure sequences. These structural varieties have consequences on the narrative level, including the potential effectiveness of closure and the perceived finality of the ending. In return, the narrative representation of these ending structures can affect their ludic functions or at least how players are prone to understand them, for example regarding ending hierarchies and the acceptability of failure and bad outcomes.

In my point of departure for eliciting what makes an ending an ending, I referred to philosopher John Dewey to illustrate the importance of context for any ending (see Chapter 2.1). His distinction between the conclusion of an intellectual experience, which "has value on its own account", and works of art, in which "the end, the terminus, is significant not by itself but as the integration of the parts" (Dewey [1934] 2005, 57), seemed to point to a fundamental difference between ludic and narrative endings, because valorisation of outcome is a prototypical ludic feature. In other words, the nature of the outcome (e.g. success or defeat) would be regarded more important than how the game emerged during play. Yet, even in non-digital and non-narrative contexts, the path to a game's outcome is often regarded as highly significant – for example, when football fans discuss a goal, or when a player of chess surprises with an outstanding move. Although in some contexts – e.g. in betting – the results of a game can be self-sufficient, this is not generally the case. Similarly – albeit probably less conventionally – in a narrative reception context, recipients who are less invested might be content with knowing whether a story has a happy ending or not. Regardless of such general considerations, it has been shown that the endings of

narrative digital games are hardly self-sufficient for several reasons. On the one hand, their narrativity presupposes the same contextual dependency of meaningfulness that characterises endings in any kind of narrative media artefact. On the other hand, even ludic features of digital game endings are often not meaningful on their own, for example regarding the level of difficulty or any other form of extraordinariness that signals the game's upcoming conclusion on the level of gameplay. Most importantly, however, the medium has increasingly replaced the traditional binary distinction between winning and losing with more nuanced outcome variations, including ambiguous valorisation in complex ending hierarchies, and occasionally even avoiding valorisation in favour of upholding the value of player choice and preferences. This specific configuration of digital game endings is just one of many signs that neither a purely narratological (or "narrativist") nor an exclusive ludological approach can do justice to the medium that strongly differs from the prototypical configurations of both the narrative and the ludic cognitive frame.

The "visibly-appointed stopping-place" (James [1875] 1986, 37) to this study is as arbitrary as the endpoint of any narrative media artefact. Yet, just as in narrative production, finding this end is not a random affair, but a "difficult, dire process of selection and comparison, of surrender and sacrifice" (James [1875] 1986, 37). To phrase it less dramatically than Henry James: Although there are still gaps and loose ends that could not be addressed (i.e. which were sacrificed along the way), this study's purpose and overall structure motivate and, hopefully, justify finishing it at this point. As always, there is room left for a "sequel", for example regarding the issue of seriality, which was briefly touched upon at several points. Its recurrence in this study suggests a profound significance of serial structures for digital game endings, including the interim endings of levels (and other forms of intracompositional segmentation). Considering that the ending's finality is frequently attacked by conventionalised means in narrative singleplayer games, it now would be time to broaden the perspective by assessing the forms of ending and continuation of online games. A study along these lines would not only have to address the social dimension of multiplayer games but also the functional variety of online features, which are increasingly prevalent in both multi- and singleplayer games. Concerning the general range of closural conventions, further insight might be gained from an analysis of endings in other media and their specific modal affordances such as comic or theatre. Another beneficial way of studying endings that contributes to the purpose of transmedial narratology might be found in a focus on closure in specific genres across media.

While it is a task for cognitive science to explain how endings are perceived by the human mind, this study aimed at identifying the framings prototypically used across media to trigger a sense of an ending. Understanding endings, their contribution to (narrative) meaning-making and their ways of causing satisfaction, frustration, or (meta-)reflection, is a

crucial part of understanding media artefacts in general. For the time being, I hope to have provided the right amount of closural signals to evoke, if not the expectation of no more insights to come, then at least a sense of an ending that does not stifle curiosity.

References

Games

ALAN WAKE. 2012. Remedy Entertainment / Remedy Entertainment.
ASSASSIN'S CREED. 2007. Ubisoft Montreal / Ubisoft.
ASSASSIN'S CREED II. 2009. Ubisoft Montreal / Ubisoft.
ASURA'S WRATH. 2012. CyberConnect2 / Capcom.
BASTION. 2011. Supergiant Games / Warner Bros. Interactive Entertainment.
BATTLEZONE. 1980. Activision / Activision.
BAYONETTA. 2009. Platinum Games / Sega.
BEYOND: TWO SOULS. 2013. Quantic Dream / Sony Computer Entertainment.
THE BINDING OF ISAAC. 2011. Edmund McMillen / Edmund McMillen.
BIOSHOCK. 2007. 2K Boston and 2K Australia / 2K Games.
BIOSHOCK INFINITE. 2013. Irrational Games / 2K Games.
BLOODBORNE. 2015. FromSoftware / Sony Computer Entertainment.
BORDERLANDS 2. 2012. Gearbox Software / 2K Games.
BORDERLANDS 2: TINY TINA'S ASSAULT ON DRAGON KEEP. DLC. 2013. Gearbox
 Software / 2K Games.
BRAID. 2009. Number None / Number None.
CASTLEVANIA: SYMPHONY OF THE NIGHT. 1997. Konami Computer Entertainment
 Tokyo / Konami.
CATHERINE. 2011. Atlus / Deep Silver.
THE CURSE OF MONKEY ISLAND. 1997. LucasArts / LucasArts.
DARK SOULS. 2011. FromSoftware / Namco Bandai Games.
THE DARKNESS. 2007. Starbreeze Studios / 2K Games.
DEAD SPACE 2. 2011. Visceral Games / Electronic Arts.
DEAD SPACE 3. 2013. Visceral Games / Electronic Arts.
DEAD SPACE 3: AWAKENED. DLC. 2013. Visceral Games / Electronic Arts.
DEADLY PREMONITION. 2010. Access Games. List.
DEAR ESTHER. 2012. The Chinese Room / The Chinese Room.
DETROID: BECOME HUMAN. 2018. Quantic Dream / Sony Interactive Entertainment.
DEUS EX: HUMAN REVOLUTION. 2011. Eidos Montréal / Square Enix.
DEUS EX: HUMAN REVOLUTION: THE MISSING LINK. DLC. 2011. Eidos Montréal
 / Square Enix.
DEUS EX: MANKIND DIVIDED. 2016. Eidos Montréal / Square Enix.

DIG DUG. 1982. Namco / Namco.

DONKEY KONG. 1981. Nintendo Research & Development 1 / Nintendo.

DONKEY KONG COUNTRY. 1994. Rare / Nintendo.

DOOM. 1993. Id Software / GT Interactive Software.

DOOM II: HELL ON EARTH. 1994. Id Software / Virgin Interactive Entertainment.

DRAGON QUEST VIII: JOURNEY OF THE CURSED KING. 2017. Square Enix / Nintendo [Originally 2006. Level-5 / Square Enix].

DRAGON'S LAIR. 1983. Rick Dyer and Don Bluth / Cinematronics.

DYNASTY WARRIORS 8. 2013. Omega Force / Tecmo Koei.

THE EVIL WITHIN. 2014. Tango Gameworks / Bethesda Softworks.

THE EVIL WITHIN: THE ASSIGNMENT. DLC. 2015. Tango Gameworks / Bethesda Softworks.

FABLE III. 2010. Lionhead Studios / Microsoft Game Studios.

FAHRENHEIT. 2005. Quantic Dream / Atari.

FALLOUT 2. 1998. Black Isle Studios / Interplay Productions.

FALLOUT 3. 2008. Bethesda Game Studios / Bethesda Softworks.

FALLOUT 3: BROKEN STEEL. DLC. 2009. Bethesda Game Studios / Bethesda Softworks.

FALLOUT 3: MOTHERSHIP ZETA. DLC. 2009. Bethesda Game Studios / Bethesda Softworks.

FALLOUT 3: OPERATION: ANCHORAGE. DLC. 2009. Bethesda Game Studios / Bethesda Softworks.

FALLOUT 3. THE PITT. DLC. 2009. Bethesda Game Studios / Bethesda Softworks.

FALLOUT 3: POINT LOOKOUT. DLC. 2009. Bethesda Game Studios / Bethesda Softworks.

FARMVILLE. 2009. Zynga / Zynga.

FINAL FANTASY. Series. 1987–2016. Square / Square Enix.

FINAL FANTASY VII. 1997. Square / Square.

FINAL FANTASY VIII. 1999. Square / Square.

FINAL FANTASY XIII. 2010. Square Enix Product Development Division 1 / Square Enix.

FINAL FANTASY XV. 2016. Square Enix / Square Enix.

GOAT SIMULATOR. 2014. Coffee Stain Studios / Coffee Stain Studios.

GRAND THEFT AUTO V. 2013. Rockstar North / Rockstar Games.

HALF-LIFE. 1998. Valve / Sierra Studios.

HALF-LIFE 2. 2004. Valve Corporation / Valve Corporation.

HALO: REACH. 2010. Bungie / Microsoft Game Studios.

HEAVY RAIN. 2010. Quantic Dream / Sony Computer Entertainment.

HELLBLADE: SENUA'S SACRIFICE. 2017. Ninja Theory / Ninja Theory.

HITMAN: BLOOD MONEY. 2006. IO Interactive / Eidos Interactive.

HOTLINE MIAMI. 2012. Dennaton Games / Devolver Digital.

JOURNEY. 2012. thatgamecompany / Sony Computer Entertainment.

KID ICARUS: UPRISING. 2012. Project Sora / Nintendo.

KILLZONE SHADOW FALL. 2013. Guerilla Games / Sony Computer Entertainment.

L.A. NOIRE. 2011. Team Bondi / Rockstar Games.

THE LAST OF US. 2013. Naughty Dog / Sony Computer Entertainment.

THE LEGEND OF ZELDA. Series. 1986–2017. Nintendo Research & Development 4, Nintendo EAD, Capcom and Flagship, Nintendo EPD / Nintendo.

THE LEGEND OF ZELDA: MAJORA'S MASK. 2000. Nintendo EAD / Nintendo.

The Legend of Zelda: Twilight Princess. 2006. Nintendo EAD / Nintendo.
Life Is Strange. 2015. Dontnod Entertainment / Square Enix.
Limbo. 2010. Playdead / Playdead.
Lose/Lose. 2009. Zack Gage.
Mass Effect. 2007. BioWare / Electronic Arts.
Mass Effect 2. 2010. BioWare / Electronic Arts.
Mass Effect 3. 2012. BioWare / Electronic Arts.
Metal Gear Solid. 1998. Konami Computer Entertainment Japan / Konami.
Metal Gear Solid 2: Sons of Liberty. 2000. Konami Computer Entertainment Japan / Konami.
Metal Gear Solid 3: Snake Eater. 2004. Konami Computer Entertainment Japan / Konami.
Metal Gear Solid 4: Guns of the Patriots. 2008. Kojima Productions / Konami.
Metal Gear Solid V: The Phantom Pain. 2015. Kojima Productions / Konami Digital Entertainment.
Metro 2033. 2010. 4A Games / THQ.
Metro Last Light. 2013. 4A Games / Deep Silver.
Minecraft. 2011. Mojang / Mojang.
Monster Hunter: World. 2018. Capcom / Capcom.
Myst. 1993. Cyan / Red Orb Entertainment.
Ni No Kuni: Wrath of the White Witch. 2013. Level-5 / Level-5.
NieR. 2010. Cavia / Square Enix.
NightCry. 2016. Nude Maker / Playism Games.
Pac-Man. 1980. Namco / Namco.
Part IV: Nirvana. DLC. 2012. CyberConnect2 / Capcom.
Persona. Series. 1996–2017. Atlus, P-Studio / Atlus.
 Shin Megami Tensei: Persona 3. 2006. Atlus / Koei.
 Shin Megami Tensei: Persona 3 FES. 2007. Atlus / Koei.
 Shin Megami Tensei: Persona 4. 2008. Atlus / Square Enix.
 Persona 5. 2017. P-Studio / Atlus.
Portal. 2007. Valve Corporation / Valve Corporation.
Prison Architect. 2015. Introversion Software / Introversion Software.
Professor Layton. Series. 2007–2017. Level-5 / Level-5 and Nintendo.
Psychonauts. 2005. Double Fine Productions / Majesco Entertainment.
Rayman Legends. 2013. Ubisoft Montpellier / Ubisoft.
Red Dead Redemption. 2010. Rockstar San Diego / Rockstar Games.
Renowned Explorers. 2015. Abbey Games / Abbey Games.
Resident Evil. 1996. Capcom / Capcom.
Resident Evil 4. 2005. Capcom Production / Capcom.
S.T.A.L.K.E.R. Shadow of Chernobyl. 2007. GSC Game World / THQ.
Sam & Max: Hit the Road. 1993. LucasArts / LucasArts.
The Secret of Monkey Island. 1990. Lucasfilm Games / Lucasfilm Games.
Shadow of Memories. 2001. Konami Computer Entertainment Tokyo / Konami.
Silence of the Sleep. 2014. Jesse Makkonen.
Silent Hill. 1999. Konami Computer Entertainment Tokyo / Konami.
Silent Hill 2. 2001. Konami Computer Entertainment Tokyo / Konami.
Silent Hill 3. 2003. Konami Computer Entertainment Tokyo / Konami.
SimCity. 1989. Maxis / Maxis.

THE SIMS. 2000. Maxis / Electronic Arts.

SOKOBAN. 1982. Hiroyuki Imabayashi / Thinking Rabbit.

THE STANLEY PARABLE. 2013. Galactic Cafe / Galactic Cafe.

SUPER MARIO. Series. 1985–2017. Nintendo Creative Department, Nintendo EAD and Nintendo EPD / Nintendo.NEW SUPER MARIO BROS. WII. 2009. Nintendo EAD / Nintendo.

 SUPER MARIO BROS. 1985. Nintendo Creative Department / Nintendo.

 SUPER MARIO BROS 3. 1991. Nintendo R&D4 / Nintendo.

SUPER MARIO KART. 1992. Nintendo EAD / Nintendo.

SUPER MEAT BOY. 2010. Team Meat / Team Meat.

SUPER METROID. 1994. Nintendo Research & Development 1 Intelligent Systems / Nintendo.

SUPER STREET FIGHTER IV. 2010. Capcom / Capcom.

SYSTEM SHOCK. 1994. Looking Glass Technologies / Origin Systems.

SYSTEM SHOCK 2. 1999. Irrational Games and Looking Glass Studios / Electronic Arts.

THE TALOS PRINCIPLE. 2014. Croteam / Devolver Digital.

TEKKEN 5. 2005. Namco / Namco.

TEMPLE RUN. 2011. Imangi Studios / Imangi Studios.

TETRIS. 1984. Alexey Pajitnov.

TETRIS. 1989. Bullet-Proof Software / Nintendo.

TOMB RAIDER. 2013. Crystal Dynamics / Square Enix.

THE TYPING OF THE DEAD. 2001. Smilebit / Sega.

UNCHARTED. Series. 2007–2017. Naughty Dog / Sony Computer Entertainment.

UNCHARTED: DRAKE'S FORTUNE. 2007. Naughty Dog / Sony Computer Entertainment.

UNCHARTED 4: A THIEF'S END. 2016. Naughty Dog / Sony Computer Entertainment.

UNTIL DAWN. 2015. Supermassive Games / Sony Computer Entertainment.

VANQUISH. 2010. PlatinumGames / Sega.

THE WALKING DEAD. 2012. Telltale Games / Telltale Games.

THE WITCHER 2: ASSASSIN'S OF KINGS. 2011. CD Projekt Red / CD Projekt.

WORLD OF TANKS. 2010. Wargaming Minsk / Wargaming.

XCOM: ENEMY UNKNOWN. 2012. Firaxis Games / 2K Games.

XENOBLADE CHRONICLES. 2011. Monolith Software / Nintendo.

YOU HAVE TO BURN THE ROPE. 2008. Kian Bashiri.

ZERO ESCAPE. Series. 2009–2017. Spike Chunsoft and Chime / Aksys Games.

999: THE NOVEL. 2013. Chunsoft / Aksys Games.

NINE HOURS, NINE PERSONS, NINE DOORS. 2009. Chunsoft / Aksys Games.

 ZERO ESCAPE: THE NONARY GAMES. 2017. Spike Chunsoft / Spike Chunsoft.

 ZERO ESCAPE: VIRTUE'S LAST REWARD. 2012. Chunsoft / Rising Star Games.

 ZERO TIME DILEMMA. 2016. Spike Chunsoft / Aksys Games.

Film and TV

BANDERSNATCH. 2018. UK. Dir. David Slade.

BLACK MIRROR. Series. 2011–2018. UK. Prod. Charlie Brooker and Annabel Jones.

BLIND CHANCE (Orig.: PRZYPADEK). 1987. Poland. Dir. Krzysztof Kieślowski.

EDGE OF TOMORROW. 2014. USA. Dir. Doug Liman.

GROUNDHOG DAY. 1993. USA. Dir. Harold Ramis.

HAPPY DEATH DAY. 2017. USA. Dir. Christopher Landon.
INDIANA JONES AND THE TEMPLE OF DOOM. 1984. USA. Dir. Steven Spielberg.
RUN LOLA RUN (Orig. LOLA RENNT). 1998. Germany. Dir. Tom Tykwer.
SLIDING DOORS. 1998. USA / UK. Dir. Peter Howitt.
SMOKING / NO SMOKING. 1993. France. Dir. Alain Resnais.
STAR WARS: EPISODE III – REVENGE OF THE SITH. 2005. USA. Dir. George Lucas.
TERMINATOR 2: JUDGMENT DAY. 1991. USA. Dir. James Cameron.

Bibliography

Aarseth, Espen J. 1997. *Cybertext. Perspectives on Ergodic Literature*. Baltimore, MD and London: Johns Hopkins University Press.
———. 1999. "Aporia and Epiphany in *Doom* and *The Speaking Clock*. The Temporality of Ergodic Art." In *Cyberspace Textuality. Computer Technology and Literary Theory*, ed. by Marie-Laure Ryan. Bloomington: Indiana University Press. 31–41.
———. 2001a. "Allegories of Space. The Question of Spatiality in Computer Games." In *Cybertext Yearbook 2000*, ed. by Markku Eskelinen and Raine Koskimaa. Jyväskylä: University of Jyväskylä. 152–71.
———. 2001b. "Computer Game Studies, Year One." *Game Studies. The International Journal of Computer Game Research* 1 (1). Accessed March 24, 2017. www.gamestudies.org/0101/editorial.html.
———. 2004a. "Genre Trouble. Narrativism and the Art of Simulation." In *First Person,* ed. by Noah Wardrip-Fruin and Pat Harrigan. 45–55.
———. 2004b. "Quest Games as Narrative Discourse." In *Narrative across Media,* ed. by Marie-Laure Ryan. 361–76.
———. 2014. "Transreality Game Worlds. Tracing the Signified across Media." Tübingen, February 28.
Abbott, H. P. 2008. "The Future of All Narrative Futures." In *A Companion to Narrative Theory*, ed. by James Phelan and Peter J. Rabinowitz. Malden, MA: Blackwell. 529–41.
———. 2014. "Narrativity." In *Handbook of Narratology*, ed. by Peter Hühn, John Pier, Wolf Schmid, and Jörg Schönert. Vol. 1: 587–607.
Adams, John-K. 1996. "Wohin nur? Räumlichkeit in interaktiven Computerspielen und im Cyberspace-Roman." In *Hyperkultur. Zur Fiktion des Computerzeitalters*, ed. by Martin Klepper, Ruth Mayer, and Ernst-Peter Schneck. Berlin: de Gruyter. 192–201.
Allen, Rob, and Thijs van den Berg, eds. 2014. *Serialization in Popular Culture*. New York and London: Routledge.
———. 2014. "Introduction." In *Serialization in Popular Culture*, ed. by Rob Allen and Thijs van den Berg. 1–7.
Alvarez Igarzábal, Federico. 2019. *Time and Space in Video Games. A Cognitive-Formalist Approach*. Bielefeld: Transcript.
Aristotle. 2008. *Poetics*. Trans. by S. H. Butcher. New York: Cosimo.
Ascher, Franziska. 2016. "Preis der Neutralität. Die *Witcher*-Reihe als Seismograf des Decision Turns." In *"I'll remember this,"* ed. by Redaktion PAIDIA. 33–56.
Austen, Jane. [1817] 2006. *Northanger Abbey*. The Cambridge Edition of the Works of Jane Austen. Ed. by Barbara M. Benedict and Deirdre Le Faye. Cambridge: Cambridge University Press.

Avedon, Elliot M., and Brian Sutton-Smith. 1971. *The Study of Games*. New York: Wiley.

Backe, Hans-Joachim. 2008. *Strukturen und Funktionen des Erzählens im Computerspiel. Eine typologische Einführung*. Würzburg: Königshausen & Neumann.

Bartels, Klaus, and Jan-Noël Thon, eds. 2007. *Computer/Spiel/Räume. Materialien zur Einführung in die Computer Game Studies*. Hamburger Hefte zur Medienkultur 5. Hamburg: Universität Hamburg.

Baumgartner, Robert. 2016. "'Alles, was Sie von nun an tun, kann und wird gegen Sie verwendet werden.' Prozedurale Entscheidungslogik im Computerspiel." In *"I'll remember this,"* ed. by Redaktion PAIDIA. 253–72.

Beil, Benjamin. 2009. "'You are nothing but my puppet!' Die unreliable prosthesis als narrative Strategie des Computerspiels." *Navigationen. Zeitschrift für Medien- und Kulturwissenschaften* 9 (1): 74–89.

———. 2012. "Genrekonzepte des Computerspiels." In *Theorien des Computerspiels zur Einführung*, ed. by GamesCoop. 13–37.

Berghammer, Billy. 2009. "Changing the Game. The Quantic Dream *Heavy Rain* Interview Part Two." *G4TV*. Quoted in Alvarez Igarzábal 2016, 239.

Bode, Christoph, and Rainer Dietrich. 2013. *Future Narratives. Theory, Poetics, and Media-Historical Moment*. Berlin: de Gruyter.

Bogost, Ian. 2007. *Persuasive Games. The Expressive Power of Videogames*. Cambridge and London: MIT Press.

Böhnke, Alexander. 2004. "The End." In *Paratexte in Literatur, Film, Fernsehen*, ed. by Klaus Kreimeier and Georg Stanitzek. Berlin: Akademie. 193–212.

Bojahr, Philipp, and Michelle Herte. 2018. "Spielmechanik." In *Game Studies*, ed. by Benjamin Beil, Thomas Hensel, and Andreas Rauscher. Wiesbaden: Springer VS. 235–249.

Bordwell, David. 1982. "Happily Ever After, Part Two." *The Velvet Light Trap* 19: 2–7.

———. 1985. *Narration in the Fiction Film*. Madison: University of Wisconsin Press.

———. 2008. *Poetics of Cinema*. New York: Routledge.

Bordwell, David, Janet Staiger, and Kristin Thompson. [1985] 2005. *The Classical Hollywood Cinema. Film Style & Mode of Production to 1960*. London: Routledge.

Brown, Alistair. 2014. "The Sense of an Ending. The Computer Game *Fallout 3* as a Serial Fiction." In *Serialization in Popular Culture*, ed. by Rob Allen and Thijs van den Berg. 157–69.

Brütsch, Matthias. 2013. "When the Past Lies Ahead and the Future Lies Behind. Backward Narration in Film, Television and Literature." In *(Dis)orienting Media and Narrative Mazes*, ed. by Julia Eckel, Bernd Leiendecker, Daniela Olek, and Christine Piepiorka. Bielefeld: Transcript. 293–312.

Bryan, Jeffrey S. 2013. "Ergodic Effort. Dynamism and Auto-Generated Path-Making." In *Terms of Play. Essays on Words That Matter in Videogame Theory*, ed. by Zach Waggoner. London: McFarland & Company. 7–27.

Bunia, Remigius. 2006. "Framing the End." In *Framing Borders*, ed. by Werner Wolf and Walter Bernhart. 359–380.

Caillois, Roger. [1958] 2001. *Man, Play, and Games*. Urbana and Chicago: University of Illinois Press.

Calleja, Gordon. 2011. *In-Game: From Immersion to Incorporation*. Cambridge, MA: MIT Press.

Ceccherelli, Alessio. 2007. *Oltre la morte. Per una mediologia del videogioco.* Naples: Liguori.

Chatman, Seymour. 1978. *Story and Discourse. Narrative Structure in Fiction and Film.* Ithaca, NY: Cornell University Press.

———. 1990. *Coming to Terms. The Rhetoric of Narrative in Fiction and Film.* Ithaca, NY: Cornell University Press.

Christen, Thomas. 2002. *Das Ende im Spielfilm. Vom klassischen Hollywood zu Antonionis offenen Formen.* Marburg: Schüren.

Clarkson, Sparky. "*Mass Effect 3*'s Ending Disrespects Its Most Invested Players." *Kotaku.* April 12, 2013 [April 3, 2012]. Accessed October 8, 2018. https://kotaku.com/5898743/mass-effect-3s-ending-disrespects-its-most-invested-players.

Coleridge, Samuel Taylor. 1817. *Biographia Literaria, or Biographical Sketches of My Literary Life and Opinions.* Vol. II. London: S. Curtis.

Consalvo, Mia. 2007. *Cheating: Gaining Advantage in Videogames.* Cambridge: MIT Press.

Coste, Didier. 1989. *Narrative as Communication.* Minneapolis: University of Minnesota Press.

Cox, Arnie. 2001. "The Mimetic Hypothesis and Embodied Musical Meaning." *Musicae Scientiae 5* (2): 195–212.

Crawford, Chris. 1997. *The Art of Computer Game Design.* Berkeley, CA: Osborne/McGraw-Hill.

Croshaw, Ben. "Death in Videogames." *The Escapist Magazine.* March 29, 2011. Accessed December 4, 2018. www.escapistmagazine.com/articles/view/video-games/columns/extra-punctuation/8753-Death-in-Videogames.

Dena, Christy. 2010. "Beyond Multimedia, Narrative and Game. The Contributions of Multimodality and Polymorphic Fictions." In *New Perspectives on Narrative and Multimodality,* ed. by Ruth E. Page. New York: Routledge. 183–201.

Dewey, John. [1934] 2005. *Art as Experience.* New York: Perigee.

Domsch, Sebastian. 2013. *Storyplaying. Agency and Narrative in Video Games.* Berlin: de Gruyter.

Douglas, J. Yellowlees. 1994. "'How Do I Stop This Thing?' Closure and Indeterminacy in Interactive Narrative." In *Hyper/Text/Theory,* ed. by George P. Landow. Baltimore, MD: Johns Hopkins University Press. 159–88.

Elleström, Lars. 2010. "The Modalities of Media. A Model for Understanding Intermedial Relations." In *Media Borders, Multimodality and Intermediality,* ed. by Lars Elleström. Basingstoke: Palgrave Macmillan. 11–48.

———. 2014. *Media Transformation. The Transfer of Media Characteristics among Media.* Basingstoke: Palgrave Macmillan.

Elverdam, Christian, and Espen Aarseth. 2007. "Game Classification and Game Design." *Games and Culture 2* (1): 3–22.

Endres, Johannes. 2017. *Friedrich Schlegel-Handbuch. Leben - Werk - Wirkung.* Stuttgart: J. B. Metzler.

Engelns, Markus. 2014. *Spielen und Erzählen. Computerspiele und die Ebenen ihrer Realisierung.* Söchtenau: Synchron.

Eskelinen, Markku. 2001. "The Gaming Situation." *Game Studies. The International Journal of Computer Game Research 1* (1). Accessed March 30, 2017. www.gamestudies.org/0101/eskelinen/.

———. 2012. *Cybertext Poetics. The Critical Landscape of New Media Literary Theory.* New York: Continuum.

Fahle, Oliver. 2012. "Im Diesseits der Narration. Zur Ästhetik der Fernsehserie." In *Populäre Serialität*, ed. by Frank Kelleter. 169–81.

Fassone, Riccardo. 2017. *Every Game Is an Island: Endings and Extremities in Video Games*. New York: Bloomsbury Academic.

Fludernik, Monika. 1996. *Towards a 'Natural' Narratology*. London: Routledge.

Fowles, John. [1969] 1996. *The French Lieutenant's Woman*. London: Vintage.

Frasca, Gonzalo. 2003. "Simulation versus Narrative. Introduction to Ludology." In *The Video Game Theory Reader*, ed. by Mark J. P. Wolf and Bernard Perron. London and New York: Routledge. 221–36.

Friedman, Alan. 1966. *The Turn of the Novel: The Transition to Modern Fiction*. New York: Oxford University Press.

Fröhlich, Vincent. 2015. *Der Cliffhanger und die serielle Narration. Analyse einer transmedialen Erzähltechnik*. Bielefeld: Transcript.

GamesCoop, ed. 2012. *Theorien des Computerspiels zur Einführung*. Hamburg: Junius.

Gendolla, Peter, and Jörgen Schäfer. 2001. "Literatur im Netz, Netzliteratur und ihre Vorgeschichte(n)." *text + kritik* (152): 75–86.

——, eds. 2007. *The Aesthetics of Net Literature. Writing, Reading and Playing in the Programmable Media*. Bielefeld and Piscataway, NJ: Transcript; Transaction Publishers.

Genette, Gérard. [1987] 1997. *Paratexts. Thresholds of Interpretation*. Trans. by Jane E. Lewin. Cambridge: Cambridge University Press.

Gerlach, John C. 1985. *Toward the End. Closure and Structure in the American Short Story*. Tuscaloosa: University of Alabama Press.

Gläser, Tobias, and Timo Schemer-Reinhard. 2015. "You Made Your Point. Achievements als Medien medialer Selbstreflexivität." In *"The Cake is a Lie!" Polyperspektivische Betrachtungen des Computerspiels am Beispiel von 'Portal'*, ed. by Thomas Hensel, Britta Neitzel, and Rolf F. Nohr. Münster: LIT Verlag. 301–22.

Glukhovsky, Dmitry. [2007] 2012. *Metro 2033*. Trans. into German by David Drevs. München: Wilhelm Heyne Verlag.

Goetsch, Paul. 1978. "Literatursoziologische Aspekte des viktorianischen Romanschlusses." *Poetica: Zeitschrift für Sprach- und Literaturwissenschaft* 10: 236–61.

Grampp, Sven, and Jens Ruchatz. 2013. "Die Enden der Fernsehserien." In *Repositorium Medienkulturforschung 5*. Accessed March 12, 2015. http://repositorium.medienkulturforschung.de/?p=376.

Haarkötter, Hektor. 2007. *Nicht-endende Enden. Dimensionen eines literarischen Phänomens*. Würzburg: Königshausen & Neumann.

Halliwell, Stephen. 2014. "Diegesis – Mimesis." In *Handbook of Narratology*, ed. by Peter Hühn, John Pier, Wolf Schmid, Jörg Schönert. Vol. 1: 129–37.

Härig, Dominik. 2013. "Game over. Der tote Körper im Computerspiel." In *Build 'em up – Shoot 'em down. Körperlichkeit in Digitalen Spielen*, ed. by Rudolf T. Inderst and Peter Just. Glückstadt: vwh Verlag Werner Hülsbusch. 381–400.

Hausken, Liv. 2004. "Coda. Textual Theory and Blind Spots in Media Studies." In *Narrative across Media,* ed. by Marie-Laure Ryan. 391–404.

Herman, David. 2009. *Basic Elements of Narrative*. Chichester and Malden, MA: Wiley-Blackwell.

Herrnstein Smith, Barbara. 1968. *Poetic Closure. A Study of How Poems End.* Chicago, IL: University of Chicago Press.

Herte, Michelle. 2016. "'Come, Stanley, let's find the story!' On the Ludic and the Narrative Mode of Computer Games in THE STANLEY PARABLE." *IMAGE Zeitschrift für interdisziplinäre Bildwissenschaft* 23: 30–42.

———. "'The end... or is it?' Das Verhältnis von Endlichkeit und Endlosigkeit in Computerspielserien." *PAIDIA – Zeitschrift für Computerspielforschung.* March 22, 2017. Accessed November 6, 2018. www.paidia.de/the-end-or-is-it-das-verhaltnis-von-endlichkeit-und-endlosigkeit-in-computerspielen/.

Hickethier, Knut. 1991. *Die Fernsehserie und das Serielle des Fernsehens.* Lüneburg: Kultur-Medien-Kommunikation.

———. 2007. *Film- und Fernsehanalyse.* 4th ed. Stuttgart: Metzler.

Hitchens, Michael. 2006. "Time and Computer Games, or: 'No, That's Not What Happened'." In *Proceedings of the 3rd Australasian Conference of Interactive Entertainment*, ed. by Kevin K. W. Wong, Lance C. C. Fung, and Peter Cole. Perth, Australia. 44–51.

Hock, Tobias. 2015. "Film Endings." In *Last Things*, ed. by Gavin Hopps, Stella Neumann, Sven Strasen, and Peter Wenzel. 65–79.

Hocking, Clint. "Ludonarrative Dissonance in *Bioshock*." *Click Nothing. Design from a Long Time ago.* October 07, 2007. Accessed May 1, 2017. http://clicknothing.typepad.com/click_nothing/2007/10/ludonarrative-d.html.

Hopps, Gavin, Stella Neumann, Sven Strasen, and Peter Wenzel, eds. 2015. *Last Things: Essays on Ends and Endings.* Frankfurt am Main: Lang.

Hopps, Gavin, Trevor Hart, and Peter Wenzel. 2015. "Introduction." In *Last Things*, ed. by Gavin Hopps, Stella Neumann, Sven Strasen, and Peter Wenzel. 9–18.

Hühn, Peter, Jan C. Meister, John Pier, and Wolf Schmid, eds. 2014. *Handbook of Narratology.* 2nd ed. 2 vols. Berlin: de Gruyter.

Huizinga, Johan. [1949] 2003. *Homo Ludens. A Study of the Play-Elements in Culture.* Abingdon: Routledge.

Iversen, Sara Mosberg. 2012. "In the Double Grip of the Game. Challenge and Fallout 3." *Game Studies. The International Journal of Computer Game Research* 12 (2). Accessed May 1, 2017. http://gamestudies.org/1202/articles/in_the_double_grip_of_the_game.

Jakobsson, Mikael. 2011. "The Achievement Machine. Understanding Xbox 360 Achievements in Gaming Practices." *Game Studies. The International Journal of Computer Game Research* 11 (1). Accessed September 21, 2017. http://gamestudies.org/1101/articles/jakobsson.

James, Henry. [1875] 1986. *Roderick Hudson.* London and New York: Penguin Classics.

Jannidis, Fotis. 2007. "Event-Sequences, Plots and Narration in Computer Games." In *The Aesthetics of Net Literature*, ed. by Peter Gendolla and Jörgen Schäfer. 281–305.

Jenkins, Henry. 2004. "Game Design as Narrative Architecture." In *First Person*, ed. by Noah Wardrip-Fruin and Pat Harrigan. 118–30.

———. 2006. *Convergence Culture. Where Old and New Media Collide.* New York: New York University Press. Accessed October 20, 2015. www.loc.gov/catdir/enhancements/fy0730/2006007358-d.html.

Johnson, Bryan Stanley. 1964. "Broad Thoughts from a Home." In *Statement against Corpses*, ed. by Bryan Stanley Johnson and Zulfikar Ghose. London: Constable. 53–75.

Johnson, David T. 2017. "Adaptation and Fidelity." In *The Oxford Handbook of Adaptation Studies*, ed. by Thomas Leitch. 87–100.

Jørgensen, Kristine. 2009. *A Comprehensive Study of Sound in Computer Games. How Audio Affects Player Action.* Lewiston: The Edwin Mellen Press.

Joyce, Michael. [1987] 1990. *Afternoon a Story.* Eastgate Systems.

Juul, Jesper. 2004. "Introduction to Game Time." In *First Person*, ed. by Noah Wardrip-Fruin and Pat Harrigan. 131–42.

———. 2005. *Half-Real. Video Games between Real Rules and Fictional Worlds.* Cambridge: MIT Press.

———. 2007. "Without a Goal. On Open and Expressive Games." In *Videogame, Player, Text*, ed. by Barry Atkins and Tanya Krzywinska. Manchester: Manchester University Press. 191–203.

———. 2009. "Fear of Failing? The Many Meanings of Difficulty in Video Games." In *The Video Game Theory Reader 2*, ed. by Mark J. P. Wolf and Bernard Perron. New York: Routledge. 237–52. Accessed December 9, 2018. https://www.jesperjuul.net/text/fearoffailing/.

———. 2013. *The Art of Failure. An Essay on the Pain of Playing Video Games.* Cambridge: MIT Press.

Kelleter, Frank, ed. 2012. *Populäre Serialität. Narration – Evolution – Distinktion: Zum seriellen Erzählen seit dem 19. Jahrhundert.* Bielefeld and Berlin: Transcript, de Gruyter.

———. 2012. "Populäre Serialität. Eine Einführung." In *Populäre Serialität*, ed. by Frank Kelleter. 11–46.

Kelley, David. 1988. *The Art of Reasoning. An Introduction to Logic and Critical Thinking.* New York and London: Norton.

Kelly, Neon. "David Cage: 'I Remember How Scared We Were.'" *Videogamer.* August 23, 2012. Accessed December 6. 2018. https://www.videogamer.com/news/david_cage_i_remember_how_scared_we_were.

Kermode, Frank. [1967] 2000. *The Sense of an Ending. Studies in the Theory of Fiction.* Oxford and New York: Oxford University Press.

———. 1978. "Sensing Endings." *Nineteenth-Century Fiction*, Special Issue: *Narrative Endings* 33 (1): 144–58.

Klauk, Tobias, and Tilmann Köppe. 2014. "Telling vs. Showing." In *Handbook of Narratology*, ed. by Peter Hühn, John Pier, Wolf Schmid, and Jörg Schönert. Vol. 1: 846–53.

Klevjer, Rune. 2001. "Computer Game Aesthetics and Media Studies." Paper Presented at the 15th Nordic Conference on Media and Communication Research. Reykjavik, Iceland. 11–3 August 2001. Accessed April 19, 2015. http://folk.uib.no/smkrk/docs/klevjerpaper_2001.htm.

Kocher, Mela. 2007. *Folge dem Pixel-Kaninchen! Ästhetik und Narrativität digitaler Spiele.* Zürich: Chronos.

Korte, Barbara. 1985. *Techniken der Schlussgebung im Roman. Eine Untersuchung englisch- und deutschsprachiger Romane.* Frankfurt am Main and New York: Peter Lang.

Krings, Constanze. 2003. *Zur Typologie des Erzählschlusses in der englischsprachigen Kurzgeschichte.* Frankfurt am Main and New York: Peter Lang.

Kücklich, Julian. 2008. *Playability. Prolegomena zu einer Computerspielphilologie*. Saarbrücken: VDM Müller.

Kuhn, Markus. 2011. *Filmnarratologie. Ein erzähltheoretisches Analysemodell.* Berlin: de Gruyter.

Landow, George P. 2006. *Hypertext 3.0. Critical Theory and New Media in an Era of Globalization.* Baltimore, MD: Johns Hopkins University Press.

Lebowitz, Josiah, and Chris Klug. 2011. *Interactive Storytelling for Video Games. A Player-Centered Approach to Creating Memorable Characters and Stories.* Burlington, VT: Focal Press.

Leitch, Thomas, ed. 2017. *The Oxford Handbook of Adaptation Studies.* New York: Oxford University Press.

Leschke, Rainer, and Jochen Venus. 2007. "Spiele und Formen. Zur Einführung in diesen Band." In *Spielformen im Spielfilm. Zur Medienmorphologie des Kinos nach der Postmoderne*, ed. by Rainer Leschke und Jochen Venus. Bielefeld: Transcript. 7–18.

Lotman, Jurij. 1977. *The Structure of the Artistic Text.* Ann Arbor: Michigan Slavic Contributions.

Macgregor, Jody. "Telltale's Choices Aren't about Plot, but Something More Significant." *PC Gamer.* July 13, 2015. Accessed October 15, 2018. https://www.pcgamer.com/telltales-choices-arent-about-plot-but-something-more-significant/.

Mangen, Anne, and Adriaan van der Weel. 2017. "Why Don't We Read Hypertext Novels?" *Convergence. The International Journal of Research into New Media Technologies 23 (2):* 166–81.

Margolin, Uri. 2014. "Narrator." In *Handbook of Narratology*, ed. by Peter Hühn, John Pier, Wolf Schmid, and Jörg Schönert. Vol. 1: 646–66.

Matuszkiewicz, Kai. 2014. "Internarrativität. Überlegungen zum Zusammenspiel von Interaktivität und Narrativität in digitalen Spielen." *Diegesis* 3 (1). Accessed June 17, 2015. https://www.diegesis.uni-wuppertal.de/index.php/diegesis/article/view/152.

McHale, Brian. 1987. *Postmodernist Fiction.* New York and London: Methuen.

Meister, Jan C. 2014. "Narratology." In *Handbook of Narratology*, ed. by Peter Hühn, John Pier, Wolf Schmid, and Jörg Schönert. Vol. 1: 623–45.

Meister, Jan C., Tom Kindt, and Wilhelm Schernus, eds. 2005. *Narratology beyond Literary Criticism. Mediality, Disciplinarity.* Berlin and New York: Walter de Gruyter.

———. 2005. "Narratology beyond Literary Criticism. Mediality, Disciplinarity. Introduction." In *Narratology beyond Literary Criticism*, ed. by Jan C. Meister, Tom Kindt, and Wilhelm Schernus. ix–xvi.

Miller, D. A. 1981. *Narrative and Its Discontents. Problems of Closure in the Traditional Novel.* Princeton, NJ: Princeton University Press.

Miller, J. H. 1978. "The Problematic of Ending in Narrative." *Nineteenth-Century Fiction*, Special Issue: *Narrative Endings* 33 (1): 3–7.

Mittell, Jason. 2015. *Complex TV. The Poetics of Contemporary Television Storytelling.* New York: NYU Press.

Murray, Janet H. 1997. *Hamlet on the Holodeck. The Future of Narrative in Cyberspace.* Cambridge: MIT Press.

Neitzel, Britta. 2000. *Gespielte Geschichten. Struktur- und prozessanalytische Untersuchungen der Narrativität von Videospielen.* Weimar: Bauhaus University.

———. 2005. "Levels of Play and Narration." In *Narratology beyond Literary Criticism*, ed. by Jan C. Meister, Tom Kindt, and Wilhelm Schernus. 45–64.

———. 2008. "Zurück auf Anfang. Zum Tod in Computerspielen." In *ENDE. Mediale Inszenierungen von Tod und Sterben*, ed. by Petra Missomelius. Marburg: Schüren. 82–90.

———. 2012. "Involvierungsstrategien des Computerspiels." In *Theorien des Computerspiels zur Einführung*, ed. by GamesCoop. 75–103.

———. 2014. "Narrativity of Computer Games." In *Handbook of Narratology*, ed. by Peter Hühn, John Pier, Wolf Schmid, and Jörg Schönert. Vol. 1: 608–22.

Neitzel, Britta, and Rolf F. Nohr. 2010. "Game Studies." *MEDIENwissenschaft: Rezensionen | Reviews* 2010 (4): 416–35.

Neupert, Richard John. 1995. *The End. Narration and Closure in the Cinema*. Detroit: Wayne State University Press.

Nohr, Rolf F. 2007. "Raumfetischismus. Topographien des Spiels." In *Computer/Spiel/Räume*, ed. by Klaus Bartels and Jan-Noël Thon. 61–81.

———. 2014. "Wiederaufsetzen nach dem Tod. Selbstoptimierung, Normalismus und Re-Entry im Computerspiel." In *Trial and Error. Szenarien Medialen Handelns*, ed. by Andreas Wolfsteiner and Markus Rautzenberg. Paderborn: Wilhelm Fink. 251–68.

Orland, Kyle. "The Slow Death of the Game Over." *The Escapist*. June 5, 2007. Accessed December 9, 2018. https://v1.escapistmagazine.com/articles/view/video-games/issues/issue_100/556-The-Slow-Death-of-the-Game-Over.

Parlett, David. "What's a Ludeme? And Who Really Invented It?" *The Incompleat Gamester*. 2007. Accessed April 19, 2017. www.parlettgames.uk/gamester/ludemes.html.

Peckham, Matt. "Fable III: Bad or Good, What's the Difference?" *PCWorld*. October 29, 2010. Accessed July 17, 2018. https://www.pcworld.com/article/209223/fable_iii_bad_or_good_whats_the_difference.html.

Porombka, Stephan. 2001. *Hypertext. Zur Kritik eines digitalen Mythos*. München: Wilhelm Fink.

Prescott, Shaun. "Deus Ex Writer: Each Ending in Human Revolution Was the 'Correct' Ending." *PC Gamer*. November 01, 2015. Accessed November 5, 2018. https://www.pcgamer.com/deus-ex-writer-each-ending-in-human-revolution-was-the-correct-ending/.

Prince, Gerald. 1982. *Narratology. The Form and Functioning of Narrative*. Berlin, New York, and Amsterdam: Mouton Publishers.

———. [1987] 2003. *A Dictionary of Narratology*. Revised Edition. Lincoln and London: University of Nebraska Press.

———. 1996. "Remarks on Narrativity." In *Perspectives on Narratology. Papers from the Stockholm Symposium on Narratology*, ed. by Claus Wahlin. Frankfurt am Main: Peter Lang. 95–106.

———. 1999. "Revisiting Narrativity." In *Grenzüberschreitungen. Narratologie Im Kontext*, ed. by Walter Grünzweig. Tübingen: Narr. 43–51.

Rajewsky, Irina O. 2002. *Intermedialität*. Tübingen: Francke.

Redaktion PAIDIA, ed. 2016. *"I'll remember this." Funktion, Inszenierung und Wandel von Entscheidung im Computerspiel*. Glückstadt: vwh Verlag Werner.

Richter, David H. 1974. *Fable's End. Completeness and Closure in Rhetorical Fiction*. Chicago, IL: University of Chicago Press.

Rowe, Joyce A. 1988. *Equivocal Endings of Classic American Novels. The Scarlet Letter, Adventures of Huckleberry Finn, The Ambassadors, The Great Gatsby.* Cambridge: Cambridge University Press.

Ryan, Marie-Laure. 2001a. "Beyond Myth and Metaphor. The Case of Narrative in Digital Media." *Game Studies. The International Journal of Computer Game Research* 1 (1). Accessed April 20, 2015. www.gamestudies.org/0101/ryan/.

———. 2001b. *Narrative as Virtual Reality. Immersion and Interactivity in Literature and Electronic Media.* Baltimore, MD: Johns Hopkins University Press.

———, ed. 2004. *Narrative across Media. The Languages of Storytelling.* Lincoln: University of Nebraska Press.

———. 2004. "Introduction." In *Narrative across Media*, ed. by Marie-Laure Ryan. 1–40.

———. 2005. "On the Theoretical Foundations of Transmedial Narratology." In *Narratology beyond Literary Criticism.* 1–23.

———. 2006. "From Parallel Universes to Possible Worlds. Ontological Pluralism in Physics, Narratology, and Narrative." *Poetics Today* 27 (4): 633–74.

———. 2007a. "Toward a Definition of Narrative." In *The Cambridge Companion to Narrative*, ed. by David Herman. Cambridge and New York: Cambridge University Press. 22–35.

———. 2007b. "Narrative and the Split Condition of Digital Textuality." In *The Aesthetics of Net Literature*, ed. by Peter Gendolla and Jörgen Schäfer. 257–80.

———. 2017. "Transmedia Storytelling as Narrative Practice." In *The Oxford Handbook of Adaptation Studies*, ed. by Thomas Leitch. 527–41.

———. 2014a. "Narration in Various Media." In *Handbook of Narratology*, ed. by Peter Hühn, John Pier, Wolf Schmid, and Jörg Schönert. Vol. 1: 468–88.

———. 2014b. "Possible Worlds." In *Handbook of Narratology*, ed. by Peter Hühn, John Pier, Wolf Schmid, and Jörg Schönert. Vol. 1: 726–42.

Ryan, Marie-Laure, and Jan-Noël Thon, eds. 2014. *Storyworlds across Media. Toward a Media-Conscious Narratology.* Lincoln: University of Nebraska Press.

Saint-Gelais, Richard. 2011. *Fictions transfuges. La transfictionnalité et ses enjeux.* Paris: Seuil.

Salen, Katie, and Eric Zimmerman. 2003. *Rules of Play. Game Design Fundamentals.* Cambridge: MIT Press.

Sallge, Martin. 2010. "Interaktive Narration im Computerspiel." In *Das Spiel. Muster und Metapher der Mediengesellschaft*, ed. by Caja Thimm. Wiesbaden: VS Verlag für Sozialwissenschaft. 79–104.

Schäfer, Jörgen. 2007. "Gutenberg Galaxy Revis(it)ed. A Brief History of Combinatory, Hypertextual and Collaborative Literature from the Baroque Period to the Present." In *The Aesthetics of Net Literature*, ed. by Peter Gendolla and Jörgen Schäfer. 121–60.

Schmidt, Hanns Christian. 2017. "Der Große Böse Wolf in New York. Zur Konstruktion Medienübergreifender Abenteuerwelten Im Computerspiel." In *Aventiure und Eskapade. Narrative des Abenteuerlichen vom Mittelalter zur Moderne*, ed. by Jutta Eming and Ralf Schlechtweg-Jahn. Göttingen: V&R unipress. 217–34.

Schmidt, Siegfried J. 2000. *Kalte Faszination. Medien, Kultur, Wissenschaft in der Mediengesellschaft.* Weilerswist: Velbrück Wiss.

Schmöller, Verena. 2012. *Was wäre, wenn … im Film. Spielfilme mit alternativen Handlungsverläufen.* Marburg: Schüren.

THE STANLEY PARABLE *Wiki*. "Explosion Ending." Last modified January 11, 2015. Accessed April 13, 2015. http://thestanleyparable.wikia.com/wiki/Explosion_Ending.

———. "Not Stanley Ending." Last modified April 26, 2018. Accessed June 20, 2018. http://thestanleyparable.wikia.com/wiki/Not_Stanley_Ending.

Stanzel, Franz K. [1979] 2008. *Theorie des Erzählens*. Göttingen: Vandenhoeck & Ruprecht.

Sternberg, Meir. [1978] 1993. *Expositional Modes and Temporal Ordering in Fiction*. Bloomington: Indiana University Press.

———. 1982. "Proteus in Quotation-Land. Mimesis and the Forms of Reported Discourse." *Poetics Today* 3 (2): 107–56.

———. 1990. "Telling in Time (I). Chronology and Narrative Theory." *Poetics Today* 11 (4): 901–48.

———. 1992. "Telling in Time (II). Chronology, Teleology, Narrativity." *Poetics Today* 13 (3): 463–541.

Strank, Willem, and Hans Jürgen Wulff. 2014. *Twist Endings. Umdeutende Film-Enden*. Marburg: Schüren.

Suits, Bernard. 1978. *The Grasshopper. Games, Life and Utopia*. Toronto: University of Toronto Press.

Summers, Tim. 2016. *Understanding Video Game Music*. Cambridge: Cambridge University Press.

Sutton-Smith, Brian. 1997. *The Ambiguity of Play*. London and Cambridge, MA: Harvard University Press.

Taylor, Laurie. 2003. "When Seams Fall Apart. Video Game Space and the Player." *Game Studies. The International Journal of Computer Game Research* 3 (2). Accessed May 5, 2017. www.gamestudies.org/0302/taylor/.

THiLO. 2005. *Der Tempel des Schreckens. 1001 Abenteuer*. Bindlach: Loewe Verlag.

Thon, Jan-Noël. 2008. "Immersion Revisited. On the Value of a Contested Concept." In *Extending Experiences. Structure, Analysis and Design of Computer Game Player Experience*, ed. by Olli Leino, Hanna Wirman, and Amyris Fernandez. Rovaniemi: Lapland University Press. 29–43.

———. 2015. "Game Studies und Narratologie." In *Game Studies. Aktuelle Ansätze der Computerspielforschung*, ed. by Klaus Sachs-Hombach and Jan-Noël Thon. Köln: Herbert von Halem Verlag. 104–64.

———. 2016. *Transmedial Narratology and Contemporary Media Culture*. Lincoln: University of Nebraska Press.

Torgovnick, Marianna. 1981. *Closure in the Novel*. Princeton, NJ: Princeton University Press.

Tresca, Michael J. 2011. *The Evolution of Fantasy Role-Playing Games*. Jefferson, IA: McFarland.

Unterhuber, Tobias, and Marcel Schellong. 2016. "Wovon wir sprechen, wenn wir vom 'Decision Turn' sprechen." In *"I'll remember this,"* ed. by Redaktion PAIDIA. 15–31.

Wagner, Birgit. 2016. "Zur Einleitung: Serialität und Brucherzählung – ein Paradox?" In *Bruch und Ende im seriellen Erzählen. Vom Feuilletonroman zur Fernsehserie*, ed. by Birgit Wagner. Göttingen: V&R unipress. 7–16.

Walsh, Richard. 1997. "Who Is the Narrator?" *Poetics Today* 18 (4): 495–513.

Wardrip-Fruin, Noah and Pat Harrigan, eds. 2004. *First Person. New Media as Story, Performance, and Game*. Cambridge: MIT Press.

Wenzel, Peter. 2015. "Endings in Literature. A Survey." In *Last Things,* ed. by Gavin Hopps, Stella Neumann, Sven Strasen, and Peter Wenzel. 19–34.

Winters, Ben. 2008. "Corporeality, Musical Heartbeats, and Cinematic Emotion." *Music, Sound, and the Moving Image* 2 (1): 3–25.

Wolf, Mark J. P. 2002. *The Medium of the Video Game.* Austin: University of Texas Press.

Wolf, Werner. 2002a. "Intermediality Revisited. Reflections on Word and Music Relations in the Context of a General Typology of Intermediality." In *Word and Music Studies. Essays in Honor of Steven Paul Scher and on Cultural Identity and the Musical Stage,* ed. by Suzanne M. Lodato, Suzanne Aspden, and Walter Bernhart. Amsterdam and New York: RODOPI. 13–34.

———. 2002b. "Das Problem der Narrativität in Literatur, bildender Kunst und Musik. Ein Beitrag zu einer intermedialen Erzähltheorie." In *Erzähltheorie transgenerisch, intermedial, interdisziplinär,* ed. by Vera Nünning and Ansgar Nünning. Trier: WVT, Wiss. Verl. 23–104.

———. 2004. "'Cross the Border – Close That Gap.' Towards an Intermedial Narratology." *EJES – European Journal for English Studies* 8 (1): 81–103.

———. 2005. "Metalepsis as a Transgeneric and Transmedial Phenomenon. A Case Study of the Possibilities of 'Exporting' Narratological Concepts." In *Narratology beyond Literary Criticism.* 83–107.

———. 2006. "Introduction. Frames, Framings and Framing Borders in Literature and Other Media." In *Framing Borders,* ed. by Werner Wolf and Walter Bernhart. 1–40.

———. 2007. "Description as a Transmedial Mode of Representation. General Features and Possibilities of Realization in Painting, Fiction and Music." In *Description in Literature and Other Media,* ed. by Werner Wolf and Walter Bernhart. Amsterdam and New York: RODOPI. 1–87.

———. 2013. "'The sense of the precedence of [...] event[s]' – 'a defining condition of narrative' across Media?" *Germanisch-Romanische Monatsschrift* 63 (2): 245–59.

. 2014a. "Framings of Narrative in Literature and the Pictorial Arts." In *Storyworlds across Media,* ed. by Marie-Laure Ryan and Jan-Noël Thon. 126–47.

———. 2014b. "Illusion (Aesthetic)." In *Handbook of Narratology,* ed. by Peter Hühn, John Pier, Wolf Schmid, and Jörg Schönert. Vol. 1: 270–87.

———. 2017. "Transmedial Narratology. Theoretical Foundations and Some Applications (Fiction, Single Pictures, Instrumental Music)." In *Transmedial Narratology: Current Approaches,* ed. by Markus Kuhn and Jan-Noël Thon. Special issue: *Narrative* 25 (3): 256–84.

Wolf, Werner, and Walter Bernhart, eds. 2006. *Framing Borders in Literature and Other Media.* Amsterdam and New York: RODOPI.

Zagal, José P., and Michael Mateas. 2007. "Temporal Frames. A Unifying Framework for the Analysis of Game Temporality." *DiGRA 2007. Proceedings of the 2007 DiGRA International Conference: Situated Play* (4): 516–23.

Index

Note: *Italic* page numbers refer to figures and page numbers followed by "n" denote endnotes.